BEAUTIFUL BOYS/OUTLAW BODIES

BEAUTIFUL BOYS/OUTLAW BODIES: DEVISING KABUKI FEMALE-LIKENESS

Katherine Mezur

BEAUTIFUL BOYS/OUTLAW BODIES

First published in 2005 by
PALGRAVE MACMILLAN™
175 Fifth Avenue, New York, N.Y. 10010 and
Houndmills, Basingstoke, Hampshire, England RG21 6XS
Companies and representatives throughout the world.

PALGRAVE MACMILLAN is the global academic imprint of the Palgrave Macmillan division of St. Martin's Press, LLC and of Palgrave Macmillan Ltd. Macmillan® is a registered trademark in the United States, United Kingdom and other countries. Palgrave is a registered trademark in the European Union and other countries.

ISBN 1–4039–6712–1

Library of Congress Cataloging-in-Publication Data

Mezur, Katherine.
 Beautiful boys / outlaw bodies : devising kabuki female-likeness / Katherine Mezur.
 p. cm.
 Includes bibliographical references and index.
 ISBN 1–4039–6712–1
 1. Kabuki. 2. Female impersonators—Japan. I. Title.

PN2924.5.K3M43 2005
792′.0952—dc22 2005042971

A catalogue record for this book is available from the British Library.

Design by Newgen Imaging Systems (P) Ltd., Chennai, India.

First edition: October 2005

10 9 8 7 6 5 4 3 2 1

Printed in the United States of America.

To the Teachers of the Heart

CONTENTS

LIST OF ILLUSTRATIONS

Special thanks to the photographer Yoshida Chiaki and The Organization for the Preservation of Kabuki c/o The National Theatre and their administrator Kurashige Takado and also Nakata Rika, Assistant to Nakamura Jakuemon IV, for the permission to use the photographs. Special thanks to Mizuho Tsukada and the Tsubouchi Memorial Theatre Museum for the use of the prints. All photographs are credited to Yoshida Chiaki except where unknown is indicated.

Prints

Photographs

ACKNOWLEDGMENTS

The research for this book was made possible through the generous support of the Fulbright Foundation, the Social Science Research Council, and the Japan Society for the Promotion of Science. I wish to especially thank the Fulbright office in Tokyo, the Waseda University Theatre Department and the Tsubouchi Memorial Theatre Museum faculty and staff, Shōchiku Ltd. managers and staff, and The National Theatre staff, particularly Hamatani Hiroshi, for providing access to their resources and facilitating every step of my research. I wish to thank the University of California Berkeley's Beatrice M. Bain Research Group on Gender, the Visiting Scholar Program, the Department of Rhetoric, the Film Studies Program, and the Department of Theatre, Dance, and Performance Studies for their support of my research.

I am forever grateful to Gunji Masakatsu whose brilliant insights and generous time were pivotal to my research. I am deeply thankful to William Malm, who first inducted me into the world of Japanese theatre music and continued supporting my research. Leonard Pronko and Tomono Takao's dazzling performance demonstrations of onnagata stylization, first inspired me to focus on the art of the onnagata. Leonard Pronoko also introduced me to the late Onoe Baikō VII, who literally led me down the hallways of the backstage dressing rooms of the Kabuki-Za, introducing me to many onnagata and paving the way for all my subsequent years of interviews and research. David Goodman and J. Thomas Rimer have been great mentors and continue to inspire my research and writing, particularly probing my contemporary performance analysis.

I wish to extend my deepest gratitude to every onnagata who opened his heart and took the time to talk with me about his art. I am especially grateful to the late Onoe Baikō VII, Nakamura Jakuemon IV, Nakamura Shikan VII, Nakamura Ganjirō III, and Sawamura Tanosuke VII to whom I returned countless times to observe their backstage preparations. I also thank Ichikawa Ennosuke III, Bando Tamasaburō V, Kataoka Hidetarō II, Kataoka Takatarō, Nakamura Fukusuke IX, Nakamura Hashinosuke III, Nakamura Kankurō V (Kanzaburō XVIII) Nakamura Matagorō II, Nakamura Matsue V,

Nakamura Tokizō V, Nakamura Shibajaku VII, Nakamura Utaemon VI, Onoe Kikugorō VII, and other actors and their managers who took the time to consider my queries and gave me insightful and heartfelt thoughts and explanations. Each gave me his unique view of his art. Nakamura Ganjirō III was especially generous when he came to teach a workshop for my students at the California Institute of the Arts and UCLA Department of World Arts and Cultures, transforming all our lives with his incredible energy and devotion to the art of kabuki.

I am also deeply grateful to the faculty and staff at Waseda University, especially Torigoe Bunzō and Furuido Hideo whose patience and depth of knowledge inspires me still. I wish to thank those whose deeply personal experience of kabuki opened and challenged my research: the staff of Asahi Earphone Guide; my Kabuki dance teachers, Hanayagi Chiyō, Hanayagi Tarō, Fujima Toshinami, Fujima Kaniichi, and Fujima Kansome. I am indebted to Nakamura Matagoro II and Sawamura Tanosuke VII for their permission to observe their hours of teaching kabuki trainees at the National Theatre. The critic and scholar, Watanabe Tamotsu, found time to discuss his insights on the art of the onnagata from his long association with Nakamura Utaemon, which was invaluable to my research. Hattori Yukio's writings and conversations with me about "transformation" in Japanese culture greatly illuminated and clarified my main thesis on gender transformativity. My thanks to all the Waseda University theatre scholars, especially Wada Osamu, and the Tsubouchi Memorial Theatre Museum staff and research associates particularly, Okada Mariko, Maeda Manami, and Mizuho Tsukada for their in-depth knowledge and special assistance during my research. I hope this book reflects the insights that the late Faubion Bowers offered me concerning the postwar world of kabuki and his thoughts on the sensuality of the onnagata.

The Tsubouchi Memorial Theatre Museum has generously given their permission to use a few kabuki prints from their collection. I wish to thank The Organization for the Preservation of Kabuki at the National Theatre and their administrator, Kurashige Takako, for their help in procuring special permission for the actor photographs by Yoshida Chiaki. I am also indebted to Nakata Rika, special assistant to Nakamura Jakuemon IV, who was instrumental in gaining the approval for my use of the photographs in this scholarly edition.

I wish to acknowledge the dedication and brilliance of my professors at the University of Hawai'i. In particular, James R. Brandon, Juli Burk, Roger Long, Arthur Thornhill, and Elizabeth Wichmann-Walczak who spent countless hours teaching, mentoring, and challenging my theories and research. I am particularly indebted to Patricia Steinhoff who encouraged me at the most crucial moments. I could not have probed beyond the surface without

Juli Burk who first opened the world of feminist theory to me, changing my life, radically and forever. Her rigorous and discerning questions coupled with warmth and compassion kept me going over time and distance. During my first year of Japanese language study at the University of Washington, John Treat was one of the first who encouraged my onnagata research.

In all the stages of research and writing, I have benefited greatly from the wisdom and insightful comments of many scholars, artists, and friends. My thanks to Faith Bach, Annegret Bergmann, Judith Butler, Sue-Ellen Case, Peter Eckersall, Dick Hebdige, Fujita Hiroshi, Ishii Tatsurō, Susan Klein, Kisaragi Koharu, Kuniyoshi Kazuko, Sam Leiter, Carol Martin, Judy Mitoma, Nakamura Mansaku, Susan Napier, Sally Ness, Jennifer Robertson, Sasai Eisuke, Stanca Scholz-Cionca, Peta Tait, Shelia Wood, and Uchino Tadashi. Jennifer Robertson's book, *Takarazuka* was instrumental in helping me to design my onnagata gender and female-likeness arguments. Outside of kabuki, the butoh artist and teacher, Ohno Kazuo, inspired me and added his own reading of female-likeness and transformation. My Japanese tutor, Saitō Ryōko who is also a kabuki fan, deserves special accolades, for her perseverance and patience as I painstakingly translated all my recorded interviews, articles, and numerous actor diaries and critical reviews. Special thanks to Ann Foley whose insights shaped the book. My editor at Palgrave Macmillan, Anthony Wahl, and editorial assistant, Heather Van Dusen have made this book possible with their ongoing assistance, encouragement, and insight: Thank you.

During my tenure as a research scholar at the University of California Berkeley, colleagues and friends who added their insights and guidance include Chris Berry, Reiko Mochinaga Brandon, Shannon Jackson, Gee Gee Lang, Laura E. Perez, Kaja Silverman, Shannon Steen, Alan Tansman, Trinh T. Minh-ha, and Linda Williams. While participating in their seminars and presenting on my research, I gained so much from their engaged teaching, their deft and incisive inquiry, and their graduate students who added their own critical insights to my work. I think this book reflects some of the deep and challenging questions raised in those seminars.

I wish to acknowledge the women and men who work backstage taking care of all the actors, especially the onnagata. It is their warmth, labor, and deepest dedication, which makes the show go on. They gave me the most intimate glimpses into the onnagata's daily, life-long, bone-breaking struggle for and devotion to the creation of fantastic beauty.

Finally, I could never have gone so deeply into my studies nor have had such an adventure without Matthew Armour. *Kokoro kara dōmo arigatō.*

CHAPTER 1

TRANSFORMING GENDERS

*Performing the Kabuki Paradigm of
Female-likeness, Bodies Beneath, and
Beautiful Boys*

Throughout the 300-year history of professional kabuki theatre, men have performed both female and male gender roles. In the early seventeenth century, women and men performed in the formative stages of kabuki performance. Beginning with kabuki's female founder, Izumo no Okuni (act. 1603–1619)—both women and men frequently played different gender roles. With the official government edict in 1629 that prohibited women from performing in public, men, particularly youths, took over the theatrical representations of kabuki's female gender roles. In these early stages of exclusively male kabuki, performers generally specialized in either female gender roles or male gender roles. The female gender role specialists were called *onnagata*, and the male gender role specialists were called *tachiyaku*.[1] Over time, onnagata creatively formulated fantastic female-like gender roles constituted from stylized gender acts. Gradually, an ideal fiction of "female-likeness,"[2] with its own sensual and visual aesthetics, evolved through generation after generation of onnagata and their artistry, ingenuity, and perseverance.

During the Edo period (1603–1868), Kabuki onnagata invented their gender acts in accordance with the repressive discourses on ideal female-likeness and behavior set down by the governing body, the *bakufu*.[3] According to Jennifer Robertson, a performance ethnographer, Japanese women of the Edo period emulated the ideal female-likeness created by onnagata:

> The paragon of female-likeness in Tokugawa [Edo] society remained the
> Kabuki *onnagata*: male actors who modeled gender constructs developed by

male intellectuals. In effect, women's hypothetical achievement of "female" gender was tantamount to their impersonation of female-like males, who in turn, were not impersonating particular females but rather enacting an idealized version (and vision) of female-likeness. Bakufu ideology did not and could not accommodate women's control over the construction and representation for "female" gender.[4]

Thus, the onnagata did not aim at "representing" women; they performed their own many layered "vision" of a constructed female-likeness.[5]

Despite *bakufu* ideology and prescriptions, onnagata were able to claim a space in which to create and cultivate their own gender acts. The onnagata tradition in kabuki theatre, with its long history of creative development, is known for its innovation, experimentation, and refinement. It is profoundly important to understand that kabuki onnagata, from mid-seventeenth century until the late nineteenth century, had the exclusive rights to female gender role representation on the public stage in Japan.[6] During this lengthy period of time, onnagata developed and successfully established their gender art with its own particular aesthetics and iconography.

From the beginning of adult male kabuki, at the end of the seventeenth century, kabuki performers tended to specialize in roles of one gender. Male performers developed a system of stylized gender acts in order to distinguish their gender roles. The female-like gender role was among the gender role specializations.[7] Star onnagata created their gender roles through stylization techniques, which they evolved through the articulation of their bodies, voices, and costuming practices. Subsequent generations of onnagata performers imitated, refined, and remodeled the stylized techniques, fitting them to their own bodies and styles of gender performance.[8] Through a process of assimilation and sedimentation, certain techniques gradually became the standards for onnagata performance. The Edo period onnagata skillfully played with their gender acts and created a variety of female-like gender roles and a repertoire of role types with varying degrees of gender ambiguity. Leading onnagata gender role specialists, the stars of their day, contributed to setting—through repetition and innovation—the iconic images of the onnagata *yakugara* (role types)—the kabuki fictions of female-likeness.

Kabuki's social milieu, particularly the society of men and boys in the entertainment world, was a special world with its own cultural practices. *Nanshoku* (male love), that is, male same-sex love and its related performance aesthetics was an important part of the development of kabuki onnagata gender roles. In particular, *bishōnen no bi* (beauty of male youth)— the aesthetics of the beautiful boy—shaped onnagata gender acts and role types. In the early stages, onnagata elevated the adolescent boy body into a

stylized paradigm of female-likeness. Edo period Japan was not a Christianity-based culture with a history of prohibitions on homosexuality, erotic performance, or prostitution. Rather, it was a society in which the men in power integrated behavioral codes, assimilated from Confucian models, with a multilayered, diverse system of Buddhist and Shintō beliefs and practices. While some of these codes and practices favored heterosexuality, they did not condemn homosexuality. Throughout Japanese history, same-sex love between men was a highly regarded practice that went in and out of fashion depending on the style of the ruling class and their leaders' sexuality.[9]

Shudō (way of youths), the way of adolescent boy love, was part of the *nanshoku* tradition. Sexuality and sensual attraction, especially as practiced in early kabuki performance from Okuni to *wakashu* (male youth) kabuki (1600–1652), were not prescribed in heterosexual terms. *Shudō* has a long and important history in Japan, especially in relation to the performing arts and the stylization of the female gender acts. In his book, *The Love of the Samurai*, Watanabe Tsuneo[10] defends the idea of a male beauty, which, according to him, was not an appropriation of female-likeness, but a tradition of boy beauty:

> Prince Yamato Takeru (c.4th century AD) and Minamoto no Yoshitsune (1159–89), two very popular heroes, both went through various episodes of "transvesticism." . . . At the court of Heiankyō in the 12th century the courtiers and the young boys of their class used to powder themselves, paint on false eyelashes, perfume themselves and dress up very elegantly. This male tradition of makeup and beautiful costume was inherited by young samurai of high class and was further developed through the centuries of feudalism, becoming more and more widespread among the samurai and the middle classes as well. In the 17th century particularly, the manner of dress of the wakashu, the young men usually between twelve and twenty years of age became most charming and androgynous.[11]

Watanabe goes on to cite the *oyama*, another name for onnagata, as the most artistic form of these practices. He also notes that the onnagata stylized *wakashu* fashions, such as the *maegami* (long front forelock) and the kimono with long *furisode* (furling sleeves) into their gender acts. Even as onnagata aged, they maintained the stylized gender acts based on the *wakashu* tradition of adolescent boy beauty and sensuality.

It appears that the beauty of the young boy eventually became the ideal of beauty for both men and women. Even women courtesans, revered for their stunning fashions, were known to emulate *wakashu* fashions, while *wakashu* performers elaborated on their *wakashu* ambiguity of appearances.[12]

By banning women from the public stage in 1629 and boys in 1652, leaving only adult men with the privilege of professional stage performance, the government strengthened the attraction of kabuki onnagata, maintaining male supremacy in the representation of all genders. Because they were not women, onnagata had the freedom to create their own kind of female-likeness with their male bodies.

Thus, the female gender role in kabuki was never performed in imitation of real women. Rather, onnagata built on the original boy body aesthetic, designating certain theatrical elements and techniques—such as costuming, wigs, makeup and a choreography of postures, gestures, and locomotion—as kabuki female-likeness. The kabuki stylization of female-likeness generally emphasizes smallness and a soft, graceful line of the body. Therefore, on stage, the basic onnagata tenet is, kneeling or standing, to place the body slightly upstage and lower than the male gender role actors, with a slight diagonal facing to enhance the line of the body.[13]

The onnagata female-like appearance is partially constructed by the kimono and *obi* (waist sash), a long band of cloth, which the actor winds and ties around the kimono in order to bind and shape it. Contemporary onnagata kimono and *obi* completely envelope the actor's body. The only flesh that shows is that of the face, which is pulled taut and painted; the hands, and at times only the tips of the fingers; the back neckline and upper back; and sometimes the bare feet or a sliver of skin above the *tabi* (cloth socks with bifurcated toe space). Any flesh that does show is usually painted and powdered white, unless it is a lower-class role. The spectators see selectively framed and prepared glimpses of "flesh." The onnagata female-likeness is a fiction of fabric, makeup, and decorations, carefully designed to stimulate the viewers' imaginations. The onnagata subtly reveal unpainted glimpses of their male body flesh at the wig line at the back of the neck, and behind the ears at the side of the neck, which, in a delicate bow of the head, exposes a hint of their male body beneath. The spectators are aware of the male body and the onnagata gender role. They may freely imagine the onnagata's constructed body with their preferred sexual configuration.[14]

For various reasons, the onnagata's constructed fiction of female-likeness is something that real women do not perform. Many popular explanations for the continued practice of men in female roles in kabuki performance center around physical strength and endurance. This argument asserts that women cannot play onnagata roles because men have created a performance style for kabuki female role representation that requires a man's body. First, the size and strength of the male body is considered necessary to carry the weight and massiveness of costumes; second, the eroticism of the male body performing female-like representations is also considered essential.[15]

Leonard Pronko writes: "Japanese claim that only a man possesses the steel-like power hidden by softness, which is requisite to a successful onnagata creation."[16] Earle Ernst emphasizes a similar point when he writes, "According to the Japanese, although the surface of the woman portrayed should be soft, tender and beautiful, beneath this surface there should be a strong line which can be created only by a man."[17] These statements suggest that whatever it is onnagata do in kabuki theatre, Japanese women cannot attain it themselves, even if they imitate onnagata. Their imitation of onnagata would be a performance of onnagata female-likeness over a female body.

Another popular explanation for why men continue to enact kabuki female roles is that an onnagata enacts a "Woman who is more feminine than a real woman."[18] Samuel Leiter points out that, "Probably the most outstanding example of stylization in Kabuki, the onnagata . . . is a man who typifies the essence of femininity more effectively than would an actress playing the same role."[19] While I agree with Leiter that onnagata stylization is exemplary, when we reconsider onnagata stylization as constructed gender acts, their stylized acts of female-likeness contradict any concept of an "essence of femininity." Instead the female-styled construct and enact a male-body-styled fiction of femininity. In other words, onnagata gender acts have evolved into a distinct representation of a "femininity," or a female-likeness, which must be performed by a male body. Further, because onnagata emphasize that they *perform* female-likeness,[20] their intention is very different from embodying or becoming the "essence of femininity."

In contemporary performance, an onnagata enacts a fiction of the female-likeness created during the Edo period (1603–1867). The stage today reflects a reconstruction of a fictional past. Edo kabuki scholar, Hattori Yukio, discusses how elements like the onnagata of contemporary kabuki are part of a reconstructed Edo period renaissance and revival or *boomu* (boom), in contemporary theatre. How and what is being absorbed as "tradition" in contemporary Japan, he suggests, should be recognized as an idealized version and a romanticized vision of past cultural practices.[21] I would add that the fictional reconstructions, performed by contemporary kabuki onnagata, gain a strong nostalgic power as they are reshaped within today's popular culture. The onnagata images, postures, gestures, and vocal patterns have become part of a romanticized cultural heritage that glows with a fantasy-like authenticity. Like an animated film, the stage version is obviously not real. Nonetheless, contemporary onnagata in performance have mythic strength, nostalgic attraction, and popular appeal as icons from a romanticized tradition.[22]

I think that the public is deeply attracted to the onnagata image as a traditional icon, which is an exotic and theatrical representation of female-like beauty in a fictional past. Hattori calls for a further investigation of the

power and influence of tradition in modern theatre.[23] His recognition of the Edo revival in modern performance accounts, in part, for the public's continuing fascination for onnagata performance both inside and outside kabuki theatre.[24] I believe that contemporary Japanese men and women alike are attracted to the onnagata in performance. They may even incorporate certain onnagata female-like gender acts into their daily postures and gestures. This public fascination with onnagata gender performance as a fiction of female-likeness from a fantastic past may be part of what Hattori suggests as the ascendancy of a nostalgia for a fictive past.[25]

The onnagata image calls upon the past, but it also has a place in contemporary Japanese culture and gender politics. Like Hattori, I believe that the survival and current revival of certain kabuki practices such as onnagata is also an indication of their strength and adaptability to contemporary theatrical requirements and aesthetics. In particular, the onnagata's construction and performance of female-like gender acts lends itself to contemporary performance and performance theory concerning the performativity and transformativity of gender roles.

Extraordinary Gender Acts

The present study examines the creation, historical development, and contemporary performance of the onnagata role, using feminist theories of gender performativity to formulate a theory of onnagata gender performance. I focus on the onnagata's process of stylization: how he shapes his body's posture, gestures, and actions into gender acts. I follow the evolution of the onnagata's gender acts from their early stages into their full-blown fiction of female-likeness, which continues to work on stage in contemporary kabuki theatre. To this end, I analyze the performance of contemporary onnagata as an art of "gender acts," a term I use to indicate the specific physical actions that compose a role type. I trace these gender acts through the bodies of past star onnagata, whose personal styles and innovations form the traditional base, to contemporary kabuki performance. I hope to demonstrate how onnagata, with their compelling performance strategies, construct their own versions of "female-likeness," whose "female" and "likeness" is based on a fiction of a beautiful boy body.

Using the theory of the performativity of gender acts, I suggest that onnagata perform ambiguous, multiple, and transformative roles that have the potential to subvert the idea of a fixed and abiding gender identity. I use theory as an artistic tool to illuminate and creatively reconfigure particular performance constructs and practices. I am interested in how cultural expressions, like the kabuki onnagata gender performance, reflect and reinforce such cultural paradigms as the fiction of Woman or a core female

gender identity.[26] How do the aesthetic forms that onnagata employ in their gender role enactments reflect *and* disrupt an underlying system of bipolar gender identities?

My investigation of onnagata gender acts addresses several key points. First, a performative onnagata gender role is a fiction of female-likeness based on a male "body beneath."[27] In other words, the performer is actually a Japanese man (with male genitalia) underneath the onnagata stylized acts. I do not believe there are any kabuki onnagata performances without this recognition by the viewer of the male body beneath. The interaction of gaze and imagination with surface and beneath the surface is central to the onnagata art. Second, onnagata play with the characteristics of their gender acts in order to alter their meanings. Thus, these performative acts are likely to have multiple, ambiguous readings. Third, the ambiguity and transformativity of onnagata gender acts undermine the theatrical convention that links the biological body with gender acts and role types. Through stylization, onnagata denaturalize the conventions of gender, emphasizing the exteriority of the roles by playing with the illusion of surface appearances. Fourth, the illusion or fiction of a female-like gender opens the field for multiple types of gender performances, each with their unique and variable sensualities. The onnagata's subtle and flamboyant stylization practices may potentially be applied as disruptive strategies in theatrical contexts other than kabuki.

Onnagata gender performance might be regarded as an example of a theatrical reconfiguring of the gender/sex system, whereby the body of the performer regains its power as an ambiguous sign "to be inscribed only by its interpreter and rewriter and bearing no originary intent."[28] Although there may have been some imitation of female characteristics by some kabuki onnagata[29] in the early *yarō* (adult fellow) kabuki of eighteenth century, onnagata gender roles are not limited to the imitation or representation of women, the female body, or the ideal Woman as defined within a bipolar gender system.

The forms that make up onnagata gender role performance have been studied and researched in historical and live documentation. But they have not been analyzed with feminist concepts of gender performativity. First, I focus on the deconstruction of the idea of gender as a core identity or "essence," inseparable from female or male genitalia. Then, I demonstrate how the gender acts that represent ideals of beauty and attraction in female gender performance reveal their own fabrication of gender as "a fantasy instituted and inscribed on the surfaces of bodies . . ."[30] The goal is to reveal how onnagata demonstrate the performativity of gender as well as the variability and instability of the construct of gender.

To begin my investigation, I reread the history of onnagata gender performance as a male-authorized and male body-based gender performance. My account of onnagata development draws attention to the *wakashu*, the

adolescent male prostitutes of pre- and early kabuki dance and drama forms. I propose that the image and physical characteristics of the *wakashu* became the basis for onnagata gender acts in the late seventeenth and early eighteenth centuries. I selected twentieth-century onnagata gender stylizations of the body and gender role types to analyze as concrete activities of gender performance. I discuss the main aesthetic principles, including *iroke*, a form of erotic stylization, and *zankoku*, a form of stylized torture, which govern most onnagata gender performance.

In particular, I examine the characteristics of ambiguity, transformativity, and multiplicity that have emerged in my investigation of onnagata gender performance. I suggest that there is an ambiguous interplay between the male actor body and the onnagata gender role, made up of gender acts created by and with the male body beneath. Through the skillful manipulation of gender acts, the onnagata simultaneously performs both his male body beneath and his role. While on stage, an onnagata does not obscure his body beneath with the female-likeness; rather, he discloses his male body underneath the costume according to aesthetic prescriptions and personal style.

The onnagata creates multiple gender readings by revealing, concealing, fracturing, or partially obscuring his male body beneath with his onnagata gender role image, or vice versa. He "plays up" the interplay between his body beneath and the role. The onnagata varies how he relates his male body beneath to the female gender acts of his role. He creates an ambiguously gendered stage presence. Thus, spectators may hold different views of his gender and their views may also change during the course of a performance. Further, when an actor shifts between his body beneath and the gender role, the ambiguous gender image has its own unique eroticism. Onnagata gender role performance relies on both conscious shifting and accidental slippage between the male actor body beneath and the constructed gender acts.

To clarify, each onnagata interacts with the stylized gender acts and his own body with its own prescribed acts. In this complex system, onnagata gender acts cannot easily be categorized as male or female. In a sense, onnagata create their own range of genders. In their fracturing of a fixed gender/sex identity, onnagata demonstrate the complexity of the relationship between gender acts and the body beneath. Onnagata are incredible gender technicians who confound the binary gender system and its eroticism based on the attraction of "opposite" sexes.

The theme of how an onnagata, with his male body beneath the gender acts, alters the cultural constructs of female and male in theatrical presentation reverberates throughout onnagata history and role type development. The onnagata created a radical performance art based on gender ambiguity between a role type and his own body beneath. The theatrical potency and

eloquence of onnagata gender performance is based largely on the time-tested stylized gender acts and the performers' abilities to use the transformative potential of those stylized gender acts. That onnagata gender stylization practices suggest a mode of performing that transcends conventional gender identity restrictions.[31]

The idea of the body beneath is virtually inseparable from how an onnagata is perceived by spectators. Spectators interact in their imaginations with the onnagata's surface articulation and his body beneath. A spectator's perception of the body beneath is shaped by individual, cultural, racial, class, and sexual differences. Kabuki onnagata gender acts provide spectators with the opportunity for a lively and sensual encounter. They may experience desire and attraction, loathing and revulsion, or any number of feelings, all of which are charged with personal and cultural taboos. Readers of kabuki texts and spectators of kabuki must keep the onnagata presence in mind to avoid confusing female characters for representations of women. When a princess role is read as an onnagata role (a female gender role and a male body beneath), the seduction scene between a male gender priest role and the female gender princess role has an entirely different sensuality and eroticism.[32] Without the viewer's awareness that onnagata are constructing and enacting a female-likeness with a male body beneath, there is no kabuki onnagata.

The onnagata transforms his sex/gender configuration in his fluid relationship with the visual and kinaesthetic patterns of stylized gender acts. From a feminist perspective, the kabuki onnagata operates "through mobilization, subversive confusion"[33] of those categories that cement gender into gender identities. Onnagata gender role performance skills are strategic theatrical devices for altering modes of cultural production: the signs made upon the body can move beyond the hegemonic prescriptions of sex/gender systems.[34]

Intercultural Feminist Methodology

A major concern of this book is the application of feminist theories to a culture for which the theories were not developed. In researching the art of kabuki onnagata with the tools of feminist critical inquiry, I found myself shifting through various positions—foreigner, Western woman, scholar, performer, insider, and outsider—each with a distinctly different vantage point. As part of my methodology, I studied the history and context of Japanese gender signs, sexual codes, gender role paradigms, and aesthetics. In this way, I sought to contextualize Western feminist theories to avoid the possible ethnocentric misreading of the foreign material. However, I acknowledge that my examination of onnagata performance history and practice is an

experiment that crosses many borders of theories, cultures, and theatrical practices.

As this study is about the "liveness" of performance, that is, the ephemeral, visual, aural, and kinaesthetic vitality of the performers, I attempt to theorize the production of a particular performance phenomenon by studying the moments where theory and practice intersect. In her article "Geographies of Learning: Theatre Studies, Performance, and the 'Performative,'" Jill Dolan cites the unique feature of theatrical performance that "offers a temporary and useful ephemeral site at which to think through questions of the signifying body, of embodiment, of the undecidability of the visual, and the materiality of the corporeal."[35] Dolan asks, "How can the liveness of theatre performance reveal performativity?"[36] I address this question in relation to the "liveness" of onnagata gender role performance, which reveals the performativity of Japanese theatrical gender roles. By observing the action from the stage and performer point of view, I focus on the art of men whose living bodies articulate gender stylizations for the production of female gender roles.

These theories represent only the beginning of an "unlimited" reading of onnagata gender performance. As Sue-Ellen Case suggests in *Feminism and Theatre*:

> If a theory does not assume a transcendent posture, it can be used for the politics of the moment, adapted by them, and repeatedly altered or forsaken in different historical and political situations. The feminist activist-theorist can employ any techniques, methods, theories or ways of social organizing she wishes in confronting or creating the situations in which she operates.[37]

In the process of examining onnagata history, theory, and techniques, I employed several different modes of inquiry: observation and analysis, documentary research, publications, personal interviews, and participation. The variety of research methods is necessary in the interdisciplinary framework of theatrical performance. The combination of research modes reveals the intersection of historical star onnagata's gender act development with contemporary performers' gender acts. The different approaches also demonstrate how a theory of gender acts works within a system of stylized performance codes, and how theory and act can be transparent to each other.

I examined the recorded reviews and biographies of star onnagata in historical narratives, searching for descriptions of their appearances and the roles they gradually stylized into gender role types. I read several *geidan* (art discussions) as examples of performer theories and practices of onnagata stylization. The earliest of these is the *Ayamegusa* (The Words of Ayame), a collection of recorded notes by Yoshizawa Ayame I (1673–1729)[38] regarding

onnagata behavior on and offstage. Ayame I is considered the first onnagata to designate a certain style of the body and accompanying physical acts as specific and necessary to onnagata performance.

Two *geidan* written after the Edo period are: *Onnagata no Geidan* (Onnagata Art Discussions) by Onoe Baikō VI (1870–1934), and *Kabuki no Kata* (Kabuki Forms) by Nakamura Utaemon V (1866–1940). Another influential *geidan*, entitled *Danshū Hyakubanashi* (Danjūrō's One Hundred Talks), was written by the famous tachiyaku Ichikawa Danjūrō IX (1838–1903), well known for his kabuki reforms during the Meiji period. Danjūrō IX played many onnagata roles as well, becoming an authority on all gender role types and a pivotal figure at a turning point in kabuki history. His performance "notes" mark a distinct change from the onnagata of the Edo period to the contemporary onnagata style and concept. Danjūrō IX argued for an onnagata art based on techniques that an actor performs. His technical reading of onnagata performance resembles the concept of stylized gender acts. These three *geidan* represent the shift from the Edo period onnagata performance as a daily "lifestyle" to a "stage only" performance of female-like gender acts.[39]

I resided in Tokyo from September 1990 through June 1993, observing performances, rehearsals, and backstage operations at the two main venues for Grand Kabuki, the Kabuki-za and the National Theatre. I also attended numerous performances at regional theatres outside Tokyo, such the Minami-za in Kyōto and the Naka-za in Osaka. I went to many special event performances such as the yearly Kompira Kabuki, held in a small town, Kotohira, on the island of Shikoku. The theatre in Kotohira is similar to the Edo period stage, and provided the chance for me to experience some of the conditions of that era's performance, such as the proximity of actors to audience and the daylight and candlelight lighting. I had the opportunity to observe top-ranking onnagata go through every stage of performance preparation, from makeup, to kimono wrapping and wig dressing, to their entrances on the stage. Several times a week for nine months, I observed the actor training classes of a group of young students in the two-year kabuki training program at the National Theatre. I saw their physical and vocal training under the direction of Nakamura Matagorō II (1914–), Sawamura Tanosuke VI (1932–), and Nakamura Baika III (1907–1991),[40] all of whom specialize in onnagata roles. I observed several of the wig masters and costumers who were associated with main onnagata and tachiyaku family lines and studied their daily preparations and dressing techniques for onnagata costuming and wigs. I also had the opportunity to see their training of apprentices.[41] I returned again in 1995 and 1999–2000, when I had the opportunity to see the next generation of onnagata begin to take on the major onnagata roles.

When attending performances, I observed how onnagata modify the basic physical acts characteristic of an intentional ideal onnagata form, the onnagata *yakugara* (role type), and specific roles. In order to analyze onnagata gender acts and aesthetic principles, I chose those scenes I had seen live on stage and those that I could also review frequently on video. I also ensured that I saw each of these scenes performed by different onnagata, so I could begin to observe the adaptations of codes made by individual onnagata style and body type. Of the examples used in this text, I observed each one at least ten times on stage performed by a minimum of two different onnagata. I also observed video taped performances of roles from each onnagata role type played by both Onoe Baikō VII (1915–1995) and Nakamura Utaemon VI (1917–2001) in the Shōchiku Kabuki-za video archives and the National Theatre video library.

An important part of the research was interviewing. In their backstage environments, I interviewed onnagata on their preparation for performances, aspects of their stage life histories, and their explanations of onnagata *kihon* (basics), *yakugara* (role type) stylization practices, aesthetics, and "gender"[42] in performance. I also interviewed Japanese theatre scholars such as Gunji Masakatsu, Torigoe Bunzō, Furuido Hideo, and Hattori Yukio—all specialists in kabuki. All have studied the original Edo period kabuki documents of onnagata.[43] I interviewed Mizuochi Kiyoshi, Fujita Hiroshi, and Watanabe Tamotsu, who, besides being kabuki specialists, are also performance critics who write the monthly reviews of kabuki and "popular" articles on the kabuki performers and performance. Within Shōchiku Ltd., a company that contracts the Grand Kabuki performances and performers,[44] I met several times with Ito Toyoaki, a Shōchiku producer who works closely with all kabuki choreographers, and Kubodera Yoshimoto, an assistant producer who oversees the Shōchiku video archives.[45]

Despite my training and many inside experiences in the performers' backstage lives, I was and still am a guest in the kabuki onnagata world, an outsider looking in. During the research process, I consciously positioned myself as an outsider, or in some ways as "an inappropriate other."[46] My performance observations and interviews are biased on my point of view and on how comfortable each interviewee felt sharing with me. Onnagata have their own multiple and ambiguous explanations of their art and commentary on the world of kabuki. As a person outside their culture, I sometimes found it difficult to understand their references without some danger of misrepresentation. I feel my research methodology and data selection consciously reflect a balance between caution and risk taking, which I feel is necessary for new scholarship and transcultural theorizing.

Chapter Outline

In chapter 2, "Theory into Performance," I summarize the major theories of onnagata performance by the Western and Japanese kabuki scholars and provide an overview of issues concerning the construction, history, and performance aesthetics of onnagata gender acts. I then review various Western feminist theories and concepts and relate them to theories of Japanese scholars. I apply the gender performance theories of several Western feminist performance scholars to the kabuki onnagata. In addition, I use the theories of Shakespeare scholars who have analyzed the performance of male actors in female roles during Shakespeare's era. I find that by using diverse theories and frameworks, I am better able to analyze the diversity of onnagata performance, performers, and their sophisticated system of gender stylization.

In chapter 3, "Precursors and Unruly Vanguards," I review the precursors of onnagata gender performance from the Heian through the early Edo period, or from 794 to approximately 1688. I discuss the performance forms, stylization practices, and performers who set the precedent for kabuki onnagata gender performance. I examine the evolution of the wakashu (adolescent boy prostitutes) performance styles into the onnagata fiction of female-likeness. I note how male and female prostitution, dance, and erotic display influenced the first onnagata gender acts. I suggest that onnagata drew upon the erotic allure of the wakashu image.

In chapter 4, "Star Designing and Myth Making," I cover the Genroku (1688–1703) through the Bunka Bunsei (1804–1829) periods. I focus on those actors who founded the onnagata art. I study the later star onnagata, who shaped the main onnagata gender acts and gender role types. I examine how these innovative "stars" created certain signature roles, which were then imitated by their followers. Over time, the star role became a stereotypic role type of the onnagata repertoire, and the innovative techniques, originally invented to catch the eye and stand out, became a set of routine or basic acts for playing onnagata roles. I draw upon the critical studies of several feminist film scholars, who theorize the "star" construction of female Hollywood film idols. In addition, I outline the important aesthetic precepts, like hana gei (lit. flower, dance art) and jigei (lit. fruit, acting art) that have guided the onnagata art through the Edo period. I examine the key points of the Ayamegusa by Yoshizawa Ayame I, and the Onnagata Hiden (Secrets of the Onnagata) by Segawa Kikunojō I (1693–1749), to show these star performers' attitudes toward onnagata gender acts.

In chapter 5, "Exaggeration, Disintegration, and Reformation," I track through the transitional period from the end of the Edo period (1860s–1870s), through the Meiji period (1868–1912), the Taishō period (1912–1926), and into the first part of the Shōwa period (1926–1988). I describe the kinds of

transformations that occurred to the onnagata gender acts and role types brought about by the breakdown of gender role specialization during this transitional period. I present a brief summary of how Western cultural practices influenced onnagata aesthetics and gender acts. I examine how the star onnagata of this period preserved and defended the art of onnagata gender performance as one of the unique and fundamental features of kabuki. I discuss the onnagata *geidan* (art discussions) written in this century by Nakamura Utaemon V (1865–1940) and Onoe Baikō VI (1870–1934). The performance techniques and theories found in these *geidan* have become the canon for onnagata gender acts and role types used by contemporary performers.

In chapter 6, "The Aesthetics of Female-likeness," I examine the relationship between onnagata gender acts and their corresponding aesthetic values. I discuss how certain principles of stylization gained priority over others. In turn, certain aesthetic tenets became associated with the stylized patterns for onnagata gender acts. Thus, the stylized onnagata gender acts produced certain principles of stylization, out of which a set of aesthetic principles arose, constituting the ideal onnagata performance. I focus on the main aesthetic principles of *yōshikibi* (stylization), *aimai* (ambiguity), *iroke* (erotic allure), *zankoku* (torture), and *kanashimi* (deepening sorrow). In actual performance, the aesthetic principles overlap and *complement* each other. Many of the well-known onnagata gender roles have major scenes where they are the objects of physical, spiritual, and/or emotional violence. Of particular interest in my study is how the kinaesthetic communication of pain and duress is rendered beautiful through the onnagata stylization techniques. I concretely illustrate the above aesthetic principles by analyzing selected scenes.

In chapter 7, "The Intentional Body," I present my theory that the "intentional body" is composed of the basic gender acts of posture, locomotion, and gesture patterns.[47] This theory is based on observing onnagata performance during the period of 1989–1995, and on information obtained through interviews. In my concept of an onnagata's intentional body, an ideal physical image and presence is created through strenuous physical training. But, the intentional body is never attained; rather, each onnagata adapts that ideal to the individual idiosyncrasies of his body. His "body" refers to his physical body and the whole constellation of his feelings, desires, and spiritual/psychological views concerning the character and/or moment in the performance. The "intentional body" is a kind of mythic or visionary body that may be unique to each onnagata.

In chapter 8, "Performative Gender Role Types," I describe the creation and evolution of onnagata *yakugara* (gender role types). *Yakugara* is one of the main areas of Japanese historical and critical kabuki research. Evidence

of the importance of role types is abundant in the programs, picture books, actor prints and reviews, scripts, and actors' commentaries. Modern critics often judge an onnagata's techniques by his rendition of the role type formulas. Thus, *yakugara* are central to an understanding of onnagata gender role performance.

I discuss *yakugara* as variations on the intentional gender body and present them as evidence of the transformativity and multiplicity of gender acts. Onnagata categorize their techniques by role types. Each role type has its own set of gender acts particular to that role type. *Yakugara* evolved from roles that star actors created in collaboration with playwrights. Over time, a role popularized by a star performer and repeated by his followers became the "physical formula" for a role type. I conclude by analyzing the *yūjo* (courtesan) role type in detail because it serves as a "template" for most of the other *yakugara*.[48]

In chapter 9, "Toward a New Alchemy of Gender, Sex, and Sexuality," I summarize how onnagata history, construction, and contemporary performance practices and aesthetics support the concept of onnagata gender acts and "female-likeness." Onnagata gender performance is a performance of transformative and ambiguous gender acts based on beautiful boy bodies. The acts have been organized into a system of gender role types. Early performance history indicates that performance techniques and aesthetics of *wakashu*, the *bishōnen* (beautiful boys) of early kabuki, are central to onnagata gender acts. I argue that a male body beneath is an essential requirement for onnagata gender performance. I conclude that onnagata gender performance not only demonstrates the construction of gender acts and the performativity of gender roles, but also disrupts the hegemony of binary and oppositional gender roles. That is, onnagata performance moves beyond a system of bipolar female or male gender role identities. Thus, onnagata performance cannot be identified with any one gender. Instead, onnagata perform multiple, ambiguous, and transformative genders.

Finally, I suggest that the onnagata's performance of multiple genders and their methods of gender act production and stylization reveal exciting, alternative methods of stage representation. What if contemporary theatre makers and performers would use onnagata concepts of gender stylization to break the hegemony of fixed binary genders and the system of gender/ sex unity and identity? What "other" visions would we enjoy? If we imagine genders as maps with a variety of routes, passages, and places, what kind of journeys could we take through our daily performances of desire? The beautiful boys of kabuki travel these new landscapes of uncertainty, danger, and rapture.

CHAPTER 2

THEORY INTO PERFORMANCE

Transgressing Genders: Toward an Intercultural Feminist Theory of Gender Performance

Japanese Kabuki Scholars

Japanese scholars identify onnagata performance as an essential feature of kabuki theatre. There are many published studies of famous onnagata, their performance histories, and their stylization techniques. There is rarely a general book or article on kabuki that does not refer to the onnagata as a unique feature of kabuki. Scholars proudly compare the onnagata tradition to the ancient Greek practice of male actors in female roles, to Shakespeare's boy actors in female roles, and to the Beijing Opera's *dan* (female role specialist). The art of the kabuki onnagata is venerated as a Japanese tradition that may be ranked alongside other great cultural expressions of the world. The onnagata is a cultural icon bound to a past that is deeply cherished.

Japanese scholars writing on onnagata history generally refer to the traditions of early folk theatre in which men dressed as female characters. Sometimes they cite a connection to early performance traditions of *Shirabyōshi* (women who performed entertainments while dressed in male attire). In his comprehensive studies of early performance traditions connected to kabuki, Gunji Masakatsu discusses the early performance and folk entertainment traditions. He mentions the frequent separation of the sexes into all female and all male troupes, laying the groundwork for the practice of gender role playing. The nō, the classical mask theatre, set a tradition for men playing female roles. Female shamans and female prostitute performers are sometimes mentioned as precursors because they performed in male-like attire. Still, scholars most frequently turn directly to Okuni and her kabuki as the starting point for the art of kabuki gender roles.[1]

Several volumes focus on the history and creation of the art of onnagata:
notably Fujita Hiroshi's *Onnagata no Keizu* (Onnagata Geneology) and
Adachi Naoru's *Kabuki Gekijō Onnagata Fūzoku Saiken* (A Study of Kabuki
Onnagata Customs and Manners). These authors outline the early history
of onnagata performance in kabuki and then provide short biographies of
famous Edo period onnagata. Both Fujita and Adachi speculate about the
continued existence of onnagata and discuss reasons why men play these
roles in kabuki. Fujita observes, "When onnagata decay, kabuki will decay,
and when kabuki becomes extinct, onnagata will be extinct . . ."[2] His point
is that the onnagata, a man playing onnagata gender roles, is essential for
kabuki to be kabuki. Something about the onnagata makes kabuki work.
At the same time, he believes that onnagata can exist only within the kabuki
context. That is, onnagata can live only in one particular time and space
environment: a kabuki performance.

Other scholarly works focus on individual onnagata and their stage
lives—for example, Watanabe Tamotsu's *Onnagata no Unmei* (Fate of an
Onnagata), in which Watanabe describes the onnagata art and philosophy
of contemporary Nakamura Utaemon VI (1917–2001); or *Sandaimei
Sawamura Tanosuke* (Sawamura Tanosuke III), by the group Kabuki Wa
Tomodachi (Kabuki Friends), a collection of essays on the life and art of the
famous Meiji period onnagata, Sawamura Tanosuke III and his descendents.
Takahashi Hiroko's *Sandaime Utaemon no Onnagata Gei* (Utaemon III's
Onnagata Art) looks at an unusual Edo period tachiyaku who was famous
for his onnagata roles. In a different vein, Toita Yasuji's *Onnagata no Subete*
(Everything about Onnagata) is a collection of essays about his favorite
onnagata performers and their performances, as well as an outline of onnagata
history. Toita's background in performance criticism and theatre politics
adds a social dimension to his writing. He offers his personal sense of how
onnagata function in the kabuki world.

It is rare for critics or scholars to conjecture on how political, economic,
and social forces of the Edo period shaped onnagata performance. Baba
Masashi is one of the few authors who analyzes onnagata roles in the social
context of their scenes and plays. In *Onna no Serifu* (Female Lines), he
focuses on the texts of several famous onnagata speeches, reading them in
the light of the onnagata role's social status in the play. First, he details the
historical and social context of each role. Then, he explains how, in perfor-
mance, the onnagata role exceeds the expected behavior for a female role
in the context of the drama.[3]

Some Japanese Kabuki scholars, such as Watanabe Tamotsu, have focused
on single aspects of onnagata performance. In *Musume Dōjōji* (The Maiden of
Dōjō Temple), he traces the history of this famous dance through star
onnagata performers, and his *Onnagata Hyakushi* (One Hundred Images of

Onnagata) is a detailed description of both onnagata role types and famous
onnagata interpretations of these role types. Watanabe and several other
Japanese scholars attended Waseda University and then entered the world of
journalism or broadcasting while continuing their theatre research. These
scholars frequently publish invaluable short interviews with onnagata and
articles about them in the monthly journal *Engekikai* (Theatre World).

In an interview, Mizuochi Kiyoshi (1936–) stressed the impact of
economics—particularly during the 1960s and 1970s—on the performers,
their acting styles, and their lifestyles. He commented that Shōchiku Ltd.
contracts all kabuki performers and operates with a bureaucratic and box-
office vision. This huge entertainment corporation has drastically changed
kabuki performance, audiences, and flavor. Mizuochi feels that a conserva-
tive trend, spearheaded by Shōchiku Ltd., forces actors to repeat successful
programs and overworks the star performers. Because of this, there has been
little opportunity for experimentation and risk-taking. Nevertheless, he
emphasizes that onnagata like Nakamura Utaemon VI vigorously revived
the art of the onnagata and, in so doing, popularized kabuki in the crucial
postwar period. He speaks of several onnagata, like Nakamura Ganjirō III
(1931–), who clearly push the borders of their onnagata art and experi-
ments by stretching set forms and roles. In this vein, he cites Bandō
Tamasaburō V (1950–) as an example of a "truly contemporary kabuki
onnagata," who works both inside and outside the official kabuki world.[4]

Mizuochi is from the Kamigata region (Osaka and Kyoto), so he empha-
sizes differences between Edo (Tokyo) and Kamigata styled onnagata. He
observes that in Kamigata the concept of *geifu* (style of art) does not require
absolute specialization in tachiyaku or onnagata roles. He argues that,
although contemporary Edo actors play both tachiyaku and onnagata roles,
the Edo tradition requires a stricter specialization in onnagata or tachiyaku
roles. Hence, according to Mizuochi, onnagata stylization may differ
according to the regional background of the actor. Further, Mizuochi
defines onnagata performance not as a traditional art, but, as "an art of the
contemporary world. Onnagata reflect the aesthetics of the times."[5]

Furuido Hideo, a professor in Waseda University's Theatre Department,
highlights in his interview the complex history surrounding the merchant
class aesthetic of *jinkō no bi* (artificial beauty), a constructed or designed
concept of beauty that boy actors invented in their transition from *wakashu*
to *yarō* kabuki. For example, when the *wakashu* were forced to shave their
provocative forelocks in 1659, they added the *bōshi* (forehead scarf) draped
over the shaved area, which Furuido contends initiated the artificial aes-
thetic of the onnagata. He maintains that the fabricated head covering was
not intended to imitate their real hair, but instead to create a new symbol
for their erotic appeal in their new gender role. When *wakashu* adapted their

beautiful boy gender acts to their onnagata roles, the covering of their foreheads was among the first onnagata gender acts of artificial beauty. This led to later onnagata creating more and more elaborate styles of wigs and wig ornaments.[6] Furuido emphasizes that during the Edo period the theory of the artificial took the place of nature in aesthetics and ideals. He suggested that the artificial aesthetic, *jinkō no bi* is also a general characteristic of kabuki theatre and is found, to a degree, in all Japanese art forms. Furuido emphasized that stylized onnagata performance techniques arise from this aesthetic of designed artifice. By placing value on an aesthetic of the artificial, onnagata de-emphasized realistic representation as an ultimate goal. Instead, the onnagata exploited the possibilities for invention, exaggeration, diminution, abstraction, and other techniques in order to manipulate their gender role illusions. The artificial aesthetic was a perfect match for creating extraordinary gender acts. Onnagata used it to their advantage, stylizing their costumes, gestures, makeup, and even props beyond any real referent. Ultimately, onnagata created their own kind of sensuality and erotic appeal based on their artificial gender acts.[7]

Gunji Masakatsu, former head of Waseda University's Theatre Department, has written extensively on kabuki dance, stylization, and aesthetics. He writes about the "flesh of a culture" and "the aesthetics of the flesh"[8] in kabuki and in cross-cultural performance. In his discussions on onnagata gender performance, he observes that, as a result of the reformation of kabuki in the Meiji era, a more sensual and erotic style of the Edo period was suppressed. According to Gunji, the available records suggest that Edo period actors exaggerated scenes of eroticism and violence. However, he cautions that exaggeration in this context meant stylized action, not greater realism, and should not be equated with Westernized television violence or pornography.[9]

Further, Gunji emphasizes that each culture has its own sense of eros: what viewers experience as erotic and sensual, they have learned through culturally specific practices and prohibitions. He points out that the Japanese have a different sense of what body parts are sensually alluring and what actions arouse erotic feelings than other cultures. He cites the bare upper back and neckline, shaped by the kimono, as an example of what is uniquely considered an erotic area in Japan. He wonders whether the people of one culture, without learning, absorbing, and performing the aesthetic practices and cues of another culture, can relate to the sensual aesthetics of another culture. Perhaps, he suggests, the eroticism of onnagata gender performance is literally out-of-touch for a foreign audience.[10]

Discussing traditional and contemporary onnagata performance, Gunji points out the differences between Edo period onnagata and contemporary

onnagata.[11] He does not attribute the most radical changes solely to the reformations of the Meiji era or postwar commercialization. Rather, he feels that the changes have come from within kabuki itself as a result of the gradual disintegration of gender role specialization.

He explains that beginning in the late Edo period, and continuing into the Meiji period, several major actors broke with the tradition of playing onnagata or tachiyaku gender roles exclusively. Although actors had switched gender roles before, in this particular break, major acting family heads stepped outside their inherited lines of specialized gender roles to play both male and female roles. They alternated among gender role types. In Gunji's view, the subtlety of the onnagata gender art became muddled and fragmented when tachiyaku took on onnagata roles and when onnagata moved in and out of tachiyaku roles. He attributes some of this change to the successful stardom, wealth, and power of several actors, including the onnagata, Iwai Hanshirō V (1776–1847), and the tachiyaku, Nakamura Utaemon III (1778–1838), Ichikawa Danjūrō V (1751–1806), Ichikawa Danjūrō IX (1838–1903), Onoe Kikugorō V (1844–1903), and others. These actors had enough economic power and authority to create their own unique rules, roles, and gender interpretations.

Gunji explains that the appellation *kaneru yakusha* (a combination actor, one who plays many role types)[12] came into popular usage to designate the actor who could master a variety of major gender roles in the transition time of the Bunka Bunsei period (1804–1830). For several reasons, based on troupe status and the power of tachiyaku family lines, a *kaneru yakusha* was usually a tachiyaku. Gunji feels that when the actor switched gender roles, the actor mixed gender acts and this muddled his technique. In the case of the onnagata, when he played a tachiyaku role he brought his *onnarashisa*, his physical practices of female-likeness, with him into the male gender role. Onnagata were limited to playing refined tachiyaku roles. Further, tachiyaku, according to Gunji, changed the stylization of onnagata gender roles and, because of their higher status, their adaptations were copied and emulated by subsequent generations of onnagata and tachiyaku *kaneru yakusha*. Onoe Kikugorō VI (1885–1949) was an outstanding example of this tachiyaku "takeover."[13]

Gunji notes that several playwrights of the late Edo period and the Meiji period, like Tsuruya Namboku IV (1755–1829) and Kawatake Mokuami (1816–1893), in their collaboration with actors, contributed to the general breakdown of distinctive attributes of onnagata role types by deliberately mixing classes and gender role types in their kabuki thrillers. Gunji sees this mixing of gender roles as a kind of homogenization of differences. This extends not only to onnagata and tachiyaku specializations but also to distinctions between *aragoto* (wild style) and *wagoto* (gentle style) roles, or

among role types such as *yūjo* (courtesan), *musume* (young girl), or *nyōbō* (wife). Gunji contends that when specialization of the role type decreased, the distinctive edge and flavor of gender role differences was lost. The blending of gender role types also destroyed the more subtle gender ambiguity of the onnagata.[14]

Gunji contends that onnagata lost the most from this breakdown of gender role specialization. From the early seventeenth century, as part of their training, kabuki onnagata had practiced their onnagata gender acts in their offstage lives. Onnagata had a certain mystique and an aura of difference because of their unique lifestyles. When tachiyaku, like Danjūrō IX, made themselves authorities of onnagata performance, it brought into question the necessity for onnagata to live their onnagata gender acts in their daily lives. Gunji suggests that when tachiyaku jumped in to take over onnagata roles, they changed the particular erotic quality or "feeling" of the onnagata gender acts.

Gunji also points to the invention of the *akuba* (evil female) role type by the playwright Tsuruya Namboku IV, and the onnagata Iwai Hanshirō IV (1747–1800) and V (1776–1847), as an example of the mixing of onnagata and tachiyaku gender acts. The great *akuba* roles are star roles of extraordinary theatricality, played with bold postures and sensual appeal. Onnagata roles were supposed to be played, "in the shadow of the tachiyaku role."[15] According to Gunji, the "shadow" image had been fundamental to the onnagata "eros" mystique. Later onnagata, following the example of Hanshirō IV and V's *akuba*, gradually moved away from the "onnagata-as-shadow" image.

With a few exceptions, kabuki dances were once considered the domain of the onnagata. Gunji thinks that the tachiyaku Nakamura Nakazō I (1736–1790) usurped the onnagata position of master of the *shosagoto* (dance plays) with his performance in *Seki no To* (The Barrier Gate).[16] He also cites, as examples of the deterioration of a distinctive onnagata gender stylization, the trend near the end of the Edo period (1800–1868), for all actors to perform multiple gender roles in one play and spectacular, multiple-role, and quick-change dances. For example, in *Shichi Yaku no Osome* (The Seven Roles of Osome), created by the playwright Namboku and the onnagata Hanshirō V, the main performer plays seven roles of different gender and role types. During the course of the play, the actor transforms from one gender role to another with split second changes in costume, wig, and makeup. After Hanshirō V's success, many tachiyaku tried their hands at the spectacular onnagata transformation dances. Ichikawa Ennosuke III (1939–), in his contemporary rendition of *Shichi Yaku no Osome*, is an example of a tachiyaku performing multiple gender roles.[17]

Gunji concludes that his idea of the Edo style onnagata no longer exists, ceasing when performers blended female and male gender roles. Gunji does

not cite specific attributes to define the quality he feels is no longer performed; however, he does speak of "an erotic sensibility which onnagata used to effuse onstage. It was not that their *kata* (stylized forms) were different, but it was something their bodies had learned from being only onnagata."[18]

Western Kabuki Scholars

To date, there is no comprehensive study of onnagata gender performance history, theory, or technique in the English language.[19] In general, Western kabuki scholars have written about onnagata within their studies of kabuki theatrical performance and history. Earle Ernst, James R. Brandon, Samuel L. Leiter, and Leonard Pronko have written about kabuki performance techniques and *kata* (stylized forms); however, none of these studies analyzes onnagata performance as a gender role performance.

One of the purposes of Leonard Pronko's *Theatre East and West* is to detail the history of kabuki's contact with Western theatre and performers. One of the main themes Pronko explores in the Asian theatre forms he studies, is the totality of a performance genre that not only dares to involve irrationality and mystery but also does not separate the intellectual from the physical.[20] He emphasizes that the plastic and sound dimensions of performance in theatres such as kabuki, nō, and Beijing Opera are not mere accompaniments to the dialogue and characterization, but are fused with the performers' methods of stylization. Pronko profoundly argues for this integration as he claims:

> Art, and surely the art of the theatre, is a physical phenomenon that should produce a physical sensation in addition to the usual emotional or intellectual reactions we seem to consider normal. This harmony of impressions cannot be accomplished by words alone, but must arise from a combination of words and plastic, rhythmic values.[21]

He also describes how the kabuki performer plays between his own body and his character's body to create something that theatrically transcends the idea of the actor becoming the role. Pronko emphasizes, "The kabuki actor does not pretend that he is anyone except an actor playing a role."[22] He cites examples of how the kabuki actor and his role are frequently experienced separately in performance. That is, the performer may, at times, highlight performing himself as a skillful actor. Moments later, he may focus on the fictional representation of his role, but the actor is always there. According to Pronko: "The kabuki actor, using every facet of body and voice to portray character and emotion, presents himself quite frankly as a theatrical creation on a stage before an audience."[23]

Pronko singles out the performance of the kabuki onnagata as the epitome of theatrical suggestion, which goes far beyond reality or the representation of reality. Much of what Pronko describes is the performative gender art of the onnagata, who, in his words, "is able to incarnate the essence of femininity without actually imitating any woman ever seen."[24] On the kabuki actor of female roles, Pronko writes:

> He stands as a profound symbol of the mystery of metamorphosis which is the mystery of the theatre. He seems to join two totally different worlds, not only in his double identity as an actor and character, but in his dual role of man-woman. The *onnagata* is a dynamic and gigantic archetypal figure possessing, beyond this theatrical dimension, a metaphysical dimension. Whether the spectator is aware of it or not, the *onnagata* stirs in his unconsciousness a dim memory of some perfection partaking of both feminine and masculine, the great Earth Mother who is creator and sustainer, the divine androgyn in whose bisexuality both dark and light are harmonized. To approach the *onnagata* is to draw near the secrets of existence, embodied in human form through the art of the kabuki actor. At the same time we draw near to a joyously theatrical creation which appeals to our histrionic sensibility.[25]

Like Pronko, I am also deeply impressed by the art of the onnagata. But my research indicates that, while the onnagata's constructed, stylized roles have been labeled "feminine," onnagata performance is not the "essence of femininity." Rather, onnagata perform stylized gender roles that engender their own fictions of the feminine and femininity, and their fictions stir the conscious and the unconscious with their ambiguity of gender. In the earlier passage, to emphasize how the onnagata perform their own unique gender roles with their male bodies, I would change Pronko's "his dual role of man-woman" to "his multiple roles of man-onnagata genders."

Pronko also takes up the point that I mentioned, that women could not play onnagata roles because they would be imitating the acts of men. According to Pronko, "Were a woman to attempt to play a kabuki female role she would have to imitate the men who have so subtly and beautifully incarnated Woman before her."[26] Several other scholars and contemporary actors share the view that women do not have the physical strength to manage onnagata acting and dancing with the required costuming.[27] For example, Faubion Bowers argues that women continue to be absent from the kabuki stage because many dances require transformation into creatures that wear huge wigs and costumes and perform great physical feats. Bowers writes that, "The later part of these dances requires a physical exertion and virility that the slender and small physique of Japanese women cannot sustain."[28]

There is little validity to the physiological argument that Japanese women could not play onnagata roles because of a lack of strength or

stamina. With daily training, a similarly proportioned male or female body could very likely attain the same degree of strength and motor control.[29] The only valid reason a Japanese woman cannot play onnagata roles is because she does not have a male body beneath the kimono; therefore the ambience of the difference between female gender acts and the male body beneath is not possible. Indeed, the presence of male sexual organs underneath the kimono is a *requirement* for kabuki onnagata performance, because the spectator must be able to imagine a male body beneath the feminine costuming. Leonard Pronko is also a performer of onnagata roles in his own exceptional lecture-performances, in which he explains the history of kabuki, then onnagata, while putting on his makeup and costume, and then ends with a short onnagata dance or acting sequence with his exceptional performance partner Tomono Takao playing his male counterpart. In his performance, Pronko demonstrates the erotic dynamics of the body beneath, the onnagata gender kata, and female-likeness. He reclaims, to a certain degree, what Gunji Masakatsu claims to be the onnagata's lost erotic mystery, with his tall and Western-marked body adding a contemporary twist.

A. C. Scott's book, *The Kabuki Theatre of Japan* (1955), portrays onnagata as a necessary feature of genuine kabuki. In his early work, Scott introduces the art of the onnagata as the art of the female impersonator who must symbolize an ideal female. I quote Scott at length because his writing enunciates certain common themes found in early Western scholarship on kabuki onnagata:

> The Kabuki is artificial . . . everything is exaggerated, conventionalized and emphasized to make a pattern for the eye and ear. The onnagata is a major unit of this pattern and by his creation of a subtle convention for femininity provides the degree of formality which sets the standard for the whole. It is not simply a question of being effeminate, the good onnagata must symbolize feminine qualities in a way that no actress can do. He must idealize and emphasize where the actress can only fall back upon easier and more natural qualities with a loss of the power of expression dictated by a drama such as the kabuki. . . . While they [female geisha] perform with great charm and grace, they never attain the power and vigor of the male actor.[30]

Scott goes on to say that "those with the prejudice of the West" find this argument for the onnagata difference difficult. Assuming a perspective from the inside, Scott argues that the onnagata must be distinguished for being a man who has mastered a stylized grace that is more powerful because of his male body beneath. Scott emphasizes that the power of the onnagata lies in his strength and vigor, making these attributes exclusive to the male body. For example, Scott describes the art of the onnagata, Nakamura Utaemon VI

(1917–) in the following way:

> The acting of Utaemon delights the eye with its delicacy and grace of movement, and his grace of dancing once seen is never forgotten. At the same time there is strength and virility underlying the finer qualities. . . . The art of Nakamura Utaemon VI is the best possible proof that female roles in the Kabuki drama are essentially the creation of the male actor; even if women did play such parts it provides the curious position of women imitating men imitating women, and the probable result would be a degenerate and confused technique.[31]

Scott regards the onnagata as a creation of the male actor whose imitation of women has been refined and transformed into acts only a male body can perform. I think his argument might also include the erotic sensuality in his male identified attributes of vigor and strength.

Scott observes that onnagata appear to have set a stylized and artificial standard for all kabuki actors. If, as Scott claims, onnagata set "the degree of formality for the whole,"[32] it follows that the total performance depends on the stylized gender acts of the onnagata. I agree with Scott"s hypothesis on the centrality of onnagata to kabuki, and that stylization is the key to onnagata gender performance. While tachiyaku conformed to the socially acceptable sex and gender association of male body and male gender acts, what onnagata did was different and their difference was their specific performative stylization. However, Scott seems to sometimes confuse the onnagata female-like stylization with the imitation of women. I propose that onnagata completely replaced women with their own construction of female-likeness, a composite of physical appearances, gestures, and speech, to which tachiyaku responded. Imitation of real women was never the goal, but just the opposite: onnagata amplified their potential for the artificial. An actor's brilliance is demonstrated by how well he can detail and employ the artifice of appearances.[33]

Earle Ernst suggests, in his volume *The Kabuki Theatre* (1954), a definition of onnagata art that supports the requirement of the male body beneath performing onnagata gender acts. In the following quote, what Ernst terms "patterns of expression" is similar to the idea of gender acts as discussed in this book:

> The Kabuki actor does not "create" roles in the manner of the contemporary Western actor; he rather, in his training, gradually disciplines his body in the inherited patterns of expression. The personality of the actor emerges, but only through the medium of the conventional forms which interpose between the personality of the individual and the role. The Kabuki actor does not impersonate. He acts. And as with other productional elements of the Kabuki his performance is based upon his uncompromising theatricality.[34]

Ernst explains that the onnagata is an exemplary model of the use of these conventional forms to their fullest potential. However, Ernst adheres to the belief that the male body has the strength that a female body cannot possess. After a discussion of several points from the *Ayamegusa*, a treatise on the art of the onnagata, on how the ideal woman can be expressed only by a male actor who enacts the "synthetic ideal," he writes:

> From the point of view of the design of the production, the *onnagata* is necessary because, according to the Japanese, although the surface of the woman portrayed should be soft, tender, and beautiful, beneath this surface there should be a strong line which can only be created by a man. A man of eighty plays the role of a girl and, because of his mastery of the vocabulary of Kabuki acting, creates before the audience a stronger theatre reality of her essential qualities than could any woman.[35]

I agree that the onnagata is necessary. But this "soft, tender, and beautiful" woman is a male constituted entity, literally put together by male bodies.[36] According to Ernst and his Japanese sources, the soft, tender, and beautiful "woman" played by onnagata requires a male body because only a male body possesses the essential "strong line." The argument for the superiority of the onnagata's performance of a kabuki female role over a woman's performance of a kabuki female role is an essentialist one that I cannot uphold. Ernst also defends the onnagata's art because the onnagata's male body beneath is in contrast to its "female" surface. Because of his male body, the onnagata can create a "stronger theatrical reality." If contrast is required, it should follow that tachiyaku roles are not as theatrically interesting because there is no contrast between the male body of the actor and the male gender acts. Would women be better than men in kabuki male roles? Following the essentialist idea, women could produce the theatrical synthetic ideal of "male" because their female bodies possess the essential and contrasting softness, tenderness, and weakness.

Instead of these arguments, it may be more valuable to shift the focus away from such phrases as "more feminine than a real woman" and concentrate on how the onnagata invents his own unique gender role, and that his exceptional invention disrupts an exclusively bipolar view of genders. What onnagata do in performance clearly disproves the identification of one biological sex to one gender role and discloses multiple and creative possibilities for gender performance.

Although both Western scholars and Japanese scholars have formulated various explanations for onnagata performance of female-likeness, often they do not differentiate between onnagata gender acts and women when they discuss plays and characters. Female roles are analyzed as if they were

real women or as if they represented real women. In the case of onnagata, even if a role originated in a Chikamatsu Monzaemon (1653–1725) doll theatre play, the performed role is an onnagata's stylized gender acts. When speaking of onnagata performance in kabuki plays, it is more precise to refer to the female roles, or preferably the onnagata roles or characters. Using the phrase "onnagata role" makes it clear that the role is a character enacted by an onnagata using stylized onnagata gender acts. We are aware that the role is a constructed fiction of female-likeness created and enacted by an onnagata.

Thinking of kabuki roles as *tachiyaku* roles and *onnagata* roles instead of men and women, or even male and female roles, clarifies that these are gender stylizations. Naming roles by their specific acting style would be even more precise because some of these styles have evolved their own gender acts. For example, the tachiyaku role of Chūbei in *Koi Bikyaku Yamato Ōrai* (Love Messenger from Yamato) is a *wagoto* (gentle style) role and could be identified as a *wagoto* tachiyaku gender role. The onnagata roles of Agemaki of *Sukeroku* (Sukeroku), Kumo no Taema of *Narukami* (Thunder God), or Omiwa of *Imoseyama* (The Mountains of Imo and Se), are onnagata gender roles belonging to different onnagata gender role types. Agemaki is a *yūjo* (courtesan) onnagata gender role type, Kumo no Taema is a *himesama* (princess) onnagata gender role type, and Omiwa is a *musume* (young girl) onnagata gender role type. They are different from "female."

Faubion Bowers had the opportunity to meet many postwar kabuki performers and talk to them personally about the onnagata gender role within the kabuki constellation of genders, stylizations, and theatrical techniques. In *Japanese Theatre*, he relates what the late tachiyaku Matsumoto Kōshirō VII (1870–1949) told him about the great onnagata debate in the 1920s. By that time, Western theatrical concepts had saturated Japanese theatre, and the Ministry of Education asked several kabuki actors about replacing onnagata with women. It seems that the onnagata Nakamura Utaemon V (1865–1940), whom Bowers refers to as "the greatest of *onnagata* man-actresses"[37] replied, "Why should women appear when I am here?"[38] Under the circumstances, Utaemon V was probably defending his job in the kabuki theater, but he was also speaking of his own idea of the specialness of the onnagata performance that could not be represented by women. Tachiyaku also had their opinions about whether women could substitute for onnagata in onnagata roles. I suggest that in the following quote by a tachiyaku, what he calls a "type of woman" refers to the gender role that onnagata have created. Bowers quotes how Kōshirō IV addressed the question himself:

> "It is too late for women now to appear in Kabuki. A type of woman has
> been created and has become familiar in Kabuki. To change this would mean

that Kabuki would lose its flavor. If women had appeared a hundred years ago they could have created their own kind of woman for the stage; now all they could do would be to imitate what men have created for them."[39]

Bowers feels that this last answer comes closest to his own idea of the onnagata gender role in kabuki's aesthetic of "disassociation from reality."[40] He explains that the onnagata's gender acts are just one aspect of kabuki's dominant aesthetics, which include such things as delight in the odd and irrational; emphasis of the symbol over the direct representation; stylization, which arises from a combination of dance and eroticism, to name a few that apply to onnagata gender act patterns. He also cites the performance techniques from the puppet theatre, which onnagata assimilated into their gender acts, making their performance further removed from human references.[41] All of these kabuki aesthetics and performance skills, according to Bowers, clearly demonstrate how onnagata performance has also created its own gender performance and associated aesthetics.[42]

As noted earlier, James Brandon and Leonard Pronko are known for their extensive kabuki research, publications, lectures, and performances. Their scholarship reflects their personal involvement in the stage practice of kabuki performance. They may justifiably be called "performance scholars" because they have participated in kabuki actor training and directed kabuki performances with non-kabuki performers, in addition to researching, writing, and teaching on every aspect of kabuki history, theory, and practice. Brandon and Pronko bring their performance perspectives to their explanations of onnagata art. Both scholars had the opportunity to participate in the National Theatre kabuki actor training program and have studied tachiyaku and onnagata gender acts and stylization.

In the chapter, "Form in Kabuki Acting" in *Studies in Kabuki: Its Acting, Music, and Historical Context*, Brandon delineates the difficult concept of *kata* (stylized forms) in kabuki performance. It is interesting to note that his analysis, which is based on Kagayama Naozō's *Kabuki no Kata* (Kabuki Forms), the authoritative analysis of kabuki *kata*, does not devote a specific section to onnagata form or style. Brandon does note that onnagata were central to the development of dance plays. However, it is Brandon's explanation of *kata* that is key to my formulation of onnagata gender act theory. That is, Brandon's explanation of the concept of kabuki *kata*, the patterned codes of stylization, which are essential to all aspects of kabuki performance, could be used as a working definition for stylized gender acts. His description of *kata* in acting parallels how onnagata employ formulae and codes to "act" their onnagata genders:

The traditional ways of performing are called *kata*, literally form, pattern, or model. The actor's vocal and movement *kata* are central elements of most

kata, but production elements such as costuming, makeup, and scenic effects are thought of as extensions of the kabuki actor's technique, and they too are usually discussed as part of the *kata* of acting. Some *kata* are ephemeral and pass as quickly as they are created. But other *kata* of "patterned acting" have been polished and perfected over generations, and these form the foundation of kabuki performing art.[43]

Brandon organizes the variable and multiple acting *kata* into a three-tiered structure of *kata* types: "broad, overall styles of performance as one level and specific performance techniques as a second. In addition to this . . . different actors have created individual *kata* that are personal variations of specific performance techniques."[44] Onnagata gender acts are exactly this type of patterned acting. These *kata* categories can be applied to onnagata gender acts as follows: general codes for female-likeness, more specific codes for onnagata gender role types, and the gender acts created and adapted by star performers for specific characters.

In a lecture at the University of Hawai'i, Brandon also classifies "onnagata" *along* with *wagato* and *aragoto* as acting styles.[45] Kawatake Toshio, a Japanese kabuki scholar, also considers these to be the main styles of acting and the basic designations in the complex kabuki aesthetics of stylized beauty. According to Kawatake, performers in early kabuki initiated these three styles, which gradually became the foundation of kabuki.[46] I believe there are significant differences between *wagato* and *aragoto* on the one hand and onnagata on the other. First, the labels *aragoto* and *wagoto* may sometimes be used to identify the general style of the roles in a play dominated by *aragoto* or *wagoto* styled characters. They also have regional affiliations: *wagoto* is associated with the Kansai area, and *aragoto* with the Tokyo area. "Onnagata" is not usually associated with any one region, nor is it applied to a general style for certain roles in a play. Second, neither Brandon nor Kawatake note that onnagata is specifically a female gender role acting style, while *aragoto* and *wagoto* are, with a few exceptions, largely acting styles for male gender roles.[47]

The three styles share certain performance strategies and could all be classifications for acting styles or different genders. All three are based on, and were created by, a male body beneath. All three have distinct stylized acts: movement, costuming, and makeup techniques that specify and amplify their special characteristics: *aragoto*, wild style; *wagoto*, gentle style; and onnagata, female-like style. What makes onnagata different is that onnagata stylized acts are associated with the female gender role and, because of this, the onnagata "style" occupies a different status than *aragoto* or *wagoto*. I suggest that onnagata may be omitted as a style of acting because of their lower troupe status[48] and their earlier status as *wakashu* (young boy

prostitute performer) and *iroko* (love child, a boy prostitute), who also had a lower status in the kabuki actor society. Tachiyaku roles in any style enjoy the dominance of the male role associated with the binary division of gender roles into male and female.[49] *Aragoto, wagoto*, and onnagata are not separate but equal acting styles.

Brandon also directs kabuki plays at the University of Hawai'i at Manoa. His translations of kabuki play texts include detailed descriptions of the total theatre of kabuki: music, chant, dialogue, sound effects, staging, movement, dancing, and visual stylization, from costuming to set design. In the university productions, he hones and perfects the stylization of every visual and aural element. In the University of Hawai'i kabuki productions, Brandon's perspective on onnagata performance comes out of his intense involvement with the integration of *kata* into the dramatic moment and its effect as total theatre.

In his approach to kabuki gender roles, Brandon begins with the idea of *kata*. He focuses on how any actor body, man or woman, performs the stylized performance *kata*. Student actors train for one or two semesters in kabuki dance and vocal training for all gender role types. However, in production, women usually are cast in lead onnagata roles and men usually in lead tachiyaku roles. Minor roles may be played by either men or women and exceptions may be made in major roles. In his view, it would be impossible in the university context to cast only males because the institution's responsibility is to educate male and female students.[50]

This raises the question of whether the male body beneath is a requirement for onnagata roles. By having women play onnagata roles and men play most tachiyaku roles, it seems that Brandon matches the male body beneath with the tachiyaku roles, and female body beneath with the onnagata roles. As he pointed out, this is an English-language kabuki in Hawai'i, and it calls for differences and changes.[51] Still, even though his productions are brilliant and lively theatre, I suggest that an essential feature of kabuki is missing: the onnagata with his male body beneath and the particular sensuality and eroticism connected to that. The onnagata is replaced by women playing onnagata "roles," and the ambiguous play of onnagata gender acts in relation to the male body beneath is thereby lost.

Leonard Pronko has also produced kabuki plays and offers lecture demonstrations of kabuki performance techniques. Although Pronko knows many tachiyaku roles, his demonstrations often feature an onnagata role to show the full range and power of kabuki stylization. In one such demonstration, he performs a short scene from the dance-drama, *Masakado* (Masakado). He acts in the onnagata role of Takiyasha, who is disguised as the *oiran* (top-ranking courtesan), Kisaragi. His demonstration consists of dressing in the full costume and putting on makeup and wig, while

lecturing on the history of kabuki performance. Then he proceeds to enact a short sequence from the play, in this case a part of the *kudoki* (entreaty) section of a featured dance. In this scene, the onnagata performing the role of Kisaragi attempts to seduce the main tachiyaku character who is watching.[52]

Pronko's performance brilliantly demonstrates the theory of gender ambiguity, which is at the heart of onnagata performance. The male body is revealed more and more as it is gradually decorated, concealed, and stylized into the onnagata gender role. The spectators never lose sight of the male body. Yet, because of his skill and the strength of the onnagata *kata* (forms) created through stylized physical manipulations, layers of costume and wig, makeup, and vocal acts, Pronko transforms. On one hand we see his Western male body beneath in the onnagata role and on the other, he is an "other" gender role that is ambiguous and transformative. Usually, Pronko finishes his lecture-with-performance with a sustained section of performance, for example, a short dance scene. He articulates his voice, his kimono, *obi*, and over-kimono, and his body beneath into an onnagata gender role, which simultaneously reveals his body beneath and the onnagata stylization codes.

In an interview, Pronko spoke of his high regard for the absolute rigor of the art of the onnagata. He mentioned how arduous and exacting it is for onnagata: the daily routine of putting on makeup, costumes, and wigs for one or several different onnagata roles, and the physically demanding performance itself, from the dance pieces to the kneeling roles, which may last for hours. He emphasized that the onnagata's enormous will power and commitment to a life of total theatre is what supports their art. He added that in modern Japan, onnagata are under even more pressure than tachiyaku to perform in an extraordinary manner because of the competition of many other types of theatre. Pronko feels that the onnagata is a symbol of kabuki's uniqueness, an image that is exploited by the general media in Japan.

Pronko cited several onnagata whom he has met and watched for many years. Among them, he singled out Onoe Baikō VII (1915–1995) and Nakamura Shikan VII (1928–) as examples of onnagata who perform as *otokoppoi* (masculine) onnagata. Pronko feels that because neither one of them has the small features or willowy figure associated with an *onnappoi* (feminine) image in Japan, they have to work much harder than other, more *onnappoi*, onnagata to create the illusion of onnagata *onnarashisa* (female-likeness). Therefore, they skillfully focus on every detail of onnagata stylization to render their bodies into that image, and make their performances powerful and highly charged. In Pronko's view:

> Maybe it is because Shikan has that great huge chin and face. He cannot be pretty. He has to make his whole self beautiful through the *kata*. He sets off

the form so you see that style, the aesthetic line, expertly rendered. But you still see his face. He does not change how he looks on the surface. Part of his charm is that he is definitely *otokoppoi*; there is that resistance between his body and the image. His power is in his elegance of total performance.[53]

I was reminded of Pronko's remark of how the image of the onnagata is exploited in popular media, when I saw the December 1991 issue of *Esquire*. It featured on its front cover a head shot of the well-known onnagata Bandō Tamasaburō V (1950–) in the opening costume from *Sagimusume* (Heron Maiden),[54] which he has performed internationally. The photographic image exemplifies the onnagata "mystique" of gender ambiguity. The photographer carefully framed Tamasaburō V with his white powdered face and his red-lined dark eyes cast demurely downward. His face is made tiny and oval in its surrounding white hood scarf and white kimono. Striking in contrast, only a curve of his black wig, showing the fake root line, is visible beneath the pure white scarf. The red edge of his underkimono, set off against the pure white kimono collar, floats against his white neck and leads the spectator's eye to the bright rose red of the doll-like lips. The image is striking because it suggests sensual allure without defining gender.

The Esquire article was entitled "Kabuki, the Jewel Box of Dreams."[55] In Japan, the "*tamatebaco*" or "jewel box" of the title is similar to the Western image of a pandora's box of treasures which, if opened, will transform into evil and death for the trespasser. In the photograph, the onnagata image represented the jewel box of kabuki, and Tamasaburō V, the male performer of onnagata roles became a kind of exotic lure into that box or its ultimate treasure. The article in this issue dealt with a panorama of issues and personalities in the contemporary kabuki world, but the majority of photographs that enticed one into the article were of the *oiran uchikake*, which is the sumptuous over-kimono worn by the highest ranking courtesan role. Again, the image or stylized gender role of the onnagata was used as the point of attraction and exoticism. In my view, the Japanese edition of *Esquire* is an example of how the onnagata image is used in contemporary society as an icon of beauty that simultaneously advertises its gender ambiguity and its male body beneath. Even though Tamasaburō V may represent the *onnappoi* (feminine) onnagata and Shikan VII, the *otokoppoi* (masculine) onnagata, they both perform with what Pronko refers to as a "resistance" between their male body and the onnagata image. Both their images entice the spectator with their different gender ambiguity.

This issue of *Esquire* also contained an article written by Edward Seidensticker, a scholar and translator of Japanese literature, on Mishima Yukio's kabuki plays. While explaining how Mishima had written five of his

six kabuki scripts for today's oldest onnagata, Nakamura Utaemon VI, he mentioned that Mishima felt that onnagata were the core of kabuki—not tachiyaku. Although many critics and scholars would disagree, Seidensticker describes the fascination for "onnagata who joins together the male gender and the female gender," relating them to the eighteenth-century *castrati*, who, he feels, "joined the male body with the female voice, and after that more than any strong female soprano, they were stronger sopranos."[56] Continuing with the theme of strength, he sees onnagata as a combination of strong male body movement and a strong female voice. In his view, superior kabuki dance is an art that only onnagata have the physical prowess to perform well. Although Japanese scholars may not state this openly, Seidensticker underscores the prevailing assumption.

Seidensticker presents his interpretation of onnagata in this way: "Because [onnagata] abstracted the essence of female characteristics, onnagata female-likeness arises from an extreme culmination of female-likeness which women cannot imitate."[57] His idea of abstracting an essence seems to indicate that there is an ultimate female identity. This is a construct many scholars maintain because it supports the polarized binary gender system based on bipolar gender identities. Throughout my review scholars writing about onnagata have frequently referred to a core identity or essence of female-likeness or femininity that onnagata perform. In the following section, I examine feminist theories of gender performance, which may shed a different light on this interpretation of the onnagata fiction of female-likeness.

Performative Gender Theories

I examine the performative acts that constitute the onnagata gender role types by investigating onnagata performance history and the development of onnagata *yakugara* (role types) that were created within a system of kinesthetic/visual stylization and aesthetics.[58] Historically, onnagata used certain stylized techniques for certain types of roles. Gradually, major *yakugara* emerged. In my study, specific onnagata gender acts characterize each onnagata *yakugara*. Each of these *yakugara* features its own characteristics of constructed female-likeness based on a male body. Every historical star onnagata had a detailed and individual strategy for performing his onnagata gender roles. Today, stylized gender acts, within a system of gendered aesthetics, are subject to continuous revision and innovation by individual performers, resulting in what, in feminist theories, would be called multiple Fictions of the Feminine.

In making a feminist analysis of the onnagata gender role, I apply specific points from the works of several Western theorists who focus on gender performance.[59] I am chiefly concerned with the following points: (1) gender as

stylized acts; (2) the disruption of a bipolar system of genders; and (3) the performance of gender acts as a continuing process of invention that freely plays with ambiguity and transformation. Throughout this book, I frequently use the terms "gender acts," "gender roles," and "gender performance," to explain my theory of what onnagata do onstage.

I define "gender acts" as those actions performed by the material bodies of performers for the purpose of producing gender (in the case of onnagata, onnagata female-likeness) in the space and time of kabuki performance. Among the types of gender acts that compose onnagata performance art are: gestures, postures, costuming, employing wigs and props, vocal patterns, pronunciation, blocking, and musical accompaniment. Even scenic and architectural elements are used to highlight the gender acts of an onnagata role. Kabuki is an ideal form in which to study the design of gender acts because it is a stylized form of theatrical performance in which every aural and visual element is patterned to produce a specific effect.[60] While all kabuki roles are made up of stylized gender acts, I focus on the specific characteristics that distinguish the onnagata gender acts from other gender acts. The distinctive feature of onnagata gender acts is the communication of *iroke* (sensual allure). Although certain male gender role types may also emphasize *iroke*, it is an essential aesthetic attribute for every onnagata role type.

Gunji Masakatsu, writing on kabuki aesthetics in *Kabuki no Bigaku* (Kabuki Aesthetics), states that erotic allure played an essential role in shaping what I call onnagata gender acts.[61] Over time, the sensual acts of onnagata became more subtle, obscuring their overt eroticism. Nonetheless, sensuality remains central to onnagata gender acts, and performers have gradually fashioned their own versions of stylized sensual allure. An onnagata may be erotically attractive to spectators of different genders and sexualities.

I have drawn on Judith Butler's performative gender theories in formulating my concept of "gender roles":

> Gender ought not to be construed as a stable identity or locus of agency from which various acts follow; rather, gender is an identity tenuously constituted in time, instituted in an exterior space through a stylized repetition of acts. The effect of gender is produced through the stylization of the body and, hence, must be understood as the mundane way in which bodily gestures, movements, and styles of various kinds constitute the illusion of an abiding gendered self.[62]

When onnagata perform stylized gender acts, like a turned-in walk, or wear particular costumes, such as a long-sleeved kimono, and repeat these acts in formulaic patterns, they are creating onnagata "gender roles." Onnagata

gender roles represent a stylized fiction of female-likeness, or a fiction of Woman[63] on the kabuki stage. My definition of onnagata gender roles echoes Butler's definition of gender:

> Gender is the repeated stylization of the body, a set of repeated acts within a highly rigid regulatory frame that congeal over time to produce the appearance of substance, of a natural sort of being . . . [64]

An onnagata's "gender performance," then, is his enactment, or doing of his gender acts for the purpose of presenting a particular gender role in a kabuki performance. Further, the history of Edo period government bans on onnagata point to how this gender body art gained notoriety and approval,

> the construction [of gender] "compels" our belief in its necessity and naturalness. The historical possibilities materialized through various corporeal styles are nothing other than those punitively regulated cultural fictions alternately embodied and deflected under duress.[65]

Several key points are important to bear in mind during this feminist explanation of onnagata gender acts and roles. First, onnagata gender acts were the exclusive representation of female roles on the public stage until fewer than one hundred years ago. Second, the thorough erasure of women performers from any commercial performance cannot be overstated. Other major professional theatrical forms such as nō and kyōgen were also all-male troupes. It took a decade into the twentieth century before the effect of the ban on women performers gradually lifted and women began to perform on stage regularly. Even then, directors, playwrights, and producers were men, with only a few exceptions. The earliest generations of women performers were trained by men, who were greatly influenced by onnagata gender performance. Consequently, their first attempts to act were imitations of onnagata.

In *Gender Impersonation Onstage*, Jill Dolan describes a similar phenomenon in several Western theatrical traditions:

> The cross-dressing tradition of male casts in Greek, Shakespeare, and popular theatrical forms in England and America effectively erased women, substituting the man-made Woman for women to emulate. The theatrical mirror is really an empty frame. The images reflected in it have been consciously constructed according to political necessity, with a particular, perceiving subject in mind who looks into the mirror for *his* identity . . . both men and women, lesbians and gay men, are implicated in the polarized gender structure theatre reflects. Men, however, are implicated and involved as the subject

of theatrical representation. Women, absent from the system and constituted only as Other, are in the outsider's critical position. In terms of deconstructing gender opposition, then, the feminist perspective edges out the others. . . . we find men in control of the mirror, with women looking into it for appropriate reflections. Shining back at them from the male mirror, however, was a socially constructed concept of Woman that served the guiding male ideology.[66]

What happens in the kabuki mirror? In Edo period kabuki, male actors substituted the onnagata-made female-likeness for women, which served the dominant male ideology. The onnagata reflection in the kabuki mirror shines back as a constructed image of onnagata female-likeness. But this image is a special fantasy gender, differing from the Western polarized gender roles. Even with the male body in control of the mirror, the onnagata image was gender ambiguous. Both men and women looked into the mirror, emulating the onnagata gender ambiguity and performance style. Indeed, the kabuki stage was a mirror to all the merchant class of the Edo period.[67] I argue that early kabuki onnagata invented a fiction distinct from women because they created gender acts for their own fiction of female-likeness that was based on the male youth body. Early onnagata were even coerced to not imitate women, but instead, to invent their own extraordinary, outside-the-law fictional gender role.

To fully appreciate the invented gender roles of the onnagata, I emphasize that there is a distinction between the onnagata stylized gender acts and roles and those of actual women. What onnagata perform on the stage is neither a representation of actual women, nor an ideal representation of an innate womanliness or female essence. Rather, onnagata are men performing onnagata gender roles. The male body and its onnagata acts together create ambiguous gender acts and variable eroticisms through codified theatrical stylization. The onnagata gender act system excludes women and female bodies.[68] As Nakamura Matsue V (1948–) stated, "I am a man so I perform 'onna'—'gata.' I must perform female-likeness, but I must not be a woman."[69]

The perspective of Sue-Ellen Case, in her investigations of the portrayal of women in Western classical theatre, supports my argument disengaging onnagata gender roles from women. Her explanation of the fiction of Woman created by the patriarchy of the classical Greek culture can be correlated with the onnagata fiction of Woman. She begins by describing the practice within classical cultures of dividing public life from private life along the lines of gender:

> The public life becomes privileged in the classical plays and histories, while the private life remains relatively invisible. The new feminist analyses prove that this is gender-specific, i.e., the public life is the property of men

and women are relegated to the invisible private sphere. The result of the suppression of actual women in the classical world created the invention of a representation of the gender "Woman" within the culture. This "Woman" appeared on the stage, in the myths, and in the plastic arts, representing the patriarchal values attached to the gender of "Woman" while suppressing the experiences, stories, feelings, and fantasies of actual women. The new feminist approach to these cultural fictions divides this "Woman" as a male-produced fiction from historical women, insisting that there is little connection between the two categories. Within theatre practice, the clearest illustration of this division is in the tradition of the all-male stage. "Woman" was played by male actors in drag, while actual women were banned from the stage. The classical acting practice reveals the construction of the fictional gender created by the patriarchy.[70]

Case goes on to discuss the ways in which women were suppressed, and how the fiction of Woman in plays and theatrical practice came to replace them completely. I propose that in a similar way, onnagata were the inventors of a fiction of Woman in the Edo period. However, I would make two additional points that reflect my concern for cultural specificity and a transnational feminist positioning.

First, the division of the gender specific public and private domains and their relationships to theatre was somewhat different in Japan. The world of courtesans, the women entertainers in the private sphere of the licensed quarters, did in fact intersect with the world of kabuki theatre and the male actors in the public sphere. It is noteworthy that courtesans were performing for men and surviving on how well they portrayed the masculinist fiction of Woman.[71] Nevertheless, the relationship was dominated by the male actors who had the public freedom to create all stage gender roles. It is probable that women entertainers emulated the onnagata gender role techniques, and incorporated those gender acts into their own performances.[72]

Second, in kabuki's early history, performers made gender acting and transformation a part of their art and entertainment. Male performers were named onnagata when the governing bakufu forced performers to specialize in either female-like or male-like gender roles.[73] From the outset, onnagata was recognized as a male-body-performed gender role, and the onnagata gender acts were stylized acts—a great part of which were derived from dances performed by young boys. The onnagata gender role types developed as further elaborations, exaggerations, and adaptations of basic onnagata gender acts.

When the onnagata gender role was initially formulated in kabuki in the seventeenth and eighteenth centuries, heterosexuality was not held up as the governing principle of moral rectitude in Japan. In researching onnagata gender acts throughout the Edo period, I have observed that early onnagata

may have followed a culturally accepted style of sexuality, *shudō* (the way of boy love), which had its own gender acts, aesthetics, and erotic practices.[74] It follows then, that gender acts are not necessarily fixed binary gender codes constructed to appear opposite to the male gender roles.[75] Onnagata may have represented female gender roles, but, in a sense, onnagata gender acts did not have to comply with an image or the allure of the heterosexual female role as an opposite to the tachiyaku gender role.[76] Kabuki performers were also outsiders to the rest of society because of their *hinin* (nonhuman) status.[77] To a degree, the kabuki stage was a discursive "other" space, outside regular society, where performers could create their own multiple gender roles.

Why choose gender performance as the site for transcultural performance analysis? According to Sue-Ellen Case, gender is one of the most effective modes of repression.[78] Dominant powers in many cultures have effectively used binary gender roles to delineate position in society, economic value, occupational value, mental and physical ability, and physical characteristics to such a degree that oppositional gender role characteristics have been naturalized offstage as well as onstage. Similarly, Judith Butler writes, "Gender is the cultural transformation of a biological polysexuality into a culturally mandated heterosexuality."[79] Analyzing gender performance as culturally prescribed physical acts breaks up the illusion of a natural binary sex/gender identity.

Gender performance may be one of the best locations for observing differences that disturb our cultural order and cannot be easily assimilated. Gender role distinctions may function like visible signs of race, and mark characters with a set place in a culture. In addition, these distinctions may be so subtle and carefully nuanced that only a handful of the cultural elite can read the gender differences. Kabuki onnagata gender roles are rich with both subtle and obvious points of difference and distinction. On one level, we may appreciate onnagata performance as a history of innovative actors who created gender acts through stylization techniques. Simultaneously, on another level, onnagata performance can be seen as an example of gender role construction and transformation that dismantles the illusion of a natural or essential gender identity.

Contemporary Onnagata and Gender Performance

Contemporary onnagata exploit the differences between their kabuki stylized gender role and their male bodies by playing with the boundaries of sex, gender, and sexuality. Onnagata gender roles have an imaginary sexuality that is assumed to be erotically aroused by male gender roles. It is a kind of imaginary body, because we never see it without kimono. Onstage,

onnagata style and alter visible and kinesthetic acts to demonstrate their gender roles. They work extremely hard, to the point of physical pain, to achieve *these* gendered appearances. Props, costuming devices, and set design are utilized as extensions of their appearance. They design this outward display to achieve a totally stylized beauty, which has gradually become the aim of contemporary kabuki in the twentieth century.

Whether traditional or flamboyant in their onstage onnagata gender role styles, contemporary onnagata perform their onnagata gender roles in relationship to their own sex, gender, and sexuality configuration. Since the *Ayamegusa* (Words of Ayame), the first recorded teachings on the art of onnagata by Yoshizawa Ayame I (1673–1729), a distinguishing feature of onnagata gender performance has been that an onnagata should maintain his gender performance offstage.[80] However, there are no recorded lessons that state that an onnagata should also maintain a constructed representation of sexuality as part of his onstage onnagata gender role. Therefore, the on and offstage gender acts of onnagata are distinct from their off and onstage sexualities.

Contemporary performers themselves indicate that their methods of onnagata performance are a kind of gender performance. Each has his own physical relationship to the gender ambiguity in his art. The performer can fine tune the degree of gender ambiguity he wants according to his skills of execution and the choices he makes among the many details of gender stylization. In interviews, onnagata emphasize the constructedness of their roles. They speak of the stylized acts they perform to produce their onnagata movement, voice, and visual appearance. The performers' comments can be related to feminist theories of gender performance as produced through prescribed acts. For example, Sawamura Tanosuke VI (1932–) comments that an onnagata is something that is first and foremost "made up, constructed from the prescribed forms for the female roles."[81] He thinks that the onnagata *kata* were made for the stage, not to imitate the real world or real women, but to create "kabuki realism."[82]

Another onnagata, Bandō Tamasaburō V (1950–), says, "I perform onnagata, do you know what I mean? Perform. To perform is the most important thing."[83] He emphasizes that "perform" does not mean becoming a character, but achieving the total design, the perfect line and form in every *kata*. Everything he did onstage as an onnagata, to the finest detail of his wig line or kimono hem, had to be shaped and coordinated to produce the perfect form. When asked if he found some roles more "natural" to his body, he was quick to reply, "I don't think there is anything natural about playing onnagata."[84] His theory of gender performance arises from a conscious and constant control and refinement through a moment-to-moment consciousness of performing stylized acts.

Nakamura Tokizō V (1955–) considers his onnagata techniques to be applicable to any role type. In his words, "All roles are the same to me. It's really a matter of performing the *kata* to create different fictions. In an onnagata role, I enact female-likeness; as a samurai, I enact samurai-likeness; as a wife, wife-likeness."[85] Tokizō V also acknowledges that in onnagata roles there is a kind of charged beauty that arises from the discipline and rigor of reshaping his body into the required stylized forms.[86] The late Onoe Baikō VII also emphasized techniques and refinement as the base for onnagata gender acts. Everything about an onnagata, he said, has to appear refined, beautiful, and graceful—even if it takes brutal strength and great pain to perform. Baikō VII described the paradoxical nature of onnagata gender performance: "Only grace and gentleness is not enough, you have to exhibit female-likeness over the male body."[87] He emphasized that, for him, his male body was always present, and there was a tension between his male body and his onnagata *kata*.

The relationship of the actor's body to the gender role adds another dimension to gender performance. The onnagata may see his body as fitting certain gender role types better than others because of his image of himself and the ideal role type image. Some kabuki performers see certain onnagata gender role types as requiring a more "feminine" female-likeness, while other role types need less. Although he is not an onnagata, Nakamura Kankurō V (1955–) frequently plays onnagata gender roles. He emphasizes that he wants to perform only certain onnagata role types like the *musume* (young girl) or *nyōbō* (wife), role types that he feels are ambiguously gendered. *Yūjo* (courtesan) roles are the most difficult for him because he feels these roles require an extreme female-likeness, "I just can't do *yūjo* roles. In fact, I hate doing *yūjo* roles. Why? [laughing] No one would buy me, that's why. . . . You have to have that kind of body, right?"[88] As an example of "that kind of body," Kankurō V described a tall, slim, and sensual body type. Kankurō V himself is short and a little stout. Kankurō V has a set gender image for the *yūjo* role type that he feels he cannot achieve, no matter what the costume or *kata*. He emphasizes that his male body never disappears in his onnagata roles and that some role types and gender acts match his body better than others. Kankurō's perception of his body beneath in relationship to the onnagata acts reveals the complexity of the performer's relationship to gender acts and gender roles. His comments on the *yūjo* role type seemed to indicate his sensitivity to being cast in a role that requires overt erotic acts directed at other male actors.

Nakamura Shikan VII (1928–) added his perception of how he plays with gender ambiguity:

> What do you see when you watch an onnagata onstage? You know that I'm a man. For me to go onstage and look completely like a woman would be

bad. Instead, I'm a little concealed in a female disguise. But, gradually you see me, Shikan, a man, as the female [on stage]. But you see a man, too, right?[89]

Perhaps, Shikan VII suggests that we grow accustomed to a certain set of gender acts, which take on the meaning of "female" gender in kabuki performance. But, I also think he means that there is something more about the onnagata gender performance that dissolves and reforms before our eyes. That is, the onnagata gender performance is supposed to be something that plays with each person's imagination. As Judith Butler writes,

> Genders can be neither true nor false, neither real nor apparent, neither original nor derived. As credible bearers of those attributes [gender acts], however, genders can be rendered thoroughly and radically *incredible*.[90]

Following the idea of radical otherness, then, onnagata frequently refer to their stylized acts as *tsukutta mono* (made-up things). They see themselves as the bearers and creators of gender acts that have become more other-worldly and more virtuosic in their kabuki contexts.[91]

Onnagata frequently refer to their gender acts as transformative, and that quality as central to their performance. Not only do they adapt the gender acts to their bodies, but the gender acts themselves may have variable qualities, allowing for multiple readings from the performer's and spectator's points of view.[92] In this book, I examine this idea of transformativity when I analyze some of the most common onnagata gender acts, for example, the gender acts of kimono wrapping and manipulation. I suggest that kabuki onnagata, by using the transformativity of their gender acts, work every moment onstage subverting the categories that Butler claims fix gender into gender identities.[93] That is, the transformativity of their gender acts undoes or "subverts" a linear pattern of equivalence: this gender act is equal to "female" only. Onnagata gender role performance skills could be considered strategic theatrical devices in which the signs over the body may or may not create a likeness to what is labeled "male" and "female" gender. Onnagata gender performance is a process through which any and all physical acts of gesture, voice, appearance, stage space, and sound continually transform the reading of the performer body.

Judith Butler writes:

> If sex and gender are radically distinct, then it does not follow that to be a given sex is to become a given gender; in other words, "woman" need not be the cultural construction of the female body, and "man" need not interpret male bodies. This radical formulation of the sex/gender distinction suggests that sexed bodies can be an occasion for a number of different genders, and further, that

gender itself need not be restricted to the usual two. If sex does not limit gender, then perhaps there are genders, ways of culturally interpreting the sexed body, that in no way are restricted by the apparent duality of sex.[94]

Central to my theory of onnagata gender performance is the concept that onnagata gender acts are "live history" examples of the *performativity* of gender. That is, the gender acts constitute or construct a gender role type; they do not express or reveal a gender identity. I disagree with the interpretation of the onnagata gender role as a role that "expresses" a female gender, implying a deeply buried female gender identity/essence. Instead, I suggest that onnagata gender acts deliberately reveal their performativity onstage and use their demonstrations of gender "acting" as a subversive theatrical activity. By "subversive" I mean that onnagata gender performance undermines the idea that they are representing any kind of essential female identity, on purpose. The onnagata gender art is constructed to undo itself, to reveal its own illusion. I quote Butler to clarify my emphasis on onnagata gender performativity:

> The distinction between expression and performance is crucial. If gender attributes and acts, the various ways in which the body shows or produces its cultural signification, are performative, then there is no preexisting identity by which an act or attribute might be measured; there would be no true or false, real or distorted acts of gender, and the postulation of a true gender identity would be revealed as a regulatory fiction.[95]

That is, onnagata gender roles are made up of gender acts that a performer utilizes to produce, onstage, his kabuki onnagata female-likeness. The body of the performer produces the onnagata gender role by performing certain gender acts, which were created over time as onnagata *kata*. A "true onnagata gender identity" like a "true female gender identity," is a constructed performance of creative, ambiguous acts. The onnagata's gender performativity reveals both gender's performativity and society's control and enforcement of "real" and "essential" gender and sex categories, which Butler affirms:

> That gender reality is created through sustained social performances means that the very notions of an essential sex and a true and abiding masculinity and femininity are also constituted as part of the strategy that conceals gender's performative character and the performative possibilities for proliferating gender configurations outside the restrictive frames of masculinist domination and compulsory heterosexuality.[96]

Jennifer Robertson has researched gender performance in Japan with the all-female Takarazuka Review. I have found her cross-cultural gender analysis

and delineation of Japanese expressions for sex, gender, and sexuality useful in my analysis of onnagata gender acts. Robertson accounts for the processing of gender roles in Takarazuka through her study of how male company directors have created a system of fictional genders for their female performers. Subsequently, the girl stars become fictional gender idols for their fan clubs. She has analyzed gender performativity in the Takarazuka context, drawing on theories of Teresa de Lauretis and Judith Butler, among others. Robertson works with de Lauretis's discourse that a sex-gender system is:

> both a sociocultural construct and a semiotic apparatus, a system of representation which assigns meaning (identity, value, prestige, location in kinship, status in the social hierarchy, etc.) to individuals within the society. . . . *The construction of gender is both the product and the process of its representation* [author's emphasis].[97]

I have found several of Robertson's points on the reading of gender roles applicable to onnagata performance. Robertson notes the Japanese recognition of two sexes and two genders, but states that genders "are not ultimately regarded as the exclusive province of anatomical females and males."[98] Gender acts are not attached to a body as its markers; there is not an absolute matching of certain gender acts to a particularly sexed body. Therefore, to an extent, any sexed body may use any combination of gender acts. Robertson goes on to discuss how performers are assigned genders by the school and company directors, and how performers have subversively manipulated their enactments of gender. The social constructs of *male* and *female* are processed over and over. She also argues that the construction of Japanese sexualities is not motivated by the Anglo-American gender ideology, which she contests is based largely on homophobia.[99]

Kabuki and Takarazuka are both same-sex troupes, with gender role specialists who play with gender acts and eroticisms outside the binary system. Like Robertson, I have developed a theory of gender representation in onnagata performance through examination of the stage product and its processing by actors. However, the focal point of my research is the male body enactment of a female-like role. This is quite different from Robertson's analysis of the Takarassiene, the young female performer who enacts gender roles that are determined by a male administration. What distinguishes Robertson's research is that she recognizes differences in Japanese performance that may go unrecognized by anyone unfamiliar with the cultural context. The following passage, in particular, helped me to frame my onnagata gender theory:

> The stereotype of the Japanese as a homogeneous people has had the extended effect of whitewashing a colorful variety of gender identities and

sexual practices. . . . More often than not the differing experiences of female and male members of Japanese society have been insufficiently problematized and have been confused with dominant, naturalized gender ideals . . . and the behavior of fictive characters. This article should help to dismantle some of the more tenacious stereotypes of Japanese women and men and to provoke discussion on the complicated relations between sex, gender, and sexuality in Japan and elsewhere.[100]

While onnagata may at first appear radical and unconventional in their performances, their female-like gender acts may be part of a historical system, created within the kabuki world of sex, gender, and sexualities, which differs from an oppositional binary division of gender/sex relationships and heterosexuality. Further, I recognize that each performer has his own relationship to those acts in accordance with his individual physical aesthetic, desires, and sexualities. Certain groups of actors resist any connection with a homosexual image of sexuality, while others offer different and complex explanations of connections between their performed appearances of genders and sexualities. For example, as Ichikawa Ennosuke III (1939–) writes in his book *Ennosuke no Kabuki Kōza* (Ennosuke's Kabuki Course), and emphasizes in his interview, "an onnagata performing female-likeness is not equal to the so-called gay boy who copies women."[101] Instead, Ennosuke III offers his idea that he makes his onnagata out of *kata*, which are the "deformed" female-like features seen from a male point of view. The attraction of the onnagata, according to Ennosuke, is how far you press the truth beyond truth, braiding the truth of the male body with the fiction of the onnagata.[102]

I contend that the issue of gender is central to any informed study or viewing of kabuki performance because the art of onnagata is exclusively authored and enacted by men. Further, onnagata performance is part of a larger arena of theatrical representation, whose references are encoded in a particular culture's system of gender iconography. In my history chapters, I show the construction of the onnagata image arising from the beautiful boy iconography, which itself was constructed from an older world of samurai and boy attendants. Although I do not examine the entire Japanese gender iconography of the Edo period, my study of onnagata gender role types does present the gender role iconography of the kabuki onnagata within the Edo culture.

It is crucial to maintain the awareness of onnagata as men who are performing gender acts that other men invented in certain political circumstances. When gender acts appear more realistic and less stylized, it is likely that their stylization is more subtle and difficult to discern. Within this system, what appears natural or realistic is the product of a sociocultural model that serves an established authority.

Throughout this book, it is my intention to show how onnagata gender acts work in the system of kabuki gender roles. The onnagata gender performance is an example of a theatrical gender/sex system in which the actor body regains its power as an ambiguous sign "to be inscribed only by its interpreter and rewriter and bearing no originary intent."[103] I suggest that kabuki onnagata gender role performance is a brilliant and subversive[104] multi-gender theatre, of the kind Judith Butler envisions in *Gender Trouble*:

> What performance where will compel a reconsideration of the place and stability of the masculine and feminine? And what kind of gender perfor- mance will enact and reveal the performativity of gender itself in a way that destabilizes the naturalized categories of identity and desire?[105]

In her introduction, Butler refers to the "critical interrogation of the exclu- sionary operations by which positions are established."[106] I also argue that the onnagata subverts and questions the oppositional gender roles of *male* and *female*. Onnagata are customarily designated as the female role players in kabuki, and I challenge the *female* designation of this role. I argue that onnagata, in their gender acts, undermine the "exclusionary operations" that would interpret their performance as a kind of female impersonation.

A feminist perspective offers a framework within which to reenvision and decode the bipolar gender system. In the male-centered world of kabuki where men create and perform all gender roles, the concepts of *female* and *femininity* are a rift in the system of fundamentally opposing gender roles. An important aim of this book is to demonstrate how the onnagata fiction, controlled and shaped by and with a male body, reflects alternate gender possibilities with the potential of disrupting the prevailing masculinist ideology.

A Map of Strategies

My analysis of onnagata gender role development and performance is based on a combination of strategies from Western feminist gender theories and Japanese gender concepts. Among the central features of onnagata gender performance art that I draw on from gender studies are: (1) the repeated stylization and codification of gender acts; (2) the creation of artificial gen- der roles from stylized gender acts; and (3) the sliding between the gender role body and the body beneath.

I suggest that in onnagata gender performance, an onnagata performs acts over and with his body that construct his body into a performative gender role. At the same time, the male body beneath of the actor, although trained to support and adapt to this onnagata gender role body, resists

complete assimilation with the onnagata exterior. The onnagata disrupts the illusion of a sex/gender identity coherence that a stage role presumably requires. Numerous talks with onnagata and kabuki scholars indicate that this disruption of performative sex/gender and actor sex/gender is what creates the *onnagata no miryoku* (the fascination of the onnagata).[107] Through an examination of onnagata history, I confirm how onnagata gender performance is a constellation of selected and refined physical acts that performers developed through a process of stylization. The body of the onnagata and his role type body remained central to the enactment of onnagata gender performance. To add to the layers of gender ambiguity, the onnagata gender role types have their own subtle gender differentiations. Certain role types, such as a *jidainyōbō* (period wife) role, may exhibit more male-likeness than another role type—for example a *himesama* (princess) role type, who may go to the extreme of female-likeness.

From my reading of onnagata gender performance practices, I show that onnagata gender acts have three main characteristics: transformativity, multiplicity, and ambiguity. Onnagata, with the male body beneath, demonstrate all of these characteristics in their daily performances of onnagata gender roles. Although they often appear to reflect the conventional concept of gender in their female roles, onnagata may actually subvert the binary gender system. I propose that these performances challenge the assumption that a certain gender and repertoire of gender acts is natural to a certain sexed body. Throughout this book, I suggest not only that onnagata gender performance is ambiguous, but also that the human body is gender ambiguous.

In the chapters ahead I examine how an onnagata image is not a stable or fixed entity; instead, transformativity is built into every aspect of onnagata performance, whether it be a stylized walk or a complex *yūjo* role, like Agemaki of *Sukeroku*. Each onnagata may reveal his body beneath to different degrees and in different ways during a performance, creating subtle, changing nuances. Even in kabuki narratives and dances, kabuki onnagata characters metamorphose and evolve into other characters whose gender may not be easily named or nameable. In my analysis of onnagata gender performance, I demonstrate how onnagata use these multiple images and layers of bodies to create a gender-ambiguous performance in which spectators and performers interact.

While this book focuses on the theatrical techniques used by kabuki performers to construct an onnagata gender role, there are underlying questions concerning authority, resistance, and subversion in female representation. This study addresses these questions within the performance analysis. That is, what kind of performance could disrupt the normative heterosexual binary of male and female gender roles? Could the onnagata

techniques for performative gender roles suggest strategies for undermining the fixity of sex/gender/sexuality and identity and desire? Onnagata gender performance was created and developed in a culture outside Western and Christian traditions; consequently there are specific differences that resist certain theoretical applications. Could these differences contribute to freeing gender identities from the dominant heterosexual ideology?

Given that this is a gender role enacted exclusively by men throughout a 300-year history in which women have not been allowed to become Grand Kabuki[108] actors, how can I consider the onnagata gender performance a viable instrument for destabilizing a binary sex/gender system? My argument is that onnagata perform gender acts in a stylized, fictional kabuki world that bears little resemblance to everyday gender performance. I suggest that contemporary onnagata performance is so fantastic in its illusion and production of genders with its transparency to the body beneath, that it resists the binary division of male and female gender roles. I address these issues in detail in later chapters of this book. I do not believe this study to be a "vain utopian project"[109] in gender performativity, but a practical analysis of possible strategies for theatrical performance that do not reify the conventional gender system but go beyond or transcend that system. Jill Dolan discusses how gender "offers historical places to investigate the operation of gender as only representation, as only constructed and created through the cultural and historical moments that needed it to work."[110] In the chapters that follow, I examine how onnagata gender performance arose from political restrictions on gender and related acts of eroticism, and how contemporary performers reconstruct the historical fictional representation. For the kabuki onnagata today, the fictional representation still has its powerfully repressive tactics in place. In my analysis, the historical, contemporary, and ongoing negotiations of onnagata and their gender acts are the focus.

I suggest that onnagata gender role performance skills could be strategic theatrical devices for altering modes of cultural production, where the signs over the body may or may not create a *real-likeness*. I hope to demonstrate the process of how gesture and appearance create transformative acts with varying and multiple readings. Further, I propose that the body beneath, that is, the actor body underneath these stylized acts of appearance, may transform its sex/gender/sexuality configuration through its shifting, ambiguous relationship to the outer visual and kinesthetic gender patterns. The kabuki onnagata could work "through mobilization, subversive confusion"[111] of those categories that fix gender into male or female identities.

Onnagata gender acts arose from within a masculinist tradition of gender role stylization. A male-sexed body created the onnagata gender acts based on the body of an adolescent boy. Kabuki is part of a Japanese tradition of

male masters, strongly rooted in the repetition of hereditary formulas and strict coherence. In apparent contradiction to this rigid continuity is the living onnagata, perpetually reinventing what appears to be a set theatrical form. Kabuki performers, particularly onnagata, have managed to fabricate an illusion of coherence, which thrives on the tension between invention and coherence.

One might even wonder whether kabuki theatre would exist without onnagata as one of its most eccentric, glamorous, and sensual elements. In analyzing onnagata gender performance we should not overlook two major points: (1) kabuki exists as an art without women, and (2) the stage representation by onnagata is a male-created fiction of female-likeness based on an adolescent boy body. Further, attraction to this stage image by audience members of varying genders and sexualities seems to suggest a much more ambiguously enacted gender role than that of an ideal Woman. In the following chapters on history, performers, techniques, aesthetics, and role types, the onnagata characteristics of diversity, multiplicity, and ambiguity illustrate the play of gender between the dynamic tensions of resemblance and transformation, convention, and transgression.

CHAPTER 3

PRECURSORS AND UNRULY VANGUARDS

The Renegade Acts of Exceptional Women, Exotic Maidens, and
Erotic Boys Heian through Early Edo (794–1652)

Precursors

Throughout this historical review, I examine how onnagata gender acts evolved, paying particular attention to the role of government censorship, the erasure of women performers, the centrality of male love, and the boy prostitute performer. I also draw attention to the connections between early onnagata gender performance and prostitution, eroticism, and early onnagata stylization practices, and the significance of the boy body and gender ambiguity in onnagata performance.

The precedent for multiple gender performance was well established in Japanese performance forms before onnagata invented their particular fictions of gender. Several types of performers suggest a rich history of gender ambiguity and the rich play between gender acts and bodies. In the late Heian period (898–1185), the *shirabyōshi*, predominantly young female solo performers, performed a mixture of gender acts in their dances. Appearing around 1190, *chigo*, who were adolescent boy acolytes, were popular performers and prostitutes serving in the Buddhist temples. Later in the Middle Ages, the *wakashu*, who were boy prostitute performers, gained notoriety for their dances and skits performed by all-boy troupes. In the segregated female and male troupes of earlier genre, such as *sarugaku*, *kusemai*, or nō, a performer's gender acts were performative and separate from the actor's body beneath. Several of the precursor forms are evidence that the phenomenon of men and boys enacting a female-like role and performers playing with various gender acts did not originate in Edo period kabuki, but had a much earlier genesis.

The precursor forms of gender performance shared several characteristics. The costuming combined male and female styles of dress, making the performer's appearance gender ambiguous. Many of the precursor performance styles did not mix sexes, and multi-gendered performance styles grew up within the various single sex groups. The young boys and girls, who were sometimes associated with temples and shrines and sometimes with managed troupes, were economically bound for their existence to their various audiences and patrons. Entertainment and seduction were integral to their performance acts. I suggest that early onnagata incorporated the precursor acts into the stylized art of onnagata gender acts, role types, and roles.[1]

From the later part of the Heian period (approximately 1130), *Shirabyōshi*, the young female performers who also practiced prostitution, were noteworthy for their male-like attire and performance style. They dressed in white *suikan* robes (courtier's or priest's long-sleeved jacket), long white *hakama* (long, loose skirt-like pants), an *eboshi* (black court-style lacquered hat), and they wore a sword dangling at the hips. The male-gendered acts of wearing a sword and an eboshi, combined with their flowing *hakama*, which could be male or female attire, lent the *Shirabyōshi* an erotic allure of transformative and ambiguous genders. Young boys also performed as *Shirabyōshi*.[2] With their adolescent bodies, they too could entertain their audiences with their gender ambiguity.

Shirabyōshi performed a one-person act. Their solo works were dominated by dancing and singing. To accompany themselves, they used fans as clackers; or they played flutes, cymbals, and small hand drums. Although of the lowest caste status, the young performers were frequently entertainers at court banquets[3] and combined prostitution with their art. Their mixed status as social outcasts, entertainers, and prostitutes subjected them to many social prohibitions.[4] Kawatake Shigetoshi suggests that *Shirabyōshi* performance was assimilated into the *onna kusemai*, a women's dance and song performance genre that Zeami Motokiyo (1363–1443) took over into the all male nō.[5] Ultimately, the songs and dances of *yūjo* kabuki (courtesan kabuki) were part of this line of entertainment in which ambiguously gendered young bodies mixed the sensuality of dance with the religious imagery of songs.[6]

Woven into this history of segregated male and female performance genres are those that featured young boys. Kawatake Shigetoshi traces the *wakashu* (boy prostitute) kabuki lineage back to the Heian period (794–1185), when boys performed certain *bugaku* (court dances) in the courts. Among the *wakashu* precursors, Kawatake cites, are the *warabemai* (children's dance), *kochō* (butterfly), and *karyōbin* (dragon-type) dance forms "performed by

four ten year old boys in female attire, wearing magnificent feathered headgear and wings on their shoulders."[7] During the same period, boy performers in the temples were known as *kozushi*, a boy version of *zushi*—performers of exorcism, divination, and theatrical acts.[8]

With the rise in economic power of the Buddhist temples and priests in the late twelfth century, the combined arts of boy love and boy entertainments flourished. *Ennen* (banquet entertainment) was a popular form that included dances, songs, recitations, and skits. In *chigo ennen*, a boy-acolyte version of *ennen*, *chigo*, "wearing female-style costumes of colorful *kosode* [short sleeve style of kimono] and red *hakama* (skirt-like, pleated trousers),"[9] performed in-group dance celebrations such as *itoyori* (lit. braiding threads), a graceful weaving line dance with choral singing in *wakane* (high-pitched boy soprano) voices. Kawatake claims that elements of the *chigo ennen* performance, particularly the *itoyori* style, were assimilated into kabuki onnagata performance.[10]

In the temple version, *chigo ennen*, the performers were a combination of the *chigo* and *daishu* (lower-ranking young priests):

> In 1199, the songs and dances of altar boys (*chigo*) and the Sarugaku of priests (*daishu*) were performed at the Todaiji monastery as an Ennen program. The *chigo* were the good looking boys who were the objects of the love of priests in temples and performed dances combined with popular dances (*Ranbyōshi* and *Shirabyōshi*) and children's dances (*warabemai*). The *daishu* were lower class priests, some of whom were semi-professionals and were responsible for the performances ranging from songs-and-dances to acts and conversations.[11]

While all-female troupes performed programs of nō acts and dances, the boy acolytes dominated the enclosed performance world of the temples. Boys and men had an ongoing history of same-sex love, based on the master–servant and teacher–pupil relationships of the court, temples, military camps, and castles.[12] Women and girls could not occupy their positions of learning, loyalty, or sexuality. The all-female nō troupes never gained the support of the shogunate or professional status. Watanabe Tamotsu points out that performances were sometimes restricted to men:

> Women and girls always had that stigma of being somehow polluted in some way because of having periods and bleeding. . . . Female bodies, no matter what, were dirty and strange. The female sex still belonged to a darker world.[13]

The tradition of boy performance began in this secluded world of temples, apart from both a binary gender system and a theatrical context requiring

the imitation of girls or women. I suggest that because the *chigo* lived in the isolated world of the temples, with their livelihoods assured, they were able to develop their own distinct style. Following the *Shirabyōshi* and the *chigo*, performance forms changed frequently, yet the aesthetic of gender ambiguity and eroticism associated with the *bishōnen* (beautiful boy) continued to evolve from the court, temple, and shrine performances to the streets and brothels, and finally onto the makeshift kabuki stages of the early Edo period. Gradually, because of complex economic and class forces, the all-male troupes prevailed, and the beautiful boy body won enormous popularity. The *bishōnen* eventually became arbiters of fashion and taste in the early Edo period.

Okuni's *Kabuku* Performance Art

In the history of Japanese gender performance, Izumo no Okuni (act. 1603–?), is very important in the line of women performers, including the *Shirabyōshi* and *miko* (virgin temple maidens), who made their living by manipulating male-likeness through acts of costuming and gesture. Kabuki history traditionally cites Okuni—a famous temple dancer, riverside prostitute entertainer, and troupe director—as the initiator of *kabuku* (to slant, to shift off center, to be outside the norm) performance art.[14] Okuni created a review that combined revamped folk dances with religious chants, ritual, and prayer gestures from a Buddhist incantation and dance. She crowned this with an irreverent mixture of gender and class acts of costuming, accessories, and movement.

Domoto Yatarō emphasizes that Okuni's show was really a spectacle. It was not simply that she dressed in men's clothing, but the stunning and bizarre innovations she made with them. He quotes from the *Kabuki no Zōshi* (Kabuki Storybook):

> For that day's outfit, Okuni wore, a red plum colored *kosode* as an under kimono, and draped about over that another colorful, bright and garish *kosode* and a *haori* of dark red ground with gold brocade, braided with light green; tied tightly with a brilliant purple obi. She had crystal rosary beads hung about her neck, and she tied on a sword with a golden hilt and a white shark skin sheath of two *shaku* six sun in length, along with a short sword in a gold case about two shaku in length. Dangling from her waist, there were assorted items like an *nashiji* gold and silver inlaid lacquered seal case, a dark blue and gold brocade money purse, and a golden gourd, all jumbled together.[15]

From this and other descriptions, it seems that Okuni not only enjoyed flamboyant costuming, but also every part of her troupe's performance aimed to *kabuku*—defying conventions of socially prescribed behavior,

gender roles, and social class. For example, one of her dances included a male character dance, called the *Narihira* dance. Ariwara no Narihira (825–880) was a famous legendary lover and poet of great beauty, frequently referred to for his mixture of feminine and masculine attributes.[16] Okuni performed her version of *Narihira* somewhere between male and female, even confounding her audience as to whether she was a man or woman, "If it looks like a female, it could be a male, or . . ."[17]

Okuni created and enacted several nō-styled dramatic skits, among them *keiseikai*,[18] which was based on the advertising, selling, and buying of a prostitute. This simple introduction and bargaining skit was to become the nuclear scene for later kabuki plays. When Okuni performed the *keiseikai*, she played the character of the male customer buying the female courtesan. Her male partner performed the role of the female courtesan. They mixed dance and stylized gestures to the musical accompaniment of nō instruments. The male partner as female courtesan dressed in a colorful kimono and scarf, made his entrance from the audience, while Okuni, as the male buyer in one of her awesome male-like *kabuku* outfits, strutted out on the nō stage's *hashigakari* (bridge form passageway). Such changes were innovative during that period, particularly in their use of the spiritually and aesthetically sophisticated nō style.[19]

Watanabe Tamotsu remarks that the male performer's female gender role was supposed to be comic. He wore female-styled kimono. To cover the portion of his head that was shaved, he sported a type of *bōshi* (scarf-like head covering), in this case, an elaborate white headdress, borrowed from kyōgen's comic nagging-wife role type. Watanabe suggests that the male performer was to make Okuni look good. He was supposed to be seen as a man wearing odd female clothes, going through exaggerated female-like motions. The male actor's prostitute role was more clown-like than female-like. From a print of Okuni kabuki's performance of buying a prostitute, called *chaya asobi* (teahouse entertainments), Watanabe describes the male performer's female gender image in this way: "As Okuni's *waki* (supporting role) . . . hiding his lips behind a fan and kneeling coquettishly, he presented the figure of a *chaya* [house of prostitution] woman. From his sideburns and big nose, this woman is clearly a man."[20]

Gunji Masakatsu argues that Okuni's performance was not derivative of nō, although she used some of its conventions to her advantage. Nō was considered an art for the upper classes and therefore out of the commoners' reach. Okuni exploited nō as a high-culture icon for profit and pleasure. When she dressed up in outrageous finery and performed a scene in a brothel using the nō stage, musical instruments, and some of the dramatic characters, she knew her audience recognized the forms and enjoyed her comic and even risqué adaptations. Perhaps, by playing sensually with nō's

lofty spiritual concepts, Okuni disengaged their sacred social status while enlivening the nō forms with erotic appeal. The results may have been exciting for her popular audiences, yet transgressive to the emerging social hierarchy of the new *bakufu*. After Okuni's kabuki, ensuing bans suggest that Okuni's and her troupe's acts might have drawn attention because they appeared as a threat to the strict class- and gender-based society that was being established by the Edo government at that time.

Okuni's shows were "unique" because she played with gender acts, transforming herself into a mixture of male- and samurai-likeness.[21] However, Okuni's acts should not be confused with impersonation, for her intent was neither duplication nor disguise. Rather, Okuni's creative alterations of the stereotypic gender and class behavior codes were what made her dangerously and seductively entertaining. She played ingeniously with charged political and social iconography, producing delightful and sensual confusion. Okuni mingled the sacred, the sensual, and the social, appropriating male roles such as a prostitute buyer, a merchant, and a samurai.

Okuni's acts contradicted the conventional appearances for men and women, classes, and occupations. Her mixed gender roles inspired troupes of young women to dress and dance in male clothing.[22] Her performances distort and subvert culturally prescribed gendered acts. In her multiple gender attire, she emphasized the masquerade of male-likeness, demonstrating how "the various acts of gender create the idea of gender, and without those acts there would be no gender at all."[23] Thus, she revealed gender acts to be performative and not essential or biologically determined identities.

Onnagata performance owes much to Okuni's contribution to the Edo period *kabuku* behavior that generally deviated from socially prescribed actions and appearances. Although there are different theories, "kabuki" may have been derived from the verb form, *kabuku*, which came into use during the Muromachi period (1338–1573) and meant doing something violently and chaotically.[24] At the peak of Okuni's popularity, records show that "the dance and mimicry formulated by Okuni were named kabuki."[25] Domoto suggests that it was a perfect fit because Okuni's performances were so popular and outrageous that they attracted large audiences and may have caused various altercations. Second, Okuni's shows demonstrated a kind of rebellion against the status quo, particularly Okuni's "look" and male roles that appear to have been exotic and erotic. For myself, it was a beneficial alliance: "kabuki" implies something outside the norm, something active and disturbing. Okuni's acts fell outside the binary gender system, and her dances and skits attracted a mixture of classes, making them potentially disruptive. I think the label of "kabuki" helped propel Okuni's performances into more creative gender roles and notoriety.

Benito Ortolani explains that the new Tokugawa government had set up a repressive military dictatorship. Some of those who fell outside the system were called *kabuki mono* (kabuki people). Many *kabuki mono* were executed for their subversive behavior.[26] Okuni's kabuki gender performance arose as a part of this subculture of creative and subversive performers. She set the stage and claimed the outlaw territory for the flamboyant female-like stylization by later onnagata.

Okuni is not the only woman performer of early kabuki, but she is among the very few who are noted as having had significant influence on kabuki. In Japanese theatre history texts, she is usually given a space for her innovative performance contributions in the foundational period of kabuki.[27] Domoto Yataro considers Okuni's performances to be the first "people's" theatre that gave expression to the urban populace classed below the military and court classes. Okuni's dance drama, the prostitute buying scene, was especially remarkable because it dramatized the characters and situations of the lower classes while using some of the dramatic forms from the nō, primarily an upper-class performance form. Gunji and Domoto point out that Okuni catalyzed a crucial moment of change by mixing sacred and social dances and "acting out" scenes from the sensual, yet sad, world of prostitution.[28] However, while the prostitute buying scene continued at the center of all kabuki forms, Okuni's contributions are rarely mentioned as influential in any other phase of kabuki development. I think she should be recognized for initiating some of the most fundamental elements of kabuki performance. After Okuni, the kabuki stage was gradually and thoroughly masculinized by eliminating female bodies from public professional stage performance, but the mark of her *kabuku* art remains.

In summary, Okuni's transformative gender acts were particularly important to the innovative gender role development of onnagata performance. Her special disruption of the normative gender-sex matching system stands out from the history of gender performances because her troupe was made up of both men and women. Further, her flamboyant play with ambiguous gender acts and class roles in the world of the urban classes became central to the all-male kabuki. Subsequent kabuki performers also show the influence of her exploitation of gender and class acts, religious iconography, eroticism, and transformativity. Okuni not only continued gender performance based on the separation of the body beneath from performative gender acts, but she also established an artistic license for the classless performing artist. As we see in chapter 4 of this book, the next generations of "star" onnagata made use of Okuni's flamboyant and subversive practices throughout their development of the onnagata gender art.

Yūjo Kabuki

Two groups of performers gained notoriety in the wave of popularity set off by Okuni's performances: *yūjo* kabuki (female prostitute kabuki) and *wakashu* kabuki (boy prostitute kabuki). The *yūjo* and *wakashu* each contributed their styles of erotic gender play to the development of onnagata art. Toita Yasuji describes how "The concept of 'kabuki' had established a bizarre art, where exotic beings filled the stage, . . . For the initial period of kabuki, these unusual glamorous figures made up its total fascination."[29]

Gender performance techniques were already in practice within genres like nō and kyōgen, and popular ritual–performance arts, such as the *kagura* (a Shintō performance occasion for the gods). However, *yūjo* and *wakashu* created a performance "revolution" propelled by government bans on mixed male and female troupes in 1629,[30] military maneuvers, and the changing economics and tastes of the rising merchant class. Although their work was simply labeled as "reviews" and "dances," these performers daringly played radical gender and class acts within the context of seductive performance. I suggest that the subversive acts of *yūjo* and *wakashu* kabuki remain alive in the contemporary art of onnagata performance, yet are camouflaged under layers of aesthetic stylization.

Yūjo kabuki, which is also called *onna* kabuki (female kabuki), developed Okuni's innovative kabuki style to better advertise their artistic, erotic skills. *Yūjo* at that time meant a prostitute, literally a woman of pleasure, whose professional occupation combined entertainment such as singing, dancing, and playing musical instruments with prostitution. Many of the *yūjo* troupes were organized by male managers of houses of female prostitution. The formation of licensed, enclosed pleasure quarters occurred along with the rise of *yūjo* kabuki troupes between 1602 and 1618. Although there were some independent *yūjo* kabuki troupes, they were much fewer in number and without the financial backing of the brothel-managed performers.[31] Therefore, *yūjo* kabuki, in its urban setting, was a performance "entertainment" that advertised the prostitutes belonging to a brothel. At its most active time, from 1615 to 1629, *yūjo* kabuki made several distinct contributions to the gender performance and style of later kabuki.

First, the troupes were made up of women who played all gender roles. They continued to enact short scenes like Okuni's prostitute buying scene, where women played the male roles.[32] *Yūjo* kabuki performers reinforced the idea of gender ambiguity by taking male stage names and following Okuni's initiative, dancing in male kimonos, and adorning themselves with such items as Catholic rosaries, Buddhist beads, and samurai swords.[33] The display of performers' bodies and talents through the medium of dance also

characterized these early forms of kabuki. Dance was used as a means of communication combining gesture, music, and lyrics to suggest character, emotion, gender, and sexuality. Although they imitated Okuni's dances and skits, *yūjo* kabuki performers featured large group dances of flamboyant display and presented reviews that were essentially "erotic shows."[34] In the center of the large group of dancers, a star *yūjo* often took a soloist's position, playing the newly introduced instrument, the *shamisen* (three-stringed, lute-like instrument).[35]

The *shamisen*[36] was added to the nō drums and flute to accompany the dancing and lyrical narratives of *yūjo* kabuki. Its unique sound and adaptability to narrative and lyric style made it the perfect voice for various types of dancing and skits. Even with the later bans on public performance by women, the *shamisen* and *yūjo* relationship continued within the licensed brothels. I suggest that later onnagata employed the intimate connection between *shamisen* music and performed gestures, postures, and vocalization patterns, which originated in *yūjo* kabuki to stylize their gender acts. The *shamisen*'s particular sound and the techniques of plucking, pulling, and sliding on the strings underline and heighten the erotic and emotional expressivity of gestures and poses. In contemporary kabuki, *shamisen* music in its myriad of forms also creates an atmosphere that heightens the sensuality of onnagata gender acts because of its historical association with the world of sensual pleasures and courtesans.[37]

Another contribution of *yūjo* kabuki to the art of the onnagata was the relationship between *yūjo* performers and their audiences. The *yūjo* performance was what Jacob Raz refers to as a "side-show to another event or service—the main concern of the audience."[38] In other words, the liaison between patrons and prostitutes after the show was more important than what occurred onstage. Throughout the *yūjo* kabuki dances and scenes, Raz says, "the audience saw the prostitute behind the dancer . . . [and] came to appreciate not only the artistic-theatrical event, but also the non-artistic powers or talents that the players possessed."[39] The performer as a doubled image composed of the stylized gender role character and the actor's body beneath, transparent to each other, continued as a key concept in the art of the onnagata. Thus, the dance acts of the *yūjo* performers paved the way for *iroke no bi* (beauty of erotic allure), which became the basis for the aesthetic stylization of all onnagata gender acts.

Bakufu Bans

In the early part of the seventeenth century, a new regime had just begun to establish its class and gender role criteria and methods of enforcement.

After 1603, the *bakufu*, the military shogunal government established by the Tokugawa family, created and maintained,

> peace and stability for two and a half centuries—and at the same time determined the parameters of development of the unique Tokugawa society, thoroughly isolated from the rest of the world, and extraordinarily punctilious in its control of a hierarchical organization of each aspect of public and private life.[40]

Along with cutting off foreign trade, one of the *bakufu*'s main strategies for governance and control was to enforce a rigid system of class restrictions based on occupation. The divisions were as follows: court nobility, military, farmers, artisans, and lastly the merchants,[41] for whom the *bakufu* had the greatest contempt. They sought to insure that citizens would work, live, and die within one class, thereby consolidating power within the military class.[42]

This was the sociopolitical environment in which kabuki and the gender art of the onnagata arose and flourished.[43] The merchant class of the new urban society adopted kabuki as its entertainment and aesthetic style. The performers themselves, as entertainers and/or prostitutes, were considered outcasts or *hinin* (nonhumans), outside the official classes entirely.[44] It was in this lowly, outsider social position, with no official family names, that kabuki performers created their lush, erotic form of gender theatre. The oppressed merchant class made the licensed quarters of prostitution and the kabuki theatres into " 'their' world . . . a showplace for their economic success, the venting of their veiled criticism of forbidden topics and of their masked aspirations for social recognition."[45]

Through restrictions, bans, and constant surveillance, the *bakufu* attempted to solidify class distinctions. However, members of the military class, the samurai, were infamous for crossing the borders, associating with the "classless" kabuki performers, and generally upsetting *bakufu* regimentation. No longer employed through warfare and out of money, samurai infiltrated the merchant class, seeking new employment and entertainment. This meant the samurai were violating *bakufu*-created barriers between social groups and blurring the social distinctions between groups upon which the *bakufu* depended. The masterless samurai made up the majority of those called *kabuki mono*, literally, "people who did *kabuku*," or acted outside the norm.

Ortolani comments on how the verb *kabuku*,

> had acquired, by the beginning of the Tokugawa era, a slang usage for any anti-establishment action that defied the conventions and proper rules of behavior. The *kabuki mono* were therefore people who expressed their anti-conformism through a series of protests against the established order, which

ranged from highly unusual ways of dressing to shocking hairdos and extravagantly decorated, enormous swords, and up to four-foot-long tobacco pipes . . . they would roam the streets and often times engage in acts of violence and riots, flaunting their revolt against all conventions and decency, by performing such acts as playing the flute with one's anus.[46]

The "fashion for rebellion" extended to the court class when a group of *kabuki mono* courtiers dressed "in women's clothing . . . entered the innermost quarters of the residence where ladies of the imperial court lived and violated the sacred taboo."[47] Because of incidents like this, the *bakufu* feared subversion from the outrageous rebels as well as the thousands of enemy masterless samurai. Their suspicion spread to the new wave of Okuni and *yūjo* performances. They regarded the development of kabuki performance as dangerous to their welfare and the authoritarian structure. Ortolani explains how the *bakufu* connected the kabuki performance style to the social outlaws, "In the eyes of the shogunate early kabuki was another form of rebellious non-conformism, perverse in its eroticism, transvesticism, outrageous costumes, and hybrid mixture of religious elements with licentious contents."[48] This idea of kabuki as extravagant, unusual, and shocking runs like a theme throughout onnagata performance history. Further, that the performance of ambiguous genders galvanized the *bakufu* to censor theatrical performance, resonates with the theme of the government "straightening" of theatre that Ayako Kano raises in her reading of the "modernizing" of Japanese theatre at the end of the nineteenth century.[49]

In 1629, a series of *bakufu* bans segregated male and female performers, then abolished public performance by women, and focused on the restriction and licensing of female prostitution.[50] The reason the *bakufu* first targeted the mixed troupes is unclear, but the combination of male and female performers was disturbing to the *bakufu*. The ban on public performance by women has been attributed to an overall *bakufu* policy of one occupation to a person. "The shogunate banned women from public stages in 1629 as part of its general policy of restricting individuals to a single occupation; prostitutes could not also be entertainers."[51] However, prostitutes who worked for the male-owned brothels continued their double occupations as entertainers (singing, dancing, and acting skits), and as prostitutes within the controlled institutions. The ban seems to have focused on independent female performers who performed and prostituted in public. Their performances were occasions for the intermingling of social classes. Without any surveillance, independent women performer–prostitutes had the potential for publicly subverting the single occupation system besides revealing the suppressive class restrictions. Their ability to move fluidly among classes of men and between occupations singularly posed a special threat to government control.

The sweeping and devastating ban of 1629 on all women performers is also attributed to the violent altercations between nobles, samurai, and merchants over *yūjo* kabuki performers during their sensually exciting performances. Ostensibly, the *bakufu* wanted to prevent the violence—especially violence that crossed class boundaries in the out-of-bounds entertainment areas. Kawatake Shigetoshi also argues that the main problem for the *bakufu* was that men of different classes were mixing and fighting at the *yūjo* kabuki performances. The popular courtesan "musical reviews" created a kind of free-for-all zone where any male of any class could go wild over a courtesan. The *bakufu* targeted public women performers as the cause of these "disorders."[52] As early as 1608, restrictions had been imposed on performances by *yūjo* or "kabuki women" and on particular dances.[53] In 1615, one prohibition limited the areas and range of activity for *yūjo* kabuki performers. These restrictions on *yūjo* kabuki reflected the campaign of appeals made by male brothel managers to control and contain the *yūjo* and their entertainments to official licensed quarters of prostitution in the first two decades of the seventeenth century in Osaka, Kyoto, and Edo.[54] Further, because of the massive samurai displacements that took place between 1600 and 1640, many unemployed samurai became brothel managers.[55]

Another aspect of the *bakufu* class divisions was to assign women to domestic tasks and family concerns, thereby removing them from public work and any independent acclaim or notoriety. "The *bakufu* . . . prohibited females from theatre related and 'non-prescribed' labor—that is, work other than domestic sewing and weaving. . . . Women working in nontraditional fields were singled out for re-socialization into *bakufu*-defined gender roles."[56] The restrictions prevented women from participating in a lucrative, independent, and popular entertainment enterprise.[57] Yet kabuki historians, for the most part, do not comment on the *bakufu's* removal of the means to a livelihood of women performer–prostitutes, nor the banning and subsequent erasure of women performing artists on the public stage.

Jennifer Robertson's research on the male-constructed ideal female gender codes of the Edo period illustrates the background of the *bakufu* policy toward women:

> Discourses on female-likeness reflect *bakufu* and private interests in the education (or rather, indoctrination) of girls and women. The entrenchment of a Confucian patriarchy, together with the bureaucratization of the samurai class, effectively indurated the concept of females as "inferior to males." Kaibara Ekken's widely circulated, consulted, and cited *Onna Daigaku* (Greater learning for women, 1672) epitomized the misogyny of the Tokugawa social system and spokespersons. A leading representative of the

"practical school" (*jitsugaku*) of Confucianism and a self-appointed critic of females, Ekken proclaimed that female genitalia, while necessary for the reproduction of male heirs, were linked to dull-wittedness, laziness, lasciviousness, a hot temper, and a tremendous capacity to bear grudges. Ironically none of these were female-like (*onnarashii*) traits; Ekken was not alone in suggesting that female sex was contrary to and precluded "female" gender. . . . Even male intellectuals whose political views clashed shared with Ekken the conviction that for females, anatomy is destiny; that the "great lifelong duty of a woman is obedience"; and that the "five infirmities" (indocility, discontent, slander, jealousy, and silliness) found in "seven or eight out of every ten women" arise from and exacerbate "the inferiority of women to men."[58]

Robertson considers the Edo period onnagata as the female ideal whose female-likeness women could not perform because they were considered to be limited by their female sexed bodies. I suggest that the bans demonstrate how, within *bakufu* ideology, women were inferior and subordinate to men and were best controlled by men to the extent that even female gender representation was better created and performed by boys or men.

The changes in the social order taking place during the Edo period drastically affected the position of women in Japanese society. The reduction of the rights and status of the *yūjo* and all women in the professional performing arts, along with their gradual subordination in all forms of public life, had profound implications. When the *bakufu* erased the bodies of women from the public stage, they also erased women from the representation of female gender roles. Men thoroughly controlled all theatrical gender representation.[59]

With the ban on women performers and "mixed" troupes of men and women, *wakashu* kabuki moved to center stage in the popular entertainment world. *Wakashu*, the beautiful young boy prostitutes of the next phase of kabuki, did not have to make themselves into substitutes for women. Rather, they focused on their own versions of gender performance, which arose from their own unique position within the Edo period society. By eliminating women from competition and comparison in gender performance, the bans opened a field for boys and then men to create their own unique art form—what would eventually become the kabuki onnagata *onnarashisa*, or performative "female-likeness."

For a while, *wakashu* kabuki escaped the *bakufu*'s extinguishing ban. Clearly, *wakashu* had created their own gender performances with their *wakashu* stylization techniques based on their boy bodies and their relationships with older men. Although they took on the forms of kabuki performance, I think it is doubtful that they imitated women or the courtesans to be like women. This may be partially attributed to their different history, status, and relationship to male authority, and their established tradition of

male love relationships.[60] Thus, the boy performer's "female" gender role art developed separately from women, even in its earliest stages of kabuki onnagata development.

Wakashu Kabuki

Wakashu kabuki arose during Okuni kabuki's wave of popularity, around 1604, and later became the training ground for the first generation of onnagata. The *wakashu* were related to a long history of *bishōnen* (beautiful boy) performance and prostitution.[61] During the turbulent war centuries (1450–1600), the *bishōnen* entertained soldiers, who were on military maneuvers, with music, dance, and sexual diversions. When the wars ended, the tradition of *bishōnen* continued as the art and entertainments were moved to the cities. The beautiful boys were still patronized by samurai and priests, while men of the rising merchant class avidly emulated samurai practices and learned the art of *shudō* (boy love).

By 1617, *wakashu* kabuki was well established in Kyoto and Edo (Tokyo). Because *yūjo* and *wakashu* kabuki were in such close proximity, they probably appropriated and assimilated popular materials and methods from each other, particularly fashions and dances. In addition, *wakashu* kabuki had elements of older popular *geinō* (performing arts and entertainments), particularly kyōgen, the classical performance form performed on the nō stage, which featured humor and parody. Fashioning their performance aesthetic with changes in kimono and hairstyles, *wakashu* made their body art the central attraction. Above all, they performed the male and female gender roles in their skits and dances as beautiful young boys for the admiration of the male patrons. The *wakashu* were the trendsetters in fashion for men and women of the merchant and court classes. Their costuming, hairstyles, and choreography quickly became the vogue among *yūjo* performers and courtesans in the licensed quarters.[62]

As *wakashu* kabuki increased in popularity, violent confrontations over the *wakashu* occurred among various classes of men. According to Hattori Yukio, when Murayama Sakon (act. 1624–1652), the first *wakashu* to be called "onnagata," arrived in Edo in 1642 with his popular "onnagata dance . . . wearing female clothes and acting out a female character,"[63] there were fierce altercations. The *wakashu* acts of "playing boys as girls, with amorous and seductive imitations"[64] drove their audiences mad and overpowered class differences. Hattori points out that the ostensible reason for the restrictions on *wakashu* kabuki was to suppress the practice of *shudō* (boy love), which the *bakufu* saw as the cause of mixing classes and violent altercations. But boy prostitution was a long-standing practice, literally woven into the samurai tradition.[65] Therefore, the *bakufu* could not easily ban

wakashu kabuki. Instead, their prohibitions sought to disrupt this relationship and its public display by destroying the kabuki *wakashu* allure.[66] Hattori points out that the *bakufu* got more and more strict, particularly prohibiting any "camouflage"[67] used by performers to appear too much like real women.

A series of bans from 1640 to 1643 were intended to "clean up" the *wakashu* performances. Mixed troupes were banned again, and then male performers were prohibited from enacting a female figure in an overtly sensual manner. Finally, the *bakufu* required all *wakashu* troupes to officially segregate male and female gender role players. Performers were required to register as either *otoko-gata* (male type) or *onna-gata* (female type).[68] This policy initiated the practice of gender role specialization that intensified and expanded the creation of performative gender acts.

Again and again, the problems with *wakashu* kabuki proved very difficult for the *bakufu* to control. The practice of *shudō*, particularly by samurai, who were very enamored with the *wakashu*, was at stake. The *bakufu* tried desperately to separate the military and merchant classes while trying to pacify the samurai. Although the *bakufu* government attempted to prohibit the practice of *shudō* in 1648, it failed.[69] Relationships of *wakashu* and samurai had reached a critical point. Moriya Takeshi's analysis of the social and theatrical interaction demonstrates the dynamic relationship that ultimately shaped kabuki performance aesthetics:

> [N]o matter what, for the founders of the feudal society, at that point in time, the big problem was that the *wakashu* stars and the samurai were intertwined through their *shudō* relationships. Of course, identifying oneself with male love in those days was a general trend, not something negative. Their problem was where to short-circuit through intermediation, the pledge of boy love: because those who made up the social peak and those who ranked at the lowest level overstepped the borders of social classes. When one takes a general view, the *bakufu*'s interest in the social status of *wakashu* kabuki had to do with negotiating their control over the entertainment system. By promoting the expulsion of the *wakashu*, in the background, they strongly advanced a negative attitude towards the elements of prostitution in kabuki. . . . [70]

The *bakufu* focused their attention on divesting the *wakashu* performers of their erotic charm by restricting their performance style and appearances in an attempt to disengage the samurai from their illegal, cross-class trysts.[71] Unlike women, *wakashu* were not prohibited from appearing onstage. Instead, the *bakufu* sought to curb the violent feuds for the physical favors of the *wakashu* performers by dismantling the beautiful boy image and erotic allure, which were crucial to the *wakashu*'s artistic and economic survival. In the second half of the sixteenth century, new bans, issued month after month, continuously pressured the *wakashu* kabuki world.[72]

One of the most profound effects on *wakashu* kabuki culture was produced by the edict of June 20, 1652, which decreed that "each and every one of the singing and dancing young boys must have their front hair lock shaved. . . ."[73] Since the *maegami* (front hair lock) was their identifying mark of youth, the prohibition literally stripped them of their status as professional boy courtesans. While this may seem like a minor change, the shaving of the forelock destroyed a deeply entrenched sign system for a long-standing tradition of love between adult men and boys. Kawatake Shigetoshi quotes from a report of those times that shaving the *maegami* had the effect of "making them ugly, made them spoil the love of men, . . . with nothing on their heads, like cutting the ears of a cat, . . . how those boys sorrow, they cry tears of blood."[74]

The *wakashu*[75] response was to invent a new erotic symbol that re-represented the *maegami*. In their first attempts, *wakashu* covered the bald spot with a simple dark cloth, or painted on dark hair. There were those *wakashu* who refused to shave and hid their forelocks under scarves. Gradually, others went a little further, flamboyantly stylizing coverings for their exposed heads with long, fluttering scarves. With their new *bōshi* (scarf-like head covering) as tantalizing as their forelocks, the *wakashu* created gender acts that were stylized variations on their own prostitute art. At first the *wakashu*-into-onnagata probably chose such strategies to outwit the *bakufu*. However, as time went on, and with the demands of new play styles and characters, it seems that they kept on creating new performative gender acts, maintaining, as a base, their *bishōnen* eros and aesthetic. Beautiful boys continued to delight, shaved or not.

The *wakashu* "act" of wrapping a *bōshi* attractively around their heads was one of the first onnagata gender acts. The *bōshi* and wigs were banned at various times, but gradually became set as *kata* for specific roles and role types by the end of the seventeenth century. Extending the idea of the forelock, the transition *wakashu*/onnagata gradually formulated more extravagant new acts, which included using luxurious scarves that were later woven into the elaborate loops of wigs. The *wakashu*-to-onnagata transformation remains visible in the *murasaki bōshi* (purple forehead scarf) and their wigs' *maegami* (front hair lock), reminding one of the lost forelock and the *wakashu* body and art. The beautiful boy eroticism remained, just below the surface, cunningly transparent or deftly intertwined in their new onnagata gender acts.

In general, the bans enforced an all-male styled performance and discouraged the direct imitation of women in "female-like" appearances. The bans directed *wakashu* to be more "*wakashu*-like"—that is, more boy-like and gender ambiguous—in their acting of female-like roles. It appears that the *wakashu* obliged by stylizing their gender acts to enhance the aesthetic

of adolescent boy beauty and behavior. According to Hattori Yukio, the *wakashu* bans continued for a period of about fifteen years after the initial 1652 bans. In response to the bans, the beautiful boy prostitutes were forced to craft and refine their stylization of onnagata gender acts. It seems that the convergent aspects of the *bakufu*'s separatist ideology propelled kabuki gender role stylization into extremes of exaggeration and refinement. Following the various bans, *wakashu* brought their acts of erotic display and adolescent gender ambiguity with them onto the new stage of kabuki, which was required to have *monomane kyōgen zukushi*, that is, fully enacted performances, emphasizing dramatic characters and situations over dance revues.

While *wakashu* kabuki came into focus in the aftermath of prohibitions on women performers, it did not simply replace *yūjo* kabuki. These adolescent boys had their own particular gender art, which evolved from a long history of boy entertainers and male love relationships.[76] Gunji Masakatsu observed that "*wakashu* and *yūjo* kabuki really served different audiences and different sexual desires, even though *wakashu* were known to have both men and women patrons."[77] Given that the institution of boy prostitutes had a long performance history and *wakashu* kabuki gained prominence with its own innovative styles, it seems unlikely that the *wakashu* imitated women in the enactment of their gender-ambiguous roles.[78]

The following comments by contemporary scholars reveal ambivalent views toward *wakashu* performance: "*Wakashu* were *shōnen*, that is, adolescent boys. You cannot distinguish a boy from a girl at that age. Their charm was in that kind of ambiguity. They were 'girlboys.' "[79]

> For what reason did adolescent boys, the beautiful child performers, gain praise and favor? Certainly on the surface, there was the pure heart of the boy, no malice (no ill intentions), beauty, simplicity, that made them charming. But, there is no doubt, that for the most part they were the objects of an abnormal [transformative] sexual desire, that is, same sex love with their patrons.[80]

In the evolution of *wakashu* into onnagata performance, the adolescent boy body image and its particular sensuality survived all attempts at censorship to become the foundation for onnagata gender acts. I suggest that the early onnagata, who matured in the *wakashu* world, brought this heritage of charm, ambiguity, and transformative sexual attraction into the next stage of kabuki's development. The first generation of onnagata continued to earn its reputation primarily through "looks and sensual skills."[81] Since the world of kabuki was inextricably linked to the worlds of female and male prostitution,[82] their dancing, singing, and role type acts were aimed at advertizing their bodies for prostitution and entertainments after the show.

Beautiful Boy Traditions and Aesthetics

Early onnagata stylized their own gender ambiguous fashions from the aesthetic base of the adolescent boy body, both on and offstage. The practice and aesthetics of onnagata gender performance owes much to the tradition of the boy prostitute performers. In particular, (1) it was an art based on the body of an adolescent boy; (2) the gender ambiguity that arose from this body type was central to their art; and (3) it was a dance-based art form that focused on entertainment, sexual attraction, and popular fashions.

As explained earlier, boy performers and prostitutes had a long history, which began in the Heian period (794–1160) before *wakashu* kabuki and the *iroko* (love child, a boy prostitute) brothels, and theatres of the Edo period. The tradition of male love was primarily a relationship between father and young boy, known as *oyajiwakashu* (father and boy). The couple consisted of an older man, who took the "male/superior role," and a performing *wakashu*, who took the "female/inferior role."[83] Later, we see how the *wakashu* who became onnagata maintained a similar position in their performative gender roles in relationship to the tachiyaku, the male gender role players on and offstage.

The theme of youth dominates the *wakashu* tradition and aesthetics, and youthfulness is a characteristic of many onnagata gender acts. The *wakashu* career was limited to the period from about eleven to twenty-two years old, and the various stages of maturation were made public through shaving and cutting the *maegami*, a front forelock of hair, in prescribed stylized patterns. According to Shibayama Hajime, the momentary peaking of beauty was the essence of the *wakashu* aesthetic, a fleeting moment, the fragility of a passing, youthful beauty. According to a 1665 publication, called "Yodarekake," (The Bib), "Like the cherry blossoms have three stages of blooming, so too *wakashu* have three stages. . . ."[84] From budding to full bloom to the falling blossoms, each age of the *wakashu* had set images governing their appearances.

Shibayama cites the image of a gentle male hero "close to a female" in the Heian court period as the first idealization of the beautiful boy.[85] During the military era of the Kamakura (1185–1333) and the Muromachi (1338–1573) periods, the image of the refined beautiful boy prevailed in the ideals of *bushidō* (way of the samurai), which also aimed at discipline and refinement of the body and spirit.[86] The legendary heroes from literature and nō drama, Yoshitsune or Narihira,[87] both boy-like refined noblemen, are examples of the *wakashu* aesthetic that was carried over into the Edo period in kabuki plays.

Shibayama points out that the *wakashu* aesthetics may seem to reflect Zeami's *hana* (lit. flower) of nō aesthetics or earlier patterns of Japanese aesthetics, but he cautions that *wakashu* had their own, different style.[88]

Shibayama observes that there was a transformation of this refined beautiful boy aesthetic during the Edo period because of the merchant-class popularization of the boy image and circumstances within kabuki theatre itself. In the Edo period of merchant-class domination, there is evidence of an evolution toward greater stylization—a transformation of "a new type, moving away from the real thing."[89] Shibayama cites evidence from kabuki and other sources that an older, more male-like man was taking the place of the *Kamigata* (Osaka-Kyoto area) refined youth type.[90] Shibayama considers the fact that early onnagata and their successors performed young role types into old age as evidence for a change in erotic sensibilities characteristic of the Edo period.[91] Greater and greater stylization of youth and beauty by older onnagata is apparent throughout onnagata history and in contemporary gender performance.

Wakashu: Onnagata Boys

The first *wakashu* onnagata[92] acts came at a crucial point in kabuki history. A great deal of theatrical experimentation took place before and during the early Genroku era (1660–1703).[93] This period is sometimes called a golden age of kabuki, in which performers established several distinctive kabuki performance styles. Through a process of stylization, the *wakashu* who became onnagata reinvented their own attractive gender acts to fit the new theatre style, which emphasized role types and acted scenes over dance reviews, called *monomane kyōgen zukushi*[94] (fully enacted performance). I suggest that in the transfer to this stage of kabuki, performers from the *wakashu* tradition reworked their stylized aesthetics of boy adolescent appearancs, physicality, and sensuality into onnagata gender acts.[95] In other words, in the transition to role type specialization, *wakashu* did not retrain as female role actors; rather, they played female roles with their stylized *wakashu* gender acts. Thus, it was the *wakashu* representation of female gender roles that evolved into the ideal female-likeness or kabuki fiction of female-likeness.

Gunji Masakatsu feels that the onnagata who achieved fame then represent, "the full blossoming of the *wakashu* tradition."[96] *Wakashu* sensuality arose from the acts of adolescent boys, performed for the dual purpose of attracting customers and performing roles in skits and dances. The prohibitions placed on *wakashu* performances first demanded changes in costuming, hairstyles, dance acts, and interaction with guests in the galleries. On the surface, the modifications were conservative, yet these changes shifted the style enough to initiate a transformation of *wakashu* aesthetics. As extensions of their original art, these changes were regarded as a new form and given the name *onnagata*.[97] The early onnagata were essentially mixing

their acts on and offstage, infusing their theatrical representations with their *wakashu* allure. The actors usually danced first and then left the stage to serve *sake* as well as sexual favors to the customers in the private box seats. If an actor had been a *wakashu*, or another type of child performer, like a *iroko*, or *butaiko*[98] (stage child), he most likely engaged in professional male prostitution called *danshō* (male prostitution). *Danshō* was a part of all early onnagata experience and their reference for creating their sensual performances.[99]

During this first stage, *wakashu* onnagata experimented with various patterns of behavior and appearance. Stylizations of the body, use of innovative head coverings like the *bōshi*, creative kimono and *obi* styles, ornamental wigs, and makeup could be considered the first onnagata gender acts. For example, their makeup consisted of whitening their faces, painting on red lips, and drawing on other features, in order to approximate the perfect round face and tiny features of the ideal *wakashu* beauty. *Wakashu* onnagata made the most of their long sleeves, exaggerated obi, and kimono skirts. The kimono's furling sleeves and trailing hems and the obi's knots and long sashes were used to add grace and exaggerate a long slim line in movements and in postures. Those without the long slim line of the ideal *wakashu* body could use the length of the kimono sleeves and obi sashes to create the ideal willow-like appearance. Kawatake Shigetoshi suggests that *wakashu* used the *haori*, a short kimono-like coat, slung low, almost off their shoulders, to accentuate their sloping shoulder line.[100]

As time passed, and the early onnagata were no longer adolescent boys, they could achieve the beautiful boy look, the *wakashu* ideal, only through manipulations of the body, costuming, and props.[101] Various prohibitions on *wakashu*—for example, bans on their female style kimono, female styled wigs, and sensual dances—forced and trained the young performers to develop physical and mechanical methods for shaping, obscuring, and exaggerating their appearances. Such manipulations became the corporeal and costuming patterns or gender acts for maintaining the *wakashu* ideal appearance.[102]

Besides restrictive bans on *wakashu* appearances, another controlling strategy of the *bakufu* was to close theatres that produced dance reviews featuring *wakashu*. Theatre owners were permitted to open their doors in 1653 on the condition that they would produce *monomane kyōgen zukushi* (fully enacted performances).[103] The *bakufu* determined that *wakashu* dancing was more like a parade or fashion show for advertising sexual favors, and the more "acted" and "imitative" scenes were designed to discourage such overt sensual display.[104] In the new *monomane kyōgen zukushi* genre, actors performed dramatic characters instead of emphasizing personal appearance for the audience. Nonetheless, these early skits included prostitute visiting and

buying scenes with short dances thrown in. The former *wakashu* played
characters from their real world of prostitutes and male buyers. In his article,
"Genealogy of the Beautiful Male," Kawatake Toshio observes that the early
monomane (mimetic, dramatic) plays did not have scripts, and by and large,
performers made up their roles on stage in the middle of the action. He
suggests that the actor played himself to the best advantage "to show off his
sensual attraction."[105] One of the popular skits during the *yarō kabuki*[106]
transition was called *Shimabara Kyōgen* (Shimabara Play),[107] which was a
descendant of the *keiseikai*, the prostitute buying scenes passed along from
yūjo to *wakashu* kabuki. The courtesan role in this play was the *wakashu* who
had now become an onnagata. From Hattori Yukio's description, there was
not much change from the *wakashu* version of this skit. That is, the *wakashu*
still played his erotic boy acts, even to the extent that the last part of the skit
was a dance by the courtesan role player.[108] I suggest that in their evolving
guise, the *wakashu* onnagata kept their boy bodies present in the "female"
role types and continued to sell their beautiful bodies to their patrons
offstage.

 Wakashu turned the bans inside out by creating, in the *monomane kyōgen
zukushi*, role type specializations based on their earlier ambiguous gender
acts—in particular, their acts of erotic display and dance skills. Scholars,
such as Torigoe Bunzō, support the theory that the *monomane kyōgen
zukushi* required the performance to be "like a mirror reflecting life, which
made male and female characters necessary. That was the reason some per-
formers became onnagata: to play the female roles."[109] To a certain degree
this may be true; however, performance records do not report substantial
changes in *wakashu* style to meet the demands of female character roles in
the *monomane kyōgen zukushi*. What may have been called a "female role"
or "woman" in the *monomane* works remained the domain of the *wakashu*
in performance style. Even the onnagata roles of wives or old women,
which may not appear as *wakashu* material, use stylizations based on
onnagata forms that are based on *wakashu* stylization. The *bishōnen*
(beautiful boy) aesthetic has endured as the ideal female-likeness amidst the
complicated process of developing gender acts for the onnagata role type
system.[110]

 Ingeniously and shrewdly *wakashu* remodeled their beautiful boy gender
acts while staying as close as they could to their own erotic codes. The
wakashu, in their transition to onnagata gender roles, transformed the female
characters of plays into *wakashu* onnagata roles. Thus, the early onnagata sub-
tly created their own stylized gender role. I suggest that as time passed, and
roles diversified into various role types, the early and later star onnagata
moved toward greater artificiality, exaggeration, and fiction, and away from
the representation of anything "real."[111] In the transference of *wakashu* acts

to onnagata gender performance on the kabuki stage, *wakashu* beauty became known as "female" beauty.[112]

The *wakashu* stylized acts of costuming, makeup, serving guests, dancing, and all mimetic gestures and postures were the physical forms and patterns that became part of the onnagata repertoire of gender acts. Certain appearances or "looks" that related to the shape and features of the face were first considered ideal for boy beauty. Young boy performers created acts to approximate the perfect round face and features by whitening their faces, painting on red lips, and drawing on other features. The same ideal features became part of onnagata gender acts. *Wakashu* onnagata stylized and reconstructed the *bishōnen* ideal appearance by exaggerating their furling sleeves, sashes and bows, and layers of trailing hems to achieve the look: the long, slim line and willow-like softness of the ideal *wakashu* body in every gesture and posture.

Most often, it appears that *wakashu* onnagata danced on the mainstage and then served customers in the private box seats.[113] The *wakashu* onnagata infused their onstage acts with their offstage eroticism. In the following quote, a contemporary scholar, Adachi Naoru comments on the fluidity of the *wakashu* performance on and offstage. He notes that their performance is "like" but not an imitation of beautiful young girls:

> During Genroku, these *butaiko* [stage children] who combined stage work and prostitution . . . went back and forth between serving *sake* to their companions in the *zashiki*, and acting in short kabuki skits. . . . those *butaiko*, with gentle features like the beauty of young girls, made up with powder and decorated with rouge, served their customers with female-like gestures.[114]

The art of sensual and erotic display was central to how the *wakashu* performers shaped their acts. After the bans, *wakashu* had to alter and stylize their postures and movement vocabulary, to a certain degree, but they still managed to exhibit their boy bodies through a system of codes. Subsequent onnagata gradually stylized these boy erotic codes into onnagata gender acts. In their onnagata gender acts, they also assimilated the *wakashu* trait of gender ambiguity. Moreover, it seems probable that the early onnagata so thoroughly incorporated the *wakashu* erotic acts into their onnagata art that onnagata standards of beauty were infused with *wakashu* sensuality.

In Ihara Saikaku's *The Great Mirror of Male Love*, descriptions of young *wakashu* who became onnagata abound. Although the stories are fictional accounts, Saikaku communicates a sense of the *wakashu* stylization and their aesthetic and erotic performance acts. He focuses on the extended entertainments of the prostitute buying skits. In one of these situations, he

describes the *wakashu*, Yoshida Iori (d. un.) and Fujimura Handayu (act. 1660–1675):

> Their figures were just like those of famous beauties of ancient times, preserved for us in paintings. All those who saw them dance in the latest style went mad with desire. The skill of these two in entertaining patrons was especially remarkable. Playful and affectionate, they were pliant without being weak.[115]

He writes of another *wakashu* onnagata, Matsushima Hanya (act. 1675–1686):

> when just a bud in the way of boy love, this youth was already as beautiful as the diving girls of Matsushima and Ojima islands. Moreover, he was deeply affectionate and sophisticated at entertaining his patrons; he excelled in the serving of sake. No other actor could even approach his love letters in style. . . . A purple kerchief was the typical head gear for male actors of the day, but he was the first to wear one of pale-blue silk crepe. It made him all the more beautiful. . . . He made sure that onstage even the way he said a little word like "hello" was attractive.[116]

Saikaku compares the *wakashu* to famous female icons, emphasizing their other-worldly and erotic beauty. For example, he connects the adolescent boy performer with the image of the women pearl divers, who are famous for their skills at diving naked for pearls. The sensuality of imagery was part of the *wakashu* mystique, which subsequent onnagata maintained: their beautiful boy image of exotic eroticism.

Wakashu onnagata stylized many of their new gender acts directly from their work as prostitute entertainers during and after performances. Tasks, such as serving sake, or preparing a patron's pipe for smoking, using prescribed *wakashu* etiquette became onnagata gender acts.[117] There were also more overtly erotic acts, which came out of the *wakashu* repertoire of sexually exciting poses and gestures that were incorporated into onnagata dances and acting roles. For example, kneeling and standing poses that are performed facing upstage in order to display bare upper backs, sloping shoulders, and elongated necklines reflect the erotic *wakashu* tradition. These back poses are trademark onnagata gender acts.[118]

Murayama Sakon (act. 1624–1652), Ukon Genzaemon (act. 1655–1660), and Tamagawa Sennojō (1648–1673) were among the first *wakashu* onnagata to create onnagata gender acts from their *wakashu* acts. They became well known for their techniques of courtesan roles in prostitute buying scenes, such as the *Shimabara Kyōgen*,[119] which reflected their *wakashu* training. In "A Secret Visit Leads to the Wrong Bed" in *The Great Mirror of Male Love*,

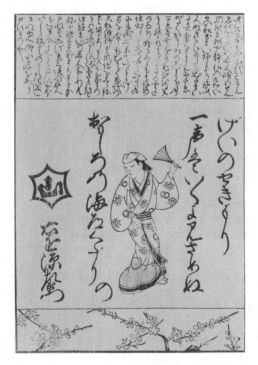

3.1 Ukon Genzaemon active (1655–1660), note *bōshi* covering forehead

Ihara Saikaku comments on the early *wakashu* onnagata's performance style, "Male actors of female roles in the old days of Ukon [Genzaemon] and [Murayama] Sakon were not particularly concerned about looking like women." He suggests that the spectators still came to see and enjoy the particular allure of *wakashu*, no matter what new costuming inventions they wore. "They simply placed towels on their heads and applied some rough makeup, and theater-goers used their imaginations to fill in the rest."[120]

Wakashu sensual allure, even without the erotic *maegami*, was frequently the object of bans. In 1656, the *bakufu* closed the kabuki theatres when Hashimoto Kinsaku (act. 1656–1657) appeared onstage, as an "onnagata with his hair loose, and because of his flirting, guests in the *sajiki* (side galleries) quarreled and drew their short blades."[121] In another example, Ukon Genzaemon (fig. 3.1), noted as the first to be called onnagata in the *Yakusha Hyōbanki* (Actors' Critiques), in 1657, was known for his stunning good looks and especially his performance of *Kaidō-kudari* (Going Down the Capitol Highway), a prostitute buying skit.[122] Over his shaved head, he wore an innovative scarf. The scarf was knotted with long streamers swinging

about his face. It is recorded how this might have been the first use of *midaregami* (astray or disordered hair), which are wisps of hair pulled out at the sides of the *bin* (puffy side locks) of the wigs of young male or female roles to indicate emotional distress and distraction or sexual arousal. *Wakashu* contributed *midaregami* to onnagata gender acts as their stylization of sexual distraction and anxiety. Later, tachiyaku also assimilated these erotic and gender ambiguous onnagata gender acts into their repertory of male gender acts.[123]

Even when incorporated into onnagata gender acts, *wakashu*-derived acts were still targeted for further prohibitions. Perhaps the *wakashu* who became onnagata, in their particular play on eroticism and gender ambiguity, remained too close to the beautiful boy ideal for the *bakufu*'s comfort. From 1653 through 1700, the *bakufu* issued prohibition after prohibition on *wakashu* onnagata performance. Prohibitions included wearing female-styled kimonos, female wigs, *wakashu* head coverings, and even the patterns, color, and fabric of their kimonos. Since these items were essential for the early onnagata main roles of *yūjo* (female courtesans), they were compelled to work around the limitations. Thus, the *bakufu* inadvertently contributed to the evolution of onnagata gender acts by encouraging their subversive creativity.[124]

Erotic Materiality

In the preceding section, I have argued that the *wakashu* who became onnagata did not portray women in idealized form, but invented their own body art, aesthetic ideal, and sensuality that delighted both men and women. We have seen how the *wakashu* aesthetic developed from acts performed by the beautiful boy body, which aimed at attraction and seduction. With their own standards of beauty and eroticism, *wakashu* used their physical idiosyncrasies to fashion their distinctive gender acts. Following the *wakashu* etiquette, onnagata gender acts were shaped by sensuality and eroticism,[125] and were initially created for erotic scenes like the *keiseikai* (prostitute buying skits). Early onnagata expanded these skills to display their physical allure in every role type and play style. In some cases, onnagata developed roles and dances to match or best show off their personal sensual style.[126] Thus, the art of performing erotic and sensual acts based on the *wakashu* beautiful boy body is fundamental to onnagata gender act formation and performance.

Early kabuki performers revolted against the spirit of abstraction and refinement of the Middle Ages. From wearing *furisode* (long furling sleeves) to lighting pipes and opening sliding doors, onnagata imbued their acts with sensual, erotic grace. In response to the demands of the characters in

new plays, onnagata stylized their gender acts to fit different role types, but they did not stop performing their special eroticism. By stylizing their sensual acts to fit new role types, onnagata erotic art flourished in variety and subtlety.[127] Even as the later onnagata performers added more abstract design and stylization to their gender acts, they did not divorce these acts from their own male corporeality and wakashu-based acts of erotic allure.

One of the obstacles to grasping the significance of eroticism in the development of onnagata gender acts has been the tendency to regard Okuni, yūjo, and wakashu kabuki as "elementary" stages before the "real" drama of kabuki emerged in the eighteenth century.[128] Onnagata gender acts did not blossom in a vacuum. The wakashu and yūjo spectacles of sensual dance and erotic display are often evaluated as lesser forms of theatre by virtue of their eroticism, sensuality, and overt connection to prostitution.[129] Often cultural differences in attitude and feeling concerning erotic and sensual performance are ignored in Western and Japanese texts. For example, Donald Shively writes that with the prohibition of wakashu forelocks and subsequent bans on the appearances of "female impersonators . . . [g]overnment repression, ironically, had inspired the transformation of these popular performances from burlesque into a more serious art form."[130] Such implications that eroticized performance is a lower form of theatrical expression deny a vital part of the sensuality and spectacle of kabuki, as a highly erotic art and aesthetic performance.

I suggest that the history and development of onnagata gender acts can better be read with a reevaluation of the essential contributions of sensual and erotic stylizations in movement, postures, vocal acts, costumes, wigs, makeup, and musical accompaniment. Gunji Masakatsu believes that Okuni's inclusion of odori, a folk dance form with energetic vertical movement, offered a new kinesthetic sense by altering the more horizontal stylized movement vocabulary of earlier forms. As we have seen, none of the bans and prohibitions could completely suppress the eroticism of the earliest kabuki performers. Instead, the bakufu "encouraged" wakashu onnagata to go to incredible lengths to creatively disguise, stylize, submerge, yet sustain their highly sensual, provocative art. Throughout this book, I hypothesize that onnagata never completely severed their connections to the early sensual and erotic prostitute performance style of the wakashu. Even in contemporary kabuki, the aesthetic concept, iroke no bi (beauty of erotic allure), which is considered essential for all aspects of onnagata performance, indicates the wakashu legacy of sensual allure.

Gunji Masakatsu, in his theory on the transformation of wakashu into onnagata in the second half of the seventeenth century, draws attention to changes in aesthetics centering on the erotic body. He emphasizes the sensual performance and the physicality of the actors—that is, the kinesthetic

sense of muscles, bones, and flesh. "As for kabuki," he writes, "compared to the symbolic taste of nō's *yūgen* [grace], it has a fleshly sense, sensuality is its characteristic. . . . It cannot be denied that this is at the foundation of kabuki aesthetics."[131] He concludes that these elements, which were not a part of the refined nō tradition, were transformed through kabuki innovations.[132] The principle that the body line in time and space must have erotic allure became central to onnagata stylization.[133] The sense of the flesh, the skin, and its performed *iro* (coloring), a sensation of erotic allure, is equally a part of the high art of characterization, dramatic dialogue, lyric, and other narrative elements of kabuki, especially for the onnagata.[134]

Gunji addresses how the stylized physical sensuality of onnagata gender acts remains connected to the erotic body of the prostitute performer. The early ties to dance and the skills of erotic display associated with prostitute entertainments formed the basic kabuki actor body sensibility. The stylized gender acts of the onnagata are rooted in the erotic acts of *wakashu* kabuki dances and skits. Gunji explains how the two different ways of love, *wakashu* and *yūjo*, were amalgamated by the early onnagata in their performances of the first *keisei* (high-ranking courtesan) roles in the *keiseikai*. Their gender acts were choreographed around the idea of selling the body while performing; that is, an onnagata played his prostitute body and his character body at the same time. Contemporary onnagata gender acts require a performer to eroticize the set forms and arouse physical sensations of pleasure in his spectators.[135] According to Gunji, the sense of the erotic body should be present even in the most designed and refined onnagata gender acts and should always remain in the spectator's awareness.

Gunji's explanation of the sensual body in performance resonates with the workings of gender transformativity and ambiguity. The human form, in its flesh and performed acts, is less stable and fixed than it appears. The unique beauty and eroticism of *wakashu* kabuki not only blended male and female, masculine and feminine traits, but also exhibited fantastic "youth" and transformative gender acts—trends that began with Okuni's skits and dances. The *wakashu* acts, rooted in the world of boy love and sexuality, were the basis for the evolution of the gender-ambiguous sensuality of contemporary onnagata gender acts. For this reason, reading the sensuality of the onnagata body requires a reevaluation of what are commonly called "feminine," "female," or "female-like" traits or qualities. Although highly stylized and abstract, contemporary onnagata gender acts not only resonate with the sensuality and eroticism of the beautiful boy bodies of the Edo *wakashu*, but clearly displace binary genders. The *wakashu* onnagata initiated a remapping of their material bodies, offering their audiences a sometimes dangerous and chaotic encounter that was ripe with their "bandit" erotic flamboyancy.

CHAPTER 4

STAR DESIGNING AND MYTH MAKING

Luminary Acts, Flamboyant Tricks, and Stylizing Erotics: Genroku (1688–1703) through Bunka Bunsei (1804–1829)

Star Gender Acts

Throughout the entire history of kabuki, star onnagata contributed performance innovations that gradually crystallized into conventions. Generation after generation of onnagata learned the innovations of star onnagata and assimilated their outstanding patterns. The star onnagata innovations became part of a "loosely fixed" system of onnagata gender acts that comprise the stylized onnagata performance *kata* (forms) of contemporary kabuki. Each star performer contributed his own technique(s), concept(s), or image(s). I focus on those innovative moments that were exploited by subsequent generations to eventually become the system of rules and standards for all onnagata gender performance. This review of star onnagata spans the early eighteenth to the early twentieth century, or the Genroku through Meiji periods.

The analysis of the contributions of individual body styles, tastes, and talents that accumulated around the kabuki idea of female-likeness reveals the complexity of popular culture's dynamic progression socially, politically, and aesthetically. Several extraordinary eras are spanned, and these have incredible reverberations in the theatre world. The innovative styles of star onnagata not only paved the way for the ambiguity, mutability, and multiplicity of contemporary onnagata gender acts, but also mapped the dynamism of art and power, desire and danger. In narrative plays onnagata enacted onnagata gender roles, but in dance works they eschewed female-likeness for transformativity. The onnagata gender roles, in each phase of their historical development, were based upon gender acts that were

ambiguous, that is, suggestive of other genders. As transformational ele-
ments, the gender acts had to be repeatable and formulaic, yet easily adapt-
able to different body types and changing fashions.

Onnagata of the development period (1680–1730)[1] designed their
gender acts according to individual physical talents. When the actors played
certain roles frequently, these acts became famous as "star" acts, which solid-
ified into a pattern or formula or even a role type. If a star onnagata was
liked for one kind of role, then he repeated his success formula in various
plays. Some star performers had enough independent backing that they
could make radical innovations on standard gender acts, thereby altering
the set repertoire of "acts." Some star onnagata adaptations came and went
like fashions, while others solidified through several generations.

There were many kinds of star gender acts. Some acts arose from a star's
specific style of kimono, *obi*, or *bōshi*. Sometimes their personal designs of
fabric or wrapping became the gender acts for specific role types. Individual
movement styles became the template of gender acts for a role type. Star
onnagata were like idols. Their personal, stylized acts became cornerstones
in the onnagata gender role iconography.

Through emulation of star onnagata styles and inventions, other onnagata
imitated the star acts so that certain general onnagata *kata* emerged. However,
these *kata* were far from an inflexible set of gender acts. Rather, star onnagata
established a range of gender acts that set up guiding parameters for other
onnagata's innovations and adaptations. Caution should be taken when con-
sidering star onnagata gender acts to have some kind of universal or mysteri-
ous feminine charm or singular femaleness. Instead, star gender acts had, first,
great popular appeal and, second, the potential for variation, transformation,
and ambiguity, which followed from the beautiful boy styles.

For example, Yoshizawa Ayame I (1673–1729) took the *wakashu* body
design of his predecessors a little further, creating his own *yūjo* (courtesan),
nyōbō (wife), and *musume* (young girl) role types. Segawa Kikunojō I
(1693–1749) initiated the concept of *maonnagata* (pure onnagata), or the
onnagata who performed only female roles. He also set the precedent
for onnagata, no matter what their ages, to play young girl roles through-
out their careers. Iwai Hanshirō V (1776–1847), together with playwright
Tsuruya Namboku IV (1755–1829), created the *akuba* (evil female) role
type. Sodezaki Karyū (?–1730) created the *onna budō* (female warrior) role
type and the *onna bushidō serifu* (speeches of noble female warrior), which,
in turn, influenced the entire *nyōbō* role type category. Mizuki Tatsunosuke
I (1673–1745) created his star roles in the dances of the then emerging
dance form known as *shosagoto* (lit. gesture piece, dance work), especially in
the *hengemono* (transformation pieces). He and Nakamura Tomijūrō I

(1719–1786) established the spectacular transformation dances as an onnagata specialty. Other star onnagata contributed concrete elements such as costuming innovations, which were widely imitated. The star onnagata had the prestige and authority to depart from established patterns. All of these illustrious performers set a precedent that reverberated through generations of onnagata: they each built on the *wakashu* charm: adding complication and nuance to their beautiful boy *iroke*.

Musume Dōjōji (The Maiden of Dōjō Temple) is an example of a *shosagoto* (dance work) in which star onnagata successfully developed onnagata gender acts. Nakamura Tomijūrō I (figure 4.1) is frequently named the originator of the star acts for *Kyōganoko Musume Dōjōji* (Capitol Fawn/Kyoto Dappled Maiden of Dōjō Temple). His version was first performed in 1753. Even before Tomijūrō I, Kikunojō I created his own star act, *Musume Dōjōji*. Thus, these onnagata established a pattern emulated by subsequent star onnagata. From the beginning of the eighteenth century to the present, there has rarely been a star onnagata who did not try his hand at some version of *Musume Dōjōji*. Watanabe Tamotsu's book, *Musume Dōjōji*, is a chronicle of the construction, evolution, and intersection of star actor bodies and designed acts that comprised this performance idol.[2]

During the history of onnagata star making and transformation, a number of distinct onnagata performer styles emerged. First, onnagata divided into *maonnagata*, those who played exclusively onnagata roles, and those who played both onnagata and tachiyaku roles. The *maonnagata* maintained his female-likeness on and offstage by performing onnagata gender acts throughout his daily life. The diversified onnagata limited his onnagata gender acts to the stage. Onnagata were also classified as *otokoppoi* (masculine) or *onnappoi* (feminine) according to their physical statures and facial features. In addition, they could be designated very female-like but some features, like their vocal timbre, might be labeled *otokoppoi*, which lent their star image a kind of gender ambiguous allure. Finally, certain stars were known for the performance style in which they excelled, such as *jigei* (lit. fruit art, acting skill) meaning their skills in the acting of roles or *hana gei* (lit. flower art, dance skill), meaning their skills in dance performance. These various qualifications indicate the complexity of the onnagata star designing process and their gender acts.

Toita Yasuji, in his *Onnagata no Subete* (Everything about Onnagata), clusters onnagata by their contributions to roles, role types, and particular gender acts during certain periods. In his version of onnagata stars and star role designing, Toita presents the Edo period onnagata as a lineage of role types. When an onnagata gained stardom by playing a certain role in a popular play, the onnagata would become identified with that role. That

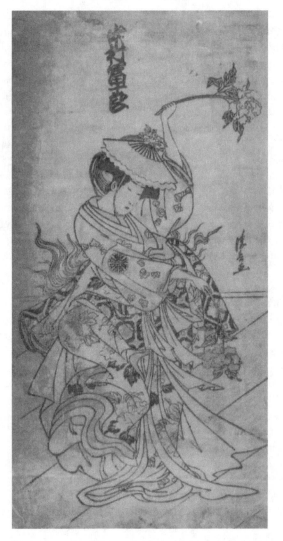

4.1 Nakamura Tomijūrō I (1719–1786) *Kyōganoko Musume Dōjōji*

onnagata might repeat a particular star role's acts in many similar roles because the troupe leaders and managers wanted to capitalize on the star's popularity.[3] For example, Tomijūrō I's *musume* (young girl) role type characteristics emerged in his other role types. Or, later, the *akuba* (evil female) role type was a brilliant collaboration of an onnagata and a playwright who knew how to build an image into a popular role type.

Toita emphasizes how the popularity of onnagata like Segawa Kikunojō III (1750–1810), who supposedly drove young girls in the audience mad with love, could alter and set new images.[4] Certain stars were supported by patrons and managers who could promote their images and fashions for the public to emulate. An onnagata's acts could be manipulated into what would sell. Toita indicates that certain star onnagata shaped not only onnagata roles and role types but also the total art of the kabuki theatre.[5]

The onnagata star making process resembles what Jane Gaines refers to as "star-designing"[6] in Hollywood filmmaking. Theorizing the female star images and costuming practices of Hollywood film designers, Gaines explains, "Star-designing effects the synthesis between character and actress, intermingling traits in such a way that the two become indistinguishable."[7] Onnagata had their own process of star designing, in which their actor bodies and stylized gender acts were synthesized into *yakugara* (role types). The star onnagata's individual physical acts, style, and fashion were made into roles, and their presence was imprinted on the role types they embodied. Making themselves into god-like apparitions was part of what reinforced star acts as iconic onnagata gender acts.

Literary and visual media also exaggerated star onnagata images. Actor reviews and prints fostered an idealization of the star onnagata in his famous role types, creating a star image from the stage performance. Onnagata participated in the star making process by using and being used by these precarious fashions. Perhaps, like the movie and rock-star personalities of today, there was a combination of myth making and commodification at work in onnagata gender act designing.[8] The actor had to first design the image, and then perform his "product" daily. Star onnagata may have worn their stage costuming in everyday life as a publicity strategy to cement a particular image in the public eye.

For example, Ayame I's performance of his onnagata *kata* in his daily life was part of his star act designing. The continuity between stage and daily life meant that Ayame I in his onstage role or his offstage role were both Ayame I, the star onnagata. His offstage onnagata performance could tantalize and stimulate his audience's imagination. Gaines notes that when a movie star's off screen and on screen image were fabricated as one and the same, "The ideal in this way becomes the transformation of the star that plays on a fascination with masquerade while remaining a transformation that stops short of complete disguise."[9] The onnagata daily life strategy resonates with Gaines's description of star making in the movies:

> The off-screen wardrobe now had to be similar to the on-screen costume in its exaggerated qualities and had to carry over a definitive style, testifying that the woman who wore the off- as well as the on-screen clothes by the star designer was, in fact, the same individual.[10]

An important "rule" of onnagata gender performance has traditionally been that one should perform "to show beauty."[11] According to Tsuchiya Keiichirō, appearance was a primary requirement for the onnagata; that is, he was supposed to have a beautiful face, figure, gestures, and dance expertise. Tsuchiya quotes from the *Yakushaguchi Samisen* ("Actor's Lips" Shamisen)[12] of 1699 in the *Yakusha Hyōbanki* (Actor Reviews): "For Onnagata, their appearance is their most important instrument . . . Surely, an onnagata's looks are his most important tools."[13] Tsuchiya points out that "looks" did not necessarily refer to natural beauty, but to the appearance of beauty, which could be achieved with makeup, costuming, and distance from the audience.[14]

Onnagata also used their dance art to develop the gendered appearance and form that characterized onnagata star designing. The *Yakusha Hyōbanki* rating standards for good looks included the onnagata's figure or *sugata* (postural shape) and *sen* (line) of his coded postures. Reviews note the carriage of the actor's body with the correct line of kimono, *uchikake* (over kimono), and *obi* from pose to pose, from kneeling to standing, in exits and entrances. Writers also critiqued the shape and movement of the body while executing all mundane tasks, from pouring sake to sliding doors open and closed. The onnagata's face and figure had to possess or elicit *iroke* (erotic allure), that is, a sensual charm with erotic overtones. Appearance, which mediated their gender role representation, included everything visual and kinetic, as well as everything worn or directly used by the body.

Thus, for the early star onnagata, stage beauty was part of a whole series of acts performed on or with his own body. Star onnagata employed the surface articulations and stylizations to design his *kiryō* (image). As we have seen, once they attained star status, onnagata had the power to rewrite the aesthetic canons. Each star performer can be considered to have added his gender acts to a gradually growing repertoire of onnagata "beauty" acts. Eventually these acts were amalgamated into the onnagata "intentional body,"[15] which is an ideal each onnagata strives to attain. The ideal beauty, then, belonged to the individual onnagata who was frequently identified with a role and role type.

From the early stages, onnagata played with ambiguity and mutability through their gendered beauty acts. As Tsuchiya and others have remarked, to watch a kabuki onnagata is to see a process of continually transposing layers.[16] On one layer there is a type, an image created through acts enacted by the star onnagata; on another layer there is a performer, whose personal features and posture gradually became that role type and altered the aesthetic formula. Moreover, if you saw an earlier onnagata perform this role, his acts and looks would reveal yet another layer, which shifts in and out of focus. Subsequent generations of onnagata demonstrate the gradual evolution

of a gender act system based on imitation, manipulation, and individual invention.

In the onnagata family lines, such as Segawa Kikunojō I, II, and III, and Iwai Hanshirō IV and V, the performers inherited a template of acts for the specific roles associated with that lineage. This system of inherited acts encouraged "outlaw" versions in which onnagata created variations on another performer's star role. As mentioned earlier, *Musume Dōjōji*, a solo multiple change dance noted for its dynamic range of movement, emotion, and technical skill, provided many opportunities for breaking off into innovative manipulations of star acts.

In the following pages, I discuss the star designing and myth making process of several star onnagata of the Edo period. My sources include the *Yakusha Hyōbanki*[17] and commentaries by contemporary Japanese and foreign scholars. In the early years of the Genroku era, these reviewers describe the four *wakaonnagata* (young onnagata) "gods": Mizuki Tatsunosuke I (1673–1745), Yoshizawa Ayame I (1673–1729), Ogino Samanojō I (1656–1704), and Sodezaki Karyū I (?–1730).[18] In this first generation of stars, Yoshizawa Ayame I and Mizuki Tatsunosuke I set the main patterns for onnagata gender performance and their later expansion. Although all onnagata contributed to the onnagata star designing and myth making process, I focus here on the stars as the designers and the designed.

The formula for the *Yakusha Hyōbanki* critique usually included a omparison of the onnagata to his predecessors. Early kabuki onnagata were complimented by the star onnagata they resembled in various role types. They literally put on the gender acts of another star onnagata to gain recognition. Additionally, they had to innovate on the star onnagata gender acts in order to gain their own star positions. Thus, a rising star onnagata first modeled himself after a recognized star onnagata's legacy of popular "images," particularly the star iconography captured in the critiques and prints. Then, after he earned praise for his resemblance to a star onnagata, he could push beyond the limits of imitation. Thus, the practice and recognition of imitation helped solidify the onnagata gender acts.

Mizuki Tatsunosuke I (1673–1745)

Mizuki Tatsunosuke I (figure 4.2) is noted for originating unusual, energetic, and highly theatrical solo dances. He was known for his acrobatic skills, vigorous rhythms, and his atmospheric phantom dances when he danced a vengeful lover's ghost with an other-worldly effect.[19] At sixteen, he was already a kabuki star, lauded for his specialties: the spear dance, cat dance, and transformation dance performances. His dance acts were featured as intervals in story plays or as the grand finale to a day's program.

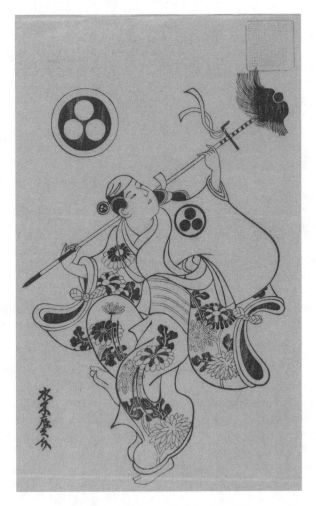

4.2 Mizuki Tatsunosuke I (1673–1745)

Later, the star onnagata Nakamura Tomijūrō I (1719–1786) imitated
Tatsunosuke I's intoxicating solo dances and added his own special charac-
terization, as in the famous, *Kyōganoko Musume Dōjōji*.[20]

During Tatsunosuke I's life, the recorded actor critiques still aimed
at selling performers for offstage entertainments, including prostitution.
However, Tatsunosuke I was an exception. Through the performative qual-
ities he infused in his dances, his vigor and strong stylization made his per-
formance style one that transcended the early onnagata dependence on
beauty and eroticism. In his studies of the Genroku period performers,

Tsuchiya Keiichirō noted that the descriptions of Tatsunosuke I scarcely, if ever, referred to him as beautiful. His actor prints show a stylized, conventionally pretty face with the male-sized head,[21] small features in a round face, and a high-bridged nose. However, descriptions of Tatsunosuke I seem contrary to this ideal face, describing his hanging cheeks, flat nose, and boastful look.[22] According to Tsuchiya, Tatsunosuke I's star act and image arose from his outstanding solo dance skills. His reviews frequently praised his bold look, his spectacular dancing, and his rhythmic, acrobatic, and martial arts skills, but rarely his beauty.

Yoshizawa Ayame I and Ogino Sawanojō (1656–1704), who ranked with Tatsunosuke I as the top three onnagata of their era, were often complimented in critiques for their beautiful "looks." For example, the top onnagata of his day, like Ayame I, were compared to certain flowers with erotic innuendos. Ayame I was compared to the hibiscus, and Tamagawa Handayū (act. 1690–1711) to the peony, while Tatsunosuke I was compared to a "plum blossom in the snow."[23] For an onnagata, this "plum" image implied that he had no *iroke* (sensual allure),[24] which was considered central to onnagata art. Tsuchiya carefully analyzes actor prints and *Yakusha Hyōbanki* commentary to get a sense of the star onnagata's performance qualities and appearance. He suggests that Tatsunosuke I must have been a "top star" for reasons beyond his "looks and erotic appeal."[25] Tsuchiya concludes that Tatsunosuke I was an artist who created his own performance style and whose artistry of stylization through rhythm, form, repetition, and dynamism has echoed through the kabuki onnagata's performance history. Even though having the looks and sensual appeal were an onnagata's selling points and were considered the onnagata's major "tools" for success, Tatsunosuke I's dynamic and designed dance acts overruled the established ideals and necessity of "real" physical beauty.

His performance was not like Ayame I, ". . . one of taste and charm. In the figure of Tatsunosuke I lived the speed, rhythm and repetition of the dance, which became the *yōshiki* [stylization], or 'way' which continues to live within kabuki dance [today]."[26] Without using seduction, coyness, or beautiful features to draw his spectators, Tatsunosuke I's star acts revolved around his innovative *hana gei* (dance art). Tsuchiya Keiichirō describes Tatsunosuke I's dance as having a centripetal force such that "the spectators were pulled in to where the dance's rhythm was centered, and riding that surge of intoxication, they danced together. . . . What Tatsunosuke sold was his art."[27]

Tatsunosuke I's star dance acts broke the tradition of the onnagata as a beautiful boy advertising his body onstage as a commodity for after the show. Before, and even during, Tatsunosuke I's popularity, onnagata roles were typically *yūjo* (courtesan) roles in the *keiseikai* (prostitute-buying scenes) or *shinjū* (love suicides). In those roles, onnagata maintained a

prostitute or "selling the body" relationship with the audience by enacting their own sensuality, emotions, and beauty on the stage. But Tatsunosuke I's spear dance with martial art skills and his cat dance of madness and transformation drew his audiences into the world of the dance itself.

Above all, his focus on dance roles firmly established dance as central to kabuki and a special arena of the onnagata. While one part of kabuki performance was generally moving toward the stylized daily life drama of *monomane kyōgen* (imitation plays), Tatsunosuke I went on transforming from cat to fox to snake to spear dancer, with all his dazzling skills of dance and acrobatics. I would add that Tatsunosuke I set further standards for onnagata performance—the physical skills of dance in the costuming of the onnagata. In his dances, the manipulation of the voluminous robes, with the *furisode* (long furling sleeves), *obi*, and long *bōshi*, had to be made to appear effortless and sensual, yet precise. For later onnagata, the controlled maneuvering of costuming became a criterion for their gender art and acts. Through his flamboyant style of dance and transformation skills, Tatsunosuke I's daring also stretched the range of onnagata role types and the more restricted *jigei* (acting art) gender acts. Those who followed, including tachiyaku, emulated his dance spectacle plays. In twentieth-century kabuki, the famous tachiyaku Onoe Kikugorō VI (1885–1949) and Ichikawa Ennosuke III (1939–), who have excelled in spectacular onnagata multiple change dance roles, owe much to the bold dance acts of Tatsunosuke I.

Yoshizawa Ayame I (1673–1729)

Yoshizawa Ayame I (figure 4.3) is widely known for his written teachings, *Ayamegusa* (The Words of Ayame), and for his detailed female-likeness in dramatic scenes. Japanese scholars frequently refer to Ayame I as the one who brought about the completion of the onnagata art.[28] Ayame I is most famous for his portrayal of *keisei* (high-ranking courtesan) roles, such as Miura in *Keisei of Asamagatake* (The Courtesan of Asamagatake). The word *keisei* literally means "castle toppler," in reference to the courtesan's extraordinary cost, which could bring even the nobility to financial ruin. The *keiseikai* (courtesan/prostitute buying scene), as we have seen in Okuni, *yūjo*, and *wakashu* kabuki, was the most popular entertainment of Ayame I's era. The rules and standards for onnagata gender roles as outlined in *Ayamegusa* reflect Ayame I's strategies for enacting these *keisei* roles.

Ayame I is often quoted for insisting (1) that the onnagata should live as a woman in daily life; and (2) that the key role for onnagata art was the *keisei* or *yūjo*. Both ideas emerged from Ayame I's stage practice and position as an *iroko* (lit. love child, boy prostitute performer). Ayame I gleaned his artistic style and strategies from his life process of performance and survival.

4.3 Yoshizawa Ayame I (1673–1729)

Ayame I's life as an *iroko* would have exposed him to the influence of the *wakashu* aesthetic tradition. His performance may have been a careful and deliberate imitation of the actions and appearances of *keisei* and boy prostitutes in their entertainment worlds. Into that mix, he probably mediated his own view of the societal ideal of Woman and then crafted his unique onnagata gender. Thus, Ayame I's onnagata gender role image was complex and nuanced, neither female nor male. It had evolved beyond the phase of the *iroko*-styled female-like dance role. It is likely that his female-like gender acts, both onstage and off, arose out of performing a male-styled fiction of an assimilated and still ambiguous female-likeness.

Several points concerning Ayame I's courtesan roles are key to understanding his acting-centered style and his rules for onnagata acts. First,

because Ayame I was trained as an *iroko*, his *yūjo* role stylization was based on his training in "beautiful boy" entertainment skills, re-dressed into his "realistic fiction" of female-likeness. Because many spectators had never seen the inside of a brothel nor participated in that entertainment transaction, for the majority, kabuki plays were their encounter with that mythic world of fantasy characters. On the other hand, a privileged few came to kabuki to learn the actual etiquette, manners, and customs for participation in the business of the licensed quarters; even women courtesans emulated Ayame I's acts. Ayame I created a fictional *yūjo* role, which resonated in real life.[29]

Second, the kabuki *yūjo* was not the leading role; rather, the courtesan role's fate was dependent on the actions of the roles of male guest, buyer, and lover played by tachiyaku. Ayame I created the role of the onnagata *yūjo*, who was a commodity, an owned object. While the *Yakusha Hyūbanki* still made the *iroke* of courtesan roles a critical requirement for all onnagata performance, the early generation of kabuki artists, such as Ayame I, made great efforts to differentiate their art from the sensual dance review of *wakashu* prostitute entertainment. Perhaps it was to gain a legitimate position for the actor of female roles that Ayame I invented his own "true-to-life" training, living as an onnagata both on and off the stage. He was also turning his daily life into a gender performance. According to Jennifer Robertson:

> the theory linking the body and (secondary) gender of the "female"-gender specialist, was formulated by onnagata Yoshizawa Ayame. . . . It is a twist on the Buddhist concept of *henshin*, or bodily transformation, . . . with the exception that gender (and not sex) is involved in an onnagata's transformation from a man into Woman.[30]

Third, in his written teachings, Ayame I holds that an onnagata must be equally proficient at *hana*, the "flower" of performance or showy dance art and *mi*, the "fruit" of the earthy art of acting. He felt that for an onnagata to focus exclusively on the *hana* (flower) was to deny the *mi* (fruit) of the total performance, which required the onnagata to also concentrate on *jigei* (acting art).[31] This pivotal balance of dancing and acting skills eventually became a standard for training and performing onnagata gender roles. Ayame I's own acts were representative of *jigei*, the acting-centered art for onnagata gender roles. As a star onnagata, he focused on his detailed, imitative, and stylized acting skills. His performance history shows a pattern of imitation followed by experimentation. He advocated a type of "appropriate innovation" in that he was very careful with the degree of change he made in relation to other actors and the "real" world.[32] Thus, Ayame I laid the foundations for an art that was at once radical and subtle in its techniques and aesthetics.

Perhaps Yoshizawa Ayame I as the legendary onnagata idol is an example of star making that has gone through several stages of political refinement.

An idol in any age or culture is not a natural phenomenon. Designing a star image and fashioning a legend are processes by which a human being is elevated to an ideal in order to serve a specific purpose for the star makers. A star performer's looks, talent, and uniqueness can be linked to selling an image governed by the conditions of a specific class, race, or sexuality that are, in turn, dictated to serve a specific authority.

In the case of Ayame I, it would be naive to attribute his contribution to the formation of onnagata art to his good looks and natural talent. Ayame I styled and constructed himself as a star onnagata in order to gain the support of patrons who helped him financially and made connections for him.[33] His survival depended on his star status. What purpose did his star status serve? His legacy was selectively preserved in a written document, the *Ayamegusa*, legitimizing his performance strategies, suggestions, and entire living style into a performance technique. In 1713, when he was forty years old, a haiku was written in the *Yakusha Hyōbanki* describing Ayame I's appearance onstage: "Mount Fuji, numerous / clouds surrounding / a winter journey."[34] Tsuchiya reads this image of Ayame I's performance, viewing the crystal clear geometry of Mount Fuji amidst clouds, as one of perfect composure. Ayame I's body and acts became the foundations for the onnagata performance art and ultimately the Woman of the kabuki stage. Perhaps the early star onnagata such as Ayame I served the *bakufu* strategy of separating and ordering classes and genders and occupations, by creating a kind of *monomane* (imitation) of Woman who obeyed the order of society on stage. The onnagata's role is an example of a fictional role based on a fictional heterosexual gender system.

The Ayamegusa (The Words of Ayame)

The *Ayamegusa* is the earliest extant document, compiled in approximately 1750, devoted to the art of the onnagata. Recorded by Fukuoka Yagoshirō, an actor and playwright of the early eighteenth century, it is a treatise on acting styles and techniques for onnagata roles with suggestions for training.[35] There is rarely an article about the onnagata that does not mention Ayame I's advice on practicing daily life as Woman and his images and prerogatives for onnagata acting. As a section in the *Yakushabanashi* or *Yakusha Rongo* (The Actor's Analects), a collection of writings on early kabuki acting, the *Ayamegusa* is one of the few documents that has been translated into a combined English/Japanese version.[36] As a result of such popular, intercultural exposure, Ayame I and his notes have been elevated to an iconographic reference for all onnagata gender art.

The *Ayamegusa* is structured as a collection of brief observations, anecdotes, and strategies for onnagata performance. The notes are presented like

lessons including tales, examples of role type styles, corrections, and advice. Their status as a "collection" endows them with a sense of unity and purpose necessary for the practice of an art form. Perhaps Ayame I was inspired to give the onnagata gender role performance the status, mystery, and type of spirituality that the court-class art forms maintained as essential to art making. The artistic commentary of a nonclass performer in a popular entertainment medium gained prestige by imitating the performance treatises of the *noh* theatre, a court-class form. Thus, the existence of a written document on onnagata endows both Ayame I and onnagata art with the prestige of tradition.

During Ayame I's era, the performer of female roles was just beginning to distinguish himself from the *wakashu*-styled female role player. Ayame I's teachings required onstage and offstage performance skills and practices, which reinforced this distinction. The *Ayamegusa* contains recurring admonitions that form the basis for Yoshizawa Ayame I's advocacy and defense of a distinct gender role, the onnagata. The treatise also serves to propagate the notion of the onnagata as equal in theatrical status to the tachiyaku. Ayame I and his recorder, Fukuoka Yagoshirō, do not define onnagata as an identity, but give examples of how onnagata should behave under various circumstances, particularly in relationship to tachiyaku. Ayame I's notes contain frequent warnings against acting like a tachiyaku.[37] In order to avoid this, the onnagata's primary skill is remaining an onnagata in everyday life.[38]

The *Ayamegusa* provides ways to think through the body and train for the stage through daily experience. A mixture of the poetic and the practical, Ayame I's teachings established a general onnagata performance style. The anecdotes, advice, and theories concern appearances, as well as an internal attitude that an onnagata must cultivate to create onnagata onstage. The *Ayamegusa* frequently refers to the necessity of practicing feminine behavior in daily life and transferring this behavior to the stage. Ayame I insists that an onnagata must consider his everyday life as the most important place for "playing onnagata."[39] He was recorded as saying, "fundamentally, a body does not exist which can become both a man and a woman."[40] This is one point among many from his treatise that speaks to a singular onnagata art, exacting a total commitment to a particular body style and way of life.

The *Ayamegusa* demonstrates that onnagata gender art, from its inception, had its own aesthetic that went beyond any kind of impersonation of women. First, Ayame I selected and adapted gender role models and gender acts that fit and enhanced the physical skills learned from his *iroko* performance training. Over time, he refined these to construct a distinct onnagata female gender role, the courtesan, as a basis for his onnagata art. Thus, the *Ayamegusa* delineates a particular performance style for onnagata gender roles. In general, Ayame I advised actors to perfect, through daily practice

and careful attention, the nuances of an emerging gender art of subtlety in postures, gestures, and costuming.

Robertson reads Ayame I's suggestions as steps toward a set onnagata gender performance style:

> Ayame insisted that an *onnagata* embody femininity in his daily life. Simply impersonating a given female/woman was neither adequate nor appropriate. To clinch his point, Ayame insisted that the construction of Woman could not be left to idiosyncratic notions of a particular actor. Instead, he introduced ideal-type categories for Woman, each with predetermined characteristics.[41]

I propose that during the Edo period, Ayame I's "ideal-type categories for Woman" eventually became the *yakugara* (role types), and what Robertson calls "predetermined characteristics" became the stylized onnagata gender acts.

The characteristics and requirements for the *Ayamegusa* ideal Woman were apparently derived from Confucian standards and popular interpretations. It seems that Ayame I constructed his own set of onnagata feminine habits from his version of societal ideals for female behavior. In stage action, Woman remains enduring and calm, usually in the background, and does not speak or show any aggressive behavior, even when wielding a sword. Ayame I advocates softness, charm, eroticism,[42] and gentleness on every occasion. The appearance of charm, erotic allure, and playful seductiveness must always have a pure, chaste, and virtuous heart beneath. Behavior that is not considered pretty, such as eating or laughing, is not to be done in front of others; this would break the perfect image. Only high-ranking courtesan roles seem to have moments or appearances of exceptional behavior. Ayame I's standards for women and Woman were as fictional and constructed as his standards for onnagata gender roles onstage.

Moreover, Ayame I holds that the real work of skillful performance is not on the stage but in the daily life practices of Woman.[43] In constructing the onnagata difference, Ayame I's descriptions seem to play with ambiguity, sometimes fusing role, actor, gender role, and possibly sexuality. The interplay of roles onstage and off are delightfully and somewhat transparently layered over each other. For example, Ayame I admonishes the onnagata to eat in the expected manner of women, that is, in private, away from others, quietly, without unsightly chewing. The onnagata should never allow the tachiyaku, who is his role's lover, to see him in a state of "unwomanliness." The onnagata is in charge of the illusion, and it is up to him to maintain the fiction at all times. The offstage gender role behavior compels all performers to maintain their gender role specializations.

According to contemporary onnagata, like Nakamura Shikan VII (1928–) and Bandō Tamasaburō V (1950–), the charm and talent most admired in the

onnagata is the ability to hint at both worlds and manipulate their differences onstage. Nakamura Jakuemon IV (1920–) observed that the backstage world is yet another place for playing with those differences for the benefit of guests and admirers who visit the dressing rooms.[44] Ayame I's daily life practice of onnagata gender acts contributed to the gender ambiguity of the onstage performances between tachiyaku and onnagata. His training for onnagata gender art reflects the "play between psyche and appearance."[45] Perhaps Ayame I's advocacy of onnagata stage and daily life practices is evidence for his performative sense of ambiguity between sex and gender appearances.

Theatre historians frequently cite Ayame I's notes that onnagata should lead a woman's life offstage.[46] For example, Benito Ortolani states:

> From Ayame derives the codification of the teaching and the practice of extending the impersonation of a woman to the actor's private life, in an effort to achieve true realism on the stage. This tradition was followed to the extremes of wearing female clothes all the time, carefully concealing the fact of being married and having fathered children, and even tacitly being allowed to bathe in the women's section of the public bathhouse, . . .[47]

Perhaps instead of impersonation or realism, Ayame I practiced a hyperreal theatricality, which referenced the appearances, customs, and manners of female-likeness. Ayame I does not speak of disguising his body or voice to appear as a real woman. Rather, he modeled his style of dressing and behavior outside the theatre on his stage construction and performance of a kabuki fiction of Woman, which he designed based on his *iroko* training.

It should be clarified that the daily life practices of an onnagata were not the same as those of real women. Onnagata attire, manners, and behavior patterns were those of onnagata, that is, men who were performers of female gender roles in the theatrical world of kabuki. Their onnagata behavior was part of the kabuki world. It follows that onnagata extended the fiction of their stage lives into their daily lives for its advantages. It was a way of maintaining an eccentric star image as well as advertising their entertainment after the show. Further, their flaunting of difference by performing their onnagata gender acts outside the stage area frustrated the *bakufu* government, who wanted to identify and maintain the social divisions of class, gender, and occupation. Watanabe conjectures:

> Theirs was a "daily life" which was created for the purpose of creating a "*nikutai*" [flesh/substance/body] which was for the purpose of living as "Woman" on the stage but in this fabricated "daily life" the onnagata did not go so far as to completely change into "Woman."[48]

The onnagata created and performed an appearance that was, at once, a constructed fiction and a means for representing female genders in the

world of kabuki. They fabricated this lifestyle as they went along, in response to fashion, patrons, tachiyaku, *bakufu* restrictions, and their own economic position and artistic tastes.

In his teachings, Ayame I was not advocating impersonation or disguise but rather the approximation of gender norms. In *Bodies That Matter*, Judith Butler explains that "[g]ender norms operate by requiring the embodiment of certain ideals of femininity and masculinity, ones that are almost always related to the idealization of the heterosexual bond."[49] As a star onnagata, Ayame I had the prerogative to appropriate the Edo period feminine ideals and reinvent them as acts of *onnarashisa* (female-likeness). In the kabuki system of gender role enactment, he aimed to define and substantiate the onnagata's "being" as distinct from the tachiyaku. In order to create a distinct onnagata position, Ayame I chose to perform his onnagata gender role off-stage as well. Although some onnagata may not have performed their offstage lives as onnagata, there is a distinct difference and prestige accorded those onnagata who did. Most importantly, Ayame I had a mission. He chose his daily life method as a distinctive training process for embodying the art of the onnagata and carving out a distinctive space for onnagata.

The final note in the *Ayamegusa* raises the connection between youth and female-likeness. For subsequent and contemporary onnagata, the interplay of aging bodies with youthful roles is central to their stylization of onnagata gender acts. Besides creating female-likeness, onnagata created their own acts of youth-likeness to continue playing any age role type. Further, the youthful acts associated with onnagata gender acts are directly related to the acts of the boy prostitute performers, who had to remain young-looking to make their living. For this reason, onnagata are still bound in some ways to the world of the *wakashu*.[50]

Ayame I's world was not the heterosexist or binary feminine and masculine space of much Western gender theory. It would be tempting to reduce the *Ayamegusa* to a simplistic or exotic explanation of onnagata art as an ideal Woman, or a kind of drag star. However, the onnagata's stylized acts and lifestyle training process destabilized the gender/sex core paradigm, and authenticated the play between the inside, hidden, and articulated appearances. Ayame I crafted a performance style from ideal feminine psyche and body and from societal restraints placed upon women. The *Ayamegusa* sets forth the advocacy of Ayame I for a separate and distinct onnagata gender role, which requires the performance of onnagata gender acts both onstage and in daily life.

While the *Ayamegusa* is undoubtedly an important document, much of its content has been generalized and lifted out of its particular cultural and historic milieu. It is difficult to determine how Ayame I's admonitions and suggestions for onnagata art as gender performance are manifested in

contemporary onnagata performance. Nonetheless, contemporary onnagata still refer to the *Ayamegusa* when they speak of the onnagata historic formulation. Comments by contemporary onnagata involving their interpretations of the *Ayamegusa* demonstrate their ongoing concern with a distinct gender role. Clearly, onnagata gender acts have evolved and flourished far beyond the principles set forth in the *Ayamegusa*.

Hana Gei *and* Jigei

Mizuki Tatsunosuke I and Yoshizawa Ayame I together articulated the first onnagata performance techniques that distinguished onnagata as a distinct *yakugara* (role type). Tatsunosuke I's brilliant and flamboyant dancing established the patterns of gesture, locomotion, and forms articulated to music, lyrics, percussion, chant, or dialogue, as the primary medium for onnagata gender performance. The dance acts within the dramas were eventually featured in many play types as prime opportunities for onnagata to show off their looks, physical skills, costume styles, and latest innovations. Tatsunosuke I's focus on *hana gei*, referring to dance-centered art, together with Ayame I's focus on *jigei*, referring to acting-centered art, became the two arenas for the development of onnagata gender acts.

Hana and *jigei* both complemented and contrasted with each other. For example, an onnagata playing a courtesan character may have been asked to sing and dance to entertain guests. Dances often included a section known as *kudoki*,[51] in which the performer danced and acted two characters such as a courtesan and lover, who resolve to die together. Dance skills, such as the line of the moving body in space and time, the rhythmic articulation of the costume, and the stylized gestures to lyrics and shamisen were most important in this performance style. But *jigei* was also necessary for communicating the story line and role type characterization, which might require spoken lines and gestures of specific character or emotional content. *Jigei* skills, such as types of line delivery, role type characterizations through gesture patterns and speech, and stylized emotional expressions were central to the narrative type performances.

These two performance styles, *hana gei* and *jigei*, demonstrate key strategies that the onnagata used to vary and distinguish their gender performance. The two types greatly influenced each other, and the dance art, particularly, became the basis for all gestural and postural codes for onnagata. While onnagata perform dance gestures with no textual meaning, they ground all gestures in dramatic or mimetic stylized movement patterns. All gestures, no matter how abstract, aim at communicating specific meaning. In every onnagata gender act, the barely observable, almost habitual stylized actions reveal the merging of *hana* and *jigei*.

On the whole, kabuki dance preserves the functional and concrete refer-
ents within its movement codes. When *hana* and *jigei* skills overlap, the
enactment of the "real" merges with the stylized forms and requirements of
the dance that include line, space, and dynamics of musical accompaniment.
The dynamic arena where the skills of *hana* and *jigei* come together is the site
of the creation of onnagata stylized gender acts. An exceptional example of
merging *hana* and *jigei* can be seen in the *jōruri* (chanted drama of the pup-
pet theatre) based plays. Here the *tayu* (chanter) describes the feelings or adds
to the narrative concerning the onnagata role while the onnagata dances and
acts the scene. Onnagata gender codes arose from the stylization process of
different actors compounding their dance and acting skills into gender acts.

Consider the early onnagata, who used the dance elements of gesture,
rhythmic change, and repetition to abstract the act of weeping. If they
merely imitated a woman crying, it would not be seen by the audience, nor
would it show off their onnagata-styled fiction of the female-likeness. In
order to communicate, the vocabulary of acts had to combine form, for
clarity, with variability, for dynamic interest. To achieve the desired grace,
they used their dance skills of musicality and composition to create the gen-
der act of crying. Thus, they disassembled a concrete gesture through the
manipulation of space and time and stylized it into an onnagata gender act.
Similarly, the onnagata dances were infused with their acting skills. Many
sleeve and hand gestures, which at first appear abstract, arise from mimetic
gender acts such as combing long hair, writing a love letter, gesturing in
anger, calling after someone, or looking off into the distance, remembering
a lover. There are also abstract acts, particularly gestures with the sleeves and
the head, that are not concrete or mimetic, but, instead, exhibit qualities
such as the special grace infused with lush sensuality, which onnagata created
as their onnagata gender trademark.

Ayame I, renowned primarily for his *jigei*, nonetheless advocated a
mutual ground of performance acts with a dynamic relationship between
dance and acting. Ayame I warned: "Just seeing the flowers [dance art],
without the earth [acting art], is equal to there being no fruit [dramatic
performance] . . . If, from the blossoming of flowers you produce fruit,
then you must prepare the earth for the flowers."[52] He emphasized the
mutual interaction and transformation between the dance and acting arts as
key to onnagata performance. Ayame I cast onnagata performance within a
dynamic field of stylization, in which an actor could utilize a variety of
abstract, dance-like, and realistic techniques to create the stylized patterns
for their gender acts. The diversity in role playing and dance/acting skills
was very important. High-ranking onnagata gained prestige for performing
in all role types, dance styles, and play types throughout their stage lives.

Still, the onnagata dance, linked back through the early onnagata to the *wakashu* dances, was the heart of early onnagata performance. According to Gunji Masakatsu, even in Genroku, with the *bakufu* push for *monomane kyōgen zukushi* (fully enacted plays) advocated by Ayame I, dance was still the onnagata's basic skill. Gunji believes that the emphasis on imitative acting contributed to the development of the kabuki *shosagoto* (dance work), which combined *hana* and *jigei*, the two sides of the onnagata art represented by Tatsunosuke I and Ayame I.[53] Gunji conjectures that when the *bakufu* required continuous fully enacted or imitation plays to curb the seductive dances of the *wakashu*, the early onnagata expanded the "story line" of plays to include dance transitions, dance sequences, and dance transformations. They also reworked the dances to include imitative gesture sequences to go with songs. The result of these experiments was the *shosagoto*. Although it was still a dance, the difference was that the dance gestures, coupled with song or chanted text, communicated concrete or symbolic meaning and narrative.[54] Further, onnagata costuming, which became more elaborate and heavier, both restricted the onnagata to his refined and constructed shape and liberated him to create an innovative language of gesture patterns using the long sleeves, hems, and *obi* ties to go with the danced lyric narratives. The onnagata performance as the *oiran* (high-ranking courtesan) role, Yūgiri, in *Kuruwa Bunshō* (Love Letter from the Licensed Quarter), clearly demonstrates the correlation between the onnagata *hana gei* and *jigei*.[55] I believe it also shows their evolution from the earlier *wakashu* sensual dance art.

Gunji suggests that the development of transformation sections in dance works was a means for onnagata gender art to develop variety, for star onnagata to gain greater acclaim, and for onnagata to play with their ambiguous sensuality.[56] Various star onnagata, such as Tomijūrō I and Kikunojō I, constructed their versions of *Musume Dōjōji* on the idea of slipping between role types and characters, tantalizing their audiences with their ambiguous gender acts in their transitions from *musume* to *shirabyōshi* to female-like serpent demon. Onnagata clearly use the power of the ambiguity and referentiality of their stylized dance gestures in the transformation type of *shosagoto*. Onnagata took full advantage of their *hana gei*, using the strong stylization of their dance gestures in all their gender acts throughout their performances. There is great subtlety and depth to these onnagata gender acts of gesture dance narrative that can move the heart through abstraction and suggestion rather than through direct concrete representation. This concept lies at the core of onnagata gender performance.[57]

Segawa Kikunojō I (1693–1749)

Segawa Kikunojō I (figure 4.4) was born during the "golden age of kabuki," the Genroku period (1688–1703). Thus, he had the opportunity to emulate

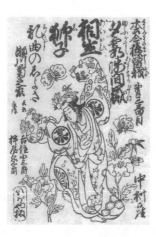

4.4 Segawa Kikunojō I (1693–1749)

the first onnagata stars such as Sakata Tōjūrō I (1647–1709) and Yoshizawa Ayame I. Kikunojō I began his career in Dotomburi, the central entertainment and prostitution area of Osaka. At age sixteen, Kikunojō I made his *iroko* debut in Dotomburi at the Arashi Sanjūrō theatre. Kikunojō I was another onnagata who began his career as an *iroko*, a young boy prostitute who performed dances or varied entertainments in order to solicit patrons. According to Watanabe Tamotsu, "Real *iroko* did not do art, they didn't have even one line of dialogue. After the show, they became the partners of paying guests."[58] In most cases, at about age sixteen, an *iroko* who intended to continue his stage life usually made his debut as an onnagata. However, Kikunojō I was quite late, making his debut at about twenty-three.

In 1712, Kikunojō I debuted as a *wakaonnagata* (young onnagata), the period's role type designation for a female gender performer in kabuki, at the Ogino Yaegiri theatre in Osaka. From there, he apparently traveled from theatre to theatre in the Kamigata area, performing to unfavorable reviews, one of which declared that he "had a poisonous atmosphere or air about his art."[59] Discouraged and without patrons, at age twenty-three, he retired from the stage for three years. Watanabe Tamotsu suggests that Kikunojō I was not an instant success on the stage because the aesthetics of the period had to change before his particular talent could gain acceptance.

Kikunojō I is an example of the change in female-likeness that was gradually altering aesthetics on the stage. Like Ayame I, he practiced living daily life as an onnagata. But he also, on his return to the stage, focused on creating an exaggerated image of female-likeness out of his imagination. He was not naturally beautiful, but he could invent and perform an exaggerated stylized beauty. If the kabuki female role was the product of staged

representations by boys and men, it seems likely that the aesthetics of female-likeness would also be determined by boys and men. Watanabe conjectures that it took time for the shifting aesthetics to include what Kikunojō I could do without "natural looks."[60] First, the boy prostitute image and iconography had to transform into onnagata gender acts and aesthetics. Kikunojō I was among the onnagata who moved their images away from the *bishōnen* (beautiful boy) body mystique to the diverse onnagata gender images and styles that flourished in the subsequent eras of kabuki. However, the beautiful boy aesthetic, because of its ambiguity and ability to transform, still lies at the base of onnagata aesthetics even with the great variety and diversity of onnagata styles and "looks."

Kikunojō I had to invent his own stylized attraction composed of his own gender acts. Watanabe attributes Kikunojō I's singular approach to his struggle for stardom in an era of transition. The "Capitol Women"[61] from Kyoto were considered the ultimate in feminine beauty, the aesthetic ideal for onnagata of the early Edo period. Although he was born in Kyoto, Kikunojō I, ". . . never was beautiful. Just average. His voice was low and hoarse.[62]" Watanabe conjectures that Kikunojō I, as an *iroko* and *wakaonnagata*, had tried to imitate a fashion that did not fit him. He had not yet made the transition from his prostitute performance style to theatrical performance style. When he took time off from the stage and worked in the merchant world, he experienced being a man looking at the stage from the outside point of view. Watanabe takes off from this idea, interpreting Kikunojō I's transformation like this:

> From being like a Woman in the world of male prostitution, to living as a man in the merchant world, for the first time, he was conscious of the meaning of the fiction of onnagata. Living as a Woman on the stage, suppressing the man within oneself, unsettling reality, was not at all like the world of prostitution. Perhaps in the world of male prostitution and the world of onnagata there is one point of similarity. The male prostitute sells his body. Performers also, sell their bodies to the gaze of the spectators. The selling of this body is the only thing that is the same, . . . but the actor who only exposes his body to the gaze of the spectators will never be a famous actor. . . . In this case, the prostitute is completely different from the actor, for whom as an artist, the way is open [to his creativity]. That, for an onnagata, meant living within a fiction of Woman [both on and offstage]. During his time away from the stage, Kikunojō gained an understanding of that meaning [fiction].[63]

When Kikunojō I began performing again after three years, his reviews were immediately favorable and his career was launched. Watanabe points out that when Kikunojō I returned to the stage, he was still not beautiful,

he was no longer young, he did not have a good voice, and he had no reputation to ride on. With and despite these disadvantages, he re-created his stage self, his star image. First, he chose to live his daily life as an onnagata, like Ayame I, his predecessor. Kikunojō I wore his onnagata *bōshi*, makeup, kimono, *obi*, and sleeves—everything knotted and tied in an elegant onnagata manner daily—until the day he died. Then, to make a fiction of beauty from the external point of view, he designed his total image through exaggerated artifice:

> Living daily life as a Woman is the remodeling of one's own flesh and blood. On top of that remodeled flesh/body, through stylization, he designed, from the point of view of other people, an artificial Female. That was the result of the experience of a three-year offstage period.[64]

In 1723, Kikunojō I achieved recognition as *tateoyama*, the highest rank in a troupe for an onnagata, primarily from solo dance dramas. Four years later, he succeeded in gaining notoriety for his performances in dance works like *Musume Dōjōji, Shakkyō* (Stone Bridge), and *Mugen no Kane* (Mugen Temple Bell).[65] Kikunojō I gained his star status when he performed with great success in Edo in 1731. The dance works and transformation roles like high priestess in *Onna Narukami* (Female Thunder God), eventually propelled his star machine to the highest accolades, as the best in three major cities: Osaka, Edo, and Kyoto. In 1744, at the age of fifty-two, he had gained the highest possible status for onnagata.[66]

What further defined Kikunojō I's stardom was being the first onnagata to play only onnagata roles. In the Genroku period, it was not unusual for an onnagata to sometimes play a refined high-ranking young lord role such as Katsuyori of *Honchō Nijūshikō* (The Twenty-four Examples of Filial Piety).[67] Or, as onnagata aged, they usually retired into playing male roles because of the emphasis on youth and beauty for female gender roles. While Ayame I advocated playing only onnagata roles, Kikunojō I went a step further by refusing to play any male roles at all. When assigned the role of a young lord, Kikunojō supposedly replied, "I am an onnagata. If it is a female role, I will play it, however, in this case, even if it is a young lord, a man is a man. I cannot perform it."[68] In this case, the playwrights apparently rewrote the play to make Kikunojō I's role a female gender role. His refusal to perform male gender roles made him quite famous and established the idea of *maonnagata*, an onnagata who enacts only onnagata roles.

Kikunojō I is an example of how a star performer's individual style could become definitive features of onnagata gender performance. By maintaining his separateness, Kikunojō I was carefully defining the territory of his onnagata gender role. His refusal to play a male gender role raised the status

of onnagata by clearly showing the constructed and unnatural nature of gender acts. Moreover, defining onnagata art as a specialized skill brought with it some of the distinction and prestige associated with tachiyaku. Perhaps Kikunojō I created the practice of *maonnagata* in order to appear as exotic and alluring as possible, adding to his star mystique. A man who is seen on the public stage as only an onnagata, gradually becomes that gender role in the public eye.[69] The practice of *maonnagata* continues today, maintaining its aura of gender difference. The *maonnagata* type is part of the onnagata star making strategy that emphasized the onnagata's gender exoticism and ambiguity.

Kikunojō I continued to play young onnagata roles throughout his life. He portrayed youth-like gender roles with his stylized acts, distinguishing himself as the "forever young" onnagata. With his stylized *musume* (young girl) gender acts, he managed to disengage his real age from that of the character. The disconnection between the actor's age and role type age brought about a pivotal and crucial performative theory for onnagata gender stylization. During the first half of the eighteenth century, it was the established practice that older onnagata would "retire" into male roles or middle-aged female roles. However, it seems that Kikunojō I's performative stylization of young female roles allowed him to convince the public of his performative youth until his death at the age of fifty-nine. Segawa Kikunojō I is remarked on as playing *musume* roles in their swinging sleeves until his death.[70] He is eulogized in a poem, written for him at age fifty-seven: "The face that does not change/ even as autumn wanes/ how our waking and sleeping is unknown to others."[71] His youthful gender art was an enormous contribution to onnagata art, because it lengthened the careers of great onnagata, who could now play young roles into old age. Additionally, it may be seen as another layer in the fabrication that took onnagata gender acts even further beyond the imitation of real women.

To stylize "youth" into gender acts required more exaggerated costumes, movements, makeup, and other techniques to obscure and reconstruct the aging actor's body beneath. Such strategies created a fiction of youth that was not restricted by the age of the performer. Even the spectators were taught to focus on the stylized youth acts of the onnagata, and not on his wrinkled face or jowls, or his stiffening postures. Kikunojō I was an astonishing figure whose innovative styles were modeled and assimilated by subsequent onnagata. Thus, he altered the connection of the *wakashu* boy prostitute to the onnagata image: the onnagata had become a specialist in a performative gender role that was not contingent on an actor's age or looks. An apprentice could then study the art of onnagata as a set of skills with which to create gender acts and assemble role types. This is an important difference from matching age and appearance to an individual actor's age

and body. Paradoxically, by establishing the *maonnagata* (pure onnagata) performer, Kikunojō I strengthened the separation of the actor body and the gender role and the identification of the onnagata gender role with the male body beneath.

Kikunojō I's Onnagata Hiden

Ayame I was only one of several stars who set standards for Edo period onnagata. Top artists frequently wrote lessons and guideline notes as a way of passing on their art. A document from the Genroku era, the *Onnagata Hiden* (Secrets of the Onnagata),[72] only portions of which are extant, was formulated by Segawa Kikunojō I.[73] Kikunojō I's art discussions contain concrete skills and practical descriptions of acts such as postures, costume pieces, and so forth, required for performing certain role types and characters. In contrast to Ayame I's teachings of a general lifestyle practice, Kikunojō I conceived of onnagata acts as stage stylizations that could be taught and learned. His acts went beyond everyday life experience.

In an article entitled "Thoughts on Connecting Onnagata Art Discourse," Uehara Teruo discusses the attributes of the early onnagata *geidan* (art discussions), Yoshizawa Ayame I's *Ayamegusa* and Segawa Kikunojō I's *Onnagata Hiden*. He describes the evolution of the two different approaches through Edo period star onnagata such as Nakamura Tomijūrō I, who followed Ayame I's approach, and Iwai Hanshirō IV and V, whose art followed the Kikunojō I model. Uehara emphasizes that the onnagata art developed through star onnagatas' variations on role types and gender role diversification.[74] He is careful not to oversimplify the art lessons and advice of the two historical figures. From their structures and written styles, he concludes that their main differences are in the area of techniques and performance objectives.

Juxtaposing the two most famous onnagata discourses is useful in understanding the dominant methodologies followed. According to Uehara, Ayame I's performance art arose from the inside out, was directed from the heart, and was aimed at becoming Woman. Kikunojō's performance art, on the other hand, focused on physical skills and constructed acts, that is, *kata*, that the onnagata had to master. In Kikunojō I's case, the outer form gave rise to a female-likeness; the emphasis on visual stylization created through the deliberate manipulation of appearances. Uehara writes that Kikunojō I's methods aimed "to extinguish the agony of the living body (flesh and blood) approach which was in the *Ayamegusa*."[75]

In his recorded teachings, Ayame I discusses his methodology by using examples of both onstage and offstage theatrical life. His approach is a general adaptation to female-likeness. He advises onnagata to live from the

heart, as onnagata, at all times and in all of their daily routines. He cautions that an onnagata will not advance in his art unless "[w]hen someone mentions your wife, you conceal the fact that you have a wife and blush from the heart."[76] By contrast, Kikunojō I describes specific actions in actual performance situations, such as "[i]n the instance of female anger, before speaking, you should cry."[77] Kikunojō I underlies the practice of onnagata gender performance as a discipline of constructed skills. Toita Yasuji observes that Kikunojō I's *Onnagata no Hiden*, compared to the *Ayamegusa*, was much more concrete, prescribing certain stylized acts for certain roles and situations. Toita remarks that Kikunojō I "wrote about such things as the differences between embraces for going through the motions of pretending to fall in love with a man and for really falling in love."[78] He described the positions of the sleeves, the tilt of the head, and the exact position and line of the onnagata body.

Throughout the Edo period, these two strategies were the dominant streams of onnagata performance methods. Subsequent onnagata, for the most part, created variations on these designs and practices. Neither Ayame I nor Kikunojō I intended to propagate or create a complete method, but rather, they wished to establish a distinct position for onnagata and their art. Their common concern was that the onnagata achieve a female-likeness through various disciplines requiring specialized skills and control.

One of Ayame I's sayings is that an onnagata should have "[t]he appearance of a courtesan, the heart of a chaste woman." This principle reflects the two main gender role types created by these two powerful onnagata. That is, the *keisei*, a high-ranking *yūjo* role was central to Ayame I's onnagata gender role discourse, and the *musume*, who was usually a chaste and innocent young girl, was the model role for Kikunojō I. These two role types had characteristics that gradually became the dominant disciplines for onnagata gender act *kata*. The *yūjo* roles required stylization patterns associated with *iroke*, the central onnagata aesthetic of eroticism. In this way, the star Ayame I and the stylization of his role merged into an onnagata role type and aesthetic paradigm. Kikunojō I's *musume* was a combination of his physical traits and techniques, acts of sensuality, and the girl-like role type. His stylization in this role laid the groundwork for the important onnagata aesthetic of youthful beauty, a constructed beauty of innocence and charm that onnagata could perform at any age.

Several of Kikunojō I's performance characteristics illustrate his focus on constructing an onnagata image and gender acts in his *Onnagata Hiden*. For Kikunojō I, the superficial gender act was the defining onnagata aesthetic mode. According to Ruth Shaver, Kikunojō I insisted that the onnagata keep his makeup beautiful at all times. In portraying ugliness or evil, as in ghost roles or demon transformations, an onnagata could change gestures,

costuming and wigs, but he should preserve his superficial facial beauty with his onnagata makeup no matter what the character change.[79] Even in his *Shakkyō*, a transformation lion dance, Kikunojō I maintained his onnagata makeup and kimono instead of completely transforming into the makeup, costuming, and wig of the lion spirit. Kawatake Shigetoshi cites his transformation dance roles as pivotal to his career, particularly their flamboyant technical *kata*, like the sudden ripping off of his sleeves in *Mugen no Kane*.[80] According to Shaver, Kikunojō I built his onnagata acts with excessive costuming and was harassed by the *bakufu* for his extravagance.[81] Watanabe conjectures that Kikunojō I's star onnagata design was a dramatic performative deception, and that he had literally re-created himself as the onnagata Kikunojō I, ". . . there was no unpainted face, his very self was the character who danced, . . . living within a fiction, Kikunojō only recognized himself being within that fiction."[82]

Kikunojō III (1751–1810)

Segawa Kikunojō I (1693–1749), II (1741–1773) (figure 4.5), and III (1751–1810) (figure 4.6) formed one of the major lines of onnagata, which spanned most of the Edo period. These three, along with the line of Iwai Hanshirō IV (1747–1800), V (1776–1847), and VIII (1829–1882) demonstrate the solidifying of onnagata stylization practices. In particular, the star onnagata Kikunojō III's contrasting style and rivalry with the Iwai Hanshirō line, contributed to the development of distinctive onnagata role types, as well as to regional and individual styles.

Segawa Kikunojō III matured in the second half of the eighteenth century. At this juncture in kabuki history, onnagata performance was recognized as a profession. While the onnagata art appeared to grow further removed from the art of the *wakashu*, the *iroko* milieu now served as a training ground for new onnagata Still, the slight differences contributed to raising the status of the onnagata art.

Kikunojō III was born in 1751 into a choreographer's household. This gave him immediate access to performance venues. At the age of sixteen, he made his debut as an *iroko* in Osaka. He first apprenticed in the Ichikawa actor family line as Ichikawa Tomisaburō. Then, invited into the Segawa line through various negotiations, he succeeded to the name Kikunojō III at age twenty-five. By the time he died at the age of sixty, he had created his own star impact on the onnagata world. His career of thirty-five years spanned several periods of upheaval in Edo government and society, demonstrating his resilience and adaptability to the demands of both government restrictions and popular culture.

Although gifted in dance, Kikunojō III's art reportedly blossomed in the *keisei* roles, especially the *jigei* scenes. Both his *keisei* and his *musume* roles

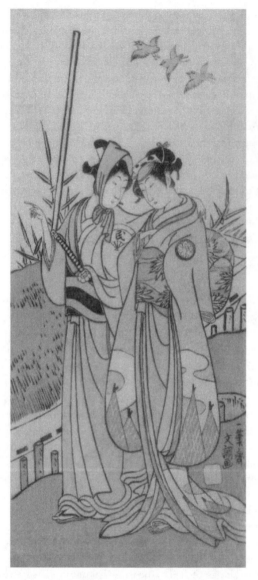

4.5 Segawa Kikunojō II (1741–1773) figure on right, in *furisode* and *bōshi*

were described as "dripping with moisture,"[83] meaning that he was sensu-
ally exciting. Kawatake Shigetoshi is careful to emphasize that his eroticism
was not in the style of "realism," but performed through stylization. His
weak point was that he might overindulge in his gesture patterns. He

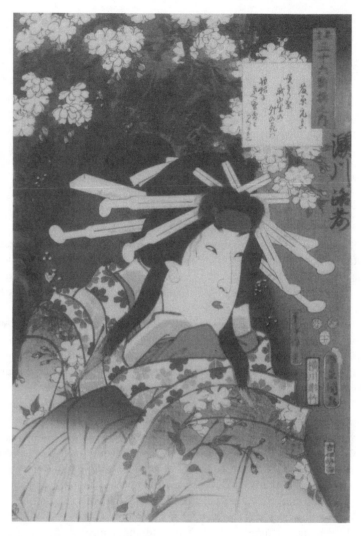

4.6 Segawa Kikunojō III (1751–1810) *yūjo* role type Sumizome

enriched his style with the details of costuming and gesture, and knew how
to draw out a moment with just the right pose and timing. Apparently his
elocution was beautiful and flowing, and he had a talent for handling long
speeches. Among the *yūjo* roles that matched his style were the *oiran*
(top-ranking courtesan) roles such as Yūgiri, Takao, and Tamagiku, and
courtesans like Sumizome and Koman.[84] Kikunojō III was famous for his
facial expressions, for example, opening his mouth for expressive moments

in love scenes, which made the scenes erotically visceral.[85] According to
Watanabe Tamotsu, he had an experimental or "rash" streak and would try
out a new act on a whim, just for the sake of doing it. For example, in a per-
formance of a transformation dance of a *sewanyōbō* (contemporary wife)
role that is really a female dragon role, usually the onnagata would go off-
stage and return transformed in the dragon-like costume and dance the
dragon woman dance. But Kikunojō III did not go offstage. Instead, he
went directly into the dragon woman dance, still in his *sewanyōbō* kimono
and wig, and danced the female dragon transformation dance. According to
Watanabe's reading of the subsequent reviews of Kikunojō III's innovation,
the onnagata created a strange and charming image, managing to infuse the
wife role image with the female dragon feeling, which won his audiences'
attention and praise.[86] His acts of female-likeness had transparency and
ambiguity that he could readily mold into the unearthly role.

Perhaps the most important aspect of Kikunojō III's career was his rivalry
with the Edo onnagata Iwai Hanshirō IV. It was their rivalry, and the differ-
ences in their star gender acts, that created competitive situations for the two
onnagata to stylize new kata for gender acts and new variations of role types.
These two stars broke the pattern of onnagata as a shadow role to the
tachiyaku.[87] It appears that they encouraged playwrights to model characters
after their gender talents, which were broader and bolder than the earlier,
more conservative fictions of female-likeness. The rivalry between them
pushed each to excel in his own specialization and to design gender acts that
enhanced individuality and further diversified onnagata gender art.

This was a time of experimentation for onnagata. A wider range of roles
within role types began to appear, and stars had to redesign and expand on
earlier onnagata gender acts. Because of their radical experimentation, it is
likely that Kikunojō III and Hanshirō IV were the forerunners of the grad-
ual disintegration of the strict system of gender role specialization. While
they remained in their onnagata territory, they were simultaneously trying
out techniques and strategies that had previously been the privilege of
tachiyaku. In many ways, they followed on the tidal wave of innovation
by Nakamura Tomijūrō I, who expanded the onnagata's artistic range
and power within the kabuki repertoire and the troupes. Hanshirō IV and
Kikunojō III often played similar roles and would try out and test
each other's techniques and give them an individual twist. Their rivalry
contributed to their popularity. Spectators followed their performances like
matches. These two star onnagata exploited the limits of the onnagata
gender role, magnifying and mutating its invented gender acts. Above all,
their experiments demonstrated that gender stylization did not have to
arise from imitation of the real, but could take advantage of possibilities
beyond human.

Iwai Hanshirō IV (1747–1800) and
Iwai Hanshirō V (1776–1847)

Iwai Hanshirō IV was the first onnagata to be born in Edo and trained by Edo actors. As onnagata had traditionally trained in the Kamigata area, Hanshirō IV marked a great change in onnagata art. His Edo style of onnagata was part of the Edo style of kabuki, known for its flamboyantly stylized plays. He began his training under Danjūrō IV, a famous tachiyaku, and was later adopted into the Hanshirō line. He and Kikunojō III are the two onnagata who represent the era of kabuki that spanned the second half of the eighteenth century. Hanshirō IV excelled in various role and play types and was known for his mix and range of talents. One reviewer commented that Hanshirō IV combined "flower and fruit," that is, his *hana gei* and *jigei* were equally strong. He was praised as:

> a flower and fruit combination *wakaonnagata* . . . whose beauty overflows in the world; his *musumegata* [young girl type], *sewanyōbō* [contemporary wife], *oyama* [courtesan], fighting scenes, love scenes, dance works, there is nothing the *Tayu* [Hanshirō IV] can't do.[88]

Hanshirō IV's strong combination style was a major part of his star onnagata contribution. From the late eighteenth century on, subsequent onnagata would be challenged to play all role types and play types. In a sense, the expansion of onnagata role type specialization foreshadowed the breakdown of all gender role types; but it also meant that onnagata gender stylization was vitally alive and had, in its very composition, the built-in means for expansion and creativity.

Hanshirō IV began the creation of a new styled onnagata role type. In the newer style *kizewamono* (real life) plays, he created a *kizewamono* onnagata, a lower class role type, which required small changes in stylization and gender acts that reflected the common people's customs.[89] Additionally, he played *aragoto* and *wagoto* style tachiyaku roles. Hanshirō IV crossed several boundaries, demonstrating the creative latitude within gender roles and the sharing of gender-coded acts among different gender roles.

Edo audiences were infatuated with Hanshirō IV's personality and his comical and idiosyncratic gender acts. He enacted the precocious *musume* with no pretense, merging fictional and "real" worlds. Watanabe Tamotsu describes Hanshirō IV's star construction:

> [T]he people of Edo doted on him like he was their own daughter. The people who saw Kikunojō [III], did not go home, but went to buy a woman in the licensed quarter; but when they saw Hanshirō [IV], they went straight home, he was their own daughter jeering at the girl next door. Hanshirō

possessed that kind of "realism": the people of Edo's spirit and character of actual lived experience, that is, the *edokko's* [Edoites] very own expression.[90]

Hanshirō IV was himself among the sophisticated, worldly-wise children of Edo. He had a kind of bravura that had not been part of the earlier onnagata style. His art repeatedly challenged the traditional boundaries by juxtaposing unexpected gender acts. For example, in the *yūjo* role of Takao, Hanshirō IV tossed the courtesan's ransom scroll at the transgressor and smiled as the curtain closed. Ordinarily, onnagata did not smile for fear of revealing the male-likeness in their features. However, in this context, where there was no reason to smile, Hanshirō IV's smile was scornful and all the more ghastly because of the courtesan's tragic fate. His innovation gave him a bizarre attraction and charm that drew in his audiences and earned the praise of critics.[91]

Hanshirō IV broke some of the prescriptions binding the actor's body beneath to his onnagata gender act specialization. In so doing, he discovered that he could freely play with stylization, coded acts, and multiple genders. Some of his onnagata gender innovations came close to tachiyaku gender acts, such as facial expressions, which were dangerous for onnagata if they revealed too much of their maleness. Hanshirō IV's experiments with gender acts merged into the last new onnagata role type, the *akuba* (evil feminine), to be fully developed by Hanshirō V. The creation of an evil female role is significant because it was the first onnagata role type to perform any act related to wrongdoing or violence. (In fact, the *akuba* role is usually a protagonist who is central to the crimes actually perpetrated by the tachiyaku characters.) The *akuba* had a status that previously belonged only to the tachiyaku villain role type, and even triggered tachiyaku to play onnagata roles. Only a star like Hanshirō IV could turn the transgression into tachiyaku territory into a role type. Gradually, onnagata were becoming comfortable with looking less than perfectly and fictionally beautiful.

The stage images of Hanshirō IV and Kikunojō III indicate that the star onnagata acts of these rivals were extremely different. According to Watanabe, "Hanshirō was without reservations, *otokoppoi*. [masculine] and Kikunojō, *onnappoi* [feminine]."[92]

Watanabe further describes their contrasting performance styles:

For the most part, these two had different face shapes. Hanshirō's was round and full cheeked, Kikunojō's was melon shaped with a small jaw. Hanshirō had wide eyebrows and big eyes. Kikunojō drew eyebrows which were like a thin thread. His eyes were narrow too. Hanshirō had a beautiful voice which pealed like a bell and his dialogue echoed, "rin rin" in the theatre. Kikunojō's

voice was low, and his dialogue was unreliable . . . If their looks were different, then, of course their *geifu* [art], was different. Hanshirō's . . . bright splendid liveliness was straight forward. As for Kikunojō, he had this moist richness, an iroke [erotic allure] which was a little thick and dark.[93]

Watanabe concludes his summary with the images Edo spectators used to describe these star onnagata:

> In those days, the Edo population compared these two to flowers. Hanshirō was an early spring full blooming plum, Kikunojō was a spring time evening cherry. The spring plum has a clear faintness, the evening cherry has an erotic vagueness. Plum and Cherry. The differences of their art is there.[94]

In my view, the imagery of flowers more fully expresses the complex, creative ambiguity of their gender acts.

Iwai Hanshirō IV and V represent a gradual paradigm shift that firmly established onnagata preeminence in "female" gender roles. In the beginning of the nineteenth century and toward the end of the Edo period, onnagata had stylized and performed their onnagata female-likeness to the extent that a female character was an onnagata. As Watanabe Tamotsu puts it, onnagata had "digested,"[95] the representation of Woman and made it into their own gender role.

Further, Hanshirō IV and V did not arise from the *iroko* tradition. Beautiful and skilled in the specialized performative identity of onnagata, they had gained reputations that allowed them to create a new onnagata style. Besides diversifying their gender acts, they infused all onnagata gender role types with their star acts. Their world of kabuki—a world of male actors, patrons, theatre managers, and artisans—had reached a new level of artistry due to social, economic, and aesthetic changes. Thus, these stars represent the beginnings of a modern onnagata art, which had assimilated the sensuality and performance acts of the *wakashu* and moved beyond a supporting role to its own—a full-blown onnagata gender performance.

The combined talents and timeliness of Hanshirō IV and V created a different kind of onnagata art. To begin with, they were no longer in the category of male performers striving for female-likeness through their gender acts. Their own role type classifications, made up of complex sets of onnagata gender acts, had gradually displaced the fiction of Woman with the fiction of onnagata female-likeness. That is, they had achieved a singular status with an identifiable aesthetic design and sensual style, which was based on a male body enacting onnagata gender role acts. Both of these star onnagata revealed, more than ever before, their male actor body beneath. Onnagata had gained more autonomy to move among gender acts and roles.[96]

With the creation of an evil feminine role type, the Iwai Hanshirō IV and V (figure 4.7) line mixed a variety of gender acts, diversifying role types. The shift that began with Hanshirō IV and Hanshirō V moved onnagata into a new position in relation to the tachiyaku. When onnagata in their *akuba* (evil female) roles shifted to the forefront with their acts of bravura and eroticism, tachiyaku were motivated to try on those and other onnagata role types. Further, by developing alliances with playwrights, star onnagata could suggest and shape new roles that gave the onnagata center stage in the new plays. Playwrights began to create onnagata characters with gender ambiguity built into their roles. For example, Tsuruya Namboku IV (1755–1829) developed several roles for Hanshirō V, including Sakurahime of *Sakurahime Azuma Bunshō* (The Scarlet Princess of Edo) (1817), Oiwa of *Yotsuyakaidan* (The Ghost Story of Yotsuya) (1825), and Oroku of *Osome no*

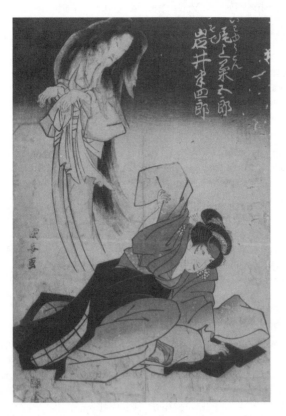

4.7 Iwai Hanshirō V (1776–1847) *akuba* role type Osode cowering Onoe Kikugorō III ghost role Oiwa

Nanayaku (The Seven Roles of Osome) (1813). Hanshirō IV contributed to developing the onnagata roles of the *kizewamono* (real life) style, such as Mikkatsuki Osen, a low cast *jorō* (female prostitute) role.[97] These roles were equivalent to the major tachiyaku roles, requiring greater ranges of emotion and character changes, speeches, and major action scenes than previous onnagata roles. Further, many of the roles were transformation roles, where they became ghosts, or male roles, or female roles of the lower or outcast class. As the star onnagata played among genders, the onnagata art expanded its own boundaries of onnagata gender acts.

Kabuki scholars Gunji Masakatsu and Torigoe Bunzō hold different ideas on the art of Iwai Hanshirō IV and V. On the one hand, these onnagata were star performers following the "tradition" of flamboyant innovation, which was an important side of kabuki artistry. On the other hand, they represented a break from the highly esteemed Genroku kabuki tradition of role type specialization. In their world of changing economic trends, public tastes, play types, role types, fashion, and appearance, Hanshirō IV and V had to stretch the traditions and challenge themselves to maintain their star status. Other actors before them had played both onnagata and tachiyaku roles, but these two onnagata were part of the rise in new roles that led to the blending of role types. Ultimately, they also enacted tachiyaku roles, breaking the *maonnagata* (pure onnagata) code.

Torigoe Bunzō called their innovations "decadent art,"[98] and Gunji believes that they contributed to the destruction of the entire system of gender role type specialization. This breakdown occurred toward the end of the Edo period, known as the Bunka Bunsei period (1804–1829), a time of widespread discontent, radical economic shifts, and chaos within the decaying shogunate. Gender role specialization gradually became corrupted for various reasons, including the artistic license of actors and playwrights. According to Gunji Masakatsu:

> Role specialization literally disintegrated. Iwai Hanshirō V, was an onnagata but he was also famous for his male roles. Utaemon III played every kind of role, but some call him an onnagata. Then tachiyaku, like Danjūrō IX and Kikugorō V, started playing onnagata roles and taught their own rules for onnagata, to the extent that young onnagata followed their advice, expounding on how to do a female role. The yakugara of gender role and role type specialists was destroyed. It's too bad, but that was the end of Edo kabuki.[99]

It may well have been the end of "Edo Kabuki," but at this point in onnagata history, onnagata had gained their highest status in terms of importance and power in the troupe system and the most breadth in roles and role types. Onnagata gender art, particularly the aesthetics of eroticism,

had reached a point of great complexity, involving a fiction of attraction and sensuality based on onnagata gender acts. If anything, the fragmentation of gender role specialization caused a wave of consolidating the best of the onnagata gender acts and roles in the next generation. The onnagata gender acts and role types that have survived prove the resilience and brilliance of their transcendent forms as well as their star onnagata creators.

CHAPTER 5

MODERNITY, NATION, AND
EROS: BOYS VERSUS WOMEN

Surviving Westernization and Realism

It is well documented that the end of the Edo period through the Meiji (1868–1912) and Taishō (1912–1926) and early Shōwa (1926–1930) eras were times of great upheaval and radical transformation for all of Japanese culture. Kabuki was elevated from its popular entertainment status to an official form of classical theatre, and kabuki performers were finally recognized as citizens. However, in the rush toward modernization, onnagata were among the elements of Edo period kabuki that were singled out for elimination. The art of the onnagata was scrutinized by public officials. Under pressure from the outside and within kabuki itself, onnagata modified their gender acts and art. In general, onnagata curbed their more flamboyant and extreme gender acts. By suppressing overt displays of sensuality and restricting acts of physical violence, onnagata subdued and refined their erotic allure. The initial Meiji period modifications of the Edo period onnagata gender acts deeply influenced the overall stylization practices of contemporary onnagata. During the first period of "Western" emulation, the onnagata irrevocably changed. Even the radical changes of the postwar and then "economic-boom" Japan, did not so acutely mutate the onnagata's stylized gender acts as did this transformative era.

With the introduction of "Western" tastes, the art of the onnagata was threatened with extinction. Westernization brought with it a different set of gender codes. The idea of men playing female roles was criticized, and it was suggested women take over female roles. Onnagata responded by maintaining and emphasizing their difference (i.e., their stylized performance techniques) from the popular "Western" models of "realism." Several points are

important to consider at this juncture of onnagata gender role development: (1) the effects of lifting the bans on women performers, (2) the new status of kabuki as a classical art, (3) the takeover of many onnagata roles by tachiyaku, and (4) the decline in the daily "lifestyle" practice of onnagata. I discuss each of these points to illustrate the complex forces at work in the background of the individual performers who persevered and prospered.

The onnagata of this transition era managed to retain their position as kabuki female gender role specialists, largely due to the power and resiliency of individual stars. In defense of their stylized gender art, the transition onnagata brilliantly negotiated their position and their art of female-likeness. Like Ayame I in the post–*wakashu* era, certain stars played a critical role in distinguishing and defending the art of the onnagata. In this chapter, Sawamura Tanosuke III (1845–1878) and Iwai Hanshirō VIII (1825–1882) are representative examples of star onnagata who struggled to maintain the onnagata lifestyle and eroticism at the end of the Edo period. Following this, I examine the *geidan* (art discussions) of Onoe Baikō VI (1870–1934) and Nakamura Utaemon V (1865–1940). These onnagata and their documents provide illuminating evidence of the modernization of onnagata art.

Transformation and Reformation

By the mid-nineteenth century, the *bakufu* was in a stage of disintegration.[1] When Japan was forcefully opened to foreign trade and cultural practices in 1868, its feudal government, social structure, and aesthetic culture were catapulted into the contemporary industrializing global society dominated by colonizing powers. In the meeting of worlds, some forms of Japanese theatre, and some kabuki actors, actively embraced the rampant emulation of things foreign. Certain elements of kabuki were lost or (like the art of the onnagata) profoundly altered. There were several stages of reformation, transformation, and retrenchment.

In the first two decades of the initial reformation (1868–1888), there was a kind of radical imitation of Western cultures, along with an active degradation of the home culture. This was followed (1888–1903) by cross-cultural experimentations, reversals, and eventually a period (1903–1930) of cultural reinstatement, in which traditional methods regained prestige in altered form. Kabuki, along with many traditional practices, lost, gained, and metamorphosed in the periods of social upheaval. During each stage of change, certain individuals and certain cultural, political, and economic events shaped the status, economics, and aesthetics of kabuki in the contemporary world.

During the initial reformation, an enforced reform for all theatre arts was part of the national movement to emulate Western cultural expressions and

methods. Kabuki was targeted as the one indigenous form with the potential to be recast in the European mold of realism for an aesthetically based theatre. The government supported the *Engeki Kairyō Kai* (Committee for the Reform of the Theatre) in its aim to clean up the eroticism and violence of kabuki. The committee published a book that prescribed the casting of women in female roles. Toita Yasuji quotes from some of its passages:

> From now on, it is no longer tenable that men play young female roles; it is decided that real *onnago* [girls] must play those [parts]. . . . Plays with noble character are impossible until we eradicate [the practice of] men playing female roles. . . . Without *onnago*, it is impossible to show the compassion of *onnago*.[2]

There is little recorded evidence of women struggling to take over onnagata roles. Early performances by women in other genres appear to have been a separate phenomenon that had little direct effect on the all-male kabuki. Several female performers managed to train within the kabuki world during the Meiji period. Among these, Danjūrō IX's daughters are mentioned as training on the kabuki stage as the little butterfly roles in the second half of *Kagamijishi* (The Dancing Lion). But butterflies are not onnagata roles.[3] One female performer, Ichikawa Kumehachi (1846–1913), was known as an *onnayakusha* (woman actor) instead of *joyū* (actress). The use of this term, *onnayakusha*, meant that this woman performer was trained and respected inside the kabuki actor's world. Ichikawa Kumehachi trained in the Iwai Hanshirō family line and then became an apprentice under Danjūrō IX. She even became known as "The Female Danjūrō." According to some sources, her performances were limited to the small theatres and the new genre, *shimpa* (lit. new school) and *shingeki* (lit. new theatre), and there is still conjecture as to whether she may have once performed in a kabuki production at the Kabuki-Za.[4] Other sources say she performed "kabuki" roles in middle size theatres and was head of her own troupe of women performers. Still, Kumehachi remained an outsider to the professional male kabuki world.

There were other women performers, called "Shimpa Danjūrō" and "Shingeki Danjūrō," who, because of their striking personalities, supposedly performed in a manner like Danjūrō IX. It was in these new theatre forms, *shimpa* and *shingeki*, that two women performers, Kawakami Sadayakko (1872–1946) of the *shimpa* world, and Matsui Sumako (1886–1919) of the *shingeki* world, began to make a place for women performers in professional theatre.[5]

Eventually, with the appearance of all female troupes, kabuki actors would direct women and perform "as mentors (*hodō*), and frequently

Kabuki plays were presented with women in the roles that had been played
by female impersonators."[6] When women played roles traditionally played
by onnagata, they were taught to imitate onnagata gender acts. But these
experiments did not last very long. Later on, in the first decade of the
twentieth century, even in the first foreign plays, onnagata played the female
roles. According to one of the first directors, Osanai Kaoru (1882–1928),
". . . the physical unbalance between male and female actors, disrupted the
harmony of the drama . . ."[7] Perhaps the "unbalance" had to do with how
female bodies disrupted the "harmony" of the constructed gender acts of
the onnagata based on a male body beneath. Onnagata gender role perfor-
mance was a legacy of the Edo period, which was not successfully disrupted
by the Meiji reforms. Even if they could challenge the onnagata art,
women's bodies did not fit into the all-male kabuki world. And, as I hypothe-
size, lacking the male body beneath, they could not perform onnagata gen-
der ambiguity and eroticism.

By the end of the Edo period, about the middle of the nineteenth
century, onnagata were performing a complete repertoire of distinctly
onnagata gender roles made up of onnagata gender acts. For over two hun-
dred and fifty years, their fiction of female-likeness based on the male body
beneath had thoroughly replaced the performance of women in female
gender roles. Onnagata gender acts had survived and attained a status and an
aesthetic identity all their own. Debates on the subject of actresses and
onnagata went on throughout the Meiji period, yet onnagata maintained
their position as the female gender role specialists in kabuki. The aim of
abolishing the onnagata in kabuki was never accomplished.[8]

Many of the Meiji reforms of the early transitional era had to do with
Japanese fascination with Western modernity, cultural practices, styles, and
manners. In trying on these cultural conventions, kabuki actors did not
become totally Westernized but assimilated certain differences into their
stage practices. Influences from Victorianism in its Western styled female
and male gender role proscriptions, along with a degree of homophobia,
probably infiltrated the kabuki actor world, directly affecting onnagata gender
performance. Among contemporary onnagata, Nakamura Jakuemon IV
(1920–) and Sawamura Tanosuke IV (1932–) suggest that the changes in
onnagata gender acts were profound during this time period. The reper-
toire of onnagata *hengemono* (transformation works), *yūjo* (courtesan) roles,
and *akuba* (evil female) roles was cut back, and those that were allowed to
continue were censored.[9] David Goodman refers to the period from 1887
through the end of World War II as an "exile of the gods" era for theatre. In
his view, aesthetic concerns dominated by realism mitigated against any
religious or spiritual associations in characters or plots.[10] These aesthetic and
social concerns, which were biased against plays that contained elements of

erotic sensuality or the grotesque or supernatural, contradicted the dominant onnagata performance.

Sawamura Tanosuke VI feels that the overtly sensual and erotic style of the onnagata died with the performers of the Edo period. He noted that many onnagata of that time preferred male love and did not hide their sexuality. For Tanosuke IV, their eroticism created an atmosphere of sensuality that no longer exists in contemporary kabuki.[11] Tanosuke VI's views suggest that a more overt demonstration of eroticism between the male performers or between male performers and patrons offstage charged the onnagata performance and made it tantalizing. This suggests another dimension of my theory of the male body beneath as requisite for onnagata performance. Perhaps the sexual ambiguity of the onnagata performers added to their gender ambiguity. Even though the sexuality of most contemporary onnagata is not discussed or performed publicly, degrees of homoeroticism may be employed by contemporary onnagata in performance. That is, some onnagata may inflect their onnagata erotic *kata* with their own contemporary homoerotic desire. The power of the onnagata *kata* lies, to some degree, in their ambiguous, porous, transparent, and transformative materiality. Contemporary onnagata may freely infuse homoerotic desire into their gender acts with or without a sexual agenda.[12] Perhaps the onnagata's performance of inflected desire references a nostalgic eroticism that is based on the *wakashu*, the beautiful boy and imbedded in their contemporary *kata*.

Edo period onnagata may have been "gay boys,"[13] but their onnagata image was above all "romantic—a romantic fantasy beyond everyday life." He feels that this romantic other-worldly quality was lost in the realistic roles of the new Meiji kabuki plays. And, according to Ichikawa Ennosuke III, who considers himself a tachiyaku who also plays onnagata roles, Edo period onnagata were more male-like. Ennosuke III feels that the Edo onnagata's *iroke* (erotic allure) arose from how they made their "male body beneath stand out"[14] when they enacted onnagata roles.

Several other onnagata agree that the foreign influence of realism and naturalism in gender role representation forced a cleanup of onnagata eroticism, sensuality, and gender ambiguity.[15] From early Meiji through early Shōwa (1926–1989), 1870 to 1935, onnagata went through several stages in which their art was severely criticized. Certain onnagata roles were dropped from the kabuki repertoire to please the reform committee in its attempt to Westernize kabuki. I think that the reforms were generally aimed at imitating Western Victorian morality, realism, and the sophisticated high art image of respectability. Among other changes, Meiji reforms advocated cleaning up the prostitute scenes in kabuki plays.[16] Since the courtesan roles and brothel scenes were a major part of the onnagata repertoire, the impact of these reforms on their art must have been considerable. Even if onnagata continued to play courtesan

roles, they were targeted for censorship. They may have gradually repressed their more overt erotic acts and subtly stylized and embedded their sensual attraction into their gender acts, creating a new layer of abstract codes.

Tachiyaku as Onnagata

Scholar critics such as Gunji cite early Meiji as the end of an era for kabuki onnagata. Gunji commented that the breakdown of role type specialization and the transformation of onnagata gender acts was the result of the takeover of major onnagata roles by tachiyaku in the early part of the nineteenth century.[17] In the resource materials on kabuki during this period, there is a great deal of emphasis on tachiyaku leadership and achievements. These actors had the privilege of assimilating onnagata gender roles while still maintaining their positions of power in the troupes. Top-ranking tachiyaku had the freedom to perform the flamboyant and exciting onnagata gender acts and choose which roles to play. The rise of the *kaneru yakusha*, tachiyaku who played both male and female roles during Meiji, indicates the popularity of transformative roles from the onnagata dance repertoire.

What effect did tachiyaku playing onnagata roles have on onnagata gender acts? It appears that onnagata were profoundly changed by the rise of the *kaneru yakusha* (lit. combination actor, a tachiyaku who plays many tachiyaku and onnagata role types) and the loss of the offstage onnagata mystique. Some roles were permanently altered, but beyond this, the tachiyaku preempted the authority of onnagata over their roles. Given their status as troupe leaders, the tachiyaku could negotiate reforms, troupe contracts, and so forth. Onnagata did not have the same political status to initiate change. Consequently, they did not expand their repertoire; they performed their gender acts within the "invaded" territory, absorbing the tachiyaku changes. At a subtle level, the takeover diminished the erotic mystique and gender ambiguity that they had cultivated on and off the stage.

Ichikawa Danjūrō IX (1838–1903) was a major force in kabuki reform and innovation during the Meiji period. He was a tachiyaku who took on major onnagata roles, wrote his own notes for onnagata performance, and added his creative touches to famous onnagata dances. Danjūrō IX was after a new naturalism, which emphasized an actor's *haragei* (lit. gut art, emotional truth) and absolute accuracy of historical detail. In his infamous *katsureki-mono* (living history plays), he introduced his own version of psychological realism for all acting styles and gender roles.[18] Danjūrō IX was a strong advocate of theatre reform in the early part of the Meiji era, but as the era progressed, he turned to the preservation of the traditional art of kabuki. Perhaps tachiyaku could sense that the undoing of the stylized onnagata

fiction was bound to their own stylized fiction and could have meant the destruction of the whole kabuki system.

The changes to kabuki during Meiji were apparently negotiated by playwrights, producers, and actors. Leading tachiyaku, like Danjūrō IX, incorporated a new naturalism into their acting methods, play content, and style. In Gunji's view, these tachiyaku changed contemporary onnagata gender acts and influenced other tachiyaku to appropriate more onnagata roles.[19] However, even though tachiyaku enacted many onnagata roles, they avoided those associated with eroticism, prostitution, and male love. Even with the breakdown of gender role specialization, there seemed to be some kind of gender border that tachiyaku refused to cross. To this day, tachiyaku who are *kaneru yakusha* have no desire to play *musume* (young girl), *hime-sama* (princess), or certain *yūjo* (courtesan) roles.[20] Perhaps tachiyaku never took over these role types because of their association with onnagata gender ambiguity, eroticism, and their legacy of *wakashu* performance, prostitution, and male love.

Besides the changes in gender role specialization, the Meiji period was a turning point in kabuki actors' social status and human rights. Danjūrō IX was central in gaining social standing and rank for kabuki actors in the new society. It was he who appealed to play for the emperor in 1887, helping to gain citizen status and recognition for kabuki and kabuki performers.[21] Gradually, kabuki distinguished itself from the lower-class entertainments, especially those connected with prostitution. What was the effect of the new status of kabuki as a classical art on onnagata gender performance? To begin with, kabuki moved away from the raw sensuality and violence that had dominated the stages in the early part of the nineteenth century, toward a more conservative theatrical form. There were fewer kabuki plays with courtesan role types or erotic and violent scenes, which cut down on the number of such parts for onnagata.[22]

Some contemporary onnagata view the Meiji changes positively, while others wonder if the art of onnagata ended in Edo period. Nakamura Jakuemon IV believes that when kabuki was recognized as a form of national theatre the changes were profound. From his performer's perspective, the Meiji reforms not only raised the status of kabuki actors to citizens but also recognized them as real artists. However, when kabuki actors gained status, they had to perform within the new category of classical "artist." One of the consequences was that onnagata rarely performed their daily life as onnagata, and when they did, they were much more subtle. The onnagata lifestyle practice was reduced to wearing a slightly female-styled kimono and maintaining onnagata-like gestures, postures, and to a certain degree, female-like speech patterns.[23]

Transitional Onnagata

During the first period of upheaval in Meiji kabuki, two onnagata managed to maintain the eroticism and daily life practices of the original onnagata gender art. Iwai Hanshirō VIII (1829–1882) and Sawamura Tanosuke III (1845–1878) participated in the experimentation, yet remained devoted to an exclusively onnagata style. Each actor left his unique mark as a *maonnagata*, performing onnagata gender roles exclusively. Together they left a legacy of definitive onnagata performance, preserving their gender ambiguous acts as an art exclusive to the male body in kabuki performance.

Iwai Hanshirō VIII (figure 5.1) was one of Danjūrō IX's constant partners. He was known for his daily life practice as an onnagata, in the style of Ayame I. During a theatre opening ceremony in which Danjūrō IX had everyone in the troupe wear European-style suit coats and pants, Hanshirō VIII wore a suit with his female-styled hair and *bōshi*, which was a symbol of his

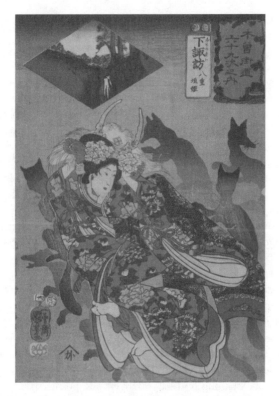

5.1 Iwai Kumesaburō III (Hanshirō VIII) (1829–1882) *himesama* role type Yaegakihime

onnagata art in life: the scarf covering his male shaved forehead. He was famous for his aura of gentleness and grace, both onstage and off. In an article concerning a visit to his home, several actors describe in detail Hanshirō VIII's female-like behavior: his female speech patterns and pitches, his quietness, his precise inclinations of the head, his choice of foot when rising or kneeling, his careful use of the red hems of his underskirts, and his leisure pastimes of playing *shamisen* and sewing kimonos for dolls. Even the decor of his room is described as reflecting his onnagata lifestyle.[24] The public was apparently fascinated by his daily life and his stage performance of onnagata.

Hanshirō VIII was often described as appearing offstage in modified onnagata makeup, wig, and kimono with *furisode* (long, furling sleeves), which were associated with youthful roles and with early kabuki *wakashu*. He was not conventionally pretty, but he knew how to use his onnagata *kata* to build his allure. Being tall, he had to stick out his bottom to look shorter; and having a striking *odeko* (prominent brow), he had to creatively camouflage his brow to look flat. Hanshirō VIII had so mastered his onnagata gender acts that his constructed image tantalized his audience. He was famous for his erotic atmosphere of gender ambiguity, which he created with "his refreshing, dripping with charm stage presence."[25] Several tachiyaku wrote about his sensual appeal on stage. Ichikawa Kodanji VI (1812–1866) remarked that when he first saw Hanshirō VIII in the courtesan role of Izayoi in *Izayoi Seishin* (Izayoi Seishin), running from the prostitute quarters in his under-kimono with a scarf tossed over his head to obscure his role's identity, he was totally swept away by his onnagata acts and wondered, "if someone had let the temple gates ajar and such a beauty could have escaped."[26]

Hanshirō VIII was one of Danjūrō IX's favorite onnagata. They were especially known for the seduction scene between the *himesama* (princess) role of Kumo no Taema and the god–priest role of Narukami in the play *Narukami* (Thunder God).[27] It was reported that when Hanshirō VIII died in 1882, Danjūrō IX would no longer act the role of Narukami because Hanshirō VIII could not play the role of Kumo no Taema. Perhaps a tachiyaku like Danjūrō IX needed Hanshirō VIII as a sensual foil and a malleable partner who would go along with his experimentation while maintaining the traditional onnagata gender acts. Tachiyaku had a great deal of influence over the stage lives of onnagata when they chose them as partners in important plays. However, Hanshirō VIII demonstrates the power of onnagata to construct their gender roles to influence tachiyaku performance styles and their male-likeness.

Onnagata of the Meiji period tended to appear conservative in comparison to their tachiyaku partners. As we have seen, it was the tachiyaku who had the freedom to play with the various layers of gender acts.[28] Tachiyaku and

their playwrights might have inadvertently restricted onnagata experimentation in order to maintain onnagata as the keepers of tradition. Perhaps onnagata, unlike their tachiyaku counterparts, were more reticent about experimenting with Western realism because their gender acts are styled from Edo period conventions. Onnagata gender acts were constructed from kimono and wig styles, certain set and staging devices, props, and musical accompaniment. Beyond appearances, onnagata gender acts construct the onnagata body, its gestures, and any movement patterns. Tachiyaku like Danjūrō IX could cut their hair and perform in Western-style costumes without the risk of losing their gender roles. But onnagata had to maintain the Edo kabuki styles in costuming and behavior because those conventions make up the gender acts, and thus the gender roles, the female-likeness of onnagata performance.

Thus, the challenge that onnagata like Hanshirō VIII faced during the Meiji reforms was that of adapting their gender construction to modern and/or Westernized gender acts. Onnagata gender acts are clearly linked to a particular time and cultural context. Hanshirō VIII, and those who followed, chose to retain the Edo period style, in which onnagata had set the standards and image for female-likeness. While he took part in many plays that involved him in gender role experimentation, Hanshirō VIII managed to preserve his traditional onnagata gender art. In this way, star onnagata were pivotal to the classicalization of kabuki. Subsequent generations of onnagata were to mark these gender acts as a classical tradition, limiting their experimentation with new fashions and styles.[29]

A contemporary of Hanshirō VIII, the eccentric Sawamura Tanosuke III (1845–1878) (figure 5.2), recharged the earlier onnagata idol of *bishōnen* (beautiful boy) female-likeness. Ihara Toshirō views Tanosuke III's onnagata art as the exact opposite of Hanshirō VIII. "Of course, he performed the female-like manners and customs," he writes of Tanosuke III, "but his acts had this male-like charge."[30] While Hanshirō VIII was known for his gentle and retiring beauty, Tanosuke III's art was sensational. His onnagata image was made into a fashion idol, and there was a craze for Tanosuke hairstyles, kimono, and obi. Even his face was used in the popular *ukiyo-e* (floating world picture) prints of female beauties printed in magazines and newspapers. During and even after his death, a courtesan could gain prestige if she was said to resemble Tanosuke III. The onnagata image and its gender ambiguity had entered the mainstream and gradually infiltrated the entire female beauty industry and culture.[31] However, Tanosuke III's glamorous image and stage life was short and tragic. Like a Hollywood star legend, he had a short golden age of fame and affliction.

Tanosuke III's trajectory to stardom began at the age of five, and by the age of sixteen he had reached *tateoyama* (lit. standing onnagata), the highest

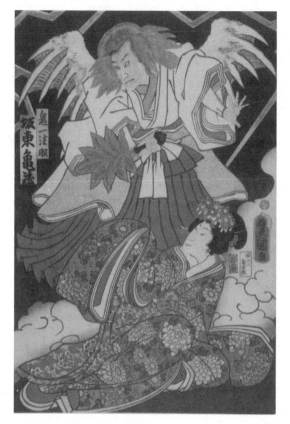

5.2 Sawamura Tanosuke III (1845–1878) *himesama* role type

rank for an onnagata. According to a special edition of *Engekikai* (Theatre World) magazine, Tanosuke III was reviewed as one of the top one hundred kabuki actors:

> His vocal tone was superior; his grieving scenes were so good, their beauty forced one to cry. He excelled in looks, his technique was skillful, and above all else, he had this absolutely intense attitude. He was an onnagata of the modern era, gifted with genius. Many novels came out on his life which went to the uttermost extreme of misfortune.[32]

Tragically, at the age of twenty-one, while playing a character who was tortured while hanging from a pine tree, Tanosuke III fell and injured both his feet and hands. His limbs became infected with gangrene. He had to have both of his feet and then parts of his hands amputated. However,

despite this incredible limitation, Tanosuke III continued acting. He had to be carried on and offstage by assistants, and sometimes he rolled himself in on a small-wheeled cart. He became even more famous for his exquisitely beautiful art of grieving, especially his "wonderful wringing of kimono sleeves."[33] In his *geidan*, Sawamura Gennosuke IV (1859–1936) describes enacting a *kamuro* (courtesan attendant) role in a play with Tanosuke III:

> His right leg had been cut from the thigh down, his left from his knee down, his right hand was cut at the wrist, and on his left hand, except the little finger, four fingers were gone. With both arms hidden inside his sleeves, his figure looked like a doll puppet body, but spectators could not know that he didn't have hands. He used gloves once, but the form was bad, so he stopped doing that.[34]

It seems there were women who would die for him and, according to Kikugorō V's (1844–1903) autobiography, "men would be overcome with grief and burst into tears when they saw Tanosuke perform without feet."[35] His performative beauty after his amputations arose from great pain and an extraordinary effort to overcome physical affliction. His strange intensity continued to draw audiences, and his image and story were further romanticized by the media of the times.[36] Tanosuke III's association with glamor seemed to obfuscate his physical condition and the trauma he must have experienced daily. He died at age thirty-four, supposedly of madness, a short time after retiring from the stage.

Tanosuke III's performance career raises questions about the extremes of onnagata gender art. How did spectators view Tanosuke III's performance, even though he carefully camouflaged the amputations of his body beneath? His image of beauty and glamor obscured a painfully disabled body, but perhaps audiences were drawn to this beauty because of what was hidden underneath.[37] There is a mysteriousness that clings to his name today, perhaps because of his strange "beauty." I suggest that there is a resonance between his onnagata image of glamor and his painfully disabled body beneath, a beauty and pain mystique.

James Brandon commented on Tanosuke III's continuing performance and popularity as somehow "voyeuristic and sensationalized."[38] I agree that there is a continuing fascination with his beauty and his grotesque state. Several articles liken Tanosuke III to a doll or a puppet. In a 1989 article entitled "Kabuki and the Fantastic," Matsuda Osamu describes how Tanosuke III's onnagata art constructed the images that fired the public imagination, gradually making him into a mythic figure. Matsuda also theorizes that Tanosuke III's art was "bathed in moonlight" as an "impossible illusion," which was created in a kind of "kabuki twilight," and that Tanosuke III ultimately "symbolized the death of kabuki."[39]

Tanosuke III revealed another side of the onnagata art: they were bizarre figures who could only exist in a kabuki landscape. Onnagata did not fit into the Westernized world. Tanosuke III performed a kind of "carnivalistic" onnagata, exhibiting:

> the free expression of latent sides of human nature in eccentric conduct, profanations, and carnavalistic misalliances, allowing the combining and uniting of the most disparate and ill-assorted things . . . with the sensuous playing out in the form of life itself, . . . the concept of carnival as a site for the playful exploration and possible challenging of traditional cultural assumptions and roles.[40]

Tanosuke III's performance of onnagata gender acts, created through his enormous physical effort, pain, and artistic skills, etched out a carnivalesque image of female-likeness. His performances pushed his already radically beautiful gender acts beyond the extraordinary, even in the world of kabuki. His fiction of female-likeness entered the realm of the surreal, or antireal, where fantasy may brutalize reality, creating a grotesque beauty.

Tanosuke III's performance after his amputations attests to the unique potential and limitations of onnagata aesthetics and eroticism. His alteration of the onnagata performance image to allow for his amputated hands and feet may seem extreme, but he was not alone. In the next generation of onnagata, Utaemon V suffered from paralysis of the lower body as a result of lead poisoning. He performed only kneeling postures and rechoreographed scenes around his kneeling figure. These performers demonstrate how onnagata gender acts may be reformulated to enhance each actor's body, subsequently changing aesthetic patterns and kinesthetic readings. Such constructed acts of mutant beauty go beyond the representation of women and even traditional onnagata female-likeness into further realms of gender performance and perception.

Onnagata *Geidan*

In his accounts of kabuki onnagata of the 1990s, in *Heisei no Kabuki* (Heisei [1989–] Kabuki) Nohara Akira regards the onnagata who lived through the transformation of kabuki into a form of classical theatre as the models for contemporary onnagata gender acts.[41] Two of these models, Nakamura Utaemon V (1865–1940) and Onoe Baikō VI (1870–1934) negotiated powerfully to reinforce the onnagata art through the sociocultural, political, and economic transformations of the Meiji, Taishō, and early Shōwa periods. Their gender acts were like templates for the preservation of onnagata gender performance. Utaemon V is frequently referred to by

contemporary onnagata, Utaemon VI, Shikan VII, Jakuemon IV, and others as the inspiration for their gender acts.

Utaemon V and Baikō VI represent two distinct onnagata styles: the interior and "naturalistic," and the *kata* (form) or skill-based, respectively. Both performed with tachiyaku of the Meiji period and continued on with the subsequent generation of tachiyaku, including Onoe Kikugorō VI (1885–1949), popularly known as "Rokudaime" (The Sixth). Rokudaime, who played some of the most important onnagata roles, such as Masaoka in *Meiboku Sendai Hagi* (The Disputed Succession), left his mark on many onnagata gender acts with his creativity, changes in formal conventions, and charismatic intensity.[42] Rokudaime reinstated the beauty of the male-like onnagata gender acts and the power of onnagata gender acts as eloquent performative tools for theatrical expression. His bravura style was absorbed by both Utaemon V and Baikō VI, and may be one of the styles most influential for today's young onnagata and tachiyaku. Nakamura Shikan VII was taught directly by Rokudaime and today teaches this tachiyaku's version of many onnagata roles to the young star onnagata.

Also during this period of widespread change, kabuki actors had to come to terms with Western performance strategies and styles. Ibsen's and Chekhov's versions of realism and Stanislavski's methods with psychological realism influenced kabuki onnagata performance. Utaemon V, Baikō VI, and Kikugorō VI invested their own psychological approaches in their roles.[43] Some elements of emotionalism and melodrama found in Western-style acting infiltrated the *kata* systems of gender acts. Life and theatre had altered drastically; onnagata gender acts and role types had been dissembled and fractured by tachiyaku, experimental kabuki, film, foreigners, foreign plays, psychological realism, women performers, human rights, and fashion, to name a few. There was no going back to an Edo style of onnagata because that world no longer existed.

In a sense, Utaemon V and Baikō VI represent a retrenchment and redefinition of onnagata stylization and methodology. They worked to clarify and establish codes and methods for onnagata roles so they could pass on their art to the younger generation of actors and theatregoers. They both wrote their own *geidan* (art discussions) concerning onnagata performance in an effort to preserve the complex onnagata gender stylization practices culled from their predecessors. They rewrote the onnagata art for a contemporary Japan. Selections from these *geidan* illustrate the coalescence of the *kokoro*[44] (heart) and *kata*, which these two onnagata strove to combine in their performance and teaching of onnagata gender acts.

Utaemon V's *Kabuki no Kata* (Kabuki Forms) and Baikō VI's *Onnagata no Geidan* (Onnagata Art Discussions) describe onnagata art in very different ways. Utaemon V's is a step-by-step descriptive analysis of specific roles,

whereas Baikō VI's approach is topical. Both convey a strong sense of the power in the forms, conventions, rules, and styles that should be thoroughly absorbed but not interpreted as rigid doctrines or formulas. Each onnagata's *geidan* reflects the availability of choices and the differences in variable performance conventions. These essays reflect the gender acts of onnagata art as it is practiced by the main lines of onnagata today.

The *geidan* are like encyclopedias of onnagata gender acts, containing the conventions that construct the onnagata gender fictions. Contemporary onnagata, such as Tamasaburō V and Jakuemon IV, refer to these *geidan* when they study a role for which one of these onnagata was famous. The two documents present the exacting artifice of the onnagata art: the strategies, methods, styles, and performance elements, including the possible variations on the prescriptions. As written guides by performers on their performances, the books have a practical immediacy that communicates the *doing* of these gender acts, repeatedly over time, and in the context of other performers, especially tachiyaku.

Utaemon V's Kabuki no Kata

Utaemon V's *Kabuki no Kata* is a description of some of the great onnagata roles he performed. His book is divided into chapters that feature one role in one or more acts. He includes other role *kata*, but he emphasizes the onnagata *kata* and his interpretation of these *kata*. He describes in minute detail the set, costumes, and major characters, and provides a synopsis of the narrative. He then goes through each scene, moment by moment, with dialogue, music, chant, and *shamisen* cues. Between the sound and word texts, he details the gestures and movements and then annotates the whole play with commentary on the performance history. It is also full of lively side comments on the actors he worked with, his encounters and problems with the role, and his opinions of these role types in the context of the world of kabuki characters, providing a sense of actor and role interaction.

In each scene, Utaemon V records the dialogue, lyrics and chanted narration, stage action (including all movement by other actors, stage assistants, and scene changes), *shamisen* signals, and sound effects. Utaemon V describes all gender acts of speech and physical expression as units of action in the overall play formula. The accumulation of detail presents the entire performance as an interactive diagram, with every gender act in its specified space/time unit. The performer following his descriptions literally embodies the acts, which assemble sequentially into a specific gender image or role. When one onnagata learns the kata of a role directly from the body of another onnagata they call this (in Japanized English) a "man-to-man"[45] process. In this "man-to-man" process, the "master" onnagata's physical

characteristics (even their flaws) become forms for voice, movement, or image and gradually solidify into stylized units of meaning in their performed context.

In Utaemon V's *geidan* we find an outstanding example of the stylization process of selecting and shaping actions into performative gender acts, which are then used to construct gender role types. Utaemon V does not "express" female-likeness; rather, he builds an onnagata gender role. First, he explains the performance history of a role and its notable performers; then he describes the play-story context, concluding with the costume, wig, and set requirements. The following is an example of Utaemon V's gender act descriptions as paraphrased from his *geidan*:

> With the *doro* [sharp strumming] sound of the *biwa* [stringed instrument], Yodogimi, with Senhime's *uchikake* [over kimono] held in the left hand, looking back to the left, then, standing up without hesitation, approaches those in the center of the stage, grasping easily the *uchikake* in both hands, she speaks, then suddenly the *biwa* sounds, *doro*, and glares directly front in an *omoiire*, an emotionally charged pause, "I (here, drop the uchikake unconsciously), whatever happens I adore you (take the dagger, stare or glare into space) I worship you, I adore you . . .," moving back two or three steps, forward and back, left and right, running up and pulling back. Pushing back and forth, twist the body around.[46]

This example illustrates the use of costumes in particular ways that have become part of the repertoire of onnagata gender acts. Utaemon V describes in his introduction how he went about researching for the role of Yodogimi, especially the mad scene. He created the Yodogimi acts of madness by referencing the real behavior he observed. He relates how he went to a hospital for the mentally ill and observed their expressive activities. He was particularly impressed by a woman who kept weeping and a girl who kept laughing. From there, he used the onnagata process of stylization to construct madness, like gender, out of specific acts.[47]

In his work with Danjūrō IX, Utaemon V expanded the range of onnagata gender acts to include many new facial expressions. Up to this point, onnagata had used their faces only in transformation roles like *oni* (demon-like spirits) or in scenes of poisoning, self-mutilation, and deformation. In many of his photographs, Utaemon V stands out because of his expressive use of facial movement. This characteristic is also noticeable in the performance videos and photographs of his son Utaemon VI. Subtle but provocative, Utaemon V's use of facial expressions has been gradually assimilated by younger onnagata into the general repertoire of onnagata gender acts.[48]

Utaemon V emphasizes that among all the onnagata roles, Masaoka, a *jidainyōbō* (period wife) role type is the most difficult, requiring

"bone-breaking strength." The character Masaoka is surrounded by ene-
mies and must be totally aware and committed to protecting the prince
"without one moment of loosening the heart."[49] Surely it is "among onna-
gata roles, the heaviest and most burdened." He comments that the charac-
ter Masaoka is referred to as "the manly woman Masaoka" in the lyrics
because, while showing a noble and somewhat tough female-likeness, the
performer must also reveal inner feelings of forgiveness as in the "world's
Mother."[50] He compares the tachiyaku Danjūrō IX and Kikugorō V in
their different approaches to Masaoka. Utaemon V confirms that, for him,
Danjūrō IX's tachiyaku–onnagata gender acts have become the model acts
for his performance of Masaoka.

Utaemon V describes the dual-sided acts of Masaoka in several peak
moments of the *Goten* (palace) scene, also known as "The Killing of
Senmatsu":

> From inside, Senmatsu comes running out, crying "Give me one of those
> sweet cakes," gobbles it down . . . he cries Aaaaaa as he begins to curl up in
> pain . . . Masaoka stands surprised, enfolds the young prince in her *uchikake*
> and unfurls the protective dagger in her left hand, ready. . . . When all have
> finally left, during this time a slow *ton-ton* and *karani* is slowly plucked; just
> before the *hanamichi* [raised ramp-way], on her knees, raises her head slightly,
> falters, falls (sometimes here, there is a happy thought, a strange laugh escapes
> from the tension) . . .; pulling her strength together, looks back again down
> the *hanamichi*, Masaoka looks back to the main stage. . . . Taking the collar of
> the *uchikake* in both hands, the chanter speaks of the sadness, she goes and cov-
> ers the dead body of Senmatsu. . . . Here she changes into a mother and cries.
>
> At this point the character Masaoka re-tells the story of Senmatsu's dying
> and sacrifice for the prince to a rhythmic cutting of *shamisen* chords and
> crying. All action for this changed speech is carefully described. Then the
> chanter repeats the death story of Senmatsu dying for duty which seems to
> double the pain of the moment. Finally Yashiō suddenly returns to catch
> Masaoka, who manages to slash and kill Yashiō. Every gesture of the last pose
> is carefully worked through, standing on the left knee, the right shoulder is
> pulled slightly back, the right hand to the *obi* in back, with the *ki* and *chon*
> sounds Masaoka executes the last moment of still held tension.[51]

Contained energy and absolute control of one's entire being in a beau-
tifully held posture, while the character painfully relinquishes control of the
stage action, requires that the onnagata perform a double-sided role:

> So "the manly woman Masaoka," as it reads in the script, takes enormous
> effort beyond the imagination because it is a role type which requires that
> one shows the chaste and strong woman, and at the same time reveal the
> other half, this beautiful depth of the heart of the world's mother.[52]

Masaoka is distinguished as a pivotal gender role, male-like, female-like, mother-like, and noble warrior-like. It is particularly important that in this transformation period, one of the leading onnagata refers to a tachiyaku for onnagata gender stylization. In the early part of the twentieth century, with the turn away from gender role specialization, it looks like onnagata could have succumbed to what Gunji calls a "tachiyaku take over."[53] However, Utaemon V's position of authority and long career in the kabuki world provided the impetus for his son Utaemon VI, as well as Baikō VI and VII to revive something of the Ayame tradition of *maonnagata* (pure onnagata) sensuality and eroticism.

Contemporary onnagata will never be the same as their Edo period counterparts, but they have reaffirmed the diversity and difference of onnagata gender acts in the twentieth and twenty-first century. Like Utaemon V, who intensified his unique onnagata performance, the subsequent generation advanced and refined the distinction between onnagata and tachiyaku stylized gender performance.[54]

Onoe Baikō VI's Onnagata no Geidan

In contrast to Utaemon V's narrative description of gender acts in role and play context, Onoe Baikō VI's *Onnagata no Geidan* (Onnagata Art Discussions)[55] reads like a dictionary of gender acts. His book is made up of two earlier versions, *Onnagata no Kata* (Onnagata Forms) (pub. 1944) and *Ume no Shitakaze* (Wind Beneath the Plum Tree) (pub. 1930). Both collections emphasize the elements and stylization techniques essential to onnagata gender act performance. *Onnagata no Geidan* is a handbook for onnagata to verify the traditional rendition of gender acts, including the use of props and the patterns of costuming.

Baikō VI's notes also include brief accounts of his own acting career, his recollections of older actor's performances, offstage experiences, and anecdotes. Baikō VI spent his entire life as a *maonnagata* (pure onnagata), playing only onnagata roles. Like Utaemon V's *geidan*, Baikō VI's notes highlight his favorite and famous roles. Because he excelled in some of the wilder ghost and madness roles, there are plentiful and practical notes on the most fabulous onnagata gender acts. For example, he details Oiwa's poisoning transformation and madness in *Yotsuyakaidan* (The Ghost of Yotsuya), Iwafuji's floating over the cherry blossom groves in *Kotsuyose Iwafuji* (Assembling the Bones [skeleton] of Iwafuji), and the claw-shaped hand stylizations for Ibaraki's one real hand in *Ibaraki* (Ibaraki).

On the whole, the *geidan* emphasizes concrete acts that the performer uses to build his roles. Some notes discuss general rules of style, such as weeping and its accompanying gestures, while others describe the actions

of characters in specific scenes. There is a sense of breaking down the acts into their particulars, like acts within the acts. Bandō Tamasaburō V points out that onnagata performance skills depend on the execution of the "fine details" that constitute each gender act. Every kinesthetic, oral, or visual expression has particular requirements and highly refined elements, which require attention and concentration. He refers to Baikō VI's *geidan, Ume no Shitakaze*, as a collection of these details in the context of scenes, characters, physical acts, and speech acts.[56]

Baikō VI also addresses the variability of most major onnagata *kata* and explains the ways an actor creatively assembles them to render his own onnagata Fiction of Woman. He lists the multiple choices for a particular gesture sequence, providing a sense of the dynamic of gender act evolution. He recalls how some forms were changed "by accident," when an actor made a mistake that became the acceptable form. He cites the tachiyaku Danjūrō IX and Kikugorō V in many examples, as well as special changes by onnagata such as Utaemon V. Notes describing the variability of "set" gender acts as they pass from body to body indicate a dynamic of assimilation and translation. The onnagata is not compelled to remain frozen in a conventional mold. At the same time, such augmenting, erasing, and mixing is grounded in *kata*, the basic forms of the onnagata intentional body, which is carefully analyzed in a later chapter.

Baikō VI carefully outlines the use of certain props that are used like extensions of the onnagata gender body. He has several notes on the *kiseru* (long smoking pipe), the long thin pipe used by courtesans; the *tenugui* (a long scarf-like towel); the various types of swords or knives; the *nakigami* (crying paper); and *mochigami* (pad of tissue papers). The later were the papers used by courtesans and geisha for various sensual and practical purposes. The acts connected to these objects are among the many onnagata stylizations that are striking for their particularly crafted and coded presentation. For contemporary onnagata, these imbedded acts are the necessary habits of their gender act art.

Baikō VI's details also demonstrate the exploitation of "variation on a theme" layers in onnagata gender acts. For example, in his note on the *tenugui*, Baikō VI begins with a short story of how a gauze scarf cannot have *iroke*, followed by a short quote by Kikugorō V, emphasizing the connection of the *tenugui* to the body and sensuality. "A *tenugui* half stained and wet, the flowers of the plum."[57] The *tenugui* is associated with emotional expressions, especially those related to love, longing, and erotic desire. He describes roles and their particular *tenugui* styles and expressions, such as the *tenugui* of Izayoi in *Izayoi Seishin*, which is used as a headscarf, to bite, to pull on, and so forth. A section of the famous dance *Musume Dōjōji* is devoted to the various manipulations of the *tenugui*. In his description, Baikō VI is careful to show

how much an onnagata can do with the *tenugui* to express desire and erotic sensuality. He also presents several examples of tachiyaku variations on the use of the *tenugui*, with different types of cloth, patterns, and colors.

Among his numerous notes on roles and role types, the articles of onnagata image-making appear as constant themes. Baikō VI carefully describes the physical manipulations of the body beneath, and then details the exterior—the crafted surfaces of the kimono, *obi, uchikake, eri* (collar), *suso* (skirts and hems), and so forth—detailing the style, pattern, and idiosyncrasies for every role. Several notes cover wigs, their balance, their decorations, and above all, their match to the onnagata's face. *Onnagata no Geidan* also describes makeup styles, as well as types and methods of application, emphasizing the adaptations to personal physiognomy.

Throughout his notes on constructing the image, Baikō VI emphasizes the acts necessary for evoking the sensuality and eroticism connected to the practical acts. Short quips also mention his own secrets for onnagata *onnarashisa* (female-likeness). In "Josei no Nioi" (Fragrance of a Female), he comments:

> In the case of roles which have a male partner, when I am about to go on stage, before I leave the mirror, I will put a little fragrant water on the hems of the kimono, inside the sleeves, on the towel I carry. . . . This is for when the male partner role touches me, so that I communicate something like a female-like smell. . . . for myself I become more Woman, and for my partner more of myself is Woman.[58]

Survival Plots

The Meiji, Taishō, early Shōwa era (1868–1930) transitions in kabuki greatly affected the onnagata lifestyle and the onnagata's erotic and sensual allure, both on and offstage. How and to what degree the erotic allure of onnagata changed is difficult to assess. Critics like Gunji, who have witnessed several generations of onnagata, affirm that onnagata act their *kata* with "too much femininity and lack that *iroke* which goes with the gender ambiguity of earlier kabuki."[59] Their art of gender acts was bound to stylizations such as kimono and wig articulations, which constructed an appearance over the male body beneath. In the craze for the foreign, onnagata may have concluded that their art of stylized gender acts did not fit the Western model of realism, either physically or psychologically. Perhaps the era's onnagata chose a conservative holding pattern to survive modernization and modernity's politics.

After the deaths of the tachiyaku Kikugorō V and Danjūrō IX in 1903, onnagata gained more influence in shaping kabuki. By the end of the Meiji period, with the sweeping criticism of Westernization, coupled with a

strong revival of Japanese traditions with the rise of nationalism, the onnagata secured their permanent place in kabuki. Another effect of rampant Westernization and cultural upheaval was the enshrinement of the Edo period as the last era of the "real" Japan. All the signature elements of kabuki, from the *hanamichi* to the onnagata, became everyday symbols of Edo nostalgic materiality. Ironically, the onnagata became more "Japanese" and more "traditional" by association with the Edo period image of constructed female gender roles. Today, the onnagata stands out as a major representation of the nationalist retrenchment of "traditional" Japan: kabuki is considered a living icon, a "national treasure," saturated with longing for a fictionalized past.

Nevertheless, contemporary onnagata continue the dynamic process of engaging performer body beneath with stylized star acts, passed on from "man to man."[60] In postwar (1945–1970) kabuki, onnagata like Utaemon VI and Baikō VII, followed by Shikan VII, and Jakuemon IV, have all striven to maintain onnagata gender role specialization. Jakuemon IV, Ganjirō III, and Tamasaburō V experimented both inside and outside kabuki, pushing the boundaries of onnagata gender art into the media of film and experimental performance. In the last two decades, Tamasaburō V has collaborated with several Western directors creating onnagata-styled Western female roles. Tachiyaku like Ennosuke III and Nakamura Kankurō V (1955–), who have also acted and/or directed outside kabuki, carry on their influential shaping of onnagata roles, furthering gender ambiguity.

The current generation of *hanagata* (young star) onnagata, such as Nakamura Tokizō V (1955–) and Nakamura Fukusuke IX (1960–), and younger onnagata like the grandson of Baikō VII, Onoe Kikunosuke V (1977–) live with the same onnagata themes: their *otokoppoi* (masculine) or *onnappoi* (feminine) images, whether to remain a specialist or to branch out into tachiyaku roles. As Tanosuke VI reiterates, "Onnagata, like *iroke*, is not one thing that you point out and say there it is; it happens on stage, it is something you do, like the shape of your lips."[61] Tamasaburō V states simply, "to perform a man performing onnagata, that is what makes onnagata."[62]

CHAPTER 6

THE AESTHETICS OF FEMALE-LIKENESS

Erotic Abstraction, Attraction, and Aversion

Certain aesthetic principles form the basis for the special *miryoku* (fascination) and beauty of onnagata gender acts. The major onnagata aesthetic principles are *yōshikibi*, the beauty of stylization; *uso*, the fiction or lie; *aimai*, ambiguity and transformativity; *iroke*, eroticism and sensuality; *zankoku*, torture; and *kanashimi*, deepening sorrow. *Yōshiki* (stylization), or the controlled design of all performance elements, is the fundamental strategy that governs the aesthetic canons for onnagata gender performance. Onnagata are aware of these principles and use them strategically to build a role's central motif.

The aesthetic elements fundamental to the *onnagata no bi* (beauty of the onnagata) are complex and best illustrated in specific performance contexts. Aesthetic principles signal the workings of a hegemony and force certain questions to arise: how did/do certain gender acts get configured to produce a particular aesthetic? Have onnagata, through their performance of onnagata gender acts, created their own subversive aesthetics? Which aesthetics have become thematic to all onnagata gender roles? Which aesthetic elements permeate all onnagata gender acts?[1] What or who do these aesthetic choices serve? The interdependence of onnagata aesthetics and onnagata gender acts reveals an underlying ideology that links violence and sensuality, sorrow and beauty to a female-like appearance. Further, the dominant thematic of gender *aimai*, that is, ambiguity and transformativity, destabilizes any set "gender identity."

Onnagata perform their gender roles by intersecting their male bodies with their stylized onnagata acts, producing an unstable composite: a hybrid gender role. An analysis of the performance techniques that constitute the gender acts reveals the physical framework of the kabuki fiction of

female-likeness. The examples, chosen by onnagata, illustrate the performative moments that best convey the *kankaku* (sensual perception) of onnagata gender performance.

Designing Beauty and Charm

Kabuki no bigaku, the study of kabuki beauty, or aesthetics of kabuki, revolves around an art of stylization that is at once flamboyant and wildly sensual, as well as subtly "natural" and painstakingly controlled. In kabuki, every element of performance must appear beautiful. As Baikō VII commented, "No matter what, in every action, an onnagata must show beauty."[2] To accomplish this, an onnagata performs within a completely stylized system of physical and vocal acts. Thus, even the most mundane tasks, like arranging sandals at the doorway, opening a sliding door, lighting a pipe, or placing a pillow, are stylized in space and time according to aesthetic codes.

The kabuki system of stylization applies to all onnagata gender acts. Onnagata articulate costuming, makeup, music, movement, song, dialogue, or narration to achieve beauty of presentation. Even emotions are shaped into aesthetic forms through stylized gestures, poses, and patterns of music, sounds, and vocalization. There are degrees of fervor and types of stylization appropriate to a role's rank, age, and circumstances, as well as rules for role type categories, or *yakugara*. Above all, stylization through abstraction, elongation, diminution, repetition, or exaggeration, highlights form over content and meaning.[3] For example, however evil, reviling, or disgusting a crime committed by a character, the performer makes that act beautiful through the particular stylization system of the kabuki stage. In a discussion of a violent scene, Brandon pinpoints the aim of kabuki's art of stylization, ". . . to create a sense of beauty irrespective of subject matter. The extended murder scenes . . . may seem sordidly real, but in performance they are eerily beautiful. Delicately lyric music accompanies actions that are executed in artfully choreographed dance patterns."[4]

Gunji Masakatsu suggests in his book, *Kabuki no Bigaku* (Kabuki Aesthetics), that the aesthetics of kabuki are very mixed and not easily classified. Because kabuki is considered a classic and traditional form of theatre today does not mean kabuki aesthetics are related to other classic theatres like nō, which emphasizes refined and subtle aesthetics. In fact, kabuki aesthetics have little in common with theatre forms created before kabuki. Kabuki evolved from the sensual and sexual entertainments of the lower classes, erotic attractions of the human body, brutality, and a fascination with pain and evil.[5] For Gunji, kabuki aesthetics have much more in common with contemporary avant-garde and experimental art and theatre.

According to Gunji, kabuki had to invent its own set of aesthetics that we see only remnants of today. Gunji attests that in early kabuki there was a darker side, a negative vein, which produced an "abnormal energy for momentary entertainment pleasure."[6] He finds it unusual that such an entertainment would flourish in an isolated and conservative feudal period, but affirms that the merchant class society flew in the face of imposed Confucianism. "Among the Edo arts, it is easy to say that kabuki is a phenomena of which you see no other, to the extent of its invigorating gorgeousness with its wild beauty and irresistible entertainment qualities."[7]

He feels that even now, ". . . in front of contemporary intellectuals it's better not to bring up kabuki's aesthetics, like the art of pleasurable [sensual] entertainment, the art of madness, the art of the common and vulgar, or even stylization and grotesque beauty."[8] The lack of critique of kabuki's special performative elements in intellectual circles is partially due to their focus on text-centered art and aesthetics. Onnagata performance aesthetics may reflect some of the older and suppressed characteristics of kabuki aesthetics, in particular, eroticism and violence.[9] Onnagata aesthetics reveal the politics of stylization: all gestures or full body movements are contained and small. The onnagata must suppress his energy to be "beautiful." Only in exceptional circumstances, such as when the female-like figure transforms into a demon or witch (when he is abject), can he exhibit direct and forceful energy and desire. The underlying question surfaces: no matter how "beautiful" the onnagata appear, what or who do the onnagata aesthetics serve? While there is not a simple answer, the process of controlling onnagata through stylization hints at how kabuki aesthetics re-form fears and desires concerning female-likeness.

Stylization: *Yōshikibi*

Stylization is a process whereby something is separated from the representation of the real through various techniques such as exaggeration, diminution, repetition, refinement, abstraction, or fragmentation. For example, crying or weeping may become abstracted to the quiet lifting of a white paper to the eye. Or wailing may be exaggerated by an onnagata to the extent of biting, wrenching, and pulling a *tenugui* (towel) or his inner kimono sleeve. Stylization can be extended to all visual, aural, and movement acts. Bandō Tamasaburō V sums up the aesthetics of onnagata gender performance as *yōshikibi*, or the aesthetics of stylized form. He refers to the system of *kata* for each role type, and every role in a given scene, as governed by the principle of *yōshikibi*. The onnagata must perfect the details of different types of stylization in order to perfect the exact nuance of each *kata*.

Performing stylized acts requires constant and careful attention to individual elements rather than to an overall form. The fold of the hem, the curve of kimono collar at the *eriashi* (back nape of the neck), the lifted pause in the middle of a bow, the changes of the pitch and tone of the voice for beginning and ending a request or a question, the pale pink coloring below two layers of white makeup, the drape of the long and luxurious *furisode* (furling kimono sleeves), the edge of the brilliant red collar fold against the marble white neck of the *oiran*, and the wandering wisps of *midaregami* (disordered hairs) at the sides of the wig that signify being distraught over love are a few of the distinct elements that coalesce into a total aesthetic form.

Tamasaburō V calls these, "*komakai diteeru*,"[10] (fine details), essential to performing an onnagata gender role. Here, Tamasaburō V is not only speaking of the specified gestures, timing, and speech patterns, but also of nuances that an onnagata must learn to fill out or complete the *kata*. For example, the shading of a line of dialogue, the matching diagonal lines of three kimono hems, the slight stressing of a vowel, the tilting of the neck, the lengthening of a tone, and the pulling on the outer edge of a sleeve are the refinements of the stylized details that an onnagata may use to intensify his performance. Tamasaburō V plays with these details until they vibrate with the life of the role type. When an onnagata performs his *kata* with such detailed refinement, he is said to *kurosu uppu suru* (make a "close-up").[11] That is, he rivets the audience's attention, making their focus zoom in like a camera and take a close-up picture of his *kata*.

The Aesthetic of the "Lie": *Uso*

Ichikawa Ennosuke III feels that, "In the West, everyone wants to see everything directly as it is, right in front of the eyes . . . hugs, kisses, and blood. Right away, right on the surface."[12] Kabuki, on the other hand, is aimed at hints and persuasive suggestions that fire the imagination about dramatic acts, but are not the acts themselves. He feels that many differences in sensuality are based on the fact that the traditional European stage was a place for dramatizing reality, while kabuki is a place for the *uso*, or "lie."[13] In kabuki, nothing should be represented in the way we would actually do it or see it. Rather, *reality* is meant to be imagined, and the actor's art is to suggest a *kabuki real*[14] experience. The methods used to suggest this version of realism have become incorporated into the stylization methods of kabuki.

Onnagata performers also refer to their gender acts as *uso*, a deliberate fantasy that goes beyond the truth.[15] The *kata* used to enact specific onnagata roles may be read like codes that produce the *uso*. The *uso* is re-created by the spectators, who have learned to read and react to certain *kata* of voice, movement, posture, costume, color, lyric, dialogue, or musical

accompaniment that are marked as having specific meanings. For example, when spectators see the *kata* for the *himesama* (princess) role type, they see the *uso* of the *himesama*. Or, if they hear and see the sequence of lyric and gesture *kata* for longing for a lover, they will see and feel the *uso* of eroticism and sadness.

Bandō Tamasaburō V refers to this *uso* of the stage as what makes onnagata performance possible.[16] Produced by skillful and painstaking articulation of surface appearances, onnagata aim beyond reality to create a vivid illusion of sensuality. However, these patterns are multilayered with cultural nuances that sometimes suggest, obscure, and/or diffuse, rendering ambiguous the sensual reading of the actor's body. While any audience member or actor is free to interpret the acts with their own sensual and sexual desires, the onnagata articulates his surface appearances according to strict *kata* forms that aim at a very "real" *uso*. Coupled with his surface *uso*, the onnagata performs his male body beneath as another layer of real "illusion,"[17] which is incorporated into the onnagata *uso*.

Ambiguity and Transformativity: *Aimai*

Ambiguity and transformativity are two complementary qualities central to onnagata gender performance. Ambiguity relates to the variability of onnagata gender acts and their sometimes vague, uncertain, or obscure readings. Transformativity has to do with how onnagata play with the ambiguity of their gender acts in order to alter their apparent gender roles. Onnagata present an ambiguous kinesthetic and visual appearance of female-likeness that does not coalesce or unify, instead maintains the dynamic distinction between the performer's physical body and his performed gender acts.

Several onnagata emphasized that the *aimai* quality or feeling was an important dimension of onnagata performance, a part of its *miryoku*, that is, its charm and fascination.[18] I have suggested that a fundamental reason for this is that the onnagata has a male body beneath the onnagata gender role he enacts onstage. This sets up the potential for instability and thus, gender ambiguity and transformativity. At times, an onnagata may appear very female-like. At another glance, he may appear slightly male-like, or adolescent-like, or boy-girl-like, or even posthuman, beyond the binary of female and male.[19]

Contemporary onnagata emphasize that the quality of female-likeness is basic to every role, but that this quality is ambiguous and transformative. Contemporary onnagata even use the term *aimai* to describe the gender of their stage roles.[20] *Aimai* may mean uncertain, ambiguous, or indirect. Onnagata use *aimai* when speaking of the degree to which they show

onnarashisa, female-likeness, in their female gender roles. They all strive for some degree of *aimai*, but their shading of *aimai* appears to be a personal choice. It is this shifting, indeterminate quality that is considered part of the charm and sensual allure of onnagata performance as well as a measurement of their performance skills.[21]

To demonstrate ambiguity and transformativity in action, I discuss the relationship of the two to onnagata gender performance. Following this, I examine how gender ambiguity and transformativity work in the construction of the onnagata *kihon* (basic) gender acts, and what I call the "intentional body,"[22] which is the ideal body that onnagata strive to perform. To illustrate how the onnagata uses *kihon* and the intentional body to produce an ambiguous and transformative performance, I analyze the costuming gender acts in the onnagata role of Agemaki the *oiran*, or top-ranking courtesan in the play, *Sukeroku*. In chapter 8 of this book, I detail how onnagata create their gender role types by using and adapting the basic gender acts and the intentional body.

As discussed earlier, gender acts arise from culturally and historically specific prescriptions, which designate certain acts to belong to certain gender roles. To know what a culture considers masculine or male-like, feminine or female-like, girlish or boyish, or ambiguous requires an understanding of how gender works in that culture's political and social hegemonic structures as well as their gender hierarchies. Contemporary kabuki, as a "classic" performance culture, has its own prescriptions and aesthetic patterns for masculine, feminine, and "other" characteristics and male, female, and "other" role types. To examine ambiguity in onnagata gender performance, it is best to focus on how onnagata gender acts transform onnagata bodies into an approximation of a model of kabuki female-likeness, which has a wide range of readings even within the kabuki culture. The *kata* themselves have built-in variability. An onnagata can "shade" his gender acts with *onnappoi* (feminine) or *otokoppoi* (masculine) elements. An onnagata may subtly shade his acts and create an *aimai* (ambiguous) version. As a result, the meaning of a *kata* may be somewhat ambiguous. Onnagata comment that the feeling of *aimai* compliments the erotic and sensual appeal of their gender acts.[23]

Certain elements specific to kabuki performance culture contribute significantly to the ambiguity and transformativity of onnagata gender acts. (1) The kimono itself, and the *obi*, worn by men, women, and children alike, have characteristics of design that make the differences between sexed bodies less apparent. The kimono becomes the surface body. (2) The ongoing influence of the adolescent beautiful boy body, which is the basis for onnagata gender acts, has made the gender-ambiguous body the ideal body for the kabuki generated female-likeness.[24]

First, the kimono is a robe-like garment that flows from the shoulders to the feet. It covers the whole body and has wide, loose fitting sleeves. It has a geometric design, with the sleeves and two body panels of the same width, based on loom size. Before it is wrapped, it falls in four panels across the body. Wrapped or unwrapped, the kimono does not reveal the shape of the body underneath; rather, it lends a certain shape to the body. In some roles, the kimono literally designs the body and becomes the body. As Ruth Shaver notes about the design of the kimono in kabuki:

> The actors for both male and female roles, are padded at the midriff in order to make the kimono look straight up and down, eliminating the curves of the body. The Japanese have always looked at the straight figure as the epitome of beauty.[25]

Other reasons for the padding are practical. The padding keeps the *obi* from riding up from the hips. But I believe that the "straight" figure to which Shaver refers reflects the aesthetic of the early kabuki *wakashu* onnagata. I think the *wakashu* adolescent boy body had a great deal of influence on the cultural aesthetic of the "straight" figure. Top kabuki costumers pride themselves on how well they can "straighten out" the "problem" figures of their onnagata with padding and wrapping techniques. At a kimono wrapping demonstration, a kabuki dresser showed the many ways he achieves the perfect straight line for the ideal onnagata, no matter what kind of body is beneath.[26] When padded and wrapped in a kimono, male and female bodies exhibit less distinguishable sex differences and appear similar in shape.

Identifiable male and female stylizations are added to the basic kimono. Yet the kimono can be a less gender-specific garment than the pants, dress, and skirt of Western European and North American cultures.[27] Certain kimono characteristics, like the style of wrapping, sleeve shapes and lengths, and color and design motifs, may well be associated with a specific gender category.[28] However, these kimono stylizations are easily adapted to different gender roles. For example, the kimono collar opening at the front and back is adjustable, as is the wrapping and opening of the kimono around the legs. A *musume* (young girl) role, and a *wakashu* (young boy) role, may have similar collars, which are pulled down in the back and sleeves that are long and fluttering. The male gender role type called *nimaime* (male lover role), usually a handsome young romantic role, may wear his kimono skirts wrapped in the onnagata style of pulling the kimono more tightly around the legs.[29]

Because the kimono lends itself so readily to transformations through changes in color, fabric, and styles of wrapping,[30] it is an ideal tool for performative gender transformation and ambiguity. Liza Dalby notes this aspect of stylization in her historical study of kimono fashion, particularly

in the era starting with the Genroku period (1688–1704) when *wakashu* were the arbiters of kimono styles. In her research of Edo woodblock prints, Dalby repeatedly draws attention to the kimono:

> A figure wearing a sword can be definitively tagged as male, and there is no doubt in the explicitly erotic prints as to who is what, but that still leaves a large crowd of Genroku figures of mercurial gender who are not easily identified at a glance. Ambiguous men and women can be distinguished by painstaking knowledge of the context of a particular work, but the idea that such a basic attribute as sex should require such an effort to discern points to a fascinating facet of Genroku culture—the mixing of male and female in the world of fashion.[31]

Dalby discusses the *wakashu* art and their fashionable trend-setting for kimono and *obi* design. As an example, she points out the *odoriko* (female child dancer) and *wakashu jorō* (*wakashu* female prostitute), who were young women entertainers and prostitutes who specialized in imitating *wakashu* styles of kimono, wigs, and dances.[32]

A contemporary example of kabuki kimono and gender transformativity may be seen in the performance of the male character Benten Kozō, in the famous disclosure and strip sequence from *Benten Kozō* (Benten Kozō). The male actor plays Benten Kozō, the male character who has disguised himself as a *machimusume* (city girl), an onnagata gender role type. When Benten Kozō, in his disguise of *machimusume* kimono and wig, is discovered to be a thief in disguise, he brashly rearranges his kimono by rewrapping it to reveal his male character. The actor deftly transforms his *machimusume*-styled kimono into that of his other gender role—a lower-class, adult male thief. To transform the gender role before the eyes of an audience, the performer does not have to change to a new kimono. Rather, he begins by rewrapping the onnagata-styled kimono into the appropriate tachiyaku style.[33] While there are many other gender acts he adds to this scene, like kicking out his legs and assuming a cross-legged male gender role pose, or winging out his elbows and showing off his tattoos by slipping off one side of the kimono, the first change is the rewrapping of the kimono. The actor uses the kimono gender acts to "dismantle" one gender for another, yet maintaining the lingering sense of the "other" gender. This is an outstanding example of the kimono's role in producing ambiguous and transformative gender roles.

The Beautiful Boy: *Bishōnen*

In Edo period society, as mentioned in chapter 3 of this book, the popularity of male love practices and the beautiful boy aesthetic may have contributed

to the gender transformativity of onnagata performance. The beauty and sensuality of the *wakashu*, the *iroko* (boy prostitute performers), and the practice of *shudō* (boy love) firmly established the adolescent boy physical attributes as central to aesthetic performance practices. Subsequently, boy beauty was modeled by both men and women, particularly onnagata, who trained in the *iroko* tradition, exploiting the adaptability and transformativity of the gender acts of boy beauty in almost every role type. I do not equate the onnagata aesthetics of boy beauty and gender ambiguity and complexity with the Western idea of androgyny as a mixture of two opposite genders.[34]

In the world of entertainers in the various licensed quarters, gender ambiguity might have evolved from their shared performance styles, fashions, and even shared patrons' tastes. Women, men, and boy prostitutes rivaled and assimilated each other's gender acts. Within the women's licensed quarters, such as the Yoshiwara in Edo, male performers were employed as male entertainers, known as *otoko no geisha* (male geisha), *hōkan* (jesters), or *taikomochi* (drummers), who "often performed bawdy dances or stripteases for customers in the courtesan brothels."[35] Apparently non-kabuki boy prostitute entertainers were also trained and "encouraged to live as women, rooming and bathing separately from male-role actors [not kabuki] and observing female etiquette in their speech and table manners. They were even expected to squat while urinating."[36] Some girl and women prostitutes, referred to as *wakashu jorō* (*wakashu* female prostitutes), were known for shaving their forelocks and dressing like men. Other women entertainers, called *kagema onna* (lit. boy prostitute woman) the equivalent of a "female onnagata," danced in male-styled kimonos, wore swords, and imitated the speech patterns of men.[37]

Gary P. Leupp, in his study of male sexualities during the Edo period, suggests that, ". . . in requiring the female-role specialist to shave his forehead, the shogunate inadvertently produced an even more ambiguous sexual object."[38] Leupp emphasizes the fascination that both men and women in popular culture had for the onnagata, for *wakashu*, and for what he calls the "mannish female prostitute."[39] He suggests that the gender ambiguity of all three reflects a general lack of rigidity in gender roles and a flux in sexualities in the growing urban Edo world. Not everyone freely practiced gender ambiguity or wanted to. But the general population did have a fascination for the ambiguity of appearances of entertainers who could be cultural outlaws because they were outside the rigid caste system.

Onnagata gender acts, created and played by the male body, arose from techniques that were highly transformable; the acts could change, their meanings blur, and their new forms take on different meanings. As I suggested in chapter 3, the government may have encouraged gender variability

and ambiguity through its many prohibitions on performers. Under constant surveillance, performers were compelled to revise their gender acts. For example, the *wakashu* forelock became a long fluttering scarf, and then a glossy cap with ties and loops, which finally evolved into extravagantly designed wigs. Star onnagata, like Nakamura Tomijūrō I (1719–1786), created elaborate transformation dances that played upon gender acts within gender acts, mixing role types and nonhuman roles.[40] Ultimately, I think that the transformativity of gender acts was essential to the onnagata's image of gender ambiguity and its erotic allure.

The gender ambiguity of the Edo period onnagata performance resembles the play of gender described by Peter Stallybass and Ann RosalindJones in their study of the Renaissance hermaphrodite:

> The problem with most existing attempts to understand this ambivalence is that they assume *either* the fixity of a binary logic *or* its dissolution. . . . For if the Renaissance hermaphrodite suggests that categorical fixity is inevitably unstable (the tyrant turns into a woman, the serpent changes sexes, the actor is both boy and woman), he/she equally embodies the fact that there was no absolute categorical fixity to begin with. . . . What is most striking of all is the extent to which gender is never *grounded*: there is no master discourse which is called upon to fix the essence of gender.[41]

In the same vein, onnagata gender acts are not "grounded" and resist fixed categories. Moreover, I do not think that onnagata perform an "other" gender that somehow coexists with the conventional, binary categories of male and female. Onnagata do not shape their acts into a gender identity at all, nor do the role types appear to be fixed gender identities. Their acts have characteristics that expand and open to multiple and variable interpretations.

Eroticism and Allure: *Iroke*

Eroticism is a culturally specific and learned perception involving our kinesthetic, aural, and visual sensory receptors. Each culture has certain objects, sounds, and senses that arouse one's erotic feelings. For example, the back neckline of the onnagata has been designated a visual area of erotic allure. When eroticized objects excite sensual and sexual feelings, they may also stimulate imaginary or remembered images and feelings of sensual pleasure. Thus, eroticism is a powerful tool. To make some thing or some action erotic is to endow it with the power to draw a spectator's attention and to direct their sensual response. It follows that onnagata would want to designate certain gender acts as erotic and use these to create an erotic aesthetic particular to their performative female-likeness. *Iroke*, or erotic allure,

is sometimes referred to as "patterns" of *iroke* and sometimes as "moments" of *iroke*.

Erotic allure may or may not be conditioned by a heterosexual and binary gender system. In the case of the onnagata, their erotic points of attraction and erotic aesthetics may have originated in the *wakashu* system of erotic codes with its own boy/man erotic points and gender ambiguity. In the case of the onnagata, some erotic points may seem very strange and exotic because the cultural references are unknown and unfamiliar. It is important to emphasize that the *wakashu* art was first and foremost a danced seduction. Gestures, postures, costuming, vocal articulation, props: everything was an "erotic" act. Only after narrative plays, role types, and abstract dances entered the kabuki repertory did the onnagata art alter those first beautiful boy gender acts to suit different theatrical purposes.

David M. Halperin suggests in his essay "Historicizing the Sexual Body":

> Bodies do not come with ready-made sexualities. Bodies are not even attracted to other bodies. It is human subjects, rather, who are attracted to various objects, including bodies, and the features of bodies that render them desirable to human subjects are contingent upon the cultural codes, the social conventions, and the political institutions that structure and inform human subjectivity itself, thereby shaping our individual erotic ideals and defining the scope of what we find attractive.[42]

Ennosuke III, a tachiyaku who plays both female and male gender roles and has worked with Western performers touring and teaching abroad, emphasized during an interview that sensuality and the stage methods used to communicate sensual perception are different in different cultures.[43] *Kankaku* (sensual perceptions) are different in every culture because they are learned responses based on shared body reference patterns peculiar to one culture. Of course some responses are similar, like our response to heat or cold, but responses to erotic sensuality may be very different because of specific cultural prescriptions and prohibitions. Examples of erotic sensual acts that are specific to kabuki culture are: the *yūjo*'s folded kimono collar that presses the red inner kimono against a stark white neck of the onnagata; the kimono collar scooped low in the back; the back hairlines, which onnagata leave outlined in white down the back of the neck; the layers of kimono and puffy rolled hems; and the slick molded mounds of black hair. Onnagata, with their male bodies beneath, invented their own sensually revealing acts that do not require baring flesh as in most Western female erotic displays that feature the low-cut front bodice and fleshy cleavage.

Onnagata *iroke* (erotic allure) has been created by designating certain performative features as attractive within the kabuki multiple gender

system. The onnagata *iroke* differs from other gender role *iroke* by virtue of a different consciousness of "being looked at." Gunji Masakatsu calls it a kind of "filter":

> It could be said that there is another layer, a powerful filter which, because of the conscious strength of concentration of a consciousness of being looked at, Onnagata differ from other *yakugara* [gender role type]. . . . It should not be mistaken that the terrible adherence of onnagata to *iroke* is one of kabuki's most important secrets of beauty.[44]

Gunji goes on to say that there is nothing natural about the eroticism of onnagata. On the contrary, if onnagata depended on the natural, or in his words, "the raw material of the body,"[45] the onnagata art would be extinct. In a somewhat macabre explanation, he describes how the beauty of onnagata borrows the flesh or spirit of a male being. It follows that, "having killed the existence of a male, onnagata *iroke* gives birth to a gloomy, cold shadow."[46]

Gunji's explanation may seem extreme, but there is something about the eroticism of onnagata gender performance that is mysterious and indefinable. The shadowy side of *iroke* is particularly notable in certain roles played by certain onnagata. For example, Tamasaburō V uses some of that dark *iroke* in the princess role of Sakurahime in the scenes from *Sakurahime*, when the downtrodden princess role must fight off the attack of a lascivious priest character. In another scene, in the role of the destitute princess, Tamasaburō V plays between princess and prostitute roles to murder a lover and villain character. There are also moments in Ganjirō III's performance of the *yūjo* role of Ohatsu, inside the brothel in *Sonezaki Shinjū* (Love Suicides at Sonezaki), when the actor reveals a darker *iroke* quality. Early in his career, Utaemon VI's portrayal of the gorgeous *oiran* role, Yatsuhashi of *Kagotsurube* (Kagotsurube—the name of a famous sword), hinted at this darker *iroke* in his portrayal of Yatsuhashi's rejection of a suitor and Yatsuhashi's murder scene.

But not all onnagata share Gunji's concept of *karada o korosu* (killing the body) to achieve sensual allure in performance. Tamasaburō V, who has read Gunji's books and enjoys his dramaturgy, disagrees with the gloomy perception. Rather, he feels that there are many shades of *iroke*. He offered several of the erotic acts of the *oiran*, Agemaki in *Sukeroku* as examples. For instance, he feels the *dōchū* (courtesan parade) entrance scene on the *hanamichi*, and a later scene where Agemaki protects the drenched lover, Sukeroku, are examples of substantially bright, non-gloomy onnagata *iroke*.[47] I find the divergent theories of onnagata *iroke* further evidence of the variability of gender acts in kabuki.

The beauty of eroticism in kabuki, *iroke no bi*, resides in the performer's skill in subtly shading, altering, and manipulating those gender acts

specifically stylized for *iroke*.[48] For example, an onnagata may arouse an erotic response when he bows and reveals his scooped white back neckline. In certain positions, if he chooses to bow very deeply, he may reveal a slender line of his own hairline and his unwhitened skin. Spectators may perceive a shift in their attraction, because they see the male actor body with the *kata* of the onnagata female-likeness. I think that in the process of seeing and perceiving the onnagata *kata* of female-likeness and the onnagata male body beneath, the perceiver's sensual pleasure gains a certain complexity and depth. In this way, onnagata can perform in a field of multiple and changing sensual attractions and perceptions that are not limited to an oppositional male-to-female, or vice versa, attraction and response.

In reference to the play of eroticism in onnagata gender acts, Onoe Kikugorō VII (1942–) cites the example of his disrobing in the Hamamatsuya scene in *Benten Kozō*. This is the same scene I referred to earlier as an example of the transformativity of gender acts. In this scene, Kikugorō VII is playing a tachiyaku role that is a thief disguised as a *machimusume* (city girl) role type. Kikugorō VII describes the moment when his *machimusume* role-as-disguise is revealed:

> When I remove the female styled kimono, and show my tattooed chest and shoulder, I keep one shoulder still covered with the *musume* kimono. Even though I pull up my legs like a man, I keep my *musume* wig in place. I love the surprise of the audience: first they see me as an onnagata in a female role, then they see a male thief role, but, with my wig and kimono still in place, there is something left of onnagata and *musume*.[49]

Onnagata in such gender roles and transformative acts appear to disrupt a binary system of sensual attraction. Ever since the *wakashu* bans and conversions in the late seventeenth century, onnagata performance has continued the play of various role types in dramatic and dance roles, which have multiple, shifting genders.[50] My focus in this study is on the possibility of disengaging the tenacity of bipolar attraction, and thereby releasing spectator and performer from the restrictions of polarized gender sensuality and eroticism.

Onnagata aesthetics, especially *iroke*, arise from the stylized performance of onnagata gender acts. Onstage an onnagata may create a unified image of the fiction of female-likeness, or he may perform his gender acts in such a way as to fracture the fictional unity of a single sex, gender, and sexuality paradigm into multiple and ambiguous variations. The moments of fracturing and ambiguity occur where the kinesthetic expression created by the performer of gender acts intersects with the spectators' kinesthetic perceptions and interpretations of the gender acts. Spectators can absorb the variations

of genders and freely imagine the various gender possibilities. For example, if spectators decide to imagine the male body beneath as a princess, their physical empathy will likely shift their reading of the performance. From the beginning, onnagata have exploited this ambiguity of gender and role type. The earliest *hengemono* (transformation) dance works, such as *Musume Dōjōji* and its many variations, initiated by star onnagata, and later works such as *Osome Hisamatsu* (Osome Hisamatsu), have continued to evolve and attract attention because of their variable and ambiguous gender acts and role types.

Further, throughout kabuki performance, dramatic conventions remind the spectators that they are, indeed, watching a male actor. Among these conventions is the *kakegoe* (calling voice): when the actor's name or family name is called out, or when the performers themselves say that the character "looks like the famous actor Kikugorō VII." The spectators may also examine the playbill or program, which features the performers' photographs without makeup. The male body beneath illumines and "ghosts" his onnagata gender acts, whether dark or light, even in the mind's eye of the spectators, where it remixes with their individual visions and desires.

The vitality of this interaction among performer body, role body, viewer body, mixed identities, and sexualities seems to be central to the way these aesthetic moments work as sensory experiences. The kinesthetic contact with the live performer clearly provokes a viewer's personal response, which is culturally programmed, to the gender acts of onnagata performance. It seems inherent in the creation of onnagata gender acts and roles that the fiction generates the ambiguity that gives rise to confusion, surprise, and/or excitement. Later in this chapter, I describe onnagata acts within dramatic scenes to give the reader a sense of the physical sensations they communicate.

Iroke involves far more than the actions of the onnagata performer. Onnagata perform their *iroke* patterns within a context of music, lyric, and dialogue. A song, a spoken phrase, or a melodic line may overlay the sequence of an onnagata manipulating erotic patterns to present a provocative image. Through its imagery or associations, the musical and verbal overlay may intensify the feeling but deliberately obscure the direct sensual meaning. Suggestion and abstraction are important in execution. Rather than a direct one-to-one meaning, the performative layers of gesture, lyric, sound, and visual cues hint at several meanings, situations, or feelings.

Onnagata *iroke* involves ambiguity created through stylized abstraction. As discussed earlier, ambiguity allows for several possibilities that may be shaped within a range by the actor. For example, an onnagata in a love scene may extend a pose or line of dialogue to color the *iroke* pattern with a shading of a feeling of despair, or sadness, or hint of anger. Onnagata may also

add *iro* (sensual coloring) to a gesture that is not necessarily a part of an *iroke* pattern, like a weeping gesture.

The phrase onnagata often use, *iroke o dasu* (lit. putting out *iroke*, radiating erotic allure) means to attract those watching. Jakuemon IV and other onnagata commented that moments of sensual coloring, or *iro*, have a "drawing in sensation."[51] They feel they actually draw away or close in, intending to pull the eye of the spectators to them.[52] The onnagata acts that arouse and display *iroke* are designed to draw attention in this manner, rather than to display themselves provocatively to the spectators. Even in a courtesan role, the onnagata does not flash his bare ankles, but instead covers them with thick white powder. The black lacquered surface of their high *geta* (tall wooden clogs) highlight that whiteness. In a play like *Sukeroku*, the onnagata in the Agemaki role reveals his feet, but only momentarily, beneath the mounds of heavy kimono layers, by walking in a unique figure eight pattern. In sequential loops, one foot swings out with a light kick, opening the kimono skirts, and then in, as the hems swoop back. Spectators, particularly those seated along the *hanamichi* during a *dōchū*, lean to see the flashes of white bare feet and black *geta*.

As mentioned in chapter 3, the *wakashu* and early onnagata had to invent new patterns of erotic attraction because of the prohibitions of the *bakufu* against erotic display. Eventually their camouflage and other stylized acts evolved into its own erotic style. Today, kabuki onnagata carefully preserve their highly stylized system of erotic attraction within their gender acts. Central to the onnagata art itself, *iroke no bi*, the art of erotic allure, infuses all onnagata gender acts.[53]

Onnagata *iroke* may arise in different kinds of performance sequences. Special prescribed patterns aim to evoke *iroke*. It may also arise when these patterns are a part of sequences of movement and postures. Sequences of movement may vary in length from several gestures to a short scene. For example, during the meeting of the two lovers Michitose and Naozamurai in *Naozamurai* (Naozamurai), the onnagata moves in and out of back poses and low kneeling poses, biting the kimono sleeve to hold back tears, and combing the lover's hair with his hair ornament. All of these movements and postures have imbedded *iroke* patterns. *Iroke* pattern sequences such as these, with spoken dialogue or music and song accompaniment, require the execution of gesture, pose, and word/sound in a unique phrasing pattern. To allow for the attraction of the spectators, onnagata must create moments of essential repose to highlight his *iroke* in the dynamic flow of movement and sound.[54] Whether performing in *shosagoto* (dance works) or *jishibai* (dialogue plays), onnagata use similar *iroke* patterns.

Another source of *iroke* is the onnagata's relationship to physical elements such as his costume, props (small hand props and larger set pieces),

wigs, and makeup. All the costume elements serve to make the sensual scene "beautiful." The onnagata adjusts the *kata* of costuming to show off the attractiveness of his body according to his own particular reading of the role and role type. This can be seen in the way he wears and manipulates the different parts of the kimono, *obi*, *uchikake*, *tabi* (bifurcated sock-like slippers), *geta*, and *tenugui*. For example, in both love scenes and rape scenes, one of the *kata* for lovemaking is the unwinding of the onnagata's *obi*. The onnagata's kimono is never completely undone, so there is no showing of flesh. The *obi* is made of a rich thick fabric, and when unwound, one can hear the sliding cloth, which makes a lush "shusshshhussh" sound. When complimented by music and lyrics, the sounds and images of the costumes build to a total kinesthetic sensation. The onnagata performs his gender acts carefully manipulating the crafted stylization of the acts to evoke in the spectators an abstract "sensation" of the character's "flesh."[55]

Costuming and props are designed for their architectural beauty. They also extend and reflect emotional states. Hand props, such as the *mochigami* (folded tissue paper), the *tenugui* (scarf-like towel), various fans, the *kiseru* (a long narrow pipe), hair ornaments, combs, and other accessories are frequently employed to add sensorial and emotional intensity to gestural sequences in seduction scenes. Each object has its own related history of eroticized meaning. Gestures made with these objects are enriched by their historical and erotic associations. Even when the exact historical association has been forgotten, the object bears with it a kind of mysterious or assumed sensuality. Over time, the object and its associated gestures have become a pattern of *iroke* particular to onnagata performance.

Specialized tasks, associated with serving guests at brothels, are also sources of *iroke*. The folding of the male actor's *haori* (short kimono coat), the serving of sake, the placing of the guest pillow, the turning of the guest's shoes in the entry so that the guest may easily slip into them, the lighting of paper lanterns, the stirring of the charcoal in the brazier are all designed to evoke *iroke*. These tasks have patterns of *iroke* embedded in the main action and gesture sequences. For example, when an onnagata performs the opening of a sliding door, he may kneel in such a way as to show off the back of his neck, and as he slides the door open, he may increase this view. If he is playing a *yūjo* role, he may also expose his bare feet as he slips over the door runner to close the door from behind.

Iroke is used by actors and critics in different ways, which complicates its meaning. Some actors suggest that, "*iroke* is not one point, or one place, or one moment, and it is not something that one consciously thinks, 'Oh, this is *iroke*.' "[56] However, Japanese kabuki critics will label a particular sequence of actions as important for showing *iroke*. They will also call attention to certain body parts and their shape, placement, and articulation, and then

critique the onnagata's performance of *iroke* based on these. Critics, based on their individual criteria, will sometimes use the expressions, *otokoppoi* (masculine) and *onnappoi* (feminine) to describe the actor's skill in performing *iroke*. For example, for a certain *yūjo* role, the onnagata may have performed a sequence in an overly *onnappoi* manner, and therefore, according to that critic, there was no *iroke*.[57] The perplexity of onnagata *iroke* performance and reception underlines its ambiguous and unstable performativity.

Some actors comment that *iroke* must arise during certain sequences. A young onnagata, Nakamura Shibajaku VII (1955–) states that there are specific sequences in an act where *iroke* should arise, and indeed is expected by the audience and will be evaluated by the critics.[58] Shibajaku VII suggests the meeting and parting of lovers are obvious sequences requiring *iroke*. But other sequences are more specific and more difficult. For example, when playing an *inakamusume* (country girl) role, the onnagata must carefully coordinate the removal of a work apron as a prelude to sleeping with a lover. First, the onnagata must untie the strings, then hang the apron over a sleeping screen, carefully patting and dangling the apron strings into a specific place. The complexity of these acts is deliberate, as it gives the onnagata time to pause, pose, and look about between actions, which lengthens the time for sensual attraction. Shibajaku emphasizes the musicality and concentration that is necessary in complicated gestural sequences to "make these moments evoke *iroke*."[59]

In all of these example there is still a male body beneath that is not seen and therefore may be imagined by the spectators to be whatever body they desire at the moment. Spectators may imagine and transform any sexual organs they want in the time/space of the performance because onnagata create an indeterminately gendered field of desires, neither heterosexual nor homosexual. On the whole, onnagata use a system of stylization in which many genders and desires have room to play. Perhaps in his divergence from the restrictions of bipolar eroticism, the onnagata performs a kind of playful pleasuring by offering multiple choices to the spectator.

What are the implications of these patterns of stylized eroticism and artificial man-made sensuality for the onnagata gender role performers and their performativity? Are they still caught in male–female heterosexual attraction constellations? Does the onnagata with his male body beneath, his stylized gender acts, and his fabricated *iroke* break up this constellation? Onnagata aesthetics of eroticism exploit, as a main source of dramatic and sensual play, "gender's performative character and the performative possibilities for proliferating gender configurations outside the restricting frames of masculinist dominations and compulsory heterosexuality."[60] While kabuki theatre exists within contemporary Japan's masculinist society and binary gender system, the onnagata gender acts could be read as a displacement of

gender norms. In his use of *iroke*, perhaps the onnagata demonstrates the submersion of the subversive, or how the repetition of constructed gender acts can be reconstituted into a female gender identity and then renaturalized by the system they originally sought to disrupt.

In summary, onnagata cannot exist without their constructed *iroke*. Patterns that evoke *iroke* are carefully framed so that they may be read in context of the scene or as separate moments. As James Brandon suggested, "Perhaps the point is that the onnagata performs 'Sensuality,' "[61] where "sensuality" is not linked to any one body type or sexuality. In a sense, early onnagata had the freedom to invent their own eroticism beyond any reference to any body, and contemporary onnagata continue to explore *iroke* as a source of power, a sensual agency, in their art.

The Art of Erotic Suggestion: Nureba

A *nureba* is a kabuki love scene. The *nure* comes from the verb *nureru*, to get wet. It may also refer to various degrees of wetness: damp, moistened, drenched, or soaked. *Nureru* can also refer to seduction and all the stages of making love. *Ba* means a place or scene in the play. Thus *nureba* in kabuki means a scene of passionate stylized encounter between lovers with their passions, figuratively, "drenching the place." The *nureba* is usually a highly stylized dance-like scene in which the partners perform almost mirrored acts in unison. While there appears to be little distinction between tachiyaku and onnagata actions, onnagata lead and initiate most action and poses in *nureba*. It is the onnagata aesthetic of *iroke* that saturates the *nureba* and gives the spectators a taste of the onnagata's unique sensual appeal.

In general, *nureba* can be divided into two performative types: a duet involving a male and a female lover role, and a solo dance-drama, in which the onnagata performs both male and female roles. An example of the latter type occurs in *Yasuna* (Yasuna), where an onnagata plays the role of a *nimaime* (young male lover) role. In this scene, the male role, mad with grief over the death of the female lover, performs with the *uchikake* as the embodiment of the lost lover. The changes between the male and female role are subtle. Shikan VII notes that the beauty and *iroke* of the *nimaime* are similar to the onnagata, perhaps related to the *wakashu* tradition.[62] At one point, the onnagata slips into the *uchikake*, becoming the female lover role. The onnagata shifts the stylized acts of the young male lover role to the stylized acts of the female lover role, using the *uchikake* to distinguish the female gender role. Certainly the *uchikake* is like the body of the *yūjo* role, a stylized sensual body, made up of a curving collar, luxurious sleeves, and long cascading skirts. Performing with the *uchikake*, the onnagata has the opportunity to manipulate his gender acts. The solo *nureba* from *Yasuna* demonstrates the ambiguity and transformativity of the gender acts that arouse *iroke*.

An example of a duet scene is the lovers' quarrel and "making up" sequence between Yūgiri, an *oiran* (high-ranking courtesan) role, and Izaemon, the young male lover role, in *Kuruwa Bunshō* (Love Letter from the Licensed Quarter). In *nureba*, onnagata employ several types of gestural sequences that are full of *iroke* patterns and moments. I describe five sequences that are examples of stock lover's patterns, in which onnagata *iroke* is a central aesthetic. To the spectators who are well versed in kabuki, these sequences are well known and loved. Even to those new to kabuki, the erotic charm associated with these signature scenes fascinates: how do two actors perform this kind of ambiguous eroticism with such delicacy and innuendo?

Lovers' Meeting Sequences

In some cases, the lover roles may meet by rushing together. But generally, the onnagata role cajoles or seduces the tachiyaku role, using small gestures of pushing, pulling, or pressing the tachiyaku to a kneeling posture. A popular style of meeting is when the performers back into each other, touch shoulders, rebound in feigned alarm, then circle each other, and perform a stylized embrace. The embrace may vary from actual touching to a stylized opening of their arms in proximity to each other. In a stylized embrace, the onnagata will kneel below the tachiyaku facing upstage, with his upper back displayed to full erotic advantage. During stylized embraces, the onnagata repeatedly exposes his *eriashi* (back nape of the neck) and sensuously manipulates the sleeve and skirts of the costume into shapes that compliment this view.

Kudoki Sequences

Kudoki may be translated as lament, longing, persuasion, or even "come on."[63] A *kudoki* is a movement sequence concerning "matters of the heart," usually performed by the onnagata in a solo mime/dance to chanted lyrics and music. Sometimes, the tachiyaku lover role may accompany or enter into parts of the sequence. Musical accompaniment is usually the *shamisen*, or the *kokkyu*, a bowed instrument with a sorrowful sound. The *kudoki* is considered to be the onnagata's special arena of emotional expression, where he may show off to the fullest, "the essence of the female-like onnagata eroticism of gestures and postures."[64] The rhythm and pacing of a *kudoki* is usually continuous and sustained, matching the onnagata's controlled grace and delicate pantomimic or abstract gestures. *Kudoki* lyrics are rich with images that create a sensual atmosphere.

Small Props and Costume Manipulation Sequences

The onnagata performs tasks such as the *kamisuki* (hair combing), in which he uses the long ornamental hairpin from his wig to adjust his partner's wig

hair. When the onnagata mimes tucking "stray hairs" in, he almost touches the bare skin near the neckline, making his actions kinesthetically risqué. Other popular examples include pouring *sake*, folding a lover's *haori* (short kimono coat), manipulating the *tenugui* (scarf-like towel) and lighting and handling the lover's *kiseru* (long narrow pipe)—all of which have particular moments of *iroke*. Costume elements such as the *obi*, the *uchikake*, the *kitsuke* (under kimono), the back kimono collar, the long kimono sleeves, the kimono layers and rolled hems, and even the *midaregami* (disordered hair), are essential elements that onnagata manipulate to create their *iroke no bi*.

Partner Dance Sequences
Tachiyaku and onnagata perform stylized duets in various types of scenes like quarrels, seductions, partings, murders, and suicides. In seductions, a common pattern is for the actors to face each other and move in mirror-like opposition to each other; coming very close, they circle around, slipping past each other, exchanging places, one in back, one in front. They loop around again, the onnagata turning away, with the tachiyaku behind. Finally they face away from each other and momentarily separate. They appear to fall backward toward each other. They touch shoulders, and sink in a slow sensual melt to their knees. Although they mirror each other and appear to move in unison, the onnagata initiates the movement pattern and direction while the tachiyaku follows. For example, the onnagata may shift in front of the tachiyaku and pull his partner to see his tilted neckline. Or the onnagata may dip low, pulling the tachiyaku with him and then shift behind the tachiyaku, positioning himself over the tachiyaku. From behind, the onnagata, with one hand on each shoulder, slowly and luxuriously presses the tachiyaku down to his knees.

Ending and Parting Sequences
In some scenes, just when the lovers appear to be sinking into an ecstatic embrace, *sudare oriru* (rolling down the screens) occurs. This literally means that thin, lattice-like bamboo curtains are slowly unrolled, accompanied by a lyrical musical accompaniment, gradually obscuring the onnagata and tachiyaku about to consummate their love. The equivalent might be the slow fade-to-black used in film to fire the spectator's imagination. The final image that is used is usually the onnagata appearing to melt into his kimono. The slow meltdown must be carefully sustained, and the onnagata must maintain his head tilt, neck suspension, and the graceful curve of his spine with a heavy ornamented wig and layers of kimono and *obi* pulling him down. The exertion of the onnagata is enormous and grueling, yet he must communicate in this last glimpse his scintillating *iroke*. A wonderful example of onnagata *iroke* in a *sudare oriru* scene is the mutual seduction

between the tachiyaku gangster role of Gonsuke and the onnagata princess role of Sakurahime in *Sakurahime*.[65]

There is also the parting of lovers in a *shinjū* (love suicide), which has its own darkly erotic stylization. The onnagata character, usually a *yūjo* role type, is killed by the tachiyaku character, a male lover role, in a viscerally painful, yet sensually stylized, sequence. Even when distraught, the onnagata maintains a kind of controlled passion in careful poses and exacting gestures, particularly amplified by musical accompaniment and lyrics. In *Sonezaki Shinjū* (Love Suicide at Sonezaki), the stabbing death of the *yūjo* role, Ohatsu, at the hands of the male lover role, Tokubei, is an example of an onnagata *iroke*-filled struggle. There are also *iroke* ending sequences that involve the murder of the onnagata character, whose death throes are lengthy and carefully choreographed with anguished postures that highlight onnagata *iroke*. Jakuemon IV explains that, for him, the dying actions of the *yūjo* role, Koman, in *Koman Gengobei* (Koman Gengobei), are examples of onnagata *iroke*.[66] These last types are performed with onnagata gender acts carefully stylized for their maximum sensual effect. In these ending scenes, slow motion, a luxurious elongation of gesture, and strategic poses are essential for the onnagata to *iroke o dasu* (put out or amplify erotic allure). These scenes demonstrate the interdependence of the onnagata's aesthetics of *iroke* and *zankoku* (torture), which follows in a later section.

Performance Example: Iroke

The lovers' scene from the dance-drama *Kuruwa Bunshō* (Love letter from the Licensed Quarter)[67] is an outstanding example of onnagata *iroke* in performance. I have divided the lovers' actions into a traditional sequential pattern: (1) *jo* (introduction) is slow and sets up the characters and action; (2) *ha* (breaking apart) may be several variable sections illustrating the complexity of plot and characters; and (3) *kyū* (acceleration) is a brief faster section signaling an end or transition. Each sequence is a separate piece attached to the next through transitions initiated by actors or musical changes. *Kuruwa Bunshō* is a *shosagoto* (dance work) from Kamigata.[68] As is typical of Kamigata love scenes or stories, the play has an alternative name, *Yūgiri Izaemon* (Yūgiri Izaemon), which is the name of the two lovers with the *yūjo* role name first.

The section of the play discussed here follows two scenes concerning the male lover role, Izaemon. His family has disowned him because of his debts and money problems, which have arisen partially over his seeing the courtesan Yūgiri, with whom he fell in love some years earlier. They have had a child. Because Izaemon sent no word to Yūgiri of his misfortunes, Yūgiri has become sick and weak from pining for him. Subsequently, she has not

been able to entertain guests, and her owners, who are nearly like her parents, are very concerned. It is the the New Year season and Izaemon, who is totally destitute, wanders over to Yūgiri's brothel to try to see her. He has no idea she is sick and assumes that she has forgotten him for other guests. The owners, who care for Izaemon, welcome him to come in and see Yūgiri. It turns out that Yūgiri is with a guest, one of the first she has seen since her illness. Izaemon has to wait for her and decides that she is just putting him off. He reveals his longing, jealousy, and impatience in a humorous mime dance sequence. The rest of the dance play is reunion of the lovers, starting off with a quarrel and ending with a renewal of their love. Finally Izaemon's fortune turns, and his family reinstates him. It appears at the end he will be able to buy Yūgiri's contract, which will allow them to marry.

The love duet begins when the brothel owners leave the room. The spectators are primed for the entrance of the onnagata by a small child playing a courtesan's *kamuro* (girl attendant), who brings in a courtesan pipe and smoking tray. The music ensemble changes to a *tokiwazu* (musical narrative form) group, whose lyrics and style are considered most fitting for dance works. The tachiyaku is feigning sleep, wrapped up in the quilt of the *kotatsu* (heated table), rudely dismissing the onnagata's entrance and giving the onnagata center stage focus. The onnagata performs a momentous *jō* (introduction) entrance sequence. Facing directly downstage, the onnagata emerges as if rushing from the "inner" chambers of the brothel through several layers of beautifully painted sliding doors. The onnagata appears to glide and billow through each set of doors with his multiple layers of kimono and the wave-like hems of his *uchikake*. To the rich sounds of the *tokiwazu* singing and music, the onnagata creates a luxurious, anxious, and sensual figure with his stylized gender acts, using his costume, wig, props, and moving set pieces. He stops and poses just inside the room, allowing the audience to take in his sumptuousness and his heartfelt longing.

The costuming of the two roles reflects their character and their state of desire. Izaemon's costume, a *kamiko* (paper kimono), once made of paper, is now made of a particularly light fabric. A *kamiko* was once a kimono made from the rice paper love letters of the courtesan and the lover. It shows the male lover role's distraught emotional state over his poverty and unfailing love. He wears his heart's message, literally, on his kimono. The tachiyaku's kimono is much more revealing than the heavy embroidered and layered costuming of the onnagata. The *kamiko* lends the tachiyaku a light and insubstantial kinesthetic sense, while the onnagata has a grounded and earthy sensuality.

Yūgiri is an *oiran* role that is one of the highest ranking *yūjo* roles. The onnagata wears a huge decorative wig, several layers of kimono with trailing

skirts, a lush, cascading front *obi* bow, and a sumptuous *uchikake*, the long skirts of which end in three padded rolls of *suso* (hems). The costuming adds volume, and consequently presence, to the onnagata's constructed role. While the tachiyaku in the *kamiko* (paper kimono) can move about freely, the monumental onnagata must labor to turn or move. The tachiyaku has physical ease, whereas the onnagata must obey, resist, or overpower the restrictions of the costume. The onnagata's *iroke* is controlled and contained by these limits. The monumentality of the onnagata's figure amplifies any of the onnagata's movements. The slightest tilt of his neck can rivet the eye. An onnagata learns to use the power of his sculptured form with a subtle sensual grace.

During his sweeping entrance, the onnagata lowers his gaze and hides his face with the *mochigami* (folded tissue paper), in a stylized gesture implying shyness and coyness. This first gesture sequence illustrates the use of a very significant small hand prop, the *mochigami*, the folded wad of tissue paper, which the onnagata reaches for inside the front fold of his kimono. The *mochigami* is also used for crying sequences, implying that the user is upset and distraught. The onnagata now turns slightly upstage, lowers one shoulder, and glances back over that shoulder, pausing to give the audience a glimpse of his scooped white neckline and a sculpted view of his cascading, embroidered *uchikake*. This striking pose is often used to capture and arrest the spectator's gaze.

Next, the onnagata moves to the sleeping tachiyaku's figure, and prepares to begin the *ha* (breaking apart) section. The onnagata takes the *shimo* (lower) stage position, and sweeps the luxurious *uchikake* over the pouting tachiyaku. The onnagata uses the *uchikake* expertly, manipulating the bulky and cumbersome hems and puffy sleeves as extensions of his own limbs. When articulated with sensual grace, the *uchikake* and voluminous front *obi* appear to flow and respond to every gesture and become highly expressive. *Iroke* is embedded in both gesture and object as the onnagata performs what the lyrics state directly, "I bring my body next to yours, within the same robe."[69] Now the onnagata removes one tissue from the folded *mochigami* by using his mouth to separate the tissues. Onnagata do not emphasize the gesture, but it is charged with *iroke*. Later, he wads it up and tosses it carelessly into his sleeve opening. Perhaps this is an expression of frustration, sorrow, or anger. Is he symbolically destroying and tossing away his love?

The *uchikake* and *mochigami* sequences are supposedly based on their connection to real brothels and prostitutes. According to Cecilia Segawa Seigle, in her book, *Yoshiwara*, many objects and costume pieces of the Edo period were highly suggestive and functioned in various stages of male or female courtesan procurement. In kabuki, the objects and costuming are theatricalized but still resonate with the sensual connotations of the world

of prostitution. For example, the *mochigami*, the folded papers, had many uses in sexual arousal, lovemaking, and even, for women prostitutes, contraception.[70] In his entrance, the onnagata uses a *mochigami* that is enlarged to almost twice the actual size, as if to point out its sensual presence. The *kōken* (stage assistant) skillfully hands the onnagata a smaller-sized one for him to take in his mouth. Even though the actual sexual uses may no longer be common knowledge, the onnagata and their audiences know that the stylized acts arose from a history of sensual entertainments and "selling" sexual encounters.

After their initial encounter, the onnagata must try to get the attention of the tachiyaku, who continues to play as if "asleep" under the *kotatsu* (heated table). The *kotatsu* is an example of an object with erotic significance. When two people sit under the quilt that is draped over the table with a *hibachi* (warming unit) under it, they can secretly "warm" and arouse each other. In this *nureba* (love scene), the *kotatsu* is used several times by the lovers recalling the warmth of their sexual encounters. In this play, the *nureba* is sometimes called the *kotatsu no kudoki* (persuasion/longing or seduction under the *kotatsu*).

Most sequences begin with the onnagata urging, instigating, or stimulating the tachiyaku into action. In turn, the tachiyaku rejects, or feigns seduction for a short time and then rejects the onnagata's advances until the very end. In this case, the tachiyaku has had a fit of anger, calling the onnagata a "streetwalker."[71] While the tachiyaku still scorns his advances, the onnagata tries to soften the tachiyaku by adjusting and smoothing his hair in a *kamisuki* (hair combing) sequence, an important onnagata *iroke* arousing pattern. Having gently pressed him down to his knees by the shoulders, the onnagata begins the *kamitsuki*. During this intimate act, the singer sings:

> From the day our flirtation, thin as watery blue,
> Became deep-dyed with loving one another. . . .[72]

The song fills in the narrative history of their passions growing deeper. The images of color and dye are related to the *iro*, meaning "color," which is part of the compound *iro* and *ke*, meaning "feeling" or "mood," that make *iroke*. The deeper color refers to the heating up of passion, both physically and emotionally. The onnagata *iroke* patterns are further stylized through the timing of gesture, word, and sound. Underlying the abstraction at all times is the layer of sensual *iroke*.

First, he takes a *kanzashi* (long spike-like hair ornament) and mimes a stylized combing of the tachiyaku's *bin* (flared side locks) near his ears, *tabo* (bun-like back loop) at the back of the neck, and the carefully placed *mage* (topknot) at the back of his head. The onnagata is not really combing the

hair of the tachiyaku, but he is drawing the spectator's attention to the round, smooth, and shiny curves of the tachiyaku's wig. The onnagata's smooth touches show off the sensual shapes as well as tantalize the audience's kinesthetic sense with the gentle and sensual pricks of the hair ornament's spike into the scalp and along the nape of the neck. The large *kanzashi* is another erotic object. Hair ornaments also have an intimate association because they were most likely gifts of a courtesan's patrons. The onnagata clearly leads the attraction and foreplay actions in this scene. But the onnagata does not act "seductively" or try to get attention; rather, onnagata gender acts are embedded with patterns to arouse *iroke*.

Inherited from *wakashu* performance, hair, hair styles, wigs, and hair ornaments have been integral to the onnagata gender acts from early on. The stylized and exaggerated wig shapes are part of each role type's gender iconography. During the Edo period, grooming of the hair was a personal and intimate experience for men and women. Great care was taken with the styling of the hair among the merchant class, samurai, and particularly among the courtesans in the licensed quarters. In the Yūgiri Izaemon scene, gestures of combing are choreographed with the onnagata standing directly behind the tachiyaku, who kneels facing the audience. The spectators can see the facial expressions of both actors. In *kamisuki* sequences, the onnagata pauses at times, cued to lyrics of the song. Gazing off into the audience as if remembering their earlier love, the onnagata's hands hover over the lover's head, underscoring the *iroke* of the action.

Next, the tachiyaku attempts to take the ornament, scorning the onnagata's advances. In the scuffle between them, the onnagata's *uchikake* becomes the object saturated with *iroke*. As stated before, the *yūjo* costume, particularly the kimono sleeves, the decorative front *obi* in the voluptuous *manaita* (lit. chopping board or front style *obi*) style, and the *uchikake* are integral to the construction of the onnagata's *yūjo* body. They are almost like extensions of his real body beneath. The onnagata performs the *yūjo* costume as if the very surface and shape of the costume had the sensuality of his flesh and blood body. In this sequence, the tachiyaku gets caught inside the *uchikake*, seemingly unaware. He is wrapped in its embrace. He ends up winning the *uchikake*. Triumphant, he drapes it over half his body, sensually mixing gender acts of pain and *iroke*. The audience applauds as the tachiyaku wins the robe and still pushes his lover away.

The lover's duet is a classic *nureba* sequence that contains two of the gestural sequences previously described: a meeting sequence and a parting sequence. A feature of the scene is the manipulation of the onnagata's *uchikake* as if it were an extension of the onnagata's courtesan's body. The meeting sequence begins with the two lovers bumping into each other's shoulders. They sway and then sink together to the floor. The tachiyaku

turns away, sweeping the *uchikake* with him. He returns and spreads the *uchikake* between them. Each wrapped in half of the *uchikake*, the onnagata kneels and the tachiyaku stands with his back to the audience, peering over his own shoulder. They pull the *uchikake* out on a long diagonal between them. Their sculptural pose recalls that of love suicide couples who, before death, bind themselves to arrive together in the next world. The tachiyaku breaks the tie. Disheveled, they look like the *ukiyō-e* (floating world picture) prints of lovers parting from their covers in the morning.

The tachiyaku continues to separate himself from the onnagata's entreaties. He attempts to light a *kiseru* (long pipe) by himself. The *kiseru* has a history as part of the courtesan–client transactions. In the brothels, when the courtesan served the client by filling the pipe and lighting it before lighting her own, it indicated a stage in their relationship. In kabuki, when the onnagata uses the same fire to light their pipes, it symbolically expresses the intimacy of the characters' relationship. After lighting the *kiseru*, both tachiyaku and onnagata may then strike an elegant back-to-back kneeling posture with one arm extended, propped up by the *kiseru* used like a small cane. Used only in *oiran* roles, this pose, with the onnagata's arm and shoulder raised, is very *otokoppoi*, shaded with gender ambiguity.

If the onnagata in his *oiran* role lit his own *kiseru* alone, it would be an act of independence signifying rejection of the client.[73] In this scene, the tachiyaku rejects the onnagata by attempting to light his own *kiseru*. When he is unable to do so, the onnagata offers a lit *kiseru*, but the tachiyaku strikes at the proffered *kiseru*. Still the onnagata attempts to calm his anger by crisscrossing their *kiseru*. But, the tachiyaku knocks the onnagata's *kiseru* away in a repeated percussive sequence. Because of the intimate connotations of the *kiseru*, there is an erotic tension in their altercation hinted at in the song:

> Though seen sharing the same bed, sleeping back to back;
> They stretch the fragile ties of love unthinkingly.[74]

After several more rejections, the onnagata presents the tachiyaku with a love letter scroll, another object of *iroke*. The love letter is used repeatedly in lover sequences. Onnagata have a beautiful stylized sequence in which they mime preparing the ink stone and brush for writing, and then writing on the scroll itself. The gestures for writing down a scroll are very sinuous and the onnagata may position himself so that one shoulder is lowered and some part of his *eriashi* (back nape of the neck) is exposed. The edge of the scroll is usually tinted with a thin crimson line. This red stain is supposed to be the lipstick smudging left by the lover on the edge of the paper. It also

mimics the red edge of the inner layer of kimono that outlines the onna-gata's whitened neck. The red stained edge is an intimate signature, a dec-laration of deep commitment to the recipient.[75] Here the tachiyaku takes the scroll as if to strike the onnagata, but tosses it away instead. The onna-gata retrieves it and, holding one end, tosses it back, so that the scroll unfurls like a long sash between them. Again, the onnagata offers an object, like a piece of himself, to the tachiyaku. The tachiyaku jerks and tears the letter in two. Both pose, each with a torn half of the scroll—a symbol of their sev-ered love. Somehow the ripped paper scroll with its red edging resonates with the onnagata's *iroke*, a testimony of sensual passion and longing.

Adding a light and humorous touch to their sensual skirmishes, the tachiyaku goes off to bury himself in the covers of the *kotatsu*. The onna-gata attempts to join him, but the tachiyaku parades here and there with the *kotatsu*, taking his "warmth" with him. Suddenly, the onnagata doubles over, overcome with a pain in the upper chest, and cries out. The tachiyaku appears to gently touch the onnagata's shoulders from behind. Finally responding to the onnagata, the moment is brief. The two actors finish in one of the standard kabuki lover sequences. The tachiyaku kneels facing directly downstage. The onnagata kneels even lower, in front, and gently presses the tachiyaku's knee or thigh with both hands. At this point, the onnagata may turn upstage or downstage and slip into the "lap" of the tachiyaku. The onnagata appears smaller and protected in this pose and gives the tachiyaku a close-up view of the bare nape of his neck. The onnagata then deeply bows his head and shakes it with the same action used for stylized weeping. The tachiyaku covers his face with one hand turning his head slightly away. Without direct eye contact, their bodies held in sculptured shapes, they are close, but not touching. Because there is still space between their bodies, *iroke* can linger and still resonate between their bodies.

The sequences of seduction and rejection in this play create a pattern used in many lovers' sequences. The onnagata enacts acts of seduction; the tachiyaku scoffs, scorns, or ignores the acts until forced into an indirect response. Then the tachiyaku frequently follows and mirrors the onnagata's seductive actions. They take on each other's seductive acts. The seductive gender acts employed by the onnagata emphasize gender ambiguity. Both onnagata and tachiyaku share the gender acts that arouse *iroke*. *Iroke no bi* could refer to a "space or atmosphere of erotic allure" created by many vari-able, erotic objects and acts. This space of allure seems less limited than the linear and bipolar attraction of female and male gendered "opposites." Perhaps, like tuning to another culture's codes of sensuality, judging and enjoying the moments of onnagata *iroke* is learned by gradual acclimation to the ambiguity of onnagata *kata*.[76]

The Beauty of Torture: *Zankoku no Bi*

In many of the most popular kabuki plays, important roles from every role type category perform as the objects of *zankoku* (cruelty or torture). Major onnagata roles frequently have scenes in which *zankoku no bi* (beauty of torture) arises. It is one central motif in onnagata gender performance.[77] Onnagata have created a variety of stylized techniques to compose these acts of pain into refined, attractive, and sensually pleasurable representations of violence. These techniques are coded as essentially *onnarashii*, or female-like. In brief, the stylization techniques of *zankoku no bi* are designed to make the violence enacted on the female-like characters beautiful.

First, I define the "beauty of torture" by placing it in the context of kabuki aesthetics and then illustrate its performative expression in a specific dramatic scene. To begin with, the *bi* refers to an element of beauty. *Zankoku* is made up of two Chinese characters, the first is *zan*, meaning cruelty, brutality, or atrocity; and the second is *koku*, meaning terrible, intense, or long lasting. As a compound, *zankoku* conveys a sense of cruelty as a prolonged state of torture, intense, lingering suffering, or brutality without mercy.[78]

Gunji Masakatsu regards *zankoku no bi* as a lush and ostentatious kind of suffering. In his view, *zankoku no bi* is an anti-aesthetic, the result of kabuki's historical and cultural context—a licensed place of evil. Other factors may have been kabuki's merchant-class origins, its relationship to prostitution, and its emphasis on physical display and sensual entertainment. Kabuki's rebellion against the subtle and spiritual mystique of the classical theatrical forms like nō made it a world of sensual and social experimentation. Thus, early kabuki was considered to be outside traditional aesthetic codes and the refined classical arts. Its actors and audiences emulated their social superiors but developed their own underground aesthetics and radical interpretations of classical aesthetics.

As for kabuki's pleasure in pain, Gunji comments that, "there was a desire for the smell of murky blood, for being in hell, that is, the world of taboo pleasures, but being out of danger."[79] He refers to kabuki's aesthetic of vulgarity and extremes as, ". . . a relish for brilliant extravagance and acrid shadows, for being steamy and naked while howling in remorse and grief."[80] He concludes that:

> Still, even if they appreciated the beauty of detail and gorgeousness in kabuki, it [their taste] differed from that kind of elegance, they had only this taste for the childish and stimulating. Even when onnagata played princesses and *wakashu* [young men] played their merchant lovers and courtiers, it cannot be denied that they followed the familiar erotic sensuality which attracted the Edo masses.[81]

As discussed earlier, onnagata techniques before the 1880s are considered by some historians and actors to be more *otokorashii* (male-like) than they are today. *Semeba* (scenes of torture) clearly illustrate how onnagata stylize their gender acts of suffering, madness, and pain to enhance and eroticize the violence and torture. Considering how kabuki was "reformed" in the ensuing wave of Japanese-styled "Victorianism," at that time, onnagata were central to the process of cleaning up kabuki to make it more respectable. In the process, aesthetic principles like *zankoku no bi* were remodeled to match the new "respectable" society. It is generally believed that most contemporary onnagata performance, while becoming more *onnappoi* (feminine), the acts of violence and torture have been considerably refined or even dropped from the repertoire.[82]

The question then arises, is there a correlation between the Edo period *otokorashii* (male-like) onnagata and *zankoku*? If an *onnappoi* onnagata is tortured, is it too painful because it gets too close to "real" women? Is torture less erotic with the refined *onnappoi* onnagata, and therefore less popular? Did onnagata choose to subdue their acts of torture to avoid greater censorship? Perhaps the changes in women's status, political upheaval, and Westernization contributed to onnagata "reform." When Japan embraced modernity, gender ambiguity, sexual play, and violence in kabuki were suppressed. Along with these tides of change, onnagata may have refined gender variations and erotic flamboyancy in favor of a reformed kabuki, which emphasized the European aesthetic style of realism and a new Japanese conservatism.[83]

My descriptive analysis focuses on how *zankoku no bi*, the aesthetic of torture, is performed through specific performance patterns (e.g., movement, gestures, vocalization, music, and costumes) that fabricate a fantastic experience of the action. The techniques for enacting gender and torture have become highly revered for anesthetizing pain and disconnecting "real experience" from the stage performance. Through a complex stylization process, pain is kinesthetically numbed and then made attractive; anguish is experienced by the audience as painfully beautiful. Onnagata role types are most frequently used in these scenes of *zankoku no bi*, since the refinement of their stylized acts makes torture look beautiful and desirable.

In the following examples, I focus on how, in kabuki, a male body is transformed into a female gender role victim. I describe how contemporary onnagata perform this female gender "victim." Because of the symbolism and abstraction onnagata use to stylize their gender acts, these acts powerfully represent ideals and ideologies. As David M. Halperin writes:

> the body is not only a thing but a sign: it functions as a site for the inscription
> of gendered and sexual meanings, among a great many other meanings . . . we

need not assume that sexuality itself is a literal, or natural, reality. Rather, sexuality is a mode of human subjectivication that operates in part by figuring the body as the literal, by pressing the body's supposed literality into the service of a metaphorical project.[84]

How is the onnagata's body "pressed into service"? On a larger scale, this investigation concerns the onnagata's physical performance and how cultural programming works to make the female-like gender role beautiful and desirable when in pain. Focusing on onnagata and *zankoku no bi*, I analyze how, in kabuki, onnagata stylize pain, torture, and sensuality of the body. It is the body of the onnagata that is the key site for investigating how a performer's body can be inscribed through stylization and "become" the beautiful, suffering victim role. The female gender victim, as performed by onnagata in kabuki, demonstrates Halperin's "metaphorical project"[85] of making the female gender role into the perfect "body" for pain and torture. And perhaps the complexity of onnagata aesthetics like *zankoku no bi* suggests that onnagata performance functions on stage, ". . . as a site for the inscription of gendered and sexual meanings, among a great many other meanings."[86]

Among the questions my investigation raises are: how is pain and torture enacted by the onnagata? What are the connections between pain, violence, eroticism, and sexuality, that are specific to the female gender role? How is torture gendered? How does the female gender role become a victim? How is this pain sensually entertaining? Do these perceptions apply transculturally? Scholars and kabuki actors alike claim that the pain is made beautiful through stylization, and for that reason it is art. Tamasaburō V remarks, "It is so painful but it is so beautiful; that makes the pain beautiful."[87] James Brandon suggests that at the heart of all kabuki is the desire to create a sense of beauty on stage, no matter what the subject matter.[88] When the onnagata is beaten, slashed, and poisoned in beautiful costumes with dance-like gestures to lyrical singing, how do the methods of theatrical representation alter the viewers' kinesthetic perceptions? Is there a distancing from the "real" thing because of the stylization of gender and torture? Does the male body beneath the female gender role somehow mitigate the pain that is portrayed? Considering these compelling questions, I view the onnagata's performance techniques of victimization in scenes of violence to be central to the understanding of onnagata gender performance.

First, what makes an onnagata role the perfect victim role? While male gender roles in kabuki are also victimized, they are rarely brutalized by female gender roles. The basic gender acts (e.g., appearing smaller and refined) of many onnagata gender role types seem to set them up as "natural" victims. For the most part, onnagata roles are defenseless because

they are costumed for slower action and restricted in movement by the fundamental premise of having to appear smaller and refined.[89] And, in many cases, the drama will go on without them, so they are dispensable to the narrative even though they are indispensable to the total "spectacle" of kabuki.

Kabuki onnagata theatricalize acts of violence through stylization practices involving choreography, music, costume, set, and props. In scenes of victimization, onnagata strive to maintain their stylized gender acts, while the violence is choreographed to fragment that surface glamor. Although they resist the undoing of their line, grace, and refinement, at the same time onnagata must perform the stylized destruction of their gender acts. In the process of being violated, the onnagata undergoes a transformation in appearance. Violent acts distort the onnagata gender acts. An "other" body emerges out of this process of fracturing the onnagata gender acts—usually a degraded body of stylized wounds, deformed postures, distorted gestures, and misshapen costuming.

The power of these scenes lies in the disassembling of stylized female gender acts, which potentially reveals the male body beneath. Going back to David Halperin's words: "Through the changing spectacle of masquerade, the limits of a single gender identity and one body-ego are pleasurably transcended."[90] Depending on the onnagata, the spectator may get a glimpse of or get to imagine some "other" gender, which is also tantalizing.

Further, the use of the female gender role in scenes of violence and abuse intensifies the horror and pain. The onnagata's gender acts of grace, delicacy, and smallness create a refined figure/image that is cherished and idealized. When those onnagata gender acts representing that idealized beauty are ravaged, the figure that emerges is chaotic and unbalanced, its gender vague and ambiguous. Witnessing the devastation of the refined figure is deeply painful because the spectator holds onto the cherished ideal, like a long awaited dream. When stylized beauty is distorted, the kinesthetic experience of the violence is more intense than when something from daily life is destroyed. Perhaps it is the extremes: the loss of the stylized ideal beauty, as opposed to something mundane, intensifies the feelings of anguish and pain.

For example, in the poisoning and death struggle of Oiwa in *Yostuyakaidan* (The Ghost of Yotsuya), the onnagata transforms on stage, from a young wife and mother role into a hideously wounded ogre. When first poisoned, the onnagata deftly applies extra makeup and a bloated, bleeding eye prosthesis. While the onnagata's face melts into a monster mask, his kimono and wig retain some semblance of the earlier young wife role. Then, the tachiyaku playing the husband role acts out ripping out the onnagata's finger nails. The onnagata grasps the edge of a screen, so we can

see the descending trails of blood, graphically displayed on its silk surface. Finally, in a brilliant scene where the onnagata uses the stylized courtesan techniques of preparing makeup and hair for a lover, the onnagata instead pulls out most of the wig hair, leaving his top scalp bald and the rest a fly-away mess. Blackened teeth was a mark of beauty in the courtesan world and if a woman was married she blackened her teeth. Here, the onnagata blackens his lips and teeth with wild brush strokes, turning his face into a hideous, gaping black hole. After a stylized struggle with a tachiyaku playing a spooked, blind masseuse, the onnagata ends it all by falling on his own knife. In a gruesome but graceful fall, the onnagata slits his throat across the blade of a knife he had previously stuck into a post. At this moment of tortured dying, a stringed instrument, the *kokkyu*, with its sweet, delicate, and sad tone, is played to underline the anguish of this scene of suffering. The bowed string instrument's drawn out and voice-like quality subtly intensifies the aching, lingering pain.[91]

Performance Example and Analysis: Zankoku no bi

I use three elements of action—time, repetition, and space/position—to analyze the stylization techniques of *zankoku no bi*. To begin with, torture takes time. To prolong the infliction and reception of pain, the kabuki actor expands time through slow motion. Second, agony is augmented by repeating the painful acts over and over again. Third, the kinesthetic feeling communicated by watching torture can be intensified by different positions of the victim's body. Certain body positions and movements are considered too painful to watch, and they are not directly enacted. Sometimes positions are changed to facing upstage, at an extreme upstage angle, or partially hidden behind a screen or scrim. If the victim's body is in full view, the action is suggested through abstraction and embellished with costumes, props, and set pieces.

For example, the actions of being bound, hit, pushed, kicked, pulled, stabbed, and slashed, are stylized to distance the kinesthetic transmission of pain. Gestures may be performed in a more rhythmically elaborate way or streamlined to the extent of becoming dance-like. Variations in timing, sculptural poses, music, and lyrics insure the freshness and intensity of pain. Musical accompaniment and song images are used contrastively to mute or transform kinesthetic sensations of pain. The refined variations may be so elaborately or subtly crafted that the technique transforms the reading of the act. No matter how he is abused, the onnagata always attempts to adjust his costume and wig into a beautiful stage picture.

An outstanding example of *zankoku no bi* occurs in the play *Onnagoroshi Abura no Jigyoku* (The Murder of a Woman in a Hell of Oil).[92] Here I focus

on how the "beauty of torture" is enacted in contemporary kabuki. Many such scenes of violence occur in kabuki plays, and they may have been much more violent in their original versions.

The scene I describe involves the slashing to death of a female character in a family oil shop. Vats of oil are overturned in the death struggle. The actors literally slip, slide, and slash through spilt water representing oil.[93] As the killing progresses, the onnagata rips open red ribbon streamers and smears on crimson blotches, stylizing his process of disintegration. Gradually, the actors' kimonos become soaked with the "oil" clinging to their bodies from their oily battle. A chanted narrative, sung with the *shamisen* and punctuated by the *shamisen* player's cries, accompanies the actors as they slide and strike statuesque and macabre poses. The actions are accompanied by the *tsuke*, two hard wood clappers, frequently used to underline dramatic action.[94] Unlike the previous description where I referred to the onnagata and tachiyaku throughout, here I use the characters' names and personal (gender) pronouns except when specifically referencing the actor. For my purposes, it is important to remember that Okichi is an onnagata role, and that the body beneath, this "she," is a male body.

The onnagata role is Okichi, a young wife of an oil shop owner, with several small children. Okichi is a *sewanyōbō* (contemporary wife) role type in a contemporary style play type. Sets and costumes are from the merchant-class world of the 1700s. Kimono and wigs are relatively simple, with less layering, decoration, and structure. The shape of the onnagata body is evident when the kimono gets wet and clings to the skin, making this a very demanding role because the onnagata must be scrupulous about his intentional body, maintaining his *kihon no kata* (basic forms). The murderer is a young male role, Yohei, who is deeply in debt. Yohei is a type of kabuki hero who is charming and seductive. A rich merchant has bought the ransom for Yohei's courtesan lover. His parents, whom he tried to blackmail, have disowned him, yet they secretly give money to Okichi to give to him. Even in his downward descent, he appears somehow innocent of his awful crimes.

The setting for Okichi's murder is a traditional merchant's home with a living area connected to the shop area. In the shop space there are large open casks of oil. The scene takes place in the evening; the lighting is shadowy and blue. Okichi's husband is out, and Okichi has just put her children to bed in a small screened room, stage left.

Yohei arrives, demanding his parents' money. Okichi promptly gives him the money, but scolds him. Yohei continues to whine and insists that he needs more by tonight. When Okichi refuses, he says he will take oil instead, making her go into the shop. As Yohei moves to murder Okichi, all

action progressively slows. By now it is dark, and Okichi falters, feeling her way in the dim light. The chanter describes Okichi's actions and feelings so there is a doubling of seeing the action and simultaneously hearing its description.

Watching Okichi fill a cask, her back to him, Yohei shakily pulls out his dagger. He approaches and slashes at Okichi. But this is not a quick kill; Okichi senses his attack and jerks away, but receives a cut across the chest. They freeze. Shocked, Okichi drops the ladle of oil. Yohei, lunging at Okichi, slips, spilling a full cask of oil. Okichi reels back and, holding her wound, she pulls another cask down as she falls. At this point, the struggle becomes a macabre dance of death for the onnagata. The actors perform choreographed slips and falls. More casks tumble down in their composed hysteria. They repeat the slides and falls and poses until thoroughly soaked and slimy. Kimono and wig hair are plastered to their skin. During the struggle, Yohei repeatedly slashes the wounded Okichi on the back, shoulder, and face.

To accentuate their struggle and the onnagata's torture, they perform several *mie* (stopped action poses), accented with percussive *tsuke* (wooden clappers beat on a board) clacks and applause from the audience. Their photographic posturing is part of the deliberate manipulation of time and space that I have mentioned. In this case, the slow murder of a female character, an onnagata gender role, is extended in space and time, amplifying the performed pain through kinesthetic communication and increasing the beauty of torture. The performers stop in specific abstracted poses, set for their maximum sculptural effect. When the violent poses are embellished with layers of sounds, like the sharp calls by the *shamisen* player and the vocalizations of the chanter, the kinesthetic pain is amplified but tempered by the designed positions of the bodies. The chanter's extended vocalization may break into a crying pattern that the onnagata will join and take over in a howling lament. Layered over these cries, inside the rooms of Okichi's home, an infant awakes. The child's muffled cries, a horn-like sound, increase in intensity. Pain is caught and suspended in the space between actions and sounds: this is controlled, articulated torture.

Meanwhile, the onnagata, as Okichi, has carefully undone his wig and kimono during the struggle. He pulls down parts of his kimono to reveal red ribbon gashes, and dishevels his wig by pulling out strands of hair. He also draws a bright red slash across one cheek. He creates a calculated image of stylized torment and agony. Yohei catches hold of Okichi's *obi*. As Yohei pulls and unwinds the *obi*, Okichi crawls into the raised living area. Her *obi* is like a ribbon trailing behind her. She desperately pulls away but she is caught and tethered. Yohei slashes Okichi through; the chanter cries, the babies wail. The onnagata gracefully drapes himself on a long diagonal

across the *tatami* (woven rice grass mats) flooring, reaching in the direction of the child's cries. Yohei grabs the money and tries to charge out. But, to keep from slipping through the "hell of oil," he shakily escapes by walking on the unwound *obi*, still attached to the sprawled out and now dead Okichi.

In the scene described above, the use of stylized acts of eroticism and torture control the communication of kinesthetic pain and pleasure. These performative techniques of pain and torture have become what scholar and critic Gunji Masakatsu refers to as the "pain of pleasure, the aesthetic of evil,"[95] or what the onnagata Bandō Tamasaburō V calls the "pleasure of torture"[96] in performance. It is crucial and disturbing that onnagata gender role characters are used as central objects and agents for an aesthetic of torture. It is even more disturbing that these scenes of torture are performed to create a beauty that is at once appalling in content and pleasurable in designed execution.

The Aesthetic of Longing and Deepening Sorrow: *Kanashimi*

Finally, I would like to draw attention to onnagata gender acts that signify despair, anguish, and sorrow. I place crying, lamenting, saddening, and longing scenes in a special aesthetic category. There are several reasons for this. First, there are numerous scenes of crying among the major onnagata roles. Second, these scenes frequently contain onnagata solo sequences of crying.[97] I agree with Gunji that crying and longing in kabuki speaks to an aesthetic of the Edo period that is different from the refined sorrow of the nō or a "pleasure in tears."[98] It is important to keep the concept of *pleasure* in mind, to the extent that an enactment of excruciating sadness by onnagata is part of an aesthetic and a taste for pleasure in pain.[99]

Onnagata crying is highly codified and controlled; every role type has a particular way to cry. Crying by humans is messy and uncomfortable. In contemporary Japanese culture, where adults limit dramatic facial expression and strong emotional display in public, onnagata stage crying reflects the channeling of outward exhibition into designed patterns and forms. The forms are not completely abstract, but maintain a strong, almost mimetic, reference to the real human emotional expression. Further, they are enhanced, that is, "made beautiful," with the use of costuming and special props. Musical accompaniment helps support the nuances of *kanashimi*. The stylized acts of *kanashimi* have become key gender acts in the onnagata repertoire. Danjūrō IX severely chastised Utaemon V for not showing the depths of sorrow necessary for playing onnagata roles: "Grief of the gut is, in other words, the sorrow of a woman whose tears flow in silence."[100]

Here, Danjūrō IX, a tachiyaku, was asking for the silent stylized crying of the onnagata. Rather than asking the onnagata to imitate a real woman, he calls for "grief of the gut," which is what the onnagata must use in these acts. What the onnagata does may appear like a woman to some, but, like Danjūrō IX, I would argue that it is the onnagata's stylized act that causes the spectator to see resemblances to women.

Key onnagata roles in many plays and almost all dance dramas perform a *kudoki*, an intensely emotive vignette of stylized movement. Peak emotional sequences are funneled into a dance or pantomime of a slow and weighted style. There are different types of *kudoki*, and many involve lamentation and loss of a lover. The *kudoki* is considered the lyrical high point of an onnagata dance or dance-drama scene. In many scenes, the *kudoki* is an extended solo section, where an onnagata has a chance to show off his dance and dramatic performance techniques and display his gorgeous costuming. The *kudoki* is accompanied by music of a slow tempo with a song or chanted lyric. In general, there is a sense of the "interior thoughts"[101] revealed, as if the lyrics and sounds and gestures are a reflection of the onnagata gender role's thoughts, memories, and desires.

The onnagata *kudoki* movement scenes are significant onnagata gender act sequences. The importance of this category of acts is underscored by their complexity and aesthetic value. The movement techniques themselves are not expressive of emotion; rather, they are performed to control emotion, almost to hide it. What is actually enacted on the stage are the aesthetic qualities of restraint, discipline, and submission. Thus, in the *kudoki*, the role of the onnagata gender acts is to regulate and subdue emotional pain. The onnagata performs the emotional state of "going to the edge" (but not over) through highly stylized gestures. An example of these controlled movements can be seen later in my performance example from *Seki no To* (The Barrier Gate), in the onnagata's dance with the dead lover's kimono sleeve on which is painted a blood-stained message of warning and farewell.

Scholars hold wide and varied opinions on the *kudoki*. Some say it is a time for the onnagata to embody longing for love, or a space for the character to express inner feelings, primarily those of longing for the loved one. Critics usually comment on an onnagata's rendition of the *kudoki* section of a scene or dance. In a review by Watanabe Tamotsu of Utaemon VI's performance of Yaegakihime's *kudoki* in *Honchō Nijūshikō* (The Twenty-Four Examples of Filial Piety), he states:

> For the first time, I thought, perhaps a kabuki *kudoki* would be like this. It is not dance, nor psychology, nor conversation. It is something delicate which the woman finds difficult to express to the man; it is a mysterious emotional expression. Here it appeared on the stage, as it was lit by the lingering light of

a setting sun. An essence for the purpose of expressing, that human life is too short and fleeting. For Utaemon and for Baikō it was this exchange of humanity's essence and the self. . . . This essence only entered the eye and had nothing to do with the person, the crippled body not able to move freely, and this essence was unrelated to the unmoving body which one could only see.[102]

Here, Watanabe is referring to Utaemon VI's deteriorating physical state. Due to his age and paralysis of one leg as a result of being afflicted in childhood by polio, Utaemon VI moved with great difficulty when wearing the onnagata costuming and wig. However, according to Watanabe, Utaemon VI's deeply nuanced performance went beyond any physical restrictions or even the imagined role image to something "mysterious."

Performance Example: Kanashimi

Seki no Tō (The Barrier Gate), also known as, *Tsumoru Koi Yuki Seki no Tō*, (Accumulated Desire at the Snow-bound Barrier Gate),[103] is an intensely dramatic *shosagoto* (dance work) that emphasizes the stylized beauty of dance gesture and musical text over spoken dialogue. The play was first performed in Edo in 1784. Segawa Kikunojō III was the first to play the dual role of Ono no Komachi and Sumizome, the two main onnagata roles.[104] The dance-drama consists of two acts of a longer play about a group of conspirators who used occult magic in an attempt to usurp the imperial throne. Loyalists oppose them, but the involvement of restless spirits complicate various love relationships and political plots. In this scene, the main tachiyaku role is the arch villain, Kuronushi, who has disguised himself as Sekibei, a guard, who is hiding out at a barrier gate, where an enchanted black cherry tree grows blossoming in the snow. Part of Kuronushi/Sekibei's plan is to cut down this enchanted cherry tree to gain access to its supernatural powers to overthrow the emperor.

The brothers, Yasusada and Munesada, have struggled against Kuronushi's evil ways. Yasusada, recently killed by Kuronushi, left a coded poem written in blood on his sleeve to warn his brother about the disguised Kuronushi/Sekibei. Kuronushi, referred to as Sekibei in this scene, has confiscated the sleeve. The brothers each have a female lover, the roles usually played by one onnagata. Munesada's lover, Komachi, a princess, came to the barrier to see him, but left to get help. Sumizome, who was the lover of the murdered brother Yasusada, is really the spirit of the black cherry tree. Sumizome, a supernatural being, loved Yasusada so much that she transformed into a human *yūjo* (courtesan) to be with him. The black cherry tree spirit knows that Sekibei is the murderer and that he has the blood-stained sleeve. In order to get the sleeve, the spirit returns to human form, as Sumizome the

courtesan. When Sekibei dozes, we see the onnagata as Sumizome gradually appear like a glowing pink mirage from the dark inner depths of the giant cherry tree trunk.[105]

Following the supernatural appearance, the onnagata as Sumizome acts out a courtesan role to seduce Sekibei into revealing the sleeve. To begin with, Sumizome humors Sekibei, and they dance-pantomime a courtesan parade, then sneaking into the brothel under the courtesan's robes. Sumizome leads Sekibei through a brothel drinking party and even a playful jealous lovers' quarrel sequence. Finally, Sumizome tricks Sekibei into revealing the sleeve and subsequently, Sekibei's villainous nature erupts. At a crucial moment in the brothel pantomime, Sekibei thinks the bed is warm from a previous lover and, outraged, accidentally drops the sleeve of Sumizome's dead lover. Sumizome sees it, snatches it up, and then freezes, transfixed. The onnagata then performs the *kudoki*,[106] which includes a sequence of onnagata gender acts of transformation. Overwhelmed with grief, pain, and anger, Sumizome dances a *kudoki* sequence manipulating the lover's sleeve like a *tenugui* (scarf-like towel), almost as if the sleeve were the lover himself. Gradually, the onnagata undoes his courtesan gender acts, revealing the black cherry tree spirit role, who is fueled by this exquisite human sadness and ready to unleash spirit/god wrath and vengeance on the human villain, Kuronushi.

In *Seki no To*, Sumizome's *kudoki* functions on two levels. Still playing the role of a courtesan for Sekibei, the onnagata acts out the hurt and jealousy for a faithless lover. Underlying this is Sumizome's deep lament for the dead lover. In many *kudoki*, when the onnagata reaches his peak of anguish, he bites a *tenugui* or an inner sleeve. In this case, he bites the dead lover's kimono sleeve, pulling it taut to hold back tears, and cries. The stretched cloth and biting intensify the repression. The onnagata shows little emotional strain on his face. Instead, the pain and duress show up in the tensions created by the pulled cloth. Sequences of weeping and anguish are prolonged through stylized and coded gestures and other devices. Through this stylization and constraint, the sharpness of the pain is softened and made endurable, for the audience and performer. Over time, through minutes of slow motion action, the aching sensation may deepen, enriched through protraction and saturation. Deep sorrow may thus become aesthetically pleasurable through the onnagata's beautifully articulated and stylized performance.

When the onnagata laments over the sleeve, his weeping and crying voice is extended and high. One of the highly developed sets of onnagata gender acts has to do with the expression of mental and spiritual pain. The voice may wail, but every movement is controlled through specified acts that are designed to contain the pain. This state is maintained until calm is

attained or until control is transformed into a stylized madness. This turning of the emotionally distraught female character into a deranged human or spirit is among the repertoire of onnagata gender acts.

In *Seki no Tō*, the sleeve's powerful message triggers the revelation that Sekibei is Otomo no Kuronushi, the arch villain, and the transformation of Sumizome as human courtesan to Sumizome as black cherry tree spirit. According to Watanabe, Sumizome is a strange mixture for an onnagata role, because of the vow she has made to avenge the death of her lover. He calls this a lust for blood, which drives her seduction of Sekibei and final transformation back into the cherry tree spirit. However, this blood-thirsty drive is profoundly tempered by the utter longing and deep sorrow for the lost lover, and, he suggests, Sumizome's longing to return to the spirit self: the cherry tree. When the onnagata dances his *kudoki*, the sleeve, with its blooded message on a white ground, is at once the scroll declaring a vow of two lovers in the licensed quarter, and the lover victim's farewell message. When seen on stage, the dark red characters against the pale white sleeve appear to be the dark-stained cherry blossoms of the magic tree, or "Sumizome's [referring to the tree and spirit as one] cherry blossoms, namely the flower petals, are bloodstains."[107] Although based on human pain of loss, longing, and sorrow, the aesthetic of *kanashimi* that arises in the performance of the onnagata is both sensual and mystical, painful but pleasurable.

The kabuki aesthetic principles presented here are central to onnagata gender performance. Historically, "beauty" for the onnagata arose from the performed actions invented by early star onnagata, and conversely, those aesthetic points now inform the criteria for contemporary onnagata gender performance. Some gender acts may appear to resemble actions of "real" women. However, no matter how many sources onnagata drew on for their gender acts, their intention was to create an "onnagata" image and aesthetic. Although dealt with separately here, the aesthetic points naturally intermingle and coalesce in actual performance. For example, *iroke*, *zankoku*, and *kanashimi* may blend and be part of the same stage moments. Further, the gender acts associated with each aesthetic point demonstrate the fictional, stylized, and transformative construction of onnagata gender performance.

CHAPTER 7

THE INTENTIONAL BODY

Desire and the "Real" Body

The highest standard that contemporary onnagata strive to achieve in all onnagata gender roles is approximating what I call the "intentional body." This is the consummate corporeal form that onnagata are taught from their early training in *onnagata no kihon* (onnagata fundamentals). An onnagata strives to mold his flesh, muscle, and bone through specific physical acts to approach this fictional model, the intentional body: a perfect composite of onnagata gender acts. I use "intentional body" here to emphasize how it is never realized, it is always in process and in transformation: an onnagata intends to achieve the ideal image, but knowingly never completely does. Every onnagata re-forms the ideal standards for onnagata gender performance with the reality of his individual body.

The intentional body results from certain techniques that the onnagata uses in his *onnagata no kihon*, which onnagata perform for almost every role. All the physical actions used to shape the intentional body, such as pressing the shoulder blades down and together, are onnagata gender acts.[1] Acts that make the onnagata appear small, like the onnagata *kamae* (physical carriage and posture), are in the *kihon* (fundamental) repertory of gender acts. To appear small and to create the postural line designated for onnagata gender roles, onnagata shape their standing postures by keeping their knees bent, turned inward, and pressed together. There are also techniques, which cannot be seen, that force or facilitate specific patterns that produce the fundamental onnagata gender acts. For example, to keep the knees bent and pressed inward and together, the abdominal muscles must contract, which forces the solar plexus down. This creates a stable posture for kneeling and standing, and also restricts quick locomotion. The "interior" posture forces the body into grounded movement patterns.[2] The onnagata gender acts and

intentional body form the basis for *kata* specifically used by onnagata.[3] In a twisted way, the ideal is intertwined with the flesh, muscles and bones are pulled and pressed into unrealizable fantastic forms.

There is a guiding principle that affects most of the basic physical techniques for onnagata gender acts. It is said that an onnagata should be like a shadow, servant, or *kōken* (stage assistant) to the tachiyaku. The onnagata must always intend to play slightly back, slightly to the side, and slightly lower than the main tachiyaku.[4] The late Onoe Baikō VII (figure 7.1) prefaced his explanation of onnagata *kihon*, affirming this principle and image:

> You know, of course, that the onnagata is supposed to be the shadow of the tachiyaku. You must appear smaller and behind the tachiyaku at all times. Onstage, an onnagata is like the *kōken* to the tachiyaku.[5]

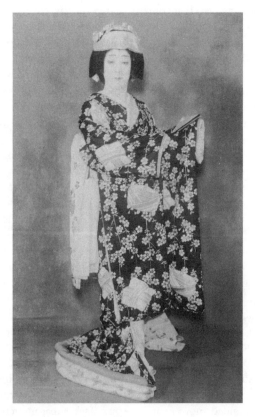

7.1 Onoe Baikō VII *musume* role type *Musume Dōjōji* (photographer unknown)

However, Baikō VII went on to describe how all the techniques of playing onnagata roles may begin with the shadow ideal, but, they are not limited to it. There are many scenes where an onnagata role is the central figure, looming larger than life, and many spectacular onnagata perform solo dance roles. Still, he affirmed that the shadow principle is "basic to what an onnagata intends to perform."[6] Baikō VII's son, Onoe Kikugorō VII (1942–), referred to an onnagata's performance position as part of a team of players, but an onnagata is usually "playing the defense to the tachiyaku's offense position."[7]

The basic gender acts and the intentional body compose a formula that onnagata use and manipulate in gender performance. But, again, an onnagata imagines the intentional body, but he performs his intentions. According to set patterns for specific role types and specific roles, he will change the intentional body. The gender acts particular to each role type are, for the most part, variations on the gender acts that make up the intentional body. Exceptions and variations abound for particular role types and specific roles.

Onnagata refer to very particular standards and ideals for each physical articulation. There is an intended, if never realized, line, shape, carriage, posture, and use of the limbs. Onnagata have an image of a body that is realized through intentionally shaping their own body as taught by master onnagata and then fitting their body characteristics to that prescribed form. The intentional body, even in the cases of certain *oni* (demon-like spirit) or possessed roles, aims at resonating with "beauty."[8]

In performance, the onnagata's body is a visual, kinesthetic, and aural instrument that he constructs from gender acts and with which he performs gender acts. First, the performer shapes his body as close as possible into the basic intentional body, which is made up of gender acts created to effect his principle "shadow" role. These gender acts are body-sculpting acts with which the performer creates what may be called the onnagata *sugata* (figure), *shisei* (pose), or *kamae* (posture or carriage). Because the basic *kamae* limits all motion patterns, then, it follows that the carriage and posture gender acts shape all gesture and locomotion gender acts. In other words, *kihon* gender acts "produce" other gender acts.

Besides the postural acts that construct his body beneath, makeup, costume, and wig designs create an onnagata's exterior architecture. Costuming and wig styles construct the surface image and remodel the onnagata's physical frame through the nature of their materials, shapes, and aesthetic rules. Costuming and wig styling are among the most complicated of onnagata gender acts. The postural acts and the acts of costuming and wig styling are the basic gender acts that onnagata use to create all gender role types.

The Art of Obscuring Maleness

Among contemporary onnagata, there are those who consider the basic gender acts to be strategies for obscuring some parts of the male body beneath. Much like fashion trends, different generations of onnagata have evolved their styles of using the basic gender acts. In his backstage dressing room in 1992, Onoe Baikō VII explained and demonstrated his onnagata intentional body. It is interesting to note what Baikō VII considers "natural" for a man but not for an onnagata:

> I'm a man, right? So I have to hide that I'm a man. Most fundamental and therefore most important, an onnagata must always keep the shoulders pressed down. You have to pull the shoulder blades together, until they touch, and until it hurts. I'm a man, so my shoulders go straight out. An onnagata's shoulders must slope downward. My hands are a man's hands, so I hide them, in the sleeves or under the obi. I make them look smaller and narrower by holding the fingers together, sometimes slightly curling up the little finger and the next one. If you hold a tea cup on one hand, hiding the little finger under the cup, and the thumb on the other side, you get the right shape for an onnagata hand, like a small seashell.[9]

The detail and exacting effort to produce the onnagata gender acts are critical and profound. Along with that focused concentration, onnagata perform with the consciousness that they are men underneath the acts. They hold different views on how to deal with their male-sexed body when playing onnagata gender roles. Baikō VII and some of the other onnagata mentioned some of the physical characteristics they worked to hide because these would reveal their "maleness," such as facial hair, big hands, big feet, a thick neck, height, or a small head and face. But, through their constant remodeling of their bodies through these physical manipulations, their everyday male bodies reflect their onnagata stylizations. Although they may speak of "hiding maleness," and their stylized acts leave only traces of their "real" body visible, the spectators' mind's eye still sees the male body beneath. This struggle exposes the tension between flesh and fiction, which contributes to the onnagata's alchemy of desire.

Onnagata speak about the particular difficulty of performing the characteristics of the onnagata roles because they are men. The "distance" between the onnagata intentional body and their own bodies, they say, requires enormous energy to even approach that ideal.[10] Several performers used the phrase *karada o korosu*[11] (killing the body), in reference to the painful physical reshaping and disciplined strength necessary for onnagata gender performance. Ichikawa Ennosuke III believes that somehow in this tortuous "body-killing,"[12] the performer gains the ability to exude and

produce the drama's erotic atmosphere or fragrance and to captivate his audience through his charm and allure.[13]

When describing their individual encounters with shaping the intentional body, onnagata share similar ideals, but they are careful to point out that another actor may do it quite differently. They have reverence for historical performative ideals that previous kabuki actors have established. They often focus on how closely they can replicate a famous predecessor's acclaimed *kata* for a certain role or role type. In order to do this, onnagata negotiate with their body beneath, the intentional body, and the historical star body. Thus, they *amend* the historical body and strive for an intentional body that will approximate the ideal image.

Unnatural and Ambiguous Acts

The process of becoming an onnagata is an individual evolution. Training and physical exertion and discipline are highly individual. Baikō VI, in his art discussions, maintains that the male body cannot become a female form because the male skeletal frame is different. He commends the efforts of onnagata of earlier times who endured enormous pain to adapt their bodies to the display of female-likeness.[14] Contemporary onnagata continue to argue that the female frame is too small and weak to maneuver the wigs and costumes. But, onnagata have invented a system of painful positions and movements to make their bodies appear like they have a small frame.

Onnagata articulate several fundamental illusions that they must create in their physical construction of onnagata gender acts. Among these illusions are smallness, grace, delicacy, and sensuality. To produce these illusions requires constant total control. They must contract and restrain their limbs and torso to maintain the required illusions. In interviews, many onnagata have emphasized the pain involved in constructing and maintaining the intentional body. Tamasaburō V remarked:

> There is nothing natural about performing onnagata . . . it is extremely difficult. There is no letting down, you must perform the finest detail, moment to moment. All onnagata roles are very difficult and take great physical exertion, mental concentration, and total devotion of the heart.[15]

The unnatural fabrication and restraint of onnagata gender acts draws attention to their theatrical stylization and ambiguity.[16] The intense attention to visual details, the muscular constraint, and the designed movement vocabulary required by the intentional body does not constitute a fixed gender identity. Rather, the physical techniques, the intentional body, and the gender acts are elements in an evolving onnagata gender construction.

The changes an onnagata makes in the gender acts demonstrate the performer's perception of his own onnagata gender image, his own gender fabrication. In all my interviews, not one onnagata said he imitated real women, but every onnagata commented on how he manipulated his body in particular ways to fit onnagata *kata*. Every onnagata has a sense of his onnagata gender look and how it works on stage.

In any culture, an ideology of perception defines the parameters for physical beauty and ugliness, sensuality and repulsiveness. As Herbert Blau states: "There is an ideology of perception which in turn affects the ideology of performance."[17] Both spectator and performer have learned the set ways of seeing and reading the performer body in its theatrical and cultural context. But, onnagata also manipulate that set of cultural perceptions (and their ideology) to create an intentionally ambiguous gender role. In this way, what onnagata do onstage, what they learn to immobilize, keep silent, or bend into a particular shape—what might be experienced as grotesque or unnatural or strange—is read as beautiful, yet strange.

Watanabe Tamotsu describes his interpretation of onnagata aesthetics and performance ideology this way:

> The onnagata then, is a fabrication. If seen through ordinary eyes, it is grotesque, something strangely offensive; after all it is nothing more than a fabrication. However, there is the moment when that strangely offensive fabrication touches a person's heart with the strength of the truth. Couldn't it be that the real meaning of onnagata, which is a fabrication, is the moment when the ugly can be seen as truly beautiful?[18]

Watanabe's hypothesis demonstrates how the onnagata intentional body is constructed, and it also illustrates its ambiguity. He goes on to explain how onnagata exploit their own physical limitations to construct the fiction of onnagata beauty and the way spectators collaborate in their fabrication. To illustrate, he uses the example of the older onnagata he has seen playing *musume* (young girl) roles throughout his lifetime. An onnagata like Utaemon VI, performing in his eighties, uses his gender acts to fabricate an image of onnagata beauty that is *grotesque*, but Watanabe suggests that onnagata grotesqueness produces its own version of "grotesque beauty."[19]

The crucial point here is that the onnagata intentional body is something "made and constructed,"[20] that is, highly artificial. The visual standard the performers strive to attain through discipline and personal inventiveness is the intentional body that is expertly controlled. The onnagata conceals the painful conventions needed for the ideal form. His line is far from "natural" because he must press, squeeze, and pull his torso into the shoulder-sloping line. The onnagata must be a master of the art of constraint, forcing

his muscles to contract and release in measured amounts to produce the onnagata grace, tinged with sensuality.

While some onnagata emphasize hiding their male bodies, others describe their aims in terms of constructing and performing gender, not male or female or *chūsei* (between genders), but an onnagata *sei* (gender).[21] Onnagata construction destabilizes the matching of performer body, gender role, and character type in theatrical representation. Onnagata point out that stylization makes everything exaggerated. The dance, in particular, magnifies through abstract stylization a fantasy of female-likeness who is outside the realm of any everyday referents.[22] In distancing themselves from the "real," onnagata free themselves from any kind of representation of women or fixed female identity and gain access to a wider interpretation of gender. Thus, the intentional body and *kihon* gender acts not only support onnagata performative gender ambiguity and transformativity, but further disrupt polarized gender identities and their ideologies.

The Basic Gender Acts: *Kihon*

In the following section, I describe the basic physical acts that onnagata perform in almost every role. In my analysis of these basic acts, or *kihon*, I observed which body parts were emphasized or hidden. I listened to how onnagata described their physical techniques and noted which movements or positions they judged as "poor" or "bad." Onnagata describe how they perform physical manipulations, how these intentionally hide some of their male-likeness, and how they strive for the ideal form for each basic act. They remodel their socially constructed male gender acts. They aim at disembodying the body composed of male gender acts,[23] to create an ideal onnagata form.

In general, the intentional body is composed of a restricted center and a controlled periphery. The torso is held in a specific manner and the limbs, in relationship to the torso, move in set, choreographed paths. But, while all movement is restricted, the restrictions, requiring great physical exertion, force an intensity of expression. Also immobility, functioning as a kind of physical silencing, is a strong component of all onnagata gender acts. Silence in speech acts and immobility in movement acts accord with onnagata precepts: to appear small and graceful and to maintain the line and design of the posture. It cannot be overemphasized that, paradoxically, the restricted acts, to a certain degree, empower and heighten the onnagata gender role image. Therefore, even if the onnagata is to shadow the tachiyaku role, he must also project sensuality, attract the eye, and, in certain courtesan role types, fill the entire stage with his presence. An onnagata must be able to perform with both riveting and luxurious grace and subtle, sensual deference.[24]

The Art of Posture

Each role type requires subtle adaptations to the basic form. The processing of gender acts through the individual styles of the onnagata body adds a fine layer of shading to the conventional patterns. The intentional body itself arose from these adaptations, which were based on abstract concepts of class, rank, and age and the physical requirements imposed by costumes and wigs. Further, the political markings of the role type require physical adjustments to the intentional body. For example, an exception to the basic two knee kneeling posture is the kneeling position of the high-ranking courtesan role type in which one knee is raised to support and show off the exaggerated costume.

The onnagata keeps his knees slightly bent and turned inward. With one knee slightly behind the other, he presses one knee into the back of the other knee. In standing postures, the onnagata twists his upper torso opposite to the knee angle, creating a twist up through the spine, which complements the front wrap line of the kimono. This basic posture makes the onnagata appear small. Further, it lowers the *koshi* (pelvic region), the center of gravity. With his center of gravity kept low and stable, the onnagata can control kneeling, rising, and changing directions. It is an ideal posture for moving fluidly with a heavy costume and wig. The control from the hips is essential for moving voluminous kimono skirts in one flowing sweep. The bent knees-in stance enables the onnagata to perform a smooth gliding walk or run, in which the whole body appears to glide horizontally over the ground, with no movement up or down on its vertical axis.

In the gliding walking style, the onnagata maintains his knees-in position by aiming his feet slightly inward. He steps by sliding each foot on an inward curving path, skimming narrowly by the other foot. He moves in half steps, just letting one foot glide halfway past the other before he shifts weight. This helps him maintain a constant, level *koshi*. In standing postures, sometimes the toe of the back foot tucks into the arch of the front foot. Onnagata train for this style of walking by moving with a paper held between the knees or thighs. If the paper slips, they have lost the tension and centeredness necessary to maintain this gliding walk. There are other foot techniques. For example, to facilitate turning, onnagata surreptitiously kick the kimono under skirts with a curved inward kick of the foot while keeping the knees locked together. There are many such tricks that the body beneath plays to maintain the illusion of grace and line.

The *nadegata* (sloping shoulders) are produced by pressing the shoulder blades down and pulling their lower points together and into the spine. This has the effect of making the neck appear longer, which, in turn, enhances the bare back neckline, where the angle of the shoulders disappears into a

long, soft curve that extends from ear lobe to sleeve tip. Onnagata say that the *nadegata* makes any torso appear long and slender.[25] Ganjirō III points out that the sleeves of a female style kimono are made to drape luxuriously off the sloping shoulder line, further increasing the long, sensual curve of the neck. The *nadegata* are clearly woven into many onnagata gender acts. Ganjirō III calls attention to the onnagata technique for exiting the stage: he dips the down stage shoulder lower than the upstage to expose his back neckline. By keeping this rakish angle, he increases the illusion of the slope of his shoulders and his appearance of slenderness.[26]

The *obi* contributes to the long curving shape. It wraps around the torso just below the shoulder blades and across the lower chest in armor-like layers, compressing and helping to maintain the correct posture. The *obi* also adds width to the torso, creating a straight line from shoulder to hips. The resulting line of the slender and sloping shoulders continues into the carriage of the arms. Onnagata usually press the upper arms to the sides of the torso, maintaining a constant narrowing tension. Young actors are told to keep their elbows closely attached to the torso, literally glued to the sides of the rib cage. Although these arm requirements produce small gestures, it takes great effort for the performer to move gracefully and soften his arm gestures while maintaining the required restraint of his postural configuration.

The Artifice of Hand Gestures

Onnagata strive to keep their hands nearly invisible inside their kimono sleeves. If they must reveal their hands, no matter what the task, onnagata have crafted skillful gender acts that create the illusion that their hands are small and slender, delicate and pale. All hand gestures, particularly the handling of kimono sleeves, the long kimono skirts, and small props, are stylized to the extreme. They are literally choreographed into dance-like patterns reflecting the early history of *wakashu* onnagata, whose gender acts were shaped by their early dance acts.

As mentioned earlier, Onoe Baikō VII demonstrated how to achieve the shape for the onnagata hand by grasping a small teacup, making sure to curve the two lower fingers under the cup, then removing the cup, taking care to keep the hand's softly rounded shape. He pointed out that onnagata frequently hide their hands in the kimono sleeves, or show only the fingertips or just up to the first knuckle. Jakuemon VI and his son Nakamura Shibajaku VII curl their little fingers to add delicacy to the shape of their hands. At all costs, onnagata must stylize the shape of the hands into tiny white shell-like forms by keeping their fingers together and their thumbs hidden. It is not just the small size that is important, but the shell-like shape and refinement of all hand gestures.[27] While small and delicate may seem

an easy fabrication, most onnagata noted the extreme effort it takes to maintain the smallness, to the point of crippling pain that often leads to arthritis in later years.

Over time, onnagata have developed exacting and exaggerated conventions for using the hands that have gone well beyond camouflage to an art. Critics and spectators may judge an onnagata's total command of a dance by the skill of his hand gestures. His hand gestures reveal his level of performance. Hand gestures accompany almost all movement; thus there is a vast hand movement vocabulary that must be mastered. In many roles, the onnagata's hands are whitened, making them stand out against the kimono. The whitened hand shapes and movements draw the eye to their sculptural forms and movement patterns. Hand gestures associated with the manipulation of certain props are particularly demanding. For example, in *oiran* (high-ranking courtesan) roles, onnagata frequently use the *kiseru* (long thin pipe) and the *mochigami* (folded tissue papers) as emotionally expressive tools. Many onnagata referred to the manipulation of hand props as an inner monologue or a time to express the role's *kokoro* (heart).[28] Like all *kihon* acts, each onnagata adapts hand gestures to best suit his own hands and his overall physical style.

Cutting a Line

Sen (line) refers to the line of the body. Tamasaburō V went so far as to say that for him, "line was the essence, everything,"[29] because it communicated emotion, design, character, beauty, sensuality, and even the narrative. The line extends from the top of the wig to the feet and includes the space around the body and any objects in that space. An onnagata's line must always have grace and sensuality. Onnagata refer to striking a pose as *sen o kiru* (cutting a line). *Sen o kiru* means that the onnagata must precisely compose his voluminous kimono, his *uchikake* of long, sweeping, multiple rolls of hems, his *obi* folds and loops, his sleeves, hand props, and wig ornaments into the perfect aesthetic line. This moment of *sen o kiru* should appear effortless.

Onnagata use hand props to extend the line of their body. For example, the wisteria branch, with huge oversized blossoms, held by the onnagata in *Fuji Musume* (Wisteria Maiden), must be held at an angle that matches and extends the line of the torso. The performer must also fit his line into the overall design of the set's enlarged tree and branches. Whether sitting, standing, kneeling, or bowing, the line of the body must be shown meticulously in relationship to the total set design. In every still moment, whether seconds or minutes in duration, the onnagata's line must be perfect as he arrives, cutting the line, without extra adjustments.

When onnagata speak of the body line, they are considering the three-dimensional architectural shape of the body in full costume in the set design. The body is always supposed to have a graceful, gentle or soft, *sen* (line). This correct line arises from the expert manipulation of the kimono-draped and wig-dressed "body." Although very difficult to manipulate correctly, the kimono obscures the torso and limbs, which are completely wrapped and draped in cascading layers of cloth. The kimono hides any actor body defects and helps the onnagata approach the perfect and required line. Even in ghost or ogre roles, under conditions of grotesque and violent acts when expressing horror or fear or despair, onnagata must still *sen o kiru*. It is these juxtapositions and these seemingly strangely constructed acts—when a young girl character suffers the pains of death while maintaining a graceful line or when a courtesan character avoids the blade of a giant hatchet by bending backward in a beautiful arch, an elongated arced line—that make the onnagata art of gender performance an art of fantastic design.

When the onnagata arranges his choreographed line in the stage environment, he places himself within a hierarchy, based on the status and gender role of characters and actors. In rehearsals, an older onnagata will adjust the position of a younger onnagata in relationship to other actors, the walls of a room, or even the distance to a sliding door. In brothel or court chamber scenes, onnagata who perform the supporting roles of attendant courtesans or court maids are extremely careful to arrange their individual body line according to a group design when they kneel or sit in clusters or lines at the rear of the stage. In order to maintain their line and design during performances, the group onnagata will adjust their posture, in unison, according to changes in position made by principal performers.[30] An example of this designed group line aesthetic occurs in the dynamic brothel scene, "Fuingiri," (Seal Breaking) from the play *Koibikyaku Yamato Orai* (Love Messenger of Yamato). During the entrances and exits of various characters and changes in emotional dynamics, the lineup of dressed-alike courtesans shifts in unison, minutely adjusting their knees, sleeve angles, and focus. They use the graphic power of their line and the dynamic pull of unison movement to direct the gaze of the spectators and to frame the stage action, both visually and emotionally.[31]

Even with their backs to the audience in total stillness, onnagata must place and maintain the line of their wigs, the scooped neckline curve of their back collars (if the back type) their *obi* ties, and the spreading hems of the *uchikake* or kimono precisely in the appropriate positions and shapes. If their physical design is not right, their still figures will detract from the main action and throw off the aesthetic balance. It is very easy to let tension or fatigue destroy the line of the body. For example, the two *jidainyōbō*

(period wife roles) Sagami and Fuji no Kata,[32] in the scene "Kumagai Jinya"
(Kumagai's Camp) of *Ichinotani* (Ichinotani), kneel with their backs to the
audience on each side of the stage during a lengthy monogatari (solo
narrative) by a tachiyaku. Their figures frame the tachiyaku playing the pro-
tagonist, Kumagai, who performs his epic tale using stylized movements
that are at once mimetic and abstract, an emotional gesture dance. He tells
of his killing of a young warrior in battle. What complicates his story and
makes the framing onnagata extremely important, is that he is describing
the death of one of the *jidainyōbō* sons. But, in actuality, Kumagai substi-
tuted his own son to spare the life of a lord's son. For the duration of this
lengthy and emotional monologue, which carries such high stakes for the
two wife and mother characters, the two onnagata rigidly maintain their set
postures. Their focused shape, line, and energy are absolutely essential to
framing, containing, and charging the emotional tension on stage.

Onnagata also use the level and placement of their gaze and their focus
to complete the body line and direct how and where the spectator should
look.[33] Onnagata seldom cast their gaze directly at another character.
Rather, they employ an indirect or slightly averted gaze, considering this to
be more potent. When taking any pose, no matter what the role type, an
onnagata sets his head and his focus at an angle that complements the line
of the constructed body, which, in turn, is part of the total stage design.

Onnagata practice many subtle acts of line and focus to draw every spec-
tator into an intimate, yet fictive encounter. Subtle acts, such as the averted
gaze, demonstrate the onnagata's consciousness of design to create their tan-
gible *uso* (lit. lie, illusion). Tamasaburō V, among others, remarks that even
in the most emotional scenes—like the death struggle of Okichi in
Onnagoroshi—he performs his line, the design of his body, not the "feeling"
of the character. To infuse the entire scene with the right balance of beauty
and horror, he doesn't recall a painful experience, or imagine terror of
death; he thinks of making his line perfect.[34] Nakamura Matsue V comments
that maintaining the design of his body in weeping and wailing scenes
forces him to repress overt expression, an action that makes his performance
stronger.[35]

The Art of Wigs

One of the most difficult technical skills for the onnagata to master is to
integrate his neck, face, wig, and wig decorations into the line and shape
created with the layers of costuming. The *katsura* (wig) and its various
looped and rounded sections are carefully crafted to complement, extend,
and exaggerate the curves and lines of the kimono and *obi*. The *tokoyama*
(wig dresser) is the artist who designs how the wig finishes the onnagata's

line and form. He compensates for the flaws of the actor's shoulder, neckline, and head and face shape by carefully sculpting the wig in ways that make the onnagata appear to have an ideal shape and line for each role type.[36]

In different family lines of onnagata, *tokoyama* have created the face and neckline shape for several generations of onnagata. To date, all *tokoyama* are men. Although there are many young women apprentices, they cannot be adopted into a family line and become official *tokoyama*. Because the wig is the last element of the costume, the onnagata places a special trust in the *tokoyama* because he finishes the onnagata's total look, and he is the one who sees the three-dimensional form of the onnagata as the audience will see him. Thus, the *tokoyama* have a position of prestige. When a *tokoyama* sets and ties on the wig, the entire shape of the onnagata transforms: the kimono wrappings, the *obi* ties, the *uchikake* neckline, suddenly settle into place. All the parts are made whole, resonating in one overall design concept.[37] While the *ishōkata* (costumer) is the primary builder of the kimono line, the *tokoyama* adds the final touch to the total shape. Thus, the *tokoyama* and *ishōkata* are master builders of the intentional body.

Wearing a wig is one of the onnagata's major gender acts. From the wig, the spectators know immediately whether the role is onnagata or tachiyaku. By its massiveness, low forehead, and close-in side hair, the onnagata's wig makes his face appear tiny and delicate. The play type and role type determine additional general wig requirements. Certain major roles have wigs that are used only for those roles. Onnagata wigs are considered much simpler and more formulaic than the tachiyaku wigs.[38]

The basic onnagata wig has four main parts, the *maegami* (front forelock), the *bin* (side locks), the *mage* (top knot), and the *tabo* (back neckline hair gathered in various shapes). The *maegami*, at the front top center of the head, outlines the forehead. The tokoyama shapes it for each role and determines the best browline for the onnagata's look. In general, the hairline is lowered on the forehead, diminishing the size of the face. The shape of the browline is supposed to give the onnagata the intentional ideal shape, which is currently a roundish oval shape. The *tokoyama* shapes the hairline to either elongate or shorten the onnagata's face. The *bin* are the two rolls of hair that sometimes fan or swell out from the sides of the face just in front of the ears. The *bin* usually come down behind the cheek bones to mid-jaw, or longer, depending on how the *tokoyama* is shaping the onnagata's face. The *tokoyama* usually checks to make sure the tips of the ear lobes appear just below the bin, "for *iroke*."[39] The *mage* is like the "crowning glory" of the wig. With few exceptions, its dome, flared shape, or bowl-likeness adds grandeur to the wig. The wig billows and swells, making the onnagata's face and body appear to shrink below the ponderous *mage*. It is often festooned with

decorations or tied with a colorful cloth, which signifies a certain role. The *tabo*, the lower back part of the hair frequently gathered into a bun or pony-tail, graces the bare white neckline and lightly shadows the upper back. Its black shape stands out in sharp contrast to the whitened skin. The *tokoyama* uses the *tabo*'s shape and its angle of curve away from the neck to make the onnagata's neck appear long and slender. Ultimately the wig parts become the wig itself. That is, each part's shape and volume create the architectural structure and "meaning" of the wig. In turn, the audience can read the character's role type, sometimes the exact role, from the selection and combination of *maegami, mage, tabo*, or *bin*.

Three different types of wig materials are used that vary from the older style to a "natural" style. In the older style, no attempt is made at simulating a scalp with hair growing. The wig fits like a cap; its edge presses against the skin in a hard dark line. The contemporary "natural" looking hairline is made to simulate a real hairline with hair growing from a scalp. The hairline has a soft edge. It is something like a Barbie Doll hairline, where you see the hair pulled through holes in a rubber scalp. The "natural" style is usually seen in the new kabuki plays, where the acting style is more "realistic." According to Ganjirō III, the "natural" style wig line is an influence from filmmaking, "to make the onnagata appear more *onnappoi* [feminine]."[40] The older, hard-line wigs belong to the artificial, fantastic, upper-class and court aesthetic in the *jidaimono* (period plays). In this style, the performers emphasize the fiction or "otherness" of the stage and their gender acts. Everything about the constructed body of the character demonstrates their extraordinariness. The wigs exaggerate the artificiality of the onnagata's female-likeness, heightening his intentional excess.

The first wigs or wig-like hairstyles were worn by *wakashu* onnagata. These styles first imitated the earlier *wakashu* styles of flamboyant and exaggerated *maegami, mage, bin*, and *tabo*. Their excessive hair styling was part of their codified erotic attraction system. As discussed in earlier chapters, courtesans and merchant- or samurai-class "men about town" who visited the brothels imitated the kabuki wig styles in their hairstyles. It is likely that the popular fashion for kabuki-like hairstyles encouraged onnagata to experiment with more extreme wigs and wig decorations, which not only set off and exaggerated their fictional female-likeness, but also strengthened their transgressive hold on erotic beauty.

The wig styles of the early onnagata changed rapidly. But certain styles caught on and were repeated and codified for each onnagata role type. In general, the enlarged wig with the lowered brow creates the illusion of a diminutive face, which is now part of the onnagata intentional body. For example, Utaemon VI's "natural" face is considered too large for his small stature. His wigs are specifically designed to diminish his face size, with a

low brow hairline and large and long *bin*. This is Utaemon VI's remodeling to approximate the intentional body, which simulates, in a kind of masquerade, a small child-like image, not unlike the early kabuki *bishōnen* (beautiful boy) ideal. The billowing and silken rounds of the onnagata's wigs clearly mark their erotic intent. Further, the "undoing" of onnagata wigs in scenes of violence or seduction not only amplifies the loss of their stylized eros, but also the possible "revealing" of different bodies and desires.

The Art of Makeup

An onnagata builds a mask-like face by applying dense white makeup and by pulling and tightening facial skin through various methods. Matsue V quoted his father Utaemon VI saying, "Your face is a living mask."[41] Utaemon VI and other older contemporary onnagata emphasize the liveness of the onnagata face. They take pride in their faces' expressivity, saying it is one of their twentieth-century innovations to onnagata art. But this should not be misconstrued to mean free-form or realistic expression. Rather, there is a greater range of stylized facial expressions and methods of making up their features. Facial "expression" depends on the individual onnagata who finds his own way to manipulate the onnagata gender standards of facial beauty: small, delicate features in a moon shaped face. A nose with a high, narrow, and straight bridge is considered an additional asset. In ordinary situations, only slight movements of the eyes, a tiny puckering between the eyebrows, and pursing the lips make up the standard vocabulary of facial expressions. Depending on the role type, under emotional duress, there are additional stylized facial expressions and makeup that will distort the features. Onnagata use large and intense facial expression only under extreme conditions such as death, mourning, or radical transformation. In Japan, smiling with teeth showing is not considered beautiful. Utaemon VI added a large, mocking smile, almost a leering grin, to his famous courtesan role Yatsuhashi of *Kagotsurube* (Kagotsurube—the name of a famous sword).[42] In this case, the courtesan role is reacting with this hideous grin to a jovial but ugly and pock-marked male country bumpkin character, who falls in love and gets used and refused. He eventually murders the courtesan. Utaemon VI's wide toothy smile was considered an incredible innovation, but now has become a standard *kata* for that role. It is striking to see the perfect painted face and rose-bud mouth crack open so suddenly and flash the face beneath.

Most onnagata paint and reconstruct their facial features into their rendition of an ideal, an "intentional" face. To this they add the makeup conventions specified for role types or a specific role. First, onnagata keep their faces, including their eyebrows, totally clean shaven. Before putting on

the standard white base, they smooth on a cream and a soft wax into the areas where they have facial hair growth. This smoothes and fills those areas and ensures a perfect surface for the desired flat whiteness. Some onnagata pull back and tape any sagging or softly wrinkled skin along their brow and jaw line. Tanosuke VI has made an art of taping (later hidden under his wig), to slightly lift and smooth his facial skin into a perfect canvas. Some onnagata may shade certain areas, like the sides of the nose or cheek bones, with a deep rose pink. After the white base is painted on, the rose darkened areas slightly model the facial features and add a glow beneath the white.

Eyebrows, eye lining, and lip painting go on top of the base white. All of these vary by role type. Some roles have no eyebrows because shaved eyebrows was an Edo period convention indicating a woman was married. Some courtesan characters also shave their eyebrows. In general, aesthetic convention dictates that the mouth should be very small, "like a rosebud."[43] The eyes should be a slightly rounded, almond shape. Eyes that are too long or too wide are problematic. To achieve the almond shape, onnagata will draw a half moon shape using a deep red liner at a strategic place on the upper eyelid. Over this they draw a thinner black line. The red creates the shadow necessary for the almond shape. Eyelashes are neither darkened nor lengthened.

Every onnagata devises his own way to get the intentional face. Onnagata consider it an art to create their own stylizations, which are based on the ideal features, but enhance their individual features. For example, Jakuemon VI is very flamboyant with his style of lining the eyes, and enjoys enlarging and lengthening the dark line under the eye. Tamasaburō V draws a red half moon shape in the very corner of each upper eyelid, which enhances the almond shape of his eyes and makes them appear larger. Ganjirō III puts the rose shadow under his white makeup on each side of his nose and then paints a stark white line down the center of his nose to accentuate the illusion of a high bridge.

Smoothing on his white mask, an onnagata first erases certain personal characteristics, then constructs a face on his face, a "living" face. Onnagata frequently remark that when they start putting on their makeup and see that "other" face emerge, that is their moment of transformation into onnagata.[44]

The Art of the Eriashi, the Nape of the Neck

The onnagata's "play" between gender role conventions and glimpses of his own body beneath adds a sensual, yet disconcerting, edge to his gender performance art. An example of this can be found in the way the onnagata may reveal his own back hairline and skin even though he whitens his *eriashi* (nape of the neck) and outlines onnagata "hairlines." The exposed *eriashi* is the onnagata's most erogenous zone. The display of the *eriashi* is considered

essential to the art of the onnagata. It is also a zone where an onnagata may choose to expose his body beneath his onnagata female-likeness. Each onnagata designs this area very carefully. To create his *eriashi* shape and line, an onnagata first paints and powders several layers of white makeup over his neck and shoulders, chest and upper back, to just below his shoulder blades. Some star onnagata may have their designated high-ranking *deshi* (apprentice) whiten their upper back to make sure it is perfectly smooth. The *eriashi* is always carefully made-up with several layers of white makeup, finely patted and powdered so that no amount of sweat will alter the smooth, white surface even after hours onstage.

In most role types, the kimono's back collar defines the lower curve of the *eriashi*. When wrapping on the kimono and *obi*, the costumer will pull the back collar into a deep oval curve meeting the top of the *obi*, which he then tightens to help hold the collar in place. At the top, the lower loop of hair at the back of the wig, the *tabo*, rests just above the base of the neck, not quite touching the carefully whitened neck and upper back. As I mentioned before, the black shining *tabo* against the whitened skin has a striking effect. Wig dressers take great pride in shaping the *tabo* to make a performer's neck appear long, slim, and willowy, with the curved *eriashi* its perfect oval compliment.

Although onnagata do not disguise that they are wearing a wig, they do create with white makeup a stylized illusion that the wig grows out of their own hairline. Descending from underneath the *tabo*, down the nape of their necks, they leave two long and narrow v-shaped lines unwhitened. The unpainted lines are supposed to represent the hairline that grows just down the neck. Young onnagata spend hours perfecting these delicate lines, which accentuate the glowing white back against the curve of the kimono collar. Sometimes an onnagata's top apprentice will take care of these lines. Others, like Tanosuke VI, who have perfected their lines, claim that only the angle of their own hand can brush the two perfect white curved lines.[45] However, for all their perfection with their wig and hairlines, when putting on the white neck makeup, onnagata do not completely whiten their ears, nor do they whiten their own hairlines so as to have it look continuous from neck to under the wig. Spectators can see the unpainted hairline and backs of their ears during certain moves, such as bows, back poses, forward tilts of the head, and various dance movements that expose the back.

When spectators see the onnagata's own skin and hairline, they see his body beneath. The spectators may read the gender role and the male body simultaneously or voyeuristically. But no matter what, the revealing is performative, a part of the onnagata gender act. After such detailed techniques of fabricating the onnagata gender appearance, it seems contradictory that a highly visible area is left slightly exposed. When asked about this, several

onnagata were surprised and replied that an onnagata should be careful not
to expose his real hairline. However, others commented that that was part
of their onnagata *iroke* (eroticism) and that some of their maleness should
show through their onnagata female-likeness: "After all, everyone knows
I am a man. To completely cover this fact would destroy the ambiguity of
the illusion. The spectators experience and enjoy the *uso* [illusion] because
there is this little reminder that, 'oh, he is a man.' "[46] Thus, the exposure
of the body beneath, consciously or unconsciously, supports the onnagata's
intentional construction of gender ambiguity.

The Art of Voice

While physical and visible acts are important gender acts for onnagata, so are
those acts related to speech. Among these are patterns of articulation and
enunciation, with their subsets of pitch, tone, and sound quality. I would add
three other categories of voice acts: silence, crying, and mimed song. The
mimed song category refers to the voice-related acts that sometimes func-
tion as silent monologues made up of gestures related to the lyrics of a song.

An onnagata's voice is critiqued, very much like a musical instrument, in
terms of pitch, nasality, tone, and clarity in pronunciation. There seems to
be a range of pitch and styles for each role type. Kabuki actors communi-
cate with a choreography of gesture and posture that enacts the words or
subtly underscores their meaning. Generally, each onnagata has his own
vocal characteristics, which he tunes to the role type and the emotional col-
oring of the dialogue. To a certain degree, contemporary onnagata inscribe
gender into their voices according to role types. But even then, the vocal
characteristics are highly individual even if the onnagata is imitating an
older famous onnagata's style for a certain role.

In the Edo tradition, there is a strong preoccupation with the *kata*, or
stylized convention of word and gesture choreography. Thus, there is a
greater emphasis on reproducing the historical conventions of gesture and
word in time and space. Several onnagata commented that roles in Edo
plays were much more exacting in the matching of gestures and words. For
contemporary onnagata, it seems that appearance and choreography are the
fundamental tools for role type characterization, and there is less emphasis
on dialogue than action. While vocal quality and delivery are important,
these may vary from onnagata to onnagata.

Silence is an important onnagata vocal gender act for several reasons.
First, there are many supporting onnagata roles, such as the lines of lower-
ranking courtesans in brothel scenes. Their still poses and silence, although
sometimes broken by short unison responses of one or two words, are an
essential part of the scene's rich atmosphere. Second, many lead onnagata

roles have long periods of silence, during which they act out certain tasks or witness scenes largely composed of tachiyaku action and speeches. The acts of silence are significant to onnagata gender art. Perhaps, in the same way that their prolonged kneeling postures are "actions," their silence can be considered a special onnagata language act. I think that these acts are based on a different system of communication similar to what Trinh T. Minh-ha describes in the context of women's speech: "Silence as a will not to say or a will to unsay and as a language of its own has barely been explored."[47]

The Art of Kneeling

Nakamura Ganjirō III carefully underscores that along with kabuki dance, an onnagata must study and practice the art of kneeling.[48] Most onnagata roles require extensive kneeling, and many gestures and movement sequences are performed in kneeling postures. While onnagata kneel for many reasons, including the need to appear smaller and lower than the tachiyaku roles, kneeling is also a beautiful way to display their kimonos and designed lines. Many onnagata role types feature distinctive forms of kneeling. Much of onnagata performance relies on this posture. Over time, through ingenuity and necessity, onnagata have created a distinct art of kneeling performance.

Long periods of stillness in kneeling positions are very painful. Even with long hours of practice, there is considerable discomfort in these positions, and onnagata must develop endurance and ways to deal with pain. These poses are debilitating for the knees and ankles. As they grow older, onnagata adapt the kneeling postures to accommodate the loss of flexibility. There is a general acceptance among older onnagata that performance requires sub-duing pain during extended kneeling postures. They have developed various methods to deal with the pain. For example, they will pad their knees with the folds of their costume or wrappings or they will use medicines. Many onnagata spoke of diverting their concentration away from the pain.

While kneeling may be very difficult, an onnagata develops incredible power in his grounded position. There is a sense of strength in his torso, hips, shoulders, and arms, which look frail when surrounded by the kimono's mass of long skirts. When an onnagata is anchored in a kneeling posture, even in a thin or simple kimono, he has the subtle power to diminish or amplify his presence. When standing, an onnagata must bend his knees and squeeze himself into a smaller body. But in the kneeling posture, he can gracefully extend his torso, arms, and neck, and perform fully, without fear of overwhelming the tachiyaku. While kneeling may be a restrictive pos-ture, it has the advantages of liberating the upper body for a greater range of expressive movements.

Kneeling and performing from kneeling postures are culturally encoded gender acts that are too often dismissed without distinguishing their complex, embedded gender codes. For example, in Japan, the lowering of the self to another, as in bowing, has many shadings of meaning. When one performs these physical gestures, there is the immediate communication of a level of respect for the other, and a degree of humbling of the self. Simultaneously, the lower person gains prestige by demonstrating the correct acknowledgment. There is an art of nuance to even the simplest communication.

Kabuki onnagata stylization patterns assimilate these cultural acts into the history of fictional female characters whose great virtues were submission, repression, and endurance. In most of their patterned gender behavior, onnagata aim to diminish the self, to recede, and to submit to the prevailing situation, which is governed by the highest-ranking male actor. Kneeling postures emphasize this status and command attention through the actor's skill, grace, and sensuality. At the same time, because of the cultural complexity of levels and iconic gesture language, these postures also transmit subtle information concerning status.

More than any standing posture, kneeling postures are the base for many gesture and locomotion patterns. From this deeply rooted position, where the lower extremities are folded into a base of support, an onnagata can perform the gamut, from ordinary task sequences to complex emotional expressions. This facility may be due in part to the nature of Japanese architecture and the body movement culture it reenforces: small rooms with *tatami*, or rice mat platforms as the flooring, minimal low furniture, and sliding doors. Part of the female role is to serve within this environment, and the kneeling posture is well suited to these activities. If the onnagata must perform lower and behind the tachiyaku, yet still be mobile to serve, it follows that kneeling postures are the most effective for his gender role status.

These kneeling postures are also positions of display for all the elements of the costume. Onnagata create unusual and stunning visual designs that arise from performing these postures in the kimono, *uchikake*, and *obi*; wearing various wigs, and manipulating hand props, such as the *tenugui* and *kiseru*. The kneeling postures afford a wide vocabulary of forms and lines that differ from those that onnagata are able to achieve in standing positions.

The movements in and out of kneeling postures are an equally important aspect of the art. Every change in kneeling direction, level, or style, and any complete change from kneeling to standing or vice versa, requires choreographed sequences for parts of the costume and the realignment of body lines. Anything attached to the body or in relationship to the body must complement the form of the gender role type. Standing, stepping, and

rising from a kneeling position is a virtual dance, and onnagata must be dancers to have an awareness of total body design.

Examples of choreographed acts of kneeling are abundant in kabuki dance dramas. Countless courtesan roles of various ranks make an art of "entrance, kneel, bow, stand, and exit." In *Kagotsurube* (Kagotsurube), two onnagata play high-ranking courtesan roles, who have been summoned for inspection by customers for the night's entertainment. Their complex kneeling postures reflect the strength necessary to support the layers of kimono, *obi, uchikake,* and wig, each decorated for greater eye-catching attention. The onnagata in the *musume* role in *Fuji Musume* (Wisteria Maiden) slumps into a seductive, low-lying posture as if in a *tatami* brothel room. The onnagata in the *himesama* role, Yaegakihime, in *Honchō Nijūshikō* (Twenty-Four Examples of Filial Piety) moves in and out of kneeling and praying, kneeling, and hugging a pillar, kneeling and posing near the male lover role. During the *kudoki* section in *Musume Dōjōji* (The Maiden of Dōjō Temple), the onnagata performs in a half-kneeling posture on one knee, while doing mime-like gestures such as writing a love poem and looking into a mirror. There are also wilder kneeling dances, as in the murder scene of *Onnagoroshi* (Woman Killer), in which the onnagata playing Okichi takes kneeling postures in spilled blood and oil. These are all performative acts of kneeling that are particularly gender coded to show grace and elegance, seduction and subordination, turmoil and torture.

There are many scenes where onnagata in supporting roles, such as maids or lower-ranking courtesans, must perform small tasks that require expert kneeling. These daily-task sequences should appear effortless and almost invisible. For example, when entering a room through the rear sliding doors, an onnagata begins with kneeling outside, bowing, rising, entering, kneeling, sliding the doors shut, bowing, and then repositioning his body in line with other roles in the interior space. These sequences change slightly with the change in class and individual status of each role. The group lines of kneeling courtesans must maintain a sense of breath and grace in their kneeling postures for an hour or longer.

Sometimes a group of onnagata must make unison responses to stage actions by main characters. These unison responses should appear wavelike and elegant, as in, for example, the row of courtesans behind the tachiyaku in the "Fuingiri" (Seal Breaking) scene of *Koibikyaku Yamato Orai* (Love Messenger of Yamato). In such cases, there can be no moment without an awareness of the group onnagata shape, composed of their individual acts of posture, costume line, and gesture. When the disliked Hachiemon enters, they shift as a unit away from him, which requires a sequential adjustment of knees, torso, kimono skirts, sleeves, and hands. The onnagata must move his body beneath within the extended body of the kimono and wig. Every

move reverberates through the kimono and wig requiring extraordinary control: his flesh and musculature simultaneously separated, repressed, and assimilated.

To control all movement in and out of the kneeling postures, onnagata concentrate on the *koshi* (pelvic region or solar plexus). The aesthetic requirements of their gender acts compel the onnagata to perform all their actions from their solar plexus. For example, by lowering their center of gravity, if they want to move their long voluminous kimono skirts, *obi*, the heavy *uchikake*, and other layers of costume into the prescribed forms and lines of the intentional onnagata body, they must lower their center of gravity into the *koshi* and direct movement from that taut solid musculature. In addition, when manipulating his kimono into place, the onnagata must keep any hand, leg, or foot movement surreptitiously hidden. An onnagata who moves from his periphery can appear awkward and rigid. But an onnagata who pulls his energy inward, toward the *koshi*, and consequently draws in the space around him, moves gracefully.[49] By directing movement from the *koshi*, the onnagata creates a sense of compactness, precision, and refinement. Ultimately, he moves with centered integrity in every movement. The Onnagata "grace" is internal.

When onnagata play top-ranking *oiran* courtesan roles, like Yatsuhashi of *Kagotsurube* and Yūgiri of *Kuruwa Bunshō*, they use kneeling postures in complex moving sequences, which require enormous strength and precise skills. They move with a low, grounded center with absolute grace. They also employ a special kneeling posture called *tatehiza* (lit. standing knee),[50] in which they kneel on one knee while the other is erect. This onnagata kneeling posture stands out from all the others, in which limbs are kept tucked in close to the torso and hips. Unlike other onnagata kneeling postures, which make the body appear smaller, the *tatehiza* makes the courtesan seem larger—almost blown up. The *uchikake* and front *obi* styles appear to blossom out from the body, and the huge wig styles compliment this broader kneeling posture. Added to this, the onnagata often slips one arm into a sleeve and leaves the bent elbow inside the sleeve, lifted away from the torso. The total effect of the *tatehiza* form is at once ostentatious and sensual.

Reading the kneeling acts as purely submissive or as beautiful female-like postures misses their full implications. Instead, I think these acts should be recognized as highly complex gender prescriptions and aesthetically erotic acts. Onnagata are never "just kneeling." They are simultaneously performing the gender acts of an onnagata role type, a particular character, and an intentional and fictional ideal, each of which uses kneeling in a different way. On top of that, onnagata also perform their own physical adaptations of the kneeling *kata*, which will evoke in their audiences an erotically sensual response.

I think it is necessary to examine onnagata kneeling postures for the way onnagata use them to communicate different meanings and feelings. For example, onnagata kneeling acts may be read not only as submissive, but also as powerful, grounded, erotic, or even subversive. When an onnagata kneels and bows and carefully pulls open a screen, we may see this as submissive, but the act is also sensual and alluring. When an onnagata in a *jidainyōbō* (period wife) role, kneels with his brocade *uchikake* fanning out around him, he commands the space. When the onnagata in a princess role kneels and prays before an altar, or kneels and offers *sake* to a priest, the kneeling onnagata momentarily steals our attention from the main action. We are kinesthetically drawn to the onnagata's line, rhythm, and shape. In the moment of kneeling, the onnagata may communicate a subtle innuendo that can shade the male hero's actions and dialogue and create a far more complex reading of the hero's character.

Onnagata utilize the kneeling posture as an important base for many of their gender acts. Mourning, seduction, and play are all played out in these kneeling postures. In general, kneeling postures accord with the general prescription that onnagata perform lower and as a shadow to the tachiyaku. Onnagata channel the forces of submission and repression into stylized expressive gestures that they must physically and spatially restrict in their low kneeling postures. But rather than limiting their power, these controlled physical postures also provide a grounded physical base, which amplifies the energy of the performer by concentrating the energy of the performer. The power of their kneeling gender acts is in their simultaneous and often contradictory intentions. Kneeling performances can be layered with gestural complexity, which may reveal, simultaneously, passionate feelings and perfect decorum.

Material Acts: The Art of Costuming

Gestures, postures, and vocalization patterns, which I have been describing, are, in some ways re-created when examined in the context of the onnagata's costuming acts. Here I examine how the onnagata's costume is a visual and kinesthetic vehicle for their gender acts and aesthetics. To begin, the costume designed for a specific role type is like a "uniform" for any role in that role type category. The costume literally embodies the role type. For different role types, the costuming devices differ, impose on, and provide different restrictions and different allowances for the actor body. It follows that the set role type costume is a major factor in determining the gender acts for that role type. Onnagata learn to use the kimono properties of texture, weight, color, and design to enhance their gender role type performance. Throughout the history of role type development, actors have renegotiated these role type "uniforms" and added or adapted the costume's prescribed

framework and parts to various exigencies of their body beneath. The play between their bodies beneath and their costuming acts sets up another space for slippage and gender ambiguity.

On one hand, onnagata can use the wrapping of the kimono to produce fictional possibilities for the viewer (figure 7.2). He may cover his bad legs,

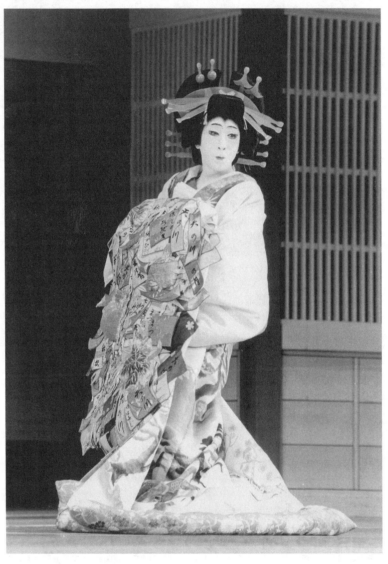

7.2 Nakamura Jakuemon IV *yūjo* role type Agemaki

his large hips, or his missing foot and create a sensual illusion of lower extremities. On the other hand, kimono aesthetics themselves dictate particular forms as ideal, and the cloth and wrapping methods hide and shape whatever is underneath. Onnagata strive to "remodel" their bodies as far as physically possible. After that, the costume's properties, with the aid of the costumer, take over the body-sculpting process to maximize the closeness to the ideal of female-likeness. In that process, the onnagata and his costumer create a dynamic tension between his body and the costume gender acts.

The Art of Costuming in Performance: Agemaki in Sukeroku

The following example of the *oiran* role, Agemaki (figure 7.3), in the play *Sukeroku Yukari no Edo Sakura* (Sukeroku: Flower of Edo), illustrates how the onnagata costume acts contribute to the construction of the *yūjo* gender role type. The onnagata demonstrates through his costume acts the power of gender construction and the simultaneous power of gender ambiguity created between the costume acts and the male body beneath. The costumed performance of an onnagata in an *oiran* role exemplifies a fabricated gender role of monumental scale. Agemaki's costuming[51] is an example of the peak potential of the onnagata costuming as gender role performance art.

How does the costume take over the body beneath and create its own shape, gestures, and locomotion patterns, it own performative gender? The onnagata playing Agemaki is a construction of fabulous layers and sumptuous colors, patterns, textures, and ornaments. Every angle of the costume "body" or construction is striking in the ways designed shape, line, and color create startling and different pictures. In addition, the costume's materiality of fabric texture, weight, color, symbols, and patterns has its own performativity, which not only moves the performer in certain ways, but also resonates with meaning to those who can read the embedded Japanese Edo period iconography.

The *oiran* is one of the most extravagant of all the onnagata gender costumes. The male actor body is reconstructed, wrapped, and decorated into a fantastic sculptural shape. In this role type, the onnagata is like a human vehicle for the exquisite art of draping, wrapping, and binding the layers of kimono and *obi*. The central performative aspect of the onnagata costume is its sculptural, designed form. The onnagata as *oiran* moves like a monument across the stage, defining the space around him. The slightest move vibrates through the costume. Although the costumed figure is massive, the *oiran* is also meant to be a vision of beauty, floating somewhere just beyond human touch. As an other-worldly and humanly sensual object on display, the costumed figure of the *oiran* is a highly stylized exhibition of contrasts.

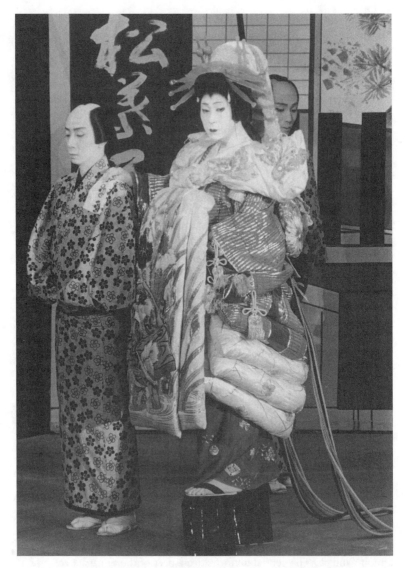

7.3 Nakamura Fukusuke IX *yūjo* role type Yatsuhashi

In the play, *Sukeroku*, the onnagata in the role of Agemaki enters on the *hanamichi*, the raised rampway through the audience to the stage, in a slow *dōchū* (courtesan parade), which shows off the finery of the *oiran* and the entourage of attendants. In licensed quarters like the Yoshiwara of Edo, the *dōchū* was a way of advertising the courtesan to potential customers.

It was part fashion show and part parade made into a performed advertisement. On the kabuki stage, the onnagata appears like a human "parade float." The actor body and gender role are on display simultaneously. The onnagata as *oiran* wears very high *geta* (wooden clogs). The onnagata's costume spectacle begins with the *geta*. He towers over and above every other performer.

As his kimono's brocade fabric shifts, gold threads catch the light, various hems slip in and out of sight, and any gesture of the onnagata's body beneath may be amplified or buried by the costume. The massive wrappings have an imposing physicality, which the onnagata must move against. The onnagata as Agemaki can barely move without assistance. He must balance with one hand on an attendant. The billowing *uchikake* is pulled up into a balloon-like shape and its padded hem rolls are tucked up near the ankles. The elaborate wig that crowns the costumed body compliments with its mounds and rolls of hair, festooned brilliantly with the decorations of gold braid and tassels and rows of tortoise shell hairpins. Onnagata speak frequently of the struggle to *sen o kiru* (cut the line) or make the perfect designed pose with such mammoth proportions of costume. They say an onnagata's art is most difficult because of having to perform with restraint in the exaggerated costumes, but that is also its extraordinary fascination.[52]

Turning to the costume itself, there are several outstanding features of kimonos that lend themselves to reconstructing the body beneath. The kimono and *obi* are extremely adaptable. The kimono is both a decorative surface and a sculptural object. It is wrapped and layered and tied. Certain features are highly moveable: for example, the sleeves, the skirts, hems, and the *uchikake*. All of these characteristics may be used to shape and shade gender role execution and to create a costumed gendered body with its own variable eroticism. Highly stylized elements of female-likeness are coded into the kimono and *obi* system.

Costumes are not constructed for ease of movement, but for specific patterns of movement and specific sculptural lines in poses and movement. An onnagata aims at having every surface and angle of his costume body arrest the eye. His performance is a "designed" sensuality. One performance concept is that the body performs best when constricted, or compressed within a form. The costumes are bound and wrapped on the body in layers. Performing through this restricted armoring, the onnagata must move subtly. There are exceptions but, for the most role types, onnagata are bound into several layers of kimono, and sometimes with padding added to not only create the correct line, but also to ensure this tight fit. However, this binding also supports the body and channels its energy.

Layering is essential to the kimono costuming system. That is, the performance body is built through layers. Costumer and onnagata work to

achieve a layered shape and to keep just the right amount of layering visible. The front opening of the collar, inverted-V opening of the kimono skirts, the back scooped neckline, the edges of the *obi*, and the edges of sleeves are special sites for exhibiting the folds of the layer underneath. These layered edges also highlight the areas of *iroke* (sensual eroticism) for the onnagata gender role, especially the back scooped neckline, which is usually edged in a contrastive color like red.

The layered edges outline the various parts of the costume, such as at the neck, upper back, sleeve openings, and hems. His movement should not change the lines of the kimono layers. However, these layers are slowly loosening during the action of the play. What is wrapped becomes slightly unwrapped. The idea of being just slightly undone, like a subtle flaw in an otherwise finished piece or an element of refined carelessness in the perfect surface is a part of costuming and appearance aesthetics. Different actors will even loosen their collar or *obi* tie just slightly after getting costumed. The slight irregularity is eye-catching. The onnagata as *oiran* exploits the flawed costume feature by folding one portion on one side of the neck collar inside out. Seemingly casually, he exposes a little more of his whitened neck against the brilliant red underlining of the folded collar.

We never see the onnagata's kimono as one piece of cloth with continuous sweeping lines. Rather, it is usually gathered and pulled, folded and tied, and divided and molded against the body into stylized shapes, specified to a role type or character. Each part of the kimono is raw material for the desired sculptural effect. Even the most lightweight body-revealing kimono is still manipulated to produce a stylized shape related to, but not replicating, the body beneath.

Nevertheless, the costume, for all its wrappings, reveals the layers underneath. In this example, the onnagata tucks up Agemaki's *uchikake*, and reveals the *dōnuki*, his under-kimono. The soft *chirimen*, or crepe-like fabric of the *dōnuki*, just touching his bare, whitened feet reveals an inch of yet another under kimono. Agemaki's back view is a landscape of cascading curves: the neckline scooping downward, the *uchikake* billowing below, with its gathered hems looped up just above the ankle. Agemaki's front view is a vertical fall of gold cords over an embroidered and embellished brocade *obi* in the front *manaita*-style (cutting board style). The *manaita obi* starts high on the chest, just parting the *uchikake*, and the V-shaped closing of the *dōnuki* arches out and down to the actor's feet.

The *dōchū uchikake*, itself, is a collage of traditional images for the New Year's celebration. On the *uchikake*'s black satin ground, a decorative *shimenawa* (the sacred Shintō shrine rope) runs across the shoulders, *konbu*, (kelp tangles) fall from this and an *osanae*, or *mochi* (a special rice cake offering) is placed in the center. Down the center is a combination of more

stylized New Year's decorations called *hondawara* (seaweed), and the *urajiro*, (fern leaves), and *Ise ebi* (spiny lobster). These are draped on the back of the onnagata, similar to the way they are hung on gates and doors during the New Year season. Also floating about on the dark ground of the *uchikake*, are traditional pine tree decorations, a *hagoita* (battledore) decorated with the two (male) gods Ebisu and Daikoku, representing the New Year's wealth and prosperity, shuttlecocks, and several *temari* (hand ball) of colored thread. The onnagata performs with the *uchikake* a moment of sensual, aesthetic, and nostalgic delight.

On reaching the main stage area, the onnagata in courtesan attendant roles scramble to unroll his *uchikake*. They untie and spread the *uchikake* and under kimono skirts so that the mounds of cloth billow out onto the floor. Then, for a moment, the onnagata attendants melt back, while the onnagata *oiran* spreads open his arms in a sweeping gesture like a large exotic butterfly. The *uchikake* is a panoramic picture of spectacular symbols. There is a moment of utter breathlessness in the theatre, then, breath, then, applause. Like an evocation to the gods, the audience responds in rapture and appreciation to the onnagata's performance of Agemaki's costume as a stunning visual display. The onnagata simultaneously displays the icons and performs the icon.

The moment is brief as onnagata attendants quickly lift up the skirts, and the onnagata as Agemaki turns to face front. The front *obi* now dominates with its *koi no taki nobori* (a carp ascending a waterfall) design that is executed in a three-dimensional style of embroidery, with a waterfall of silver and gold threads cascading over the giant, upward leaping carp, a symbol of male fertility. The carp is so brilliant and eye-catching that the onnagata looks like the waterfall, with his *uchikake* opening like a mountain crevasse. At this point, the actor half sits and half stands on a stool to maintain the frontal display during the next speeches. Settled into statuesque positions, the onnagata *oiran* and his troupe of onnagata attendants become a kind of brilliantly hued human tapestry.

Later in the same act, the onnagata playing Agemaki makes another entrance, from the gate of the brothel, center stage. He has changed his *manaita obi* and *uchikake*. Their character and imagery have a different tone. The *tokiiro* (yellow pink satin) *manaita obi* (figure 7.2) is now a hanging curtain of *tanabata* (festival of the star Vega) poem cards and children's wishes mixed with special leaves in a gold brocade embroidery. *Tanabata* is a festival of summer, which celebrates the myth of two lovers who may only meet once a year when their stars come close enough in the sky.

The costuming communicates the bitter sweetness of lovers who may never be truly united, like a prostitute courtesan and a true love, a frequent theme of kabuki plays of the licensed quarters. The *manaita obi* also resembles the traditional *tanabata* branches that children decorate with their wishes

written on poem cards at that time of the year. The branches with their dangling wishes are hung outside their houses. The *obi* is festive yet reminiscent of an unrequited love and suggests nostalgia for childhood dreams.

In the last sequence of this act, the onnagata strikes a final pose with the tachiyaku playing Sukeroku, the hero role. The onnagata takes center stage, and with a slow turn upstage, luxuriously pulls out one side of yet another *uchikake*. He leans slightly backward, dipping the downstage shoulder to allow the broadest sweep of fabric and view of the nape of his neck. The onnagata then carefully looks over his shoulder at his visual magnificence, directing all attention to his costume.

In striking contrast to the previous costume acts, this *uchikake*'s surface, executed as a *sumi-e* (black ink brush painting) on a white silk ground, is stark and austere. The black brush strokes are vivid against the pale surface and the design extends across the entire back. The motifs such as flying cranes and plum blossoms, or Mount Fuji with clouds, have been chosen by the actor and artist patron/admirer to reflect a poem of auspicious mood. Paradoxically, this painted surface draws attention back to the body beneath—that is, the male actor as onnagata.

How does Agemaki's costume construct the *yūjo* gender role? First, in its grand monumentality, the costume restricts all movement. The body beneath is manipulated and shaped by the kimono and *obi* costuming characteristics. Second, it is ornamental. It displays itself. It rivets the eye. Decorated with symbols of cultural customs, it recalls tradition and historic personalities, evoking nostalgia. Next, the costume gender act is purposefully ambiguous, attracting the eye and provoking the mind. The shape is such that any "body" could be underneath—except the spectators know it is a male body beneath. Does the costumed body become its own gender? Or are the viewers free to envision the fabricated gender role or the body beneath or various combinations to suit their own desirable gender roles? In summary, the onnagata art of gender acts depends on the performativity of the costume and its specific properties that foreground the costume gender acts over the body beneath.

Prosthetic Body Design

The gender bodybuilding techniques that onnagata assiduously practice are built on the themes of constraint, grace, and sensual attraction. The aim is to construct a designed illusion, an onnagata female-likeness. The intentional body establishes the fundamental rules for the physicalization of onnagata female-likeness. In general, the onnagata gender body aims at smallness through compression and restraint, and grace through control, stylization, and simplification bordering on austerity. The onnagata's gender role is

never really exposed as a body of muscle and flesh; rather, it is a construction of shape and line with which the onnagata creates an iconic image that is alluring through the practiced stylization of sensuality. The viewers may be attracted both by what the constructed female-like image suggests to them, as well as to the male actor body beneath.

In many kabuki plays, the prescribed conditions of restraint may seem antithetical to the play of sensuality and eroticism. However, the onnagata's restraint sets up a tension between his body beneath and his gender role, which, in turn, amplifies a gender ambiguous sensual allure in the most subtle and the most overtly erotic gender acts. The technique of controlled sensuality is present even in moments of "abandon," as in scenes of violence or seduction. For example, when an onnagata is "undressed" by a tachiyaku unwinding his *obi*, his every act is designed and controlled. The various forms of physical restraint accentuate sensuality, as when a slow-motion camera focuses and then zooms in on one part of a scene of violence. Onnagata deliberately employ their designed constraints to fuel the attraction or *miryoku* (charm) of their gender acts.

Most recently, the intentional body formula has gone through various waves of modernization, traditionalization, and even some postmodern deconstruction. Contemporary onnagata discuss *shinri* (psychology), their psychological motivation of a character or a role type, and how this is necessary to make the *kata*—the prescribed acting forms such as the intentional body— have life. The concept of *shinri* probably entered the kabuki acting world in the early part of the twentieth century. Nevertheless, the stylized intentional body learned by rigorous training and imitation comes first. The idea of the *kokoro* (heart) and *shinri* of the character only becomes important after the physical training has reached a certain level of competence.[53]

Several questions arise from analyzing the traditional onnagata body formula in a contemporary context. Although onnagata have changed the original formula for the intentional body, these body acts were based on very specific politics of class. Extricated from its time, is it possible to read the gender act configuration of the onnagata intentional body?

If onnagata are kept "closeted" as period pieces, those canons that are at once hidden and exhibited within the onnagata *kata* will remain exotified. In contrast, this thick description discloses some of the underlying ideologies of onnagata gender acts. Through carefully disembodying and fracturing the total onnagata intentional image, I am consciously taking that intentional formula beyond an aesthetic description and examining how it "works" and constructs the onnagata gender in performance. The result is not intended to support a particular ideology, but to reveal *intention* as the force that shapes the flesh body from the standpoint of the onnagata as both agent and object of his own will.[54]

CHAPTER 8

PERFORMATIVE GENDER ROLE TYPES

Wonder Boys and Their Metaphysical
Bodies, Transcendent Acts, and
Supernatural Genders

Yakugara: **Role Types**

An analysis of onnagata gender performance would not be complete without an explanation of onnagata *yakugara* (role types). The contemporary onnagata *yakugara* is a system of multiple and variable genders based on and articulated by the male body beneath. Gender role types were part of the policing regime of the Edo period *bakufu*. In its early stages, *wakashu* were required to register as onnagata. These early wonder boys already knew the power of fashion and transformation. While playwrights are often credited for the creation of more complex narratives and characters, the flamboyant *wakashu* appear to have combined their need to attract patrons, develop their range of roles, and maintain their cutting-edge fashion prestige. Successive generations of onnagata took advantage of role types in order to devise their particular celebrity profile and still preserve their beautiful boy alchemy. The onnagata *yakugara* are critical to their extraordinary protean female-likeness and they further mutate and complicate the reading of the role and the body beneath.

Each role type is made up of variations on the onnagata basic gender acts of postures, gestures, and locomotion patterns. Each role type has its own *kata* for appearances: costuming, wigs, and hand props, as well as characteristics of age, social status, marriage status, and virtue or "moral" standing. Onnagata construct each role they play, first according to its *yakugara kata*, then by the specific qualifications of the individual role. Performers are also

classified by their gender *yakugara*. For all these reasons, *yakugara*, the classification system of kabuki role types and gender roles, is one of the key sites for investigating the process of onnagata gender role construction. This chapter is an introduction to the theory and development of onnagata *yakugara* and an overview of the main onnagata *yakugara* in performance.

The word *yakugara* is made up of two Chinese characters: *yaku* (position, duty, or role) and *gara* (pattern, design, character, or nature).[1] *Yakugara* is used for two levels of role type description. First, there is the *yakugara* of gender role specialization—such as *tachiyaku* and *onnagata*. The second is the *yakugara* of specific role types classified under *onnagata* or *tachiyaku*. In other words, "onnagata" is a broad category of *yakugara* for female gender role specialists, while the *yūjo yakugara* (courtesan role type) is one of the specific role types within the onnagata gender role category.[2] A specific role like Agemaki of *Sukeroku*, belongs to the *yūjo yakugara*. In this chapter, I focus on the latter usage of *yakugara*, the onnagata gender role types.

While scholars and performers differ on the exact categories of role types within the onnagata *yakugara* system, they generally include seven major categories: *yūjo* (courtesan), *himesama* (princess), *musume* (daughter, young girl), *jidainyōbō* (period wife), *sewanyōbō* (contemporary wife), *baba* (old woman or grandmother), and *akuba* (evil female). I would also include Watanabe Tamotsu's additional *yakugara* classifications of *hengemono* (transformative role types) and *chimimōyō* (transforming spirit role types).[3] Of the seven major categories, *himesama, musume, yūjo,* and *akuba* are usually young unmarried female characters, and the majority of *jidai* and *sewanyōbō* role types are still relatively young, usually under thirty. It is noteworthy that there are few mature female roles, or roles that mature or change. This may reflect a combination of influences, for example: the dominance of *wakashu* aesthetic's emphasis on youth, the hegemony of tachiyaku over story action, and the interests of playwrights and spectators in the development of mature male roles and in the fixation of the female roles to a set age and type. There are a few roles that cross over or do not fit exactly in one role type category: roles that have several disguise roles, and roles that change into another role type within a play. For the most part, onnagata roles rarely evolve within a play. They remain in a fixed role type characterization.

Although few in number, mature onnagata roles, like some *nyōbō* or *baba* roles, are among the most famous and popular of roles. Contemporary star onnagata cite their favorite roles as those few mature roles like Masaoka (figure 8.1) of *Meiboku Sendai Hagi* (The Disputed Succession), or Tamate Gozen of *Sesshū Gappō Ga Tsuji* (Gappō and His Daughter Tsuji), which are strong *jidainyōbō* (period wife) roles. They also like the challenge of provocative roles like Sakurahime (figure 8.2) of *Sakurahime Azuma Bunshō*

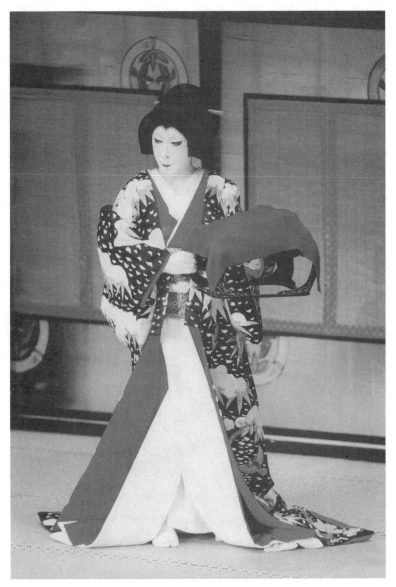

8.1 Nakamura Jakuemon IV *jidainyōbo* role type Masaoka

(The Scarlet Princess of Edo), who evolves from *himesama* (princess) to *yūjo* (courtesan) to a grim murderess, a kind of *akuba* (evil female).

Toita Yasuji offers the idea that within the onnagata, *yakugara* are also divisions of increasing complexity and sophistication for the performance

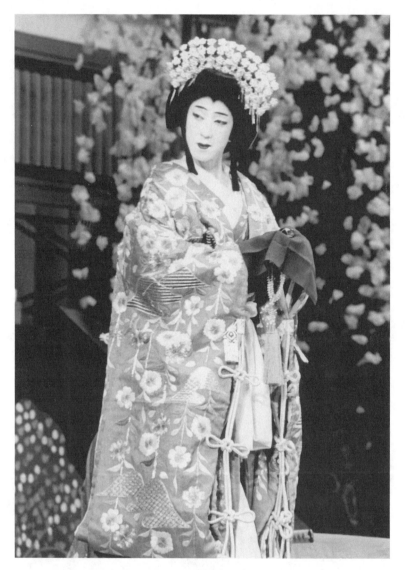

8.2 Bandō Tamasaburō V *himesama* role type Sakurahime

training of onnagata. From the *musume* (daughter, young girl) to *himesama* (princess) to the *yūjo* (courtesan), and so on, to the *baba* (old woman, grandmother), an onnagata progresses through more difficult performance problems. However, Toita emphasizes how an onnagata must perform, no

matter what the role type, the historical characteristics of youthfulness and eroticism, left over from the *wakashu* and *wakaonnagata* eras.[4] Toita adds the role type category of *geisha* (entertainer artist), reinstates the category of *kashagata* (older female), and finishes with a *fukuzatsu* (complex) category of role types that do not fit into any one category and defy any one type.[5]

Mizuochi Kiyoshi created his own classifications for onnagata roles: *Ojōsama to Gyarutachi* (Young Ladies and Girls), *Tsuma toshite Haha toshite* (As Wives and Mothers), and *Edo no Kyariya Ūman* (Edo's Career Women).[6] He bases his divisions on those of women who, in the Edo period, under the Tokugawa regime, had no real economic status or recognized independent existence. Even though they were able to make a living from their art, high-ranking courtesans were still owned and imprisoned in the licensed quarters. Mizuochi also divides the onnagata *yakugara* according to how real women of that time were expected to perform the three obediences of Confucianism. How easily the contemporary critique conflates onnagata with women. The female child who owes obedience to her father becomes his "Young Ladies and Girls" role type. The wife who owes obedience to her husband and the older woman or widow who owes obedience to her son fit into his "As Wives and Mothers" role type. Finally, those women who fell outside the Confucian chain of obediences were his "Career Girls." Interestingly, Mizuochi's "Career Girls" include Masaoka of *Meiboku Sendai Hagi*, usually classified as a *jidainyōbō* (period wife) and Kumo no Taema of *Narukami* (Thunder God), usually a *himesama* (princess) role type. Mizuochi argues that the onnagata role types are not just stereotypes, and that the complexity of the role types should be viewed from a historical perspective.[7] Given the differences among Japanese scholars, I use the following onnagata *yakugara* divisions: *musume* (young girl), *himesama* (princess), *yūjo* (courtesan), *nyōbō* (wife), *baba* (old woman or grandmother), and *akuba* (evil female). Several of these have important subdivisions that I discuss under the specific role type.

Performers most frequently distinguish *yakugara* in the traditional seven types by their distinctive stylized acts. The wigs, costuming styles, colors, and accessories are most often cited as the distinguishing elements of the onnagata *yakugara*.[8] These elements, common to all role type categories, play a significant part in shaping and affecting all movement and postures. I consider the "makeup, costuming, dramatic skills, [and] character"[9] to be performative acts, which as exterior acts themselves can be read as the marks of gender, in this case, associated with a particular onnagata *yakugara*. Hence, the distinguishing acts of each *yakugara* are variations on the basic onnagata gender acts. The gender acts identified with particular role types literally create the role type. This corresponds with the importance of the articulated surface of the onnagata gender role and intentional body—a constructed site that can be designed and adapted to actor bodies and role types.

The *yūjo* role type, for example, has its own particular ways of kneeling, posturing, walking, wearing the kimono and *uchikake*, and using hand props. In addition, kimono styles and motifs, wig styles and decorations, *obi* designs, makeup, vocal patterns, word usage, and pronunciation styles belong to the *yūjo* role type performative acts, or the *yūjo* gender acts. Roles within the *yūjo yakugara* may vary according to class, play style, and other factors requiring alterations to the basic *yūjo* gender acts. Nevertheless, the basic *yūjo* gender acts are recognizable in all roles belonging to the *yūjo yakugara*.

It follows then that the *himesama yakugara* (princess role type) requires *himesama* gender acts. The *himesama*, also known as *akahime* (red princess), is a role type who wears a distinctive long sleeved red brocade kimono. The *akahime* designation has come to stand for the princess role type in general, even though a major princess role, Yukihime, wears a pale pink kimono. The gender act of the red long sleeved brocade kimono signifies the *himesama* role type. The *jidainyōbō*'s (period wife) *kokumochi* kimono, which is a black, conservatively styled and wrapped kimono, with only a *mon* (family crest) as decoration, is a major gender act signifying the *jidainyōbō* role type. Hair and wig styles had such a great class significance in past eras that wig styles have also been used to name and distinguish onnagata role types. The *bushinyōbō* (samurai wife) role type is usually called a *katahazushi*, the name of the asymmetrical figure-eight topknot style of this *nyōbō* category. The *tayu*, or top-ranking courtesan role type, may be called by the wig name *datehyōgō*, itself named after the giant *mage*, or shell-shaped molded hair piece.[10]

The *baba yakugara* (old woman role type) has its special *baba* gender acts. The famous *baba* roles, called the *sanbaba* (three old women or grandmothers) are *jidaimono baba* (period piece older women), and are famous for their crucial and difficult scenes where they must abide by the rules of duty over human compassion. Mimyō of *Moritsuna Jinya* (Moritsuna's Camp), Koshiji of *Honshō Nijūshikō* (The Twenty-Four Examples of Filial Piety), and Kakuju of *Sugawara Denju Tenarai Kagami* (The Secret of Sugawara's Calligraphy) are the older women roles usually designated as the *sanbaba*. When he plays a *baba* role like Satsuki of *Ehon Taikōki* (The Picture Book of the Taikō), Nakamura Matagorō II comments that he aims for a kind of elegance in all actions. He performs the *kihon* onnagata *kata*, but with greater restraint and refinement. Every action is reduced. But this does not mean the *baba* are not physically or emotionally strong and expressive.[11] *Jidaimono baba*, such as the *sanbaba*, wear a pale white-gold wig with a *baba bōshi* (old woman's head scarf), which is usually a brown, beige-gold, or silver color and is worn on the front of the wig and tied under the hair knot. The *baba* kimono is usually a grey or beige fabric, with a black or

subtly colored *obi* in a simple *taiko musubi* (drum knot). Onnagata emphasize that these roles were not played "old." Their kimono and *obi* are subdued but are still sensual and charming. Even *baba* roles wear their *eriashi* pulled down, exposing their back neckline. According to Matagorō II, *baba* may wear the colors of age, but *iroke* is still present.[12] Thus, from *musume* to *baba*, the distinguishing marks of each *yakugara* are also its role type gender acts.

In *Onnagata Hyakushi* (One Hundred Images of the Onnagata), Watanabe Tamotsu informs us that "Kabuki's official census registry of personages is known as the *yakugara*."[13] Much like the performers, Watanabe emphasizes that it is the concrete stylization patterns of each *yakugara* that holds them together as a group. Watanabe refers to the onnagata roles and role types as "the inhabitants of a kabuki-land, who only live in the imagination. . . ."[14] Each role has different dramatic circumstances and characteristics, but the performance formula, or stylized gender acts, create "an entity which is elevated by the stylization into an archetype. . . ."[15] Over time, Watanabe conjectures, all the performances of a given *yakugara* role have polished the archetypal image to the utmost detail.

Watanabe even suggests that the roles themselves do not exist without the concrete stylized acts. In watching an onnagata role, the viewer should look for the concrete *yakugara* stylization patterns, since "what captures one's interest more than the psychology, character, or fate of the individual are those things like the manipulation of the sleeves, the way of walking, or the positioning on the stage. . . ."[16] In his view, the onnagata's performative role consists of the *yakugara* stylized gender acts, altered by the special required acts of each role. For example, among the *himesama* role types, he discusses "Yaegaki's *uchikake*," and among the *musume* role types, "Osato's apron" and "Omitsu's mirror" to illustrate how these stylized gender acts create meaning. The object associated with each role determines crucial action, feelings, and the fate of each of these roles. Watanabe argues that Yaegaki's performative existence depends on the *uchikake*, Osato's on the apron, and Omitsu's on the mirror.[17] In fact, without the mirror, Omitsu does not exist. In other words, there is no role without the acts that construct the role's appearance, its material presence on stage. Those constructed acts are the role's gender acts and the acts that distinguish the role within its *yakugara*. Watanabe cautions against reading the roles or role types as separate individuals.[18] I suggest that their gender acts are archetypical signs, which resonate meanings beyond an individual existence or character in a bipolar gendered world.

History and Development

Gunji Masakatsu maintains that the system of role types and role type specialization by actors is at the heart of kabuki performance aesthetics.

He explains that the variations of *yakugara* are complicated, and he uses the *onnagata* category as the pivotal location for initiating *yakugara* divisions. In his narration of *yakugara* history, he emphasizes that the initial gender role classifications were coercively produced after women were banned from the public stage in 1643, when *wakashu* were forced to register as either male or female role players.[19]

In his *yakugara* analysis, Kawatake Shigetoshi explains the *bakufu* regulation for role specialization that followed the *wakashu* prohibitions:

> classification regulations according to role type were enforced. This meant that those who imitated women had to register as actors who played female roles, and those who did otherwise, were male types and such. Onnagata as a designation came about at this time. But because this was just a rough expedient measure, it shouldn't be called a yakugara classification system. It was not until the completion of the Genroku development period, when the theatre had attained a structure, that the *yakugara* system was again subdivided, once more justified, and each actor's specialization came to be more strictly maintained.[20]

In Heibonsha's *Kabuki Jiten* (Kabuki Dictionary), Watanabe Tamotsu details the developmental stages of role type divisions:

> *Yakugara* refers to the classification of stereotypical roles. While modern theatre groups people [roles] by individual characteristics of psychology, character, and the like, kabuki distinguishes by divisions based on class, occupation, age, *monogatari*, and so forth. . . . From the ban on *wakashu* kabuki in 1652, they were required to register in onnagata or tachiyaku divisions. In the Genroku era (1688–1704) *yakugara* were further divided. From then on in the Edo period, actors were classified, according to a rule of each person [registered] in one *yakugara*. Performers were classified thusly, tachiyaku, *wakaonnagata* [young onnagata], *katakiyaku* [villain role], *jitsuaku* [truly evil], *dokegata* [clown type], *kashagata* [older wife type], *wakashugata* [youth type], *oyajigata* [male parent type], *koyaku* [child role].[21]

Yakugara arose from a complicated history of stock characters found in early skits, plays, and dances. According to Toita Yasuji, "*Yakugara* is the established classification system which distinguishes those characteristics, including gender and age, of characters who appear in kabuki and *ningyō jōruri* [doll/puppet chant theatre]."[22] Toita also mentions that the early divisions were based on actors' specialties. He cites the *musume* or *wakaonnagata* and the *kashagata* as the first onnagata *yakugara*. These three types divide by age: young, youthful, and middle-aged. These types, he says, were then differentiated through the contents of plays that had specialized role types.

Gunji Masakatsu explains that "*Yakugara* refers to kabuki's stereotypic role types, which developed throughout the Edo period. Most importantly, *yakugara* should be considered exaggerated stereotypes."[23]

Gunji and other kabuki scholars believe that the critical ranking system in a collection of courtesan reviews called the *Yūjo Hyōbanki* (Courtesan Reviews)[24] was the initial model for the early kabuki *yakugara* classification system. The first *Yūjo Hyōbanki* (1655) publication critiqued the top courtesans by lavishly praising their attributes and advertising their accomplishments for prospective buyers. The reviews and grades indicate the critique was aimed at selling the courtesans to the popular audience. The early *Yūjo Hyōbanki* were frequently illustrated with prints of the *yūjo* and *wakashu* and with poems and anecdotes that advertised their looks, charms, and entertainment skills. The descriptions, according to Gunji, were meant to give a "taste or sampling of a *yūjo*'s appearance and style of entertaining to get you to spend your money."[25]

The reviews of *wakashu* performers, first published in the *Wakashu Hyōbanki* (*Wakashu* Reviews) (n.d.), then the *Yarō Hyōbanki* (Fellow Reviews) (1656) after the *wakashu* bans in 1652, and later the *Yakusha Hyōbanki* (Actor Reviews) (1687), imitated and expanded the courtesan ranking system, establishing a hierarchy for actor gender role types. The *Yarō Hyōbanki* followed much the same format with its own sensual metaphors for the beauty and talents of the *bishōnen*. The *Yakusha Hyōbanki* advertised the top stars and rated the other performers in terms of their beauty and charms in offstage entertainment. The rank evaluations changed frequently, as did the reviewers, and there is no record of the method of evaluation. However, it appears that divisions for ranking actors and the role specializations of individual performers gradually formed the classifications of role types. It is clear that the onnagata role types and reviews were directly influenced by the *yūjo* and *wakashu* reviews.[26] In general, one could say that descriptions of the physical appearance and sensual charms of the performers dominated the reviews. I suggest that, from early on, certain physical attributes were highly rated and later incorporated into onnagata role types.

These reviews were significant in that they began to establish a classification system for actors according to appearance and talent, gradually including their dramatic performance skills. Mixtures of fiction and fact, these reviews established the actor ranking and role type categories that, in altered form, still function in contemporary kabuki. Thus, the *Yakusha Hyōbanki* may well be the source record for the creation and development of the *yakugara* system.

There are many borrowings from the *Yūjo Hyōbanki* that suggest a link between the status and work of the courtesans and that of kabuki performers, in particular the early *wakashu* peformers. The title of *tayū* designated

a high-ranking female courtesan in the licensed quarters during the early Edo period. According to Gunji Masakatsu, *tayū* also appears among the onnagata role types in the Genroku period (1688–1703).[27] Onnagata listed under the title of *tayū* were supposed to be very skillful at their *keisei* (high-ranking courtesan) or *yūjo* (courtesan) roles. Although *tayū* disappeared as a role type, it remained as a stage role and a prestigious title for the top-ranking onnagata of a kabuki troupe. During the Edo period, onnagata might have enjoyed this conflation of their stage and professional roles, which contributed to their performative gender ambiguity and erotic allure.

As detailed in chapter 3 of this book, the early onnagata gender acts were rooted in the stereotype of youth already established in the *bishōnen* aesthetics of the *wakashu*. The first generation onnagata set the trend for youth, beauty, and eroticism by creating their own role types. When the emphasis shifted from dance to dramatic role types in the *monomane zukushi* (dramatic plays) in the early eighteenth century, Ayame established the *keisei* (castle toppler), a youthful, high-ranking courtesan role. Furuido Hideo goes so far as to identify and single out the performance of the early *keisei* role and the establishment of the *yūjo yakugara* as the basis of all onnagata gender role types. He suggests that the *keisei* role launched the *yūjo yakugara* and the trend toward *wakaonnagata* (young onnagata) roles, which later differentiated into the *musume* (young girl) role types. At that time, these were the main kabuki roles available for the onnagata other than dance roles, minor attendants, wives, and servants.

As we have seen, the *bakufu* prohibitions and resultant popularity of kabuki propelled onnagata into greater exaggerations of stylization. The *keisei, musume*, and *himesama* role types began as elaborations and extensions of the *wakashu* gender performances. The sociopolitical climate with its subsequent and ongoing censorship, helped to popularize these particular images in the stage representations of female gender. All three gender role types were unmarried young women who embodied specific cultural ideals: the *yūjo* (courtesan) role type for sensual beauty, the *musume* (young girl) role type for innocence and youth, the *himesama* (princess) for class and dignity.

Although no record exists, the *yakugara* listings (as well as Ayame I's and Kikunojō I's onnagata notes) indicate the following progression: (1) *Wakashu* onnagata constructed onnagata gender acts from their *wakashu* gender acts. (2) With the transition into dramatic plays and imitative role-playing, they adapted these onnagata gender acts to the "female" roles. (3) The repetition and popularity of repeated gender acts for particular types of characters by star onnagata gradually led to the formulation of the onnagata *yakugara*.

This progression demonstrates how onnagata could "play female roles" by restaging these roles with their own gender acts. The role types evolved from a mixture of gender acts based on onnagata aesthetics and eroticism.

Thus, the *musume, yūjo, jidai, sewanyōbō, himesama, baba,* and *akuba* reveal how onnagata adapted, transformed, and classified their gender acts into archetypal stereotypes. All of these were variations on and extensions of the *wakashu* fictions of female-likeness. In a sense, the constructed onnagata *yakugara* became a pantheon of *wakashu* gender fictions.

Performativity

The remarkable iconography of the *yakugara* gender acts delineate and communicate the role type instantaneously. When onnagata perform the particular set of gender acts associated with a *yakugara* experienced spectators recognize the role type immediately. In the first moment of their entrance on stage, onnagata carefully delineate their specific role type gender acts. Most introductory scenes have a sequence of movement and a pose, in which the performer "burns" in his *yakugara* image so the spectators can read its iconography. In such moments it is possible to see both the actor and his body beneath, and to experience the gender acts and role type as separate from the actor body. Simultaneously reading the *yakugara* gender acts as the role type, perceiving the performer's body beneath, and taking in the individual role and dramatic moment are part of the audience's total experience.

An onnagata performs the construction of the *yakugara* so that the viewer can see all the pieces and how they come together. This creates a framework for understanding his specific role, the storyline, and the play genre. For example, in *Narukami* the immediate impact of Kumo no Taema on the *hanamichi* is of a *himesama* (princess) role type. The onnagata performs the requisite *himesama* (princess) gender acts by displaying the brilliant red kimono with long, brocade sleeves; the wig with hair looped over the *fukiwa* (large, drum-shaped ornament); and the *hanagushi* (glittering tiara-like hair comb). The *himesama yakugara* visual formula is recognized instantly by virtue of the distinctive *himesama* gender acts. The viewer entertains a multiple vision: the brilliant *himesama* role, the onnagata himself, perhaps, Jakuemon IV, or Shikan VII, and that onnagata's personal adaptations of the role, whether in voice, costuming, the movement of his kimono hem, or the rhythm of his gait. The spectator is free to pull any of these in or out of focus or enjoy them simultaneously.

Thus, onnagata *yakugara* performance, where stylization, based on designed abstraction and artifice, dominates every performed act, shows the spectators the interaction between the male body beneath and his gender acts. We can see the onnagata's male body beneath emerge and merge, in different stages, throughout his performance of the *yakugara* gender acts. For example, the onnagata performing a *musume,* or young girl role type, uses a

slipping walk with tiny steps and a slight side-to-side motion, referred to as a *fuafua-fuafua* walk. This is a distinctly *musume* (figure 8.4) act: doll-like, cute, artificial, and stylized. The spectator knows there is a male body beneath. The viewer can experience the gender acts distinct from the actor. In fact, I think that the performativity of the gender acts is magnified when the spectator does recognize the male body beneath. Of primary importance to my thesis is the deliberate and variable gap between the female-like gender acts and the male body beneath. In particular, the distinctive yaku-gara gender acts, like the *musume* walk, show off the differences between the body beneath and the gender acts.

Sometimes the role type and gender acts are extraordinary, and certain archetypal role types can reach mythic dimensions. Good examples abound in transformation plays. For example, in *Ibaraki* (Ibaraki), a *baba* role type, Mashiba transforms into a demon, which is the character's true form. In *Kagamijishi* (The Dancing Lion), the *musume/yūjo* role type, Yayoi,[28] possessed by a lion spirit, transforms into a lion figure. And, in *Masakado* (Masakado), the *yūjo* role type, Kisaragi, reveals a possessed *musume* role type who is transformed by magic, other-worldly powers into a demonic *musume* role. But even in these, the male body does not disappear inside the gender acts. Onnagata comment that they must exert great physical effort in performing any onnagata role type. Thus, in performance, onnagata struggle with the demands of stereotypic role types and their individual bodies. The dynamic process reflects a system of gender role type representation based on ambiguous, multilayered stylized acts that disclose the actor body beneath.

When performing any of the role types, onnagata conform to the intentional body and the basic gender acts. However, for each role type they adjust certain gender acts to fit the particular age, rank, occupation, play style, and character of each role type. In *Sukeroku*, the onnagata in the role of Agemaki, an *oiran* of the *yūjo yakugara*, frequently poses with one elbow held out to the side underneath the sleeve of the *uchikake*. Ordinarily, the elbows of the onnagata intentional body are pulled in close to the torso, but here the elbow action is a gender act particular to the *oiran* role. Such adaptations to the basic gender acts also become associated with the official *yakugara*.

The distinct gender acts of each role type arise from both the intentional body and the external acts that overlay the body. As the onnagata performs his adaptations, he is shaped by the model gender acts. In my kabuki dance training research, I observed how much the external acts such as the kimono style and *obi* wrapping, the wig, or the type of hand prop, dynamically shaped or restricted or forced a particular physical performance act. This calls into question the interaction between the actor body and the role

type. To what degree do the external acts determine the physical movement and image? To what degree do the acts of the body beneath determine the role type gender performance? Onnagata feel that each role has its checks and balances and fluctuating degrees of control from the body beneath. In general, the simpler and more lightweight the costumes and wigs, the more the actor's body controls the acts and image. However, onnagata commented that the roles with the light weight *yukata* (cotton kimono) required more skill because the male body beneath could so easily reveal itself and dominate over the gender role. With the more exaggerated costuming and wigs, the external acts virtually *become* the body of the role type, and the performer body can only respond skillfully to the shape and movement and their requirements.

One of the most important aspects of *yakugara* is that each category of basic acts (costume, wig, gestures, postures, locomotion, vocal intonation, and speech) emphasizes design and stylization. When onnagata perform the stylized gender acts, they are not attempting to be realistic or naturalistic in the roles, but to create an artificial appearance based on an artificial aesthetic, *jinkō no bi* (artificial beauty), which I discuss later in this chapter. An important part of my onnagata gender theory is that the constructed gender acts are performed to reveal their performativity, their artificiality. For example, the onnagata as Agemaki enacts a theatrical construction fashioned from the *yūjo* role type gender acts, with the addition of specific Agemaki gender acts. In the *dōchū*, and arrival on stage, the onnagata as Agemaki is so huge, attendants must literally perform the *oiran* costume with the onnagata. When the attendants spread Agemaki's *uchikake* before sitting, they display the performance of the *yūjo* role type. At the same time, the Agemaki role has a particular brightness and arrogance of gesture that the onnagata displays with a slight but magnified spreading of his arms, and sometimes a little lift of one shoulder and a quick side glance. Every gender act is displayed and performed as a stylized act.

In *The Kabuki Theatre*, Earle Ernst emphasizes that design dominates all kabuki movement. His analysis of kabuki dance applies equally to the performative stylization of onnagata gender acts and the notion of performing the artifice—what Ernst terms the "design" of gender role types:

> To regard the design as the most important aesthetic element is the principle consideration in Kabuki dance. . . . Movement taken from life and transmuted into Kabuki movement need no longer correspond to an observed reality. Rhythm and design, the essential qualities of Kabuki movement, are as frankly displayed as the other elements of production.[29]

In their artifice, the designed aesthetic configurations of each role type reflect detailed prescriptions. However, I believe that their apparent designed abstraction has the aim of intensifying their gender ambiguity.

This does not imply that the performed design of gender acts are without meaning. Each role type constellation comprises behavior patterns for female characters gendered by onnagata, thereby reinforcing standards of behavior. Although role types are "fairy tale women,"[30] or abstractions that exist only onstage, they perform a subtle and powerful aesthetic prescription for beauty and eroticism. On the one hand, these designed gender acts detail powerful archetypes and behaviors, which have been confused and conflated with representations of an ideal woman.[31] On the other hand, the gender acts in their designed performance disrupt the idea of a core gender identity by flaunting their own construction.

Transformativity

Since the first transformation dances of the early *wakashu* onnagata Mizuki Tatsunosuke I in 1687,[32] the concepts of mutability, ambiguity, and mystery have been part of the onnagata gender act construction and *yakugara* formulation.[33] While every onnagata *yakugara* has strict requirements, it also has exceptions, subcategories, and hybrid roles.

According to Gunji Masakatsu and Hattori Yukio, it was the early *hengemono* (transformation works) dances with their quick, multiple role changes that set the precedent for *yakugara* transformation techniques and aesthetics.[34] While some roles are actually known as *hengemono*, I suggest that many onnagata roles from fixed *yakugara* have ambiguous and transformative characteristics. That is, onnagata gender role type acts have, as part of their construction, changeable and variable meanings and nuances that a skillful performer may layer over, blend with, or assimilate into another role type. There is a mysterious and indefinite quality in the codified acts, which allow transformations and hybrid forms.

Hattori Yukio writes in *Hengeron* (Theories of Transformation) about two types of transformation that he feels connect the kabuki theatrical transformations to ritual and spirituality. *Henge* is complete transformation, suddenly and totally; *henka* is a gradual transformation that may occur in stages.[35] Onnagata gender role types in their hybrid manifestations illustrate these types of transformative performances. Early onnagata, like Segawa Kikunojō I and Nakamura Tomijūrō I, played with both of these "change" modes in their famous renditions of *Musume Dōjōji*, which requires an onnagata to dance through approximately six *henge* and multiple *henka* within each of the major role sections.

The role of Shizuka Gozen in *Yoshitsune Senbonzakura* (Yoshitsune and the Thousand Cherry Trees) is an example of the complex hybridity of some role type acts. The Shizuka Gozen character is a female *shirabyōshi*, an early gender role performer, entertainer, and courtesan precursor that

I discussed in chapter 3. The character Shizuka is the wife-like lover of the courtly military hero role, Yoshitsune. The role would seem to fit the *yūjo* role type, but the onnagata playing Shizuka wears the *himesama* (princess) role type costume: a red, long sleeved, brocade kimono, a long furling obi, the *hanagushi* (silver tiara-like flower comb) wig ornament, and the *fukiwa* (drum) styled wig. The onnagata as Shizuka also performs all the *himesama*-styled gender acts (gesture, walk, vocal style, and *himesama* attitude). Yet, as Shizuka, the onnagata must transform his *himesama* acts when the character performs *yūjo*-like acts in a lover's *michiyuki* (travel dance) scene, and then transform these acts to *jidainyōbō*-like (period wife) acts in a court scene. To perform the complexity of the Shizuka role, Hanshirō VIII says he had to play ". . . the heart of an onnagata who performs the role of the favored concubine but appears in the form of a red princess."[36]

Some roles in the transformation *yakugara* often make use of *keren* (trick) techniques, which clearly show the gender acts of one *yakugara* turning into another set of gender acts. The roles in the transformation *yakugara* frequently use one role type as a cover for their possessed spirit or supernatural being.[37] The initial role functions as a disguise for the other role type, a spirit between worlds. When the onnagata is performing the gender acts of one role type, there are moments when the hidden role—usually a supernatural being—surfaces through the gender acts of the initial role. Some roles set up the appearance of one role type as a contrast to make the transformation even more exciting.

Kisaragi in *Masakado* is an example of gender role type transformation. The onnagata first appears as Kisaragi, an *oiran* role belonging to the *yūjo yakugara*. But Kisaragi is a disguise for the character Takiyasha, a court-class daughter role belonging to the *musume yakugara*. To complicate the role types further, the Takiyasha character is in league with supernatural spirits and eventually transforms into a "possessed" character. In brief, the onnagata changes from the seductive courtesan role, to the mourning, vengeful daughter role, to an enraged spirit. We see the onnagata dance a courtesan's seduction dance to woo the murderer of Takiyasha's father, do battle with the samurai, and then explode into a fiery spirit.

Onnagata may perform Kisaragi's transformations differently, but both Shikan VII's (figure 8.3) and Jakuemon IV's Kisaragi gradually and deliberately expose, first, the *yūjo*, which gives way in a *kudoki* ("longing" mime/dance) to the vengeful *musume* acts. When, in the *yūjo* role, Kisaragi hears the tale of victory over her father and his death, the onnagata begins to let the *musume* take over, as though the remembrance of the father pulls out the heart of the *musume*. During the *yūjo's kudoki* sequence, the onnagata covers the heartbreak of the *musume* role with the sensual allure of the *yūjo* role. But, on hearing the tachiyaku's story of his battle with the *musume's* father,

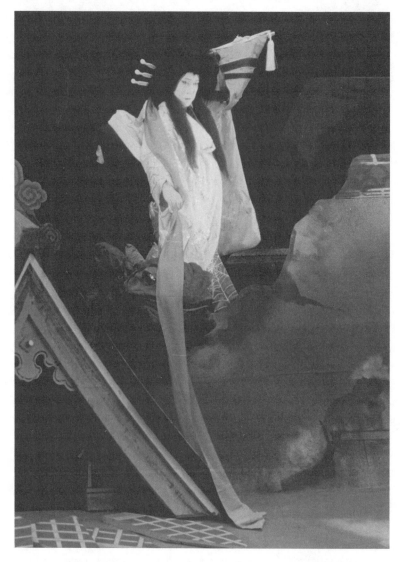

8.3 Nakamura Shikan VII transformation role in *Masakado*

the onnagata breaks from *yūjo* acts into *musume* gestures and vocal patterns. Then, as the rage of the bereft *musume* rises, the onnagata drops the *yūjo* attitude completely, until finally, the *musume*'s wildness consumes the *musume* acts. The onnagata performs a quick offstage transformation. He reappears perched on the roof of an enchanted temple in a wild and woolly

wig, fantastic red-lined makeup, and a *bukkaeri* (pulling down). From the roof top, in his last role, a *chimimōryō* (witch-like spirit) role type, the onnagata bristles and glowers alongside his supernatural companion, a giant toad (an actor in a toad-like body suit and mask). The onnagata's flailing gestures, blown-up posture, and gravely threatening voice are far from the gender acts of the *musume* or *yūjo*.

In transformation roles, like Kisaragi in *Masakado*, the onnagata has the opportunity to play a wide variety of role types. Part of the fascination for these roles is how the onnagata highlights moments of change that reveal the mechanics of the gender acts. For example, the onnagata enters, rising up in a veil of dry ice smoke on the *suppon*[38] (stage lift) on the *hanamichi*: where he is mere inches from the surrounding audience. With his frayed parasol aloft, his wig hairs slightly astray, and his *uchikake* glistening with spider web designs, he shows his *yūjo* gender acts have ragged edges. He offers glimpses of the supernatural role type. The onnagata creates ambiguous moments of transformation between the defined gender acts of each role type.

Other examples of transformative roles are the *musume* roles of Hanako in *Musume Dōjōji* and Omiwa in *Imoseyama* (figure 8.4) (The Mountains Imo and Se). Onnagata performing these roles must transform their *musume* gender acts as the characters undergo various tortures of the heart and body. Performing Omiwa or Hanako requires the actors to literally shed their *musume* appearances through various transformative processes. Onnagata perform a stylized stripping of the *musume* gender acts—costuming, wig, makeup, and gestural patterns—and take on certain acts of another role type. Moreover, the breakdown of one *yakugara*'s stylized acts does not always result in total transformation to another *yakugara*. As noted with Kisaragi, there can be stages in between where there is no clearly recognizable *yakugara*, or vestiges of one role type may remain visible mixing with the emerging hybrid role type.[39]

Onnagata use various techniques, like *hayagawari* (quick-change), which is performed on stage to transform into other *yakugara*. In these cases, the onnagata may layer *yakugara* gender acts over each other subtly or obviously. For example, you may see the onnagata's pasted-on eyebrows, or you may notice one kimono pattern showing beneath another. Onnagata may exaggerate the transformations so as to show off their techniques and their range of gender role skills to the spectators. They may choose to reveal some part of one role while concealing another part of another gender role.[40] It is part of the onnagata's art to reveal the distinctly different gender acts of both *yakugara* gender roles he is performing. The onnagata's elaborate exposure of the act of transformation of gender acts is a highlight of performance. They amplify the performativity of their role types. There is a kind

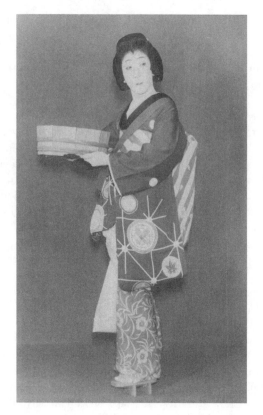

8.4 Nakamura Utaemon VI *musume* role type Omiwa (photographer unknown)

of breathless moment in the whole theater at the moment of transformation. My view is that the visibility of role type transformation heightens the performer's and the spectator's awareness of the body beneath as well as the performativity of gender acts. The transformation *yakugara* especially reveal the performativity and ambiguity of genders and gender acts, which stand out in relief as staged events.[41]

The onnagata *yakugara*, in both their archetypal and hybrid forms, demonstrate the highly developed art of stylized onnagata gender performance. Onnagata first invented gender acts for their original roles, which were *yūjo* roles. They modified these basic acts as roles diversified. Part of this diversification process was the invention of new role types by star onnagata. Playwrights also came up with new roles. All in all, fueled in part by their public appeal, certain roles and their associated acts became standard roles and were categorized into *yakugara*. Over time, the original stylized

forms, based on the *wakashu* physique, styles, and aesthetics, proliferated. Partially due to the system of enforced actor role classification, the onnagata *yakugara* gradually became a set of "stereotypes," each with its own specific stylized codes.[42] Thus the *himesama yakugara* can be largely identified by a kimono style, fabric, design, and color, a kind of walk and posture, vocal pattern, and wig style. These are the *himesama* gender acts. The onnagata *yakugara* are creative formulations of diverse gender acts that are grouped together in each *yakugara*. Each *yakugara* is a kind of onnagata gender role. The *himesama* yakugara is a *himesama* gender role, a variation on the original onnagata gender role, the *yūjo yakugara*.

The Template of Onnagata *Yakugara*: The *Yūjo* Role Type

In this section, I focus briefly on the *yūjo yakugara* as a template role type for the onnagata *yakugara* I also examine what concepts and forces have contributed to the transformative stylization techniques used to create onnagata gender acts.

The *yūjo*[43] role type was the first the *wakashu* onnagata performed in the late sixteenth century, launching the development of the onnagata *yakugara*. Roles in the *yūjo yakugara* were constructed from stylized gender acts primarily aimed at seduction and allure. As discussed in earlier chapters, many early onnagata worked and mingled in the world of brothels as *iroko* (boy prostitute performers). It was from this world of sensual performance, mixing prostitution and dramatic entertainment, that they created onnagata gender acts. Throughout the Edo period, many onnagata started their careers as *iroko* and continued to be supported by audience patronage. They also maintained the presentational mode of performance, which displayed their performative gender roles as well as their body beneath. Edo period onnagata established a transformative relationship between the body beneath and the *yūjo* gender acts. They kept this relationship and their early eroticism in their other *yakugara*.

Due to the dominance of the *yūjo yakugara* among the popular onnagata roles throughout the eighteenth and nineteenth centuries, the high-ranking *yūjo* roles like the *oiran* or *keisei* have became iconic representations of the kabuki onnagata. Contemporary onnagata describe the *yūjo yakugara* as central to all onnagata art. Moreover, they maintain that *yūjo* gender acts are the basis for all the onnagata gender acts of performative eroticism and sensuality, which are integral to onnagata *yakugara*.[44] In the following section, I analyze the *yūjo yakugara* to reveal how the formulation of *yūjo* gender acts became the springboard for subsequent role types. I also examine how onnagata maintained the erotic allure of the *yūjo* gender acts, no matter how much they assimilated and altered the *yūjo* gender acts for other *yakugara*.[45]

Thus, the onnagata *yakugara*, in general, has elements of *iroke* that relate back to the earliest *yūjo* roles performed by the beautiful *wakashu*. I would suggest that the onnagata *yakugara* are made up of gender variations from the *yūjo* gender acts.

Jinkō no Bi: *Artificial Beauty*

One of the governing principles of stylization of the onnagata *yūjo yakugara* in general is *jinkō no bi*, meaning literally, a "human made" or an "artificial" beauty.[46] Onnagata gender acts have been made, artificially, with great skill and detail. Additionally, onnagata deliberately disclose, in performance, that their performative acts are artificial. They highlight their skills and underline their stylized form. These are their governing aesthetic principles in performance. The majority of onnagata gender acts explicitly show their *jinkō no bi* (artificial beauty) so that in each *yakugara* their artificial beauty stands out in relief. The performers want the spectators to enjoy the artificiality of their gender roles.[47] In the following description of the *yūjo yakugara*, I show how the principle of *jinkō no bi* underlies onnagata gender role construction and stylization for onnagata role types.

A clue to onnagata *yakugara jinkō no bi* (artificial beauty of role type) is the exaggeration onnagata use in stylization. Exaggeration in any form or medium, whether in size, shape, color, surface articulation, timing, feeling, intensity, or sound, became an onnagata style for all gender role stylization. Contemporary onnagata often refer to their onnagata roles as *kyōchō shita mono*, "exaggerated beings," and what they do on stage, no matter what the role, as *ōkisa suru*, or "to magnify."[48]

To create a *yūjo* role, which can perform sensual and erotic acts that are concretely physical yet fantastically fictional and entertaining and represent a "female" gender, the Edo period onnagata most commonly: (1) covered his body; (2) altered his body beneath and the surface covering through stylization; (3) created a flexible set of gender acts in order for his new form to accommodate new play contexts and characters; and (4) developed and set criteria for his visual and kinesthetic gender acts. The aesthetic formula that gradually developed from the repetition of gender acts became the principle for onnagata gender acts and their adaptations for subsequent role types.

The *yūjo* role had the advantage of being a fantasy performative role created in the subcultures of kabuki entertainment. Onnagata could freely construct and stylize the *yūjo* gender acts beyond any set norms for the binary male and female behavior. Gradually, *yūjo* gender act stylizations moved away from the actor's body through greater exaggeration of costuming styles that influenced gestural and locomotion patterns. As the constructed *yūjo* role "separated" from the onnagata's body beneath, the

onnagata could perform an ambiguous transformative eroticism, playing between his constructed exterior appearance and his body beneath. The contemporary onnagata learns to strategically shift the intensities of difference, or between-ness of his body beneath and the exterior appearance.

Given that the first performances for *yūjo* roles were in the prostitute-buying scenes of advertising and selling the body, it follows that in crafting their gender acts, early onnagata chose the most eye-catching elements to draw attention to their artificial beauty. They decorated and embellished the adolescent male body beneath with all manner of designs, colors, and shapes that were not limited to a human scale. In early kabuki, according to Furuido, the onnagata were also reacting to the enormous popularity of the tachiyaku's *aragoto* (wild style) stylization, which drew on images of the *kami* (gods) in the Shintō pantheon of powerful gods and spirits.[49]

For example, the early onnagata drew on the image of the *bodhisattva* (attendants to the Buddha) statues, which in some images and statues are depicted with bars of light radiating from their heads. Onnagata assimilated the *bodhisattva* ray-like crowns into their *yūjo* wig styles and elaborate decorations. Early onnagata stuck huge hair combs and decorative pins at various angles and in various patterns into their sculpted wigs to draw attention to their artificial beauty.[50] With the sun rays bursting out of his head, the onnagata in a *yūjo* role could burn in his other-worldly, "god-like" image on the stage, possibly even outshining the tachiyaku. Out of the legacy of the *wakashu*, onnagata created in their *yūjo* roles a stylized and exotic fantasy of sensuality and grace. Their aesthetic ideal emphasized artifice and eroticism. Further, the onnagata move toward exaggeration and flamboyancy also became an aesthetic guideline that moved counter to the *bushidō* (way of the samurai) and Zen characteristics of simplicity, understatement, and austerity.[51]

While performing a *yūjo* role, onnagata could exploit the *yūjo* gender acts and construct a performance that was like a hyperbole of gender possibilities. They invented their own hierarchy of icons and strove for an artificial aesthetic. Onnagata animated a fictional gender of *yūjo*, which had its own social status and codes within the constructed world of kabuki. The success of the *yūjo yakugara's jinkō no bi* project contributed to the establishment of the onnagata fiction of female-likeness[52] and the subsequent development and diversification of other onnagata *yakugara*.[53]

Thus, early onnagata created a kind of subculture aesthetic: an artificial gender with its own eroticism and sensual attraction. As detailed in chapter 3, from 1652 on, *wakashu* were forced to remodel their erotic acts, which included dissembling boy beauty and adopting stylized forms. These manipulations were gradually refined and shaped into stylized gender acts by star onnagata. *Wakashu* made the *yūjo* role into a fetishized gender role by creating these fantastic manipulations of the body image—through costuming,

wigs, posture, and movement patterns—to disguise, yet tantalize with their boy bodies beneath.[54]

Early onnagata amplified their gender ambiguity, inherited from the *wakashu*, to enhance the artificial forms of the *yūjo* gender acts. I believe that the constructed *yūjo* role type is a flamboyant remodeling of the *wakashu* gender performance, which arose with the kabuki-identified *jinkō no bi*. An important aim of contemporary *yūjo* gender acts is to display an extraordinary artificial beauty that exposes its constructedness while providing hints of the male body beneath. We can see how the *wakashu* influence is very much alive in contemporary onnagata performance.

Every gender act onnagata perform onstage in a *yūjo* role type has undergone a gradual process of stylization through exaggeration. For example, the *bōshi* (scarf-like covering for the shaved head) were strategically lengthened and knotted to simulate fantastic hairstyles, which gave way to wigs with extraordinary decorations, woven in and out of loops, side locks, and topknots of hair. When onnagata widened the *obi* and lengthened kimono sleeves and skirts, their postures and movements changed.

Early onnagata drew on the *yūjo* gender acts for the new onnagata role types. Subsequent role types were fictions on a fiction based on a *wakashu* aesthetic of the *bishōnen*. Thus, to some degree, onnagata role type costumes, wigs, postures, and gesture codes share the *yūjo* stylized forms that reflect their *jinkō no bi* concept. When onnagata styled the other *yakugara* from the *yūjo* gender acts, they also transferred the *wakashu* aesthetic of *iroke Yūjo* gender acts, such as the *eriashi*, the scooped back neckline, and the wig styles with the exaggerated *maegami, tabo, bin*, and *mage* were among those *wakashu* acts that onnagata incorporated into the gender acts of their role types. In their process of role type diversification, onnagata assimilated the elements of *yūjo* sensuality and eroticism. Of course onnagata made changes and distinctive additions to the *yūjo* gender acts, but the *yūjo* acts, even when buried in the most innocent *musume* role or most stately *baba* role, remain present, drawing our attention to their artifice and sensual gender ambiguity.

"Selling the Body": Omote *and* Ura

Watanabe Tamotsu argues that all the roles in the *yūjo yakugara* perform some kind of "selling of the body."[55] Watanabe contends that the roles in the *yūjo yakugara* have two sides. One he calls the *omote* (surface) the front or public side of exhibition, which, he claims, is the epitome of onnagata aesthetics. The other side is the *ura* (behind), the backside or underside, which is hidden and dark, even sinister. Watanabe emphasizes that *yūjo* roles—like Yatsuhashi of *Kagotsurube*, who is slashed to death by a jealous client, or Otose of *Sannin Kichiza*, a prostitute who kills herself when she

finds that her beloved is her own brother—perform the *ura*, revealing the concrete reality of the hidden side that lies beneath but "supports the fictional aesthetics of beauty."[56] Many *yūjo* roles clearly demonstrate the *omote* side. But, according to Watanabe, these roles also show us the *ura*, the side related to the tragedies that arose from the selling of the body, the imprisoned life in the licensed quarter, and the economic bonds of prostitution. Watanabe describes the *ura* of the *yūjo* role, Satsuki of *Gosho no Gorozō* (Gosho no Gorozō):

> For money she sold her body, for money she had to speak hateful things she did not mean, for money she died. *Yūjo*, beyond all else, are bound to money. This is the pattern of their tragedy as a matter of course. . . .[57]

Satsuki later commits suicide because the lover, misunderstanding her feigned rejection of him, goes to murder Satsuki but, instead, inadvertently kills another *yūjo*, a close friend, Ōshū. The murder is beautiful as one watches the *omote*, and realizes the *ura*: the onnagata playing Ōshū wears Satsuki's gorgeous *oiran uchikake* when he is slashed through by the lover. In the death struggle, the onnagata tosses his white *mochigami* into the air. Pieces of white tissue paper flutter down like falling cherry blossoms over the now still *uchikake*. Watanabe suggests that the other-worldly beauty of the *yūjo* role type cannot be realized without both sides, *ura* and *omote*, somehow reflected in the onnagata's performance of the *yūjo* role.

In the Satsuki example, Watanabe suggests that in the world of prostitution, the theme of money governed the lives of real prostitutes, and the idea of "selling the body"[58] dominates the action and character of the *yūjo* role type. Further, he says onnagata have assimilated the "selling the body" idea into many roles of other role types that may appear different and distant from the *yūjo* role type. I concur and add that certain other *yakugara*, like *himesama* (princesses), *nyōbō* (wives), and *musume* (young girl), frequently incorporate *yūjo* gender acts of display—acts of "selling" their bodies—for different purposes involving family obligations and duty.

Sometimes the *yūjo* gender acts are obvious. Satsuki was previously a lady-in-waiting of the court, who sold herself into prostitution for a lover. Sakurahime was a *himesama* before "selling the body." In these cases of Satsuki or Sakurahime, both roles change into *yūjo* role types in the context of the play. But some roles of other role types share the *yūjo* "selling the body" elements under the guise of duty. For example, the onnagata playing Kumo no Taema, a *himesama* (princess) role, in *Narukami*, must perform sequences of "selling the body," to undo an evil plot and win a lover. Or an onnagata playing Owasa, a *jidainyōbō* (period wife) role in *Benkei Jōshi* (Benkei, the High Official) performs a dance/mime scene, using *yūjo* acts,

relating her seduction and abandonment by a lover. Following this, Owasa must let her daughter, a *musume* role type, the child of that love affair, be murdered by her long lost father. Both *nyōbō* and *musume* roles "sell the body" out of filial duty to a "lord."[59]

Yūjo Yakugara *Authority*

A point of distinction of the *yūjo yakugara* is their power and authority on the kabuki stage compared to any other onnagata *yakugara*.[60] For example, in contrast to many other onnagata gender roles, the onnagata as *yūjo* may take positions on the stage usually reserved for tachiyaku, like the *kamite* (upper part), the slightly upstage, left position usually reserved for the tachiyaku role of rank. The onnagata in a *yūjo* role may sit, talk, and entertain in ways that make the other characters act with great reverence toward him. In licensed quarter scenes, a kind of *mitate* (masquerade) was carefully enacted allowing the *yūjo* roles to perform in front of tachiyaku.

In his discussion of the *yūjo* role in *Yaku no Chii* (Role Ranks), Danjūrō IX suggests that the *yūjo* roles, even the lowest class prostitute roles, because they were unclassified citizens, could disregard other ranking codes and boundaries.[61] The onnagata in a *yūjo* role had a degree of freedom from restrictions placed on other onnagata role types. In the early kabuki plays, the onnagata as *yūjo* and the tachiyaku as paying guest played an exaggerated and choreographed version of procurement strategies, sometimes mocking those of the real licensed brothels. In a Yoshiwara brothel, for example, the client/guest, beginning with an impeccable appearance, had to follow a protocol with extended rituals of behavior. The first meeting of a client and *oiran* was much like a wedding ceremony with the exchange of sake cups between the couple.[62]

Contemporary *yūjo* gender performance seems dominated by measured restraint, control of stylized acts, and understatement of emotions. The onnagata as *yūjo* does not communicate submission or passivity through his elegant and restrained actions. Even in quiet, seated postures, the presence of an onnagata performing an *oiran* role, literally fills the stage with a sense of power and authority. His monumental presence can control the other characters' and the spectator's gaze. In *Kagotsurube*, Yatsuhashi's parade across the stage, still pose, and smile, are all moments where the *yūjo* role commands the space and becomes the focal point for all stage action and the audience's attention.

Lyrical Movement and Image Movement

More than dialogue, the *yūjo* role relies on physical action, with its abstract fluidity of expression, for communication. In dramatic sequences such as

the *kudoki* (movement sequence), *nureba* (love scenes), *shinjū* (suicide scenes), and *enkiri* (breaking-off-love scenes), onnagata use stylized, dance-like movements often performed to a special style of musical accompaniment[63] and lyric, which heighten the emotional intensity and subtly amplify the erotic power of the onnagata's *yūjo* gender acts. In such lyrical and dance-like sequences, onnagata enacting *yūjo* roles also use their sumptuous visual form as an architectural device defining and sculpting the space around them. Such abstract and mimetic movement, which communicates images and ideas, has been assimilated into the gender acts of other role types.

As mentioned earlier, the lyrics of certain accompaniment, like the *kiyomoto* style music and singing, which usually speaks of separated lovers and recalls the *yūjo* life theme of unrequited love, strengthens the ties and tensions between lover roles. The onnagata can play with many different threads of sensuality through his *yūjo* gender acts. Likewise, in a *musume* role such as Osato in *Yoshitsune Senbonzakura* (Yoshitsune and the Thousand Cherry Trees), when the onnagata gestures in dance-like *kata*, taking off his apron and looking at the moon, his gender acts recall *yūjo* acts. In the dance drama *Kurozuka* (Kurozuka),[64] the onnagata in the older woman role, before the moment of deception, dances with sensual *yūjo* overtones in a lyrical dance/mime section.

Yūjo *Love Scenes:* Nureba

As noted in chapter 6 on onnagata aesthetics, the main showcase for the *yūjo* gender role performance is the *yūjo nureba* (courtesan love scene). *Nureba* (figure 8.5) were once highlights of the early *keiseikai* (buying a prostitute) plays. Many *yūjo* gender acts are related to the acts of seduction and erotic dance movements of *nureba*. Perhaps due to their popularity and the *bakufu*'s restraints on overtly erotic dancing, *nureba*-related scenes were woven into the other kinds of plays. Consequently there are many onnagata roles of other *yakugara* involved in scenes with *nureba* characteristics.

The characteristic movements in *nureba* sequences, like leaning back into the lover's shoulder, pulling the lover's sleeves, twisting the torso, and looking down over the shoulder, are all *yūjo* gender acts. For the most part, the action in the *nureba* is compressed into dense, hieroglyphic movements with suggestive costume and prop articulation, performed to the accompaniment of lyrics and music. When the onnagata and tachiyaku lovers perform the *nureba* movements together, they are nearly mirror images of each other, exchanging similar gestures, back and forth. Their costumes, wigs, and makeup indicate their different gender roles, yet their movements share similar kinesthetic patterns that reflect the gender ambiguity of certain stylized gender acts.[65] I wondered if the Edo period public came to see the

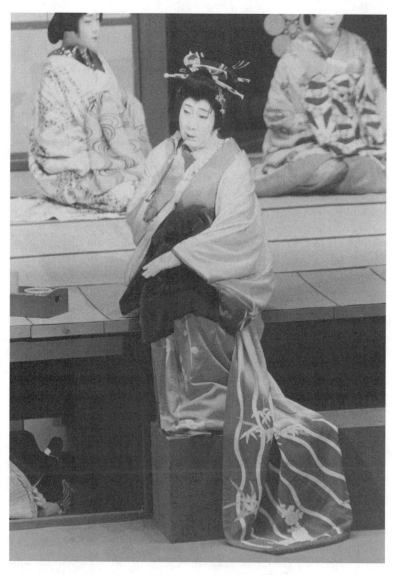

8.5 Nakamura Ganjirō III *yūjo* role type Ohatsu

seductive acts performed by two men in costume, by the male and female characters of the play played by two men, or by tachiyaku and onnagata kabuki performers. It seems these acts of seduction are shared across genders and *yakugara*.

Certain *yūjo* acts and movement characteristics from *nureba* can easily be seen in other *yakugara* gender acts. For example, pauses function as time and space intervals to allow still, held poses to register to the spectator. Suspended action within the framework of music and suggestive lyrics creates the atmosphere necessary for sensual performance. Kabuki actors move toward an embrace, but barely touch, and only sometimes embrace. By avoiding climaxes in this way, the onnagata's sensual attraction expands and even intensifies the "performed desire," which is rarely fulfilled. I suggest that the onnagata's basic stylization techniques of suggestion, abstraction, indirectness, and incompleteness were first characteristic of the *yūjo* acts and then spread to many other *yakugara*.

Less ostentatious gender acts are also aimed at intensifying the *iroke* of the *yūjo* gender acts. Among these are the small adjustments the onnagata makes to his kimono: touching the front collar opening, slipping his hands inside the sleeves or *obi* folds, and opening the skirts of the kimono. The handling of small props is another important part of the onnagata's repertory of *yūjo* gender acts in *nureba* Major *yūjo* gender acts arise from the handling of costume parts and hand props that were used in the licensed quarters of the Edo period. Many different *yakugara* use the same objects. For example, the *kanzashi*, a long pick-like decorative hair ornament, usually with a bauble at one end, is an intimate part of the *yūjo's* constructed gender acts, but other *yakugara*, like the *himesama* (princess) or *musume* (young girl) *yakugara*, also employ similar kinds of hair ornaments. The *mochigami*, the *tenugui*, the cups and bottles for *sake* serving, and the *hibachi* coal-stirring rod, to name a few, are important in *nureba* scenes and are used by most onnagata *yakugara*. The manipulation of hand props in all onnagata gender roles is considered a very important part of an onnagata's onstage *iroke* (erotic allure).[66] So special are the hand props in kabuki that onnagata often maintain their own sets of hand props, or a set belonging to their family line.[67]

Thus *nureba* acts are not restricted to *yūjo* roles; onnagata perform the same *nureba* acts no matter what the role type. For example, *musume* roles such as Osato in *Yoshitsune Senbonzakura*, and Omiwa in *Imoseyama* use similar *yūjo* acts with their tachiyaku lovers in scenes that suggest *nureba*. The *himesama* role, Yaegakihime *Honchō Nijūshikō*, performs a stylized sequence of *yūjo nureba* acts on recognizing her betrothed for the first time. In addition, Kumo no Taema of *Narukami* and Sakurahime of *Sakurahime Azuma Bunshō* are "hybrid" *himesama* role types who use *yūjo* acts in their exceptional, *nureba*-like seduction scenes. In *Yoshitsune Senbonzakura*, the *shirabyōshi* role of Shizuka Gozen, the onnagata is costumed as a *himesama* role type but is really a mixture of *musume* and *yūjo*. In one scene, the onnagata playing Sakurahime dances a kind of lover's *michiyuki* (travel dance) with a tachiyaku who plays the role of a fox disguised as a retainer. The

hybrid princess-*shirabyōshi* role performs *yūjo nureba* sequences with the hybrid retainer-fox role.[68] Even if their purposes are different, all onnagata role types share similar *kata* of seduction—the ordered stylized postures, gestures, and action sequences that are based on *yūjo* gender acts.

Supernatural Paradigms

Onnagata found an avenue for creative and free-form experimentation in the *yūjo* gender role type. It was in the exotic world of the kabuki *yūjo* where onnagata could create new rules and contest gender and class hierarchies through their *medatsu* (eye-catching) performative genders. In a sense, the onnagata could remap the territory of the body through magnification, miniaturization, and other stylization practices of costuming, postures, gestures, and vocal forms. These forms are shared by other onnagata *yakugara*.

The early onnagata *yūjo* role type was—as it is today—a male inscription based on the *wakashu* art of eroticism and seduction.[69] The *yūjo* role type was not simply a theatrical version of *yūjo* women. The kabuki theatrical context enabled onnagata to reconstruct the male body and reinscribe the conventional social order, surpassing human-likeness altogether. By extension, the *yūjo* role type liberated all onnagata role types from mere imitative or representational performance. If the onnagata-as-*yūjo* was a fiction of a fiction, created outside the socially prescribed female gender role, then the other *yakugara*—*himesama* (princess), *nyōbō* (wife), *musume* (young girl), *baba* (old woman), *akuba* (evil female)—were equally fictional, ambiguous, and erotic gender constructions. Each *yakugara* is composed of sets of variable gender acts in a transformative gender system. Their stylized acts constitute gender role types and specific characters but not an "essential" gender. Applying Judith Butler's gender discourse, I suggest that any onnagata *yakugara* is simply "a constructed identity, a performative accomplishment."[70]

As mentioned in Jennifer Robertson's critique of gender in the Takarazuka Review, and Jill Dolan's article on gender performativity (see chapter 2), the role of the performer has the potential for subverting sociocultural gender prescriptions.[71] Even as they are rooted in a male body and a masculine-authorized system, onnagata *yakugara* in performance demonstrate the fabrication of gender. In this chapter, I have attempted to examine how the onnagata *yakugara* are performative examples of multiple, hybrid, and transformative genders that disengage the onnagata gender role from a binary gender system. I analyzed the *yūjo* gender role type as a template for other *yakugara* and as the base for onnagata gender ambiguity, transformativity, and eroticism, linking contemporary onnagata performance to the early creators of the system: the beautiful adolescent boy prostitutes,

the *wakashu*. The onnagata *yakugara* are specific, detailed gender role types that are simultaneously transformative, ambiguous, and extraordinary. That is, they are extra-human: sensual and erotic yet metaphysical and transcendent. As such, the onnagata *yakugara*, their art of stylization, and their gender acts offer theatre makers and performers a suggestion for a theatre whose representation of humans does not rely on or imitate the hegemonic ideology that enforces the sex/gender system of matching a body's sexual parts with one category of gender acts and limits those gender "identities" to two.

CHAPTER 9

TOWARD A NEW ALCHEMY OF GENDER, SEX, AND SEXUALITY

Fantastic Surrogation and Physical Transformation: Performing the Synchronicity of Onnagata

Within kabuki, the art of the onnagata is striking for its breathtaking, stylized beauty: its deeply felt artificiality. What are the methods that produce this alchemy of female-likeness? How do they transform their male bodies beneath? What physical acts subtly heighten their erotic sensual allure? How do they control and painstakingly reshape their bodies? How do eighty-year-old onnagata perform *musume* roles with the fragrance of youth? How do onnagata maintain their sensual beauty in scenes of torture? What are the implications of stylized suffering and beautiful victim roles? When transforming from princess roles to fox-spirit roles, or from seductive courtesan roles to possessed spirit roles, what happens in that passing from one role to the "other"? How do they play with multiple desires and tantalize spectatorial imagination with their gender ambiguity? What is disquieting about their seductive *yūjo* roles of massive, god-like, *jinkō no bi* (artificial beauty)?[1] How do onnagata make their deep artificiality breathe? How do flesh and artifice come together in what Hirosue Tamotsu refers to as the onnagata's "double fiction," with its "residue of unearthly shadows?"[2]

As a theatre artist and student of kabuki, I have found the onnagata art of gender stylization, transformation, eroticism, and ambiguity complicates any simple notion of binary genders. The onnagata's art goes far beyond male actors playing female roles, far beyond notions of "impersonation." Explanations of how onnagata perform "traditional women"[3] on stage, or how onnagata "evoke so convincingly the essence of womanliness,"[4] belie

the depth, complexities, and differences of the onnagata gender art. On the kabuki stage, I do not see "women" at all. I see onnagata.

For this book, I have used performance theories that draw on Western feminist theories on gender and reading the body in performance, and Japanese concepts of performance related to the kabuki onnagata. I found that Western feminist theories on gender and the body in performance provided some of the tools I needed to examine, interrogate, and interpret the art of the onnagata. From among these theories, I had to select those that could work transculturally, with the least amount of cultural hegemony that can shade and misread aesthetically and ethically.

Sometimes the process of intersecting Western feminist theory with the traditional kabuki onnagata deftly reveals the differences and uniqueness of the onnagata's art. But, in some instances, a transcultural feminist analysis can seem forced and artificial because many ideas do not translate, many concepts remain too Western, or too theory-bound to work in the kabuki context. But, I find it disquieting to read articles or books on onnagata history and performance, from as recently as the 1990s, that assume that onnagata impersonate women. Rarely, if ever, do these articles or books address the male body beneath as integral and/or essential to onnagata performance.[5] Further, in reading early kabuki history through the lens of Western feminist theory, I found that the history of the *wakashu* and early *wakashu* onnagata suggested a different explanation for onnagata performance techniques. Instead of "imitating women," early onnagata based their erotic performance art on *bishōnen* (beautiful boy) aesthetics and physical characteristics. This volume demonstrates how those beautiful boy aesthetics and physical characteristics are still alive and radiant in contemporary onnagata *kata* and their stylized performance. Reading the art of the kabuki onnagata with the lens of transcultural feminist theories allows the onnagata art not to be reduced or restricted to any one interpretation or gender but to be distinguished for its complexities, differences, and multiplicities of possible "other" meanings and genders.

Thus, my research of history, performers, and performance techniques may seem like an onnagata manifesto that substantiates their particular gender art. Onnagata history, aesthetics, and techniques show us a highly developed performance of ambiguous performative "genders" based on a male body beneath. My analysis of onnagata performance functions as a kind of paradigm for transcultural feminist research. My intersection of theory and practice is not a new approach, and there are still many problems in my application of feminist theory and analysis of historical and performance evidence. However, I think this volume is a contribution to a growing field of transcultural and transnational feminist research, as well as to kabuki performance scholarship.

Onnagata Gender Theory

Onnagata perform gender roles that are made up of stylized, transformative gender acts. In their unique performance of onnagata female-likeness, onnagata demonstrate the possibility of disengaging the idea of a fixed gender identity limited to a male or female binary and oppositional gender system. Instead of following a sex/gender system of matching a body's sexual parts with one category of gender acts, onnagata creatively construct gender roles from stylized acts that emphasize their designed and sensual beauty. I have argued throughout this book that onnagata engage in a performance of "gender," which opens possibilities for future performing bodies.

In this study, I trace the evolution, elaboration, and the aesthetic formulation of the kabuki onnagata gender performance through the history of women and beautiful boy performing prostitutes, star onnagata, and contemporary performance techniques, aesthetics, and role types. For over two hundred fifty years, under great duress imposed by constant surveillance and prohibitions by the *bakufu* government, youths and men constructed a stylized performance of female-likeness. Their fantastic theatrical achievement was the art of the onnagata in performance: an iconic representation of a radical fiction of female-likeness. I believe my study of the history, techniques, and aesthetics of onnagata gender performance may provide insight into the following question posed by Judith Butler: "How does a body figure on its surface the very invisibility of its hidden depth?"[6] Throughout this book, I have sought to illuminate the profound artistry of the onnagata's performance, which is at once sensually beautiful and ambiguous on its surface and in its depths. In the following conclusion, I summarize the main points of my examination of onnagata gender performance, restating how my study utilizes feminist transcultural methods of inquiry.

Initially, I put forward the concept that the specialized and stylized performance of kabuki onnagata could be broken down into onnagata gender acts. I looked carefully at the explanations for the development of the art of the onnagata as presented by Japanese and Western scholars. Influenced by several feminist theorists—in particular, Sue-Ellen Case, Judith Butler, Jill Dolan, and Jennifer Robertson—I reread the history of kabuki's onnagata as a constructed image of female-likeness.

Precursors, Star Designing, and Myth-Making

Prior to kabuki, there were performers of transformative gender acts, such as the *shirabyōshi* (prostitute performers), who combined dance, music, acting, and erotic display. The majority of *shirabyōshi* were women or girls who combined prostitution and performance as a livelihood. Throughout different ages, male and female performers, particularly youthful performers,

"played"[7] with various gender combinations. At the beginning of the Edo period, Okuni and *yūjo* (female courtesan) kabuki performers enacted gender transformations in the context of skits and dances, setting the stage for the art of the onnagata. I found that it was not just the erasure of women from the public stage in 1629 that propelled *wakashu* (boy prostitutes) into the kabuki entertainment spotlight. Rather, Okuni's and the *yūjo* kabuki performers' performances of gender ambiguity and erotic allure had opened up a whole new genre of performance, which theatrically "mixed" the *bakufu*'s prescriptions of class and gender roles. Their flamboyant performances became a kind of rage. The bans on women performers were one way the *bakufu* could control one part of the population, curb the mixing of classes, and suppress the underlying disruption of gender roles and—overtly—sexual performances. Okuni's erotic gender performances generated a profound change in theatrical representation. While she liberated erotic, irreverent, and transformative gender roles, the government's reaction removed the female body to the private sphere.

Upon examining the historical transitions from Okuni kabuki to *wakashu* kabuki to early onnagata, I found links between Okuni's gender performance, the *bakufu* bans on mixed troupes and women performers, the restrictions placed on *wakashu* performers, the aesthetics of the beautiful boy prostitute, the associated performance practices and history of *nanshoku* (male love), and early onnagata gender act development. Through the transitions, a flamboyant style of gender performance had been part of kabuki from its inception, and the beautiful *wakashu* had played a vital role in shaping onnagata gender stylization. The transition from *wakashu* to early onnagata was gradual, and it extended over generations of onnagata. While there is evidence of early onnagata being praised for performing as if they were women, there is also evidence that suggests another evolution. There are prints, descriptions, and reviews that indicate that *wakashu* stylized their *wakashu* acts into onnagata gender acts, which they then used to enact the "female" roles in the early kabuki skits and dances. The earliest star onnagata, like Ayame I, trained as boy prostitute performers. The earliest onnagata techniques were clearly linked to the tradition of *wakashu* beauty or the *bishōnen* (beautiful boy) aesthetic. Although disguised in new *wakaonnagata* (young onnagata) roles in the new dramatic narrative plays of the early eighteenth century and praised for their female-likeness, early onnagata probably kept on performing their *wakashu* acts, gradually adding, altering, extending, and elaborating on that base of the beautiful boy body.

Star onnagata, like Ayame I, developed a specialty gender role, a variation on the onnagata gender role. In Ayame I's case, he set the patterns for the original *keisei* or *yūjo*, the courtesan role type. As Ayame I had trained as an *iroko*, a kind of *wakashu* performer, he brought this heritage with him,

innovating on his *wakashu* acts, creating and establishing his gender role type, the *yūjo* role type, as the prototype for most onnagata gender roles. Ayame I's famous notes on onnagata performance in the collection *Ayamegusa* clearly indicate a developing performance art that required specialized training and stylized forms. Later, star onnagata of the Edo period constructed their roles and role types based on their own bodies and physical styles. Sources like the *Yakusha Hyōbanki* show some reference to the imitation of women for their gender roles, but onnagata were most lauded for their various specialty acts, for example the erotic charming courtesan role, the emotionally stricken noble wife role, or the fantastic transformative dance role. Gradually, a system of *yakugara* (role types) developed as a result of star onnagata's specialties and popular character types.

Subsequent star onnagata added their own gender role type variations, adapting the *yūjo* gender acts to go with their new variations. For example, Kikunojō I's *musume* role type, required *furisode* (fluttering sleeves) and *suberi* (tiny, slipping sliding walking style), while Tomijūrō I's spectacular transformation roles in dances added more variations on gender role types, in addition to garnering the dance as the province of the onnagata. Hanshirō IV and V established their radically new gender role type, the *akuba* (evil female), which gave the onnagata an extended range of gender act variations. Ultimately, the *himesama* (princess), *yūjo* (courtesan), *nyōbō* (wife), *musume* (young girl), *baba* (old woman), *akuba* (evil female), and *hengemono* (transformative being) became standard role types, each having its own specific gender acts. In chapter 8, I discussed the importance of role types as gender variations and the *yūjo* role type as a template for the gender acts of most other role types.

With the onset of the Meiji period, kabuki went through many changes. In particular, the breakdown of gender role specialization meant that major tachiyaku, like Ichikawa Danjūrō IX, not only performed but set new *kata* for major onnagata roles. Danjūrō IX also led the reformation of kabuki, which emphasized verisimilitude, modernity, and a kind of naturalism—all of which could have threatened the art of the onnagata. This was a crucial period of transition, when kabuki became a classical art, actors gained citizenship, and the ban on women performers dissolved with the *bakufu* government. I followed the careers of Sawamura Tanosuke III and Iwai Hanshirō VIII, star onnagata, who went through the transition of the late Edo period into the Meiji period (1850–1900). I found that these two onnagata, each in his own way, responded to the challenges of reformation, but brilliantly preserved their onnagata difference, their special eroticism, their gender transformativity, and their gender ambiguity.

After the transition period, I focused on two onnagata, Nakamura Utaemon V (1865–1940) and Onoe Baikō VI (1870–1934), who were the

mentors for the oldest generation of contemporary onnagata living at the time of my study. In a sense their *kata* are the template *kata* for the senior star onnagata I have seen perform in the last two decades of the twentieth century. Their *geidan* (art discussions) from which I drew examples, are richly detailed volumes that articulate the depth, diversity, and artistry of onnagata gender role types and their gender acts. In their divergent styles, the onnagata describe not only the specialized *kata*, but also the absolute commitment necessary for their art of heart, spirit, and bone-breaking physical effort.

Onnagata Aesthetic Principles

How and when certain aesthetic concepts considered important to onnagata performance developed is difficult to say. I chose several aesthetic points and concepts that contemporary kabuki scholars cite most frequently when critiquing or describing contemporary onnagata performance or historical onnagata. In particular, Gunji Masakatsu has discussed at length, and researched extensively, the points I chose, which had the most bearing on my thesis of onnagata gender role construction. Gunji's research also extends across traditional, contemporary, and experimental Japanese theatre and dance; choreography and the aesthetics of gesture; and the relationship of culture to sensuality, eroticism, and kinesthetic perception. Gunji focuses on the following aesthetic concepts as central to all onnagata performance: *iroke* (erotic allure), *zankoku no bi* (beauty of torture), *kanashimi* (deep sadness), and *jinkō no bi* (artificial beauty) to illuminate the designing of onnagata gender acts and role types.

Although all of the above aesthetics may also function as aesthetic principles for kabuki performance in general, I found them essential to onnagata gender performance and deeply tied to the kind and style of gender acts that have become trademarks of the onnagata. I presented *iroke* in most detail because of its connection to the *wakashu* tradition, prostitute performers, advertising the body beneath, and the *yūjo* gender role type as the fundamental role type and model for onnagata performed eroticism.

Of the four aesthetic concepts, *jinkō no bi* is a more general type of aesthetic principle, as it arose within and dominated much of Edo period (1600–1868) culture. I discuss this principle in the context of the onnagata *yakugara* (role types). The concept of *jinkō no bi* is particularly important to understanding the reading of the surface of the onnagata image, as well as the kinesthetic communication of their stylized "intentional body." Designed artifice underlies all onnagata gender stylization. Onnagata gender acts, as I have shown, literally celebrate their artificiality from the turned-in knees of the intentional body beneath to the magnificent and monumental

uchikake (over kimono) of the *oiran* (high-ranking courtesan) role type. If an act was not "artificial"—constructed, manipulated, and stylized—it did not belong to the onnagata's fiction of female-likeness. Every aspect of the onnagata, according to Onoe Baikō VII, "must be made beautiful," but this is only realized when one performs the *kata* with "heart."[8] So, it follows that all gender acts must be artificially designed to achieve a beautiful form, but they must be infused with sensual allure. Then, if beauty is built on and with the body, the stage entity the onnagata produces must appear simultaneously, corporeal, sensuous, and natural, *and* synthetic, constructed, and artificial.

In scenes involving *kanashimi* (deep sadness) and *zankoku* (torture), the onnagata's beauty of form dominates over the action and its meaning. I described several examples of how the stylization of the onnagata's gender acts in scenes of murder or rape literally beautifies the violence. Subsequently, the kinesthetic communication to the audience is artificially altered. The onnagata's character's pain and suffering is beautifully stylized, yet some part of that pain, even though it is distanced through abstraction, is still present. Perhaps the draw of the spectators to such scenes is the subtlety of abstracted pain, which the onnagata performs with exquisite detailed *kata*.

I examine performance examples for each of the aesthetic concepts: *iroke*, *zankoku*, and *kanashimi*, demonstrating how onnagata stylized acts and aesthetics complement each other. That is, there is an erotic tinge to all *zankoku* scenes, and the *kanashimi* aesthetic arises from gender acts that are often infused with *iroke*. Major scenes of *zankoku*, like extended cruelty or torture to a loved one, may have long sequences of danced postures, which emphasize the gender acts associated with onnagata *iroke*.

Although I do not cover the spectator's role in aesthetic transactions between onnagata and spectators, onnagata spoke of being the one looked at and the one who provokes and arouses the spectators through their erotic designed gender acts. The point was that the onnagata did not act out or represent a sensually alluring "woman" to attract attention, but the stylized gender acts themselves, because of their beauty, were aimed at attracting the spectator's gaze.[9] The onnagata I interviewed pointed out that they were onna*gata*, emphasizing their *gata* or *kata* (form), that is, the designed "form" over mimetic representation of female-likeness. They emphasized that they play with the multiple layers of their gender role acts and their own bodies beneath to charm the audience with their transformative and ambiguous gender acts. They mix their onnagata gender role sensuality with their own sensual physical styles to produce their theatrical allure, their *iroke*.

Zankoku no bi (beauty of torture), as it arises from scenes of torture, is especially important to onnagata gender role performance. The onnagata

roles in scenes of torture are among the most frequently performed star scenes for onnagata. The acts of violence and torture are choreographed to display the erotic sensuality of the onnagata's constructed gender role and his body beneath. The onnagata gender role is in the position of being the object of the violence, which is designed to appear beautiful, no matter what the violent act. In the torture scenes, onnagata literally dance their torture through stylized gestures and acts of undoing their kimono and *obi*. Any amount of undressing gradually reveals, in a stylized manner, the construction of their gender acts and parts of their body beneath.

Iroke is also a part of the aesthetic of *kanashimi* (deep sorrow), which probably began in the early Kamigata plays of Chikamatsu Monzaemon. Many of these plays dramatize the buying and selling of *yūjo* and their entertainments, and the complications of anyone falling in love across classes. In scenes of loss over lovers or children, the onnagata enacting such roles has a repertoire of gender acts for crying, sobbing, and repressing any show of sorrow. Onnagata perform stylized and abstracted movement accompanied by lyrics and music, which make their sorrow appear beautiful and, somehow, desirable. For example, pain and anguish are elongated in the slowed tempo of the onnagata's gestural gender acts of weeping and postures associated with erotic allure are woven into the sequences of lament. In my performance examples, I examine how the mix of gender acts used to evoke *iroke* and portray *kanashimi* creates another gender performance pattern particular to the onnagata gender role.

The Intentional Body: Embodying Ideal Gender Acts

In the chapter entitled "The Intentional Body," I examine the actual physical acts and formulas contemporary onnagata employ to construct and perform their onnagata gender roles. Onnagata base their performance techniques on the concept and function of *kata* (forms), which are stylized performance codes that onnagata use to construct their gender roles. Certain onnagata gender acts are the fundamental forms, called *kihon no kata*, for constructing onnagata gender roles. During my investigation, performers and scholars cited a set of fundamental gender acts that are necessary to construct an "ideal" onnagata body. I term their "ideal body" the onnagata's "intentional body." The intentional body is the model image that onnagata are taught from their early training in *onnagata no kihon* (onnagata fundamentals). An onnagata intends to mold his flesh, muscle, and bone through specific physical acts to approach the "ideal," the onnagata intentional body, a composite of fundamental onnagata gender acts. The "intentional body" is a concept I coined to clarify how onnagata expressed themselves in relation to the ideal: no matter what the role, the onnagata performs a set of basic

physical manipulations that are necessary to approach the artificial onnagata ideal. Yet, no matter how onnagata strive or intend to reach for these ideal physical postures and gestures, they never actually achieve the ideal form.

Yakugara: Mapping Gender Role Types

The development of onnagata *yakugara* is key to the evolution of onnagata *kata*. The standard onnagata *yakugara*, the *himesama* (princess), *yūjo* (courtesan), *nyōbō* (wife), *musume* (young girl), *baba* (old woman), *akuba* (evil female), and *hengemono* (transformative being) each have their special gender acts, which distinguish them from each other. Each *yakugara* also shares certain *kihon* gender acts and the intentional body. Further, I proposed that each *yakugara* has retained some of the *yūjo* gender acts in its specialty gender acts.

Specific roles within a role type category require certain modifications to the role type *kata* (forms). And as an onnagata rises in status, he may adapt certain kinds of role type *kata* to his body and physical style. A very famous onnagata may even add his own *kata* to the mix. In my research of role type stylizations, I found that despite the diversification of role type *kata*, the role types kept certain basic acts of the *yūjo* role type as their model gender acts. Perhaps because of the intimate connection of the first onnagata gender acts to their *wakashu* origins in the *wakashu* culture of prostitution and erotic performance, certain acts and their associated aesthetic, *iroke* (erotic allure), may be found in most onnagata role type gender acts. My examination of role type development and contemporary performance of the *yūjo* role type demonstrated the diversity and variability of the gender acts that make up the repertoire of onnagata gender role types.

The *yūjo* role type, the courtesan entertainer, is the template or model role type for all onnagata role types. Historically, the courtesan role was the first role played by the earliest onnagata. *Yūjo* gender acts are linked to the first *wakashu* performances and their *bishōnen* aesthetics. All the other role types partake of the beautiful boy eros to different degrees and in different ways. In a sense, the *yūjo* role type provides the basis for the gender ambiguity and transformativity in all onnagata role types. The *yūjo* yakugara is both its own distinct *yakugara* and a larger archetypical *yakugara* from which the other types have branched or differentiated. I demonstrate how the boy-courtesan gender acts, kept as a basic "body" could be easily adapted by star onnagata into other role types. The layers of assimilated gender acts over the boy *yūjo* acts lend all the role types a delightful transparency, an ambiguous and transformative "sense" of possible bodies beneath. The onnagata is never not in transformation. He maintains that fluidity and transparency that was key to the *wakashu* erotic aesthetics. Japanese scholars have also argued that the *yūjo* role type occupies a pivotal position among the other onnagata

role types. Contemporary onnagata also attest that the gender acts that elicit *iroke*, eroticism, founded in the *yūjo* role type, are essential to all their roles.

Divining a Gender Matrix

In my theory of onnagata gender acts, I focused on the following concepts of gender performance: gender performativity, stylization, ambiguity, transformativity, and the concept of the "body beneath." Through the actor, gender acts, role types, and performance, I demonstrated how these points developed from performers' lives, bodies, and circumstances, in the context of kabuki theatre. I have emphasized how the onnagata and their acts constantly disrupt the seemingly natural binary, oppositional, and restrictive prescriptions of bipolar male or female. Although the investigation in this area is far from complete, I believe I have shown support for my hypothesis of gender acts as stylized performative forms, which, even when configured in gender role types, do not constitute or represent a fixed gender core or identity.

Judith Butler's distinction between gender acts as "performative" rather than "expressive" is pivotal to understanding my reading of onnagata gender acts and one that I used throughout this book. I return to Butler, re-quoting her passage on this difference:

> The distinction between expression and performative is crucial.
>
> If gender attributes and acts, the various ways in which a body shows or produces its cultural signification, are performative, then there is no preexisting identity by which an act or attribute might be measured; there is no true or false, real or distorted acts of gender, and the postulations of a true gender identity would be revealed as a regulatory fiction.[10]

It may seem obvious to some theatre scholars and practitioners who regularly work with the transformativity of the actor body in theatrical roles. However, I think there is still resistance to gender transformativity. When the prospect of the breakdown of the conventional gender system arises, it may be more difficult to let go of the polarity that supports a heterosexual imperative. I have suggested that the onnagata gender acts and gender role performance have the potential to subvert the idea of an "essential" masculinity and femininity. In their performance process, I have sought to show how onnagata demonstrate "the performative possibilities for proliferating gender configurations outside the restricting frames of masculinist domination and compulsory heterosexuality."[11]

To this end, I investigated the theories of gender construction in the critical writing of Japanese theatre scholars, critics, and artists, and found a

variety of supporting evidence. Critics, scholars, and performers alike affirmed that the onnagata female-likeness is an aesthetically constructed and performed *uso* (illusion). In an article on onnagata, Terayama Shūji (1935–1983) discusses the process of perceiving the onnagata female-likeness and the ambiguity of that vision in Utaemon VI's performance of *Musume Dōjōji*:

> He does not become female . . . nor is it that he destroys some self core that is male. Rather, the painful effort to make the spirit of two varieties which get divided into male and female, and put these together into gestures of the flesh, sustains his fiction . . . In society, Utaemon is really nothing more than a middle-aged man. But at the same time, you cannot forget he is a beautiful *musume* [young girl role type]. So, the middle aged man gets tied together with the beautiful *musume*, he attempts to make a body from the flesh of one body, so closely allied as male-female . . . it follows that the chance of the existence of the individual self can be organized in various ways in great variety. It is possible to conceive of "theatre" in this way.[12]

Utaemon VI commented on his own onnagata performance in an interview with Gunji Masakatsu, "The kabuki onnagata is different, I think of . . . composing the line of the body, making up the features of the face . . . it's not about 'becoming a woman.' "[13] In another interview, Onoe Kikuzō VI (1923–) illustrated his onnagata gender performance by drawing several differently shaped lips on a piece of paper, explaining how each type of lips belonged to a specific onnagata role type. Kikuzō VI concluded, "An onnagata is like these drawings: something that is made up with many, many variations."[14]

I found the theme of transformativity of gender acts in all stages of historical development as essential to the development of onnagata role types and their associated aesthetics. Over and over again, we can see how early Edo period performers followed a performative methodology, which allowed their own interpretations and variations of the onnagata gender roles. Even if contemporary onnagata do express an overt political agenda aimed at fragmenting and destabilizing any absolute binary oppositional categorization, their gender acts, their stylization methods, and their performance styles reveal themselves as performative acts over a male body beneath. Contemporary onnagata gender acts are dynamic, physical, visual, and aural operations that may be prescriptive and stylized, but, they are also transformative, even vision-like, and ultimately unstable and mutable.

As a feminist reading, I have outlined my methodologies, which are based on Western theories of gender performance. I have included previous investigations and theories of Japanese and Western kabuki scholars on onnagata. From these various sources, I attempted to formulate a transcultural

analysis of onnagata historical construction and development and contemporary onnagata gender performance. My theory begins with the hypothesis that the male "body beneath" initiates the break between gender acts and the sex of the body enacting the gender acts. In performance, spectators witness the male "body beneath" but may freely imagine the play between the male body beneath and a fictitious female-likeness created with and over the surface of the body beneath.

Above all, my thesis was aimed at examining and analyzing gender acts as transformative codes, rather than as static forms, which may represent, support, and subvert embedded ideologies. The techniques of ambiguity and transformation were explored throughout this text as the sites of variable gender choices. In historical written records, personal comments, and scholarly writings, onnagata performance defies a strict definition in gender terms. If anything, onnagata represent the performative transformativity of gender acts.

In all of my strategies, I was careful to note how onnagata gendered "acts" do not configure into an expressive constellation of a "kabuki woman" or "ideal woman." Rather, it is the transformativity and ambiguity of the onnagata *kata* that underlies the transformativity and ambiguity of onnagata gender roles. I am not being redundant. I tried to preserve the questionable, slight differences, the ever so subtle alterations of the model body by the performer who, thus, modifies the traditional iconography. My reading of onnagata gender acts requires a strict consciousness to refrain from constructing a unity or essence from data that defies rigid formulation.

After research and analysis, I concluded that the onnagata as a fiction of "Woman" was no longer a viable concept. Instead of working up a fantasy of Woman, onnagata gender performance is a fiction-making process based on the physical aesthetic of the adolescent boy.[15] What can be verified is that onnagata perform complex gender acts, and that they are a part of a theatrically performative world where performers perform gender role types that are not limited to male and female divisions. I could no longer read the onnagata as a fiction of Woman, but, rather, as a fiction of female-likeness with its own variable and transformative gender acts based on an adolescent boy body.

Japan has a complex history of a tradition of ambiguous gender configurations in its visual, literary, and performing arts. Although this book focused on only one type of female gender enactment, if evaluated in the context of Japan's final period of isolation and as a modern medieval period, the formulation of the kabuki onnagata gender acts may be considered a critical moment of cultural configuration. On one hand, onnagata gender acts valorized the masculinist society largely based on male sexuality and desire and male occupation and class distinctions. On the other hand, the onnagata gender acts

could also be read as subversive disruptions of sexual binarism and class norms demanded by the Tokugawa shogunate. They were outlaw bodies. The enactment of female-like characters by male performers subsequently shaped the development of kabuki's subject matter, role types, and performance techniques—especially physical and vocal stylizations of all gender roles. With the opening of Japan to the West in the 1860s, the onnagata earned the status of strange and bizarre juxtaposed to the naturalism of Western realistic theatre. The kabuki onnagata gradually evolved into an icon of exaggerated stylized gender acts, which still resonates in contemporary Japanese society.

Perhaps onnagata today are performers in a unique subculture, or they are themselves a subculture of performance. Like border figures, or outlaws, not belonging to the dominant culture of strictly defined male and female gender, their bodies enact their own culture, which is male embodied but not identified. Kabuki onnagata may enact an ideology of "feminine" and "masculine," but their performances are not confined to binary or polarized identities. A closer look at their history, the star onnagata, their fabricated "intentional body" and gender acts, the *yakugara*, and aesthetics arising from these various sites of inquiry, has hopefully illustrated the point that the onnagata body is a "variable boundary . . . a corporeal style, an act, as it were, which is both intentional and performative, where "performative" suggests a dramatic and contingent construction of meaning."[16]

As I asked at the beginning of this book, would kabuki theatre exist without onnagata as one of its eccentric, glamorous, sensual, and provocative elements? Onnagata gender performance distinguishes kabuki as an art without women, whose stage representations of female gender roles are onnagata gender roles, which are male-created fictions of female-likeness based on an adolescent boy body. Further, the attraction for the onnagata held by audience members of varying genders and sexualities, suggests a much more complex role for the onnagata than the representation of an ideal Woman. Just as the provocative, gender ambiguous, and transformative role of the onnagata was an integral part of kabuki's subversive history, it is still a dangerous, but commercially viable element, of the contemporary Grand Kabuki. As I have shown in their history, onnagata of the Edo period repeatedly transformed their performances of gender acts, creating new role types and new gender acts. Further, the onnagata aesthetic of *jinkō no bi*, supports the fantastic stylized construction of onnagata gender acts, which to me suggests that onnagata gender performance could be an answer to Butler's question, ". . . what kind of gender performance will enact and reveal the performativity of gender itself in such a way that destabilizes the naturalized categories of identity and desire?"[17]

In conclusion, I offer my analysis that past onnagata created and performed outside and beyond a polarized framework of binary genders, and

contemporary onnagata continue to perform their legacy. I suggest that onnagata, in their refined articulation of flamboyant and fantastic stylized forms, theatrically substantiate Butler's proposal, which I quoted at the beginning of this book: "Genders can be neither true nor false, neither real nor apparent, neither original nor derived. As credible bearers of those attributes however, genders can also be rendered thoroughly and radically *incredible*."[18]

I believe this study affirms what the onnagata perform and speak: "There is nothing 'natural' about the onnagata."[19] The challenge from this examination is for contemporary theatre makers and scholars to go beyond a binary gender formula for the enactment of human roles. Breaking up binary oppositional gender roles, enjoying transformativity, and reveling in ambiguity could lead to, as Kathy Foley suggests, "a theatre of mythic dimensions,"[20] and thus, to more radical relationalities of bodies in transformation. Onnagata perform simultaneously in mythic and human dimensions. Perhaps the future of "performance" lies in such ambiguous transformative performances in which human and "other" bodies traverse multiple dimensions of space, time, and consciousness in synchronous, yet out-of-synch, roles. The beautiful boy/onnagata is an aggregate of "differing" desires, extraordinary and outlaw. As many onnagata affirm: "I *perform* onnagata and myself."[21]

NOTES

Chapter 1 Transforming Genders

1. In general, I italicize Japanese terms except in the case of generally known or frequently used terms such as kabuki, tachiyaku, and onnagata. For most Japanese terms, I cite an English equivalent after the first use of the Japanese term. In some cases, I have chosen to use a Japanese term after explaining it in English when I feel the Japanese term does not readily translate without losing meaning. When I reintroduce a Japanese term in a later chapter, I again cite the English equivalent. In my translations of quoted passages, I keep key terms in Japanese and italicize them.

2. There were many other types of restrictions the government placed on all kabuki performers that are beyond the scope of my study.

3. The term *bakufu* refers to the governing body of the Tokugawa period, also known as the Edo period (1603–1868). I use the Japanese period names, accompanied by the Western calendar dates when necessary. The Japanese period names designate a very particular time frame with cultural nuances. Kabuki developments, performers, and plays are often closely associated with these cultural time periods. The Japanese period names have a resonance that is lost in their translation into Western calendar years. With respect to the meaning of Japanese traditional "time," in the following chapters, I use the Japanese period names, followed by Western dates for the first usage, when appropriate to the topic or performer. Sometimes I restate the Western dates for clarity.

4. Jennifer Robertson, "The Shingaku Woman: Straight from the Heart," *Recreating Japanese Woman, 1600–1945*, ed. Gail Lee Bernstein (Berkeley: University of California Press, 1991) 106. Robertson details the main discourses on female-likeness for women as prescribed by the *bakufu* during the Tokugawa period. See also Kaibara Ekken, *Onna Daigaku* (1672), *Women and Wisdom of Japan*, ed. Takaishi Shingoro (1905; London: John Murray, 1979) 33–46. In his widely read primer on female behavior, Kaibara Ekken affirmed that the female sex was linked to inferior and dangerous traits, which had to be controlled and brought to conform to an ideal model of female-likeness.

5. My use of "female-likeness" is particular to my thesis of female gender construction. I use likeness to refer to the total fantasy and constructedness of the

onnagata's gender role performance art. I am not implying that onnagata were trying to be "like" women, or that they aimed at deriving or referring to a woman "identity." In this thesis, female-likeness emphasizes the stylized construction of the onnagata gender role. Therefore, when I use the English term "female-like" to describe onnagata gender performance, I am describing the onnagata's close approximation of an ideal "female," which is a constructed kabuki "female," based on a male body beneath.

6. See detailed explanation on bans of women performers in chapter 3. In other forms of traditional theatre like nō and kyōgen, male performers also enact female roles, but they do not specialize in female roles. Each genre has distinct and different techniques for gender role performance, but any comparison is beyond the scope of my investigation.

7. It may be argued that all kabuki gender roles are variations on a male body gender art. In this document, I limited my investigation to onnagata and their gender role performance.

8. For an explanation of kabuki stylization and the tradition of change of *kata* (forms) see, James R. Brandon, "Forms in Kabuki Acting," James R. Brandon, William P. Malm, and Donald H. Shively, *Studies in Kabuki: Its Acting, Music, and Historical Context* (1978; Honolulu: University of Hawaii Press, 1979) 120–126.

9. Gary P. Leupp, *Male Colors: The Construction of Homosexuality in Tokugawa Japan* (Berkeley: University of California Press, 1995) 27–57.

10. All Japanese names are given in the Japanese order of family name first, followed by the given name. In this text, for the first reference of an actor, I use his full stage name and generation number. For most subsequent references, I use their given stage names and, to avoid confusion, their generation numbers. For example, Onoe Baikō VII (1915–1995), becomes Baikō VII, or Nakamura Jakuemon IV (1920–) becomes Jakuemon IV. There are some exceptions where I use their full name for clarity or because of the context.

11. Watanabe Tsuneo and Iwata Jun'ichi, *The Love of the Samurai*, trans. D. R. Roberts (London: GMP Publishers Ltd., 1989) 128–129.

12. Furuido Hideo, personal interview, Tokyo, 1993. See Leupp, *Male Colors* 176–177.

13. Onoe Baikō, personal interview, Tokyo, 1992. Most onnagata I interviewed would begin their explanation of onnagata *kata* (forms) with a description of how onnagata must stay behind and lower than the tachiyaku in order to look small and graceful.

14. Contemporary onnagata have highly individual interpretations of these feminine rules. Even with set conventions, there is a great deal of latitude in terms of how these conventions are interpreted by the individual actor body. In kabuki, the audience view the actor body and the character body simultaneously.

15. A.C. Scott, *The Kabuki Theatre of Japan* (1955; New York: Collier Books, 1966) 171–172; Fujita Hiroshi, *Onnagata no Keizu* (Tokyo: Shindokushosha, 1970) 47, 44–54. Fujita deals with the question of whether *joyū* (female performers) could replace onnagata in kabuki. He cites various Japanese

scholars' arguments about the requirements of strength and the skill of transformativity for onnagata performance.

16. Leonard Pronko, *Theatre East and West* (Berkeley: University of California Press, 1967) 195.

17. Earle Earnst, *The Kabuki Theatre* (1954; Honolulu: University of Hawaii Press, 1974) 195.

18. For further supporting evidence, see chapter 2 of this book on performative gender theories.

19. Samuel L. Leiter, trans, and comm., *The Art of Kabuki: Famous Plays in Performance* (Berkeley: University of California Press, 1979) 258.

20. Bandō Tamasaburō V, personal interview, Tokyo, 1993.

21. Hattori Yukio, *Edo Kabuki* (Tokyo: Iwanami Shoten, 1993) 3–5.

22. In particular, the image of the Edo period woman in luxurious kimono, obi, and wig is a popular icon of Edo period nostalgia. See articles by Gunji Masakatsu, Sasai Eisuke, and others in "On the Scene: Theatre Romanticism," *Yasō* 28 (1991).

23. Hattori Yukio, *Edo Kabuki* 5–19.

24. For example, the kabuki onnagata, Bandō Tamasaburō V, performs female gender roles in contemporary theatre plays such as the role of Nastazja in *Nastazja*, directed by Andrei Wajda. Sasai Eisuke, a modern theatre actor trained in kabuki dance, performs female gender roles in contemporary theatre and styles himself as a modern theatre onnagata. The neo-kabuki theatre company, Hanagumi Shibai (The Flower Troupe Theatre), is an all male troupe, whose members frequently use onnagata gender performance practices.

25. Hattori Yukio, personal interview, Tokyo, June 1993.

26. Sue-Ellen Case, *Feminism and Theatre* (New York: Methuen, 1988) 5–12. Case rereads the patriarchal production of 'Woman' and the "fictionality" of gender in Western classical theatre.

27. Peter Stallybass, "Transvestism and the 'Body Beneath,' " *Erotic Politics: Desire on the Renaissance Stage*, ed. Susan Zimmerman (London: Routledge, 1992) 64–83.

28. Julia Epstein and Kristina Straub, "Introduction: The Guarded Body," *Body Guards: The Cultural Politics of Gender*, ed. Julia Epstein and Kristina Straub (New York: Routledge, 1991) 21. See their whole introduction, on pages 1–28, for their overview of the cultural and historical contexts for investigations of sexual and gender ambiguity. They also discuss the cultural politics of the body, body symbolism and manipulation, sex/gender systems and construction, and the tyranny of binary sex/gender oppositions.

29. See chapters 3 and 4 of this book on Yoshizawa Ayame I (1673–1729), and other early onnagata, whose records and notes allude to their "imitation" of women. I suggest reading Jennifer Robertson's explanation of women's imitation and negotiation of the *bakufu* discourse on female-likeness in "The Shingaku Woman," 105–107.

30. Judith Butler, *Gender Trouble* (New York: Routledge, Chapman and Hall, 1989) 136.

31. Judith Butler, *Bodies That Matter* (New York: Routledge, 1993) 123–128; Peggy Phelan, *Unmarked* (New York: Routledge, 1993) 99–104. Butler and

Phelan analyze the denaturalization of gender in American drag and drag performance in the film *Paris is Burning*. For my thesis, I do not use "drag" or "crossdressing" to describe onnagata gender performance. These terms are culture specific.

32. See the seduction scene between Narukami and Princess Taema in the play *Narukami* (Thunder God). James R. Brandon, trans. and comm., Act III, scene 2, "St. Narukami," *Saint Narukami and the God Fudō, Kabuki, Five Classic Plays* (Cambridge: Harvard University Press, 1975) 134–159. See particularly 150–154.

33. Judith Butler, *Gender Trouble* 32.

34. Julia Epstein and Kristina Straub, introduction, *Body Guards* 3.

35. Jill Dolan, "Geographies of Learning: Theatre Studies, Performance and the 'Performative,' " *Theatre Journal* 45 (1993): 426.

36. Jill Dolan, "Geographies of Learning" 431.

37. Sue-Ellen Case, *Feminism and Theatre* 131.

38. Dates for kabuki performers' births, deaths, and stage activity may vary from text to text. For performer related dates in this document, see Nojima Jusaburō, *Kabuki Jinmei Jiten* (Tokyo: Nichigai Associates, Inc., 1988).

39. Certain onnagata continued to perform onnagata gender acts in their daily lives. For example, Utaemon V is said to have kept his daily life habits in the onnagata style, and his son, the contemporary Utaemon VI (1917–2001) has followed this to a certain degree. However, from my observation and inquiries made with Nakamura Fukusuke IX (1960–), Utaemon VI's grandson, the way Utaemon VI maintains his onnagata gender acts is by keeping a more traditional Japanese lifestyle and home, and by staying in the kneeling position for many hours a day.

40. Nakamura Baika III (1907–1991) advised many young onnagata in the Nakamura Utaemon VI line because he was an apprentice under Nakamura Utaemon V and worked closely with Utaemon VI. He died in 1991, the year I observed his teaching.

41. I participated in several intensive workshops in kabuki performance training and Nihon Buyō (kabuki dance), in which I learned basic physical patterns for onnagata and tachiyaku role types. The following programs played a significant part in my research: (1) Traditional Theatre Training (TTT), Nihon Buyō (kabuki dance), during which I learned and performed the dance *Echigo Jishi* (Lion of Echigo), under the tutelage of Fujima Kansome (Kyoto, July through August 1987); (2) International Theatre Institute (ITI) Japan Centre, Kabuki Dance Workshop, in which I studied *Musume Dōjōji* (Maiden of Dōjōji), under the tutelage of Fujima Toshinami (Tokyo, August 1991); (3) ITI Japan Centre, Kabuki Seminar and Workshop, in which I studied various roles from *Kurumabiki* (Pulling the Carriage Apart), under the tutelage of Nakamura Matagorō II and Sawamura Tanosuke VI (Tokyo, August 1993); (4) Individual lessons, Nihon Buyō, in which I studied *Sciokumi* (Salt Gathering), under the tutelage of Fujima Kaniichi (Tokyo, October–December 1992); (5) Individual lessons, Nihon Buyō, in which I studied *Fujimusume* (Wysteria Maiden), under the tutelage of Hanayagi Chiyō and Hanayagi

Tarō (Tokyo, January–July 1993); Group sessions, *Nihon Buyō Kihon no Kata* (Fundamental Forms of Nihon Buyō), in which I studied the fundamentals for both tachiyaku and onnagata roles under the tutelage of Hanayagi Tarō (Tokyo, January–July 1993, April–June 1995). By participating in several performance recitals, I experienced the complete process of professional kabuki makeup, costuming, wig frame fitting, and wig dressing.

42. I translated "gender" as "*sei*," but found the *katakana* (loan word from a foreign language) of gender, "*genda*" better understood. I distinguished "gender" from physical sex and explained "gender" as stylized acts associated with their onnagata roles.

43. Most Edo period documents, like theatre bills, play picture books, reviews, and actor commentaries, were written and printed in a script that takes special training and study to read. At Waseda University, Torigoe Bunzō and Furuido Hideo showed me many Edo kabuki documents and explained their contents, use, and particularities. My research of the Edo documents was limited to reading the prints and texts that are available in printed type.

44. The National Theatre also negotiates contracts. The relationship of Shōchiku Ltd. and the kabuki performers is very complex. See Leiter, "Shōchiku," *Kabuki Encyclopedia: An English-Language Adaptation of* Kabuki Jiten (Westport: Greenwood Press, 1979) 365.

45. From September 1992 through June 1993, I had the opportunity to look at videos and/or video copies of films, dating from 1949 in the Shochiku archives. The video viewing area was also the photography area used by the official Shochiku photographers. The video, photographs, and photo texts communicate a kinaesthetic and visual history of contemporary onnagata. For early twentieth-century photographs of onnagata, besides magazines, I combed through Gunji Masakatsu, ed. and comm., *Kabuki Meiyū Jidai, Butai Shashin: Taishō kara Shōwa e*, phot. Mitsui Takanaru (Tokyo: Nigensha,1988).

46. Trinh T. Minh-ha, "Not You/Like You: Post-Colonial Women and the Interlocking Questions of Identity and Difference," *Making Face, Making Soul: Haciendo Caras*, ed. Gloria Anzaldua (San Francisco: Aunt Lute Foundation, 1990) 374–375. I use this term as one who was inside the kabuki culture as a scholar, but outside as a foreigner and sometimes as a woman. I realize my usage differs from Trinh's usage, but I feel that my process of cultural positioning is related to her explanation.

47. I include costuming, makeup, and the handling of hand props.

48. Note that even the *baba* (old woman) and *akuba* (evil female) role types use certain *yūjo* gender acts, such as the lowered back neckline.

Chapter 2 Theory into Performance

1. See chapter 3 of this book.
2. Fujita Hiroshi, *Onnagata no Keizu* 49.
3. Baba Masashi, *Onna no Serifu* (Tokyo: NHK Books, Nihon Hoshoshuppan Kyōkai, 1992) 5.
4. Mizuochi Kiyoshi, personal interview, Tokyo, 1993.

5. Mizuochi Kiyoshi, interview.

6. Furuido Hideo, interview, 1993.

7. Furuido Hideo, interview.

8. Gunji Maskatsu, "Nikutai no Bi," The Body in Asia Forum, Space Zero, Tokyo, 5 March 1993.

9. Gunji Maskatsu, personal interview, Tokyo, 1990–1995. All interview references, which are not otherwise documented, are from a series of interviews and discussions held over a five-year period in Tokyo.

10. Gunji Maskatsu, interview. Gunji's ideas on culturally based sensuality arise from his extensive research in international dance and theatre performance theory. It is beyond the parameters of this dissertation to take up his point on comparative and cross-cultural eroticism and kinesthetics. I mention his skepticism here because I think it is important to question our assumptions concerning cross-cultural communication and what may be thought of as "universal" or "natural."

11. Gunji Maskatsu, interview.

12. Samuel L. Leiter, Kabuki Encyclopaedia 172. See also Fukuda Tetsunosuke, "kaneru," Kabuki Jiten, ed. Shimonaka Hiroshi (1983; Tokyo: Heibonsha, 1991) 115.

13. Gunji Maskatsu, interview, cited the entrance of Hanako in Musume Dōjōji and Yayoi in Kagami Jishi (The Dancing Lion) as examples of roles that tachiyaku have changed.

14. Gunji Maskatsu, interview.

15. Gunji Maskatsu, interview.

16. Gunji Maskatsu, "The Development of Kabuki," trans. Andrew L. Markus, Tokugawa Japan: The Social and Economic Antecedents of Modern Japan, ed. Chie Nakane and Shinsaburō Oishi (Tokyo: University of Tokyo Press, 1990) 206.

17. Gunji Maskatsu, interview.

18. Gunji Maskatsu, interview. He mentioned Kataoka Gadō XII (1910–1993) and the late shimpa (new school, a popular theatre form from the late nineteenth century) onnagata, Hanayagi Shotarō, as examples of this kind of onnagata eroticism.

19. There has been research done in onnagata roles and female characters, but not in onnagata performance. For examples, see James Leo Secor, Kabuki and Morals: The "Onnagata" Heroine as Ethical Example in the Late Eighteenth Century, diss. 1987 (Ann Arbor: University of Michigan Press, 1989).

20. Leonard Pronko, Theatre East and West Berkeley: University of California Press, 1947 198–199.

21. Leonard Pronko, Theatre East and West 186.

22. Leonard Pronko, Theatre East and West 158.

23. Leonard Pronko, Theatre East and West 163.

24. Leonard Pronko, Theatre East and West 195.

25. Leonard Pronko, Theatre East and West 196.

26. Leonard Pronko, Theatre East and West 195.

27. Kawatake Toshio, lecture, ITI Kabuki Workshop, National Theatre, Tokyo, August 1993; Onoe Baikō VII, personal interview, Tokyo, 1992.

28. Faubion Bowers, *Japanese Theatre* (1952; New York: Hill and Wang, 1959) 174.

29. Fujima Toshinami, then in her seventies, replied to a question about whether women had the strength to perform in kabuki, "It is often said that women cannot perform with the heavy wigs and kimono. But I say, just give me a chance to perform twenty-five days a month for ten years or so and we'll see if I cannot perform onnagata roles. If women had the daily training and the daily opportunity to wear the heavy wigs and kimono, of course we would be strong enough!" Lecture, ITI Nihon Buyō Workshop, Tokyo, August 1992.

30. A. C. Scott, *The Kabuki Theatre of Japan*, 2nd ed. (1955; New York: Macmillan; New York: Collier, 1966) 171–172.

31. A. C. Scott, *The Kabuki Theatre of Japan* 172–173.

32. A. C. Scott, *The Kabuki Theatre of Japan* 172.

33. Perhaps we should cease to argue that women are not capable of acting the male-created feminine ideal. Rather, women cannot enact the onnagata fiction of female-likeness because they do not have a male sexed body beneath.

34. Earle Ernst, *The Kabuki Theatre* (1954; Honolulu: University of Hawaii Press, 1974) 194.

35. Earle Ernst, *The Kabuki Theatre* 195.

36. In subsequent chapters of this book, I discuss how, in the Edo period, male bodies fashioned the gender acts for almost every body.

37. Faubion Bowers, *Japanese Theatre* 194.

38. Faubion Bowers, *Japanese Theatre* 194.

39. Faubion Bowers, *Japanese Theatre* 194.

40. Faubion Bowers, *Japanese Theatre* 195.

41. Faubion Bowers, *Japanese Theatre* 195.

42. Faubion Bowers, personal interview, Tokyo, 1993.

43. James R. Brandon, "Form in Kabuki Acting," *Studies in Kabuki*, ed. James R. Brandon, William P. Malm, Donald H. Shively (1978; Honolulu: University of Hawaii Press, 1979) 65.

44. James R. Brandon, "Form in Kabuki Acting" 66.

45. James R. Brandon, lecture, University of Hawaii, 1989.

46. Kawatake Toshio, History and Performance Lecture, ITI Kabuki Workshop, The National Theatre, Tokyo, August 1993.

47. Please note that Brandon was following the *kata* categories laid out in the authoritative volume, *Kabuki no Kata* by Kagayama Naozo.

48. Onoe Baikō VII, personal interview, Tokyo, 1992.

49. See chapter 8 of this book for further explanation of multiple gender roles that eschew a binary division.

50. James R. Brandon, phone conversation, Seattle, December 1994.

51. James R. Brandon, conversation, Honolulu, HI, March 1994.

52. Leonard Pronko, Lecture Demonstration, "Onnagata Design and Performance: *Masakadō*," assisted by Takao Tomono, When Art Became Fashion: Kosode in Edo–Period Japan, Exhibition and Conference, Los Angeles County Museum of Art, Los Angeles, 16 November 1992.

53. Leonard Pronko, personal interview, Tokyo, 1992.

54. *Sagimusume* (Heron Maiden) is a quick-change dance in which the performer transforms through several types of *musume* (young girl) roles into a "heron girl," who ultimately dies.

55. "KABUKI: Yume no Tamatebaco," *Esquire* (Japan Edition) December 1991: 84–139. I deliberately chose this popular culture magazine, edited for Japanese men, because it is an example of how much the onnagata image and art appears in a variety of media for diverse audiences.

56. Edward Seidensticker, "Mishima Yukio to Kabuki no Sekai, Kabuki *Kusaya* ni Nitari," trans. Ansai Tetsuo in "KABUKI: Yume no Tamatebaco," *Esquire* (Japan Edition) December 1991: 124.

57. Edward Seidensticker, "Mishima Yukio to Kabuki no Sekai, Kabuki *Kusaya* ni Nitari" 124.

58. In this study I focus on the interaction of the visual and the kinesthetic. I do not cover the aural acts of instrumentation, lyrics, sound effects, chant, and the whole constellation of elocutionary acts. For further study of these aspects, see the "Vocal *Kata*" section in James Brandon's "Form in Kabuki Acting," 101–106. See also William Malm, "Music in the Kabuki Theatre," *Studies in Kabuki: Its Acting, Music, and Historical Context*, ed. James R. Brandon, William P. Malm, and Donald H. Shively, 1978; (Honolulu: University of Hawaii Press, 1979) 133–175.

59. In this usage, "gender performance" is not limited to theatrical performance. Some theorists, like Judith Butler, use many theatrical terms, but are referring to both daily enactment in society, and "staged" performances ranging from bar visits, demonstrations, and the like, to the further formalized theatre, film, and performance art.

60. Kagayama Naozo, *Kabuki no Kata* (Tokyo: Sogensha, 1957) 11–24. Kagayama, one of the sources Brandon uses for his *kata* explanation, introduces the complex theories and types of *kata*.

61. Gunji Maskatsu, *Kabuki no Bigaku* (Tokyo: Engeki Shuppansha, 1963). See the following sections: "Koshoku no Bi," 301–318, and "Onnagata no Iroke," 312–318.

62. Judith Butler, *Gender Trouble* 140.

63. Sue-Ellen Case, *Feminism and Theatre* 7, 11, 15. Note Case's use of the capitalized "W" in Woman in her explanation of female role representation in Greek and Elizabethan performance.

64. Judith Butler, *Gender Trouble* 33.

65. Judith Butler, *Gender Trouble* 140.

66. Jill Dolan, "Gender Impersonation Onstage," *Gender in Performance*, ed. Laurence Senelick (Hannover: University of New England Press, 1992) 4–5.

67. Torigoe Bunzō, personal interview, Tokyo, 1993.

68. For discussion and research on women's gender roles and status see Sharon L. Sievers, *Flowers in Salt: The Beginnings of Feminist Consciousness in Modern Japan* (Stanford: Stanford University Press, 1983), and Sharon H. Nolte and Sally Ann Hastings, "The Meiji State's Policy Toward Women, 1890–1910," *Recreating Japanese Women, 1600–1945*, ed. Gail Lee Bernstein (Berkeley: University of California Press, 1991) 151–174.

69. Nakamura Matsue V, personal interview, 1993.

70. Sue-Ellen Case, "Classic Drag: The Greek Creation of Female Parts," *Theatre Journal* 37 (1985): 318.

71. See Cecilia Segawa Seigle, *Yoshiwara: The Glittering World of the Japanese Courtesan* (Honolulu: University of Hawaii Press, 1993) for a detailed study of Edo courtesans, their history, and their world.

72. Mark Oshima, "The Keisei as a Meeting Point of Different Worlds: Courtesan and the Kabuki *Onnagata*," *The Women of the Pleasure Quarters*, ed. Elizabeth de Sabato Swinton (Worcester: Worcester Art Museum, 1995) 87.

73. See chapters 3 and 4 of this book for data and explanations of *bakufu* regulations.

74. Paul Gordon Schalow, introduction, *The Great Mirror of Male Love*, Ihara Saikaku (Stanford: Stanford University Press, 1990) 28. In the case of male love, from which early onnagata derived many of their erotic techniques, the partners' roles were based on a hierarchy of age, the older/superior and the younger/inferior. Schalow discusses the place of boy love in premodern Japan, as an example of a culturally sanctioned style of sexuality participated in by married, single, and clergy men.

75. This is not the same as gender hierarchy, which is quite extreme in kabuki role types, and where tachiyaku gender roles have the highest rank. Age and class may alter the rank of any gender role, but an onnagata gender role of equal status and age will always rank below that of an equal tachiyaku gender role.

76. Watanabe Tsuneo and Iwata Jun'ichi, *The Love of the Samurai* (London: GMP Publishers, 1989) 128–131. The authors set up an interesting argument to explain the repression of homosexuality in Japan as part of the "disappearance of the aesthetic function of the male body," and the "de-eroticization of the male body" (131).

77. Gunji Maskatsu, *Kabuki Nyūmon* (Tokyo: Bokuyōsha, 1990) 61–62.

78. Sue-Ellen Case, *Feminism and Theatre* 132.

79. Judith Butler, *Gender Trouble* 75.

80. See chapter 4 of this book on Yoshizawa Ayame I.

81. Sawamura Tanosuke VI, personal interview, Tokyo, 1992.

82. Sawamura Tanosuke VI, interview.

83. Bandō Tamasaburō V, personal interview, Tokyo, 1993.

84. Bandō Tamasaburō V, interview.

85. Nakamura Tokizō V, personal interview, Tokyo, 1992.

86. Nakamura Tokizō V, interview.

87. Onoe Baikō VII, interview.

88. Nakamura Kankurō V, personal interview, Tokyo, 1992.

89. Nakamura Shikan VII, personal interview, Tokyo, 1992.

90. Judith Butler, *Gender Trouble* 141.

91. Onoe Baikō VII, interview. Nakamura Matsue V, interview. Nakamura Tokizō V, interview. Sawamura Tanosuke VI, interview, 1992.

92. Ichikawa Ennosuke III, personal interview, Tokyo, 1993. Nakamura Shikan VII, interview.

93. Judith Butler, *Gender Trouble* 31–32.

94. Judith Butler, *Gender Trouble* 112.

95. Judith Butler, *Gender Trouble* 141.

96. Judith Butler, *Gender Trouble* 141.

97. Teresa de Lauretis, *Technologies of Gender* (Bloomington: Indiana University Press, 1987) 5.

98. Jennifer Robertson, "Gender-Bending in Paradise: Doing 'Female' and 'Male' in Japan," *Genders* Number 5 (Summer 1989): 51.

99. Jennifer Robertson, "Gender-Bending" 63.

100. Jennifer Robertson, "The Politics of Androgyny in Japan: Sexuality and Subversion in the Theatre and Beyond," *American Ethnologist*. Volume 19 Number 3 (August 1992): 420.

101. Ichikawa Ennosuke III, interview. See also Ichikawa Ennosuke, *Ennosuke no Kabuki Kōza* (Tokyo: Shinchosha, 1984) 56.

102. Ichikawa Ennosuke, *Ennosuke no Kabuki Kōza* 56–57.

103. Julia Epstein and Kristina Straub, "Introduction: The Guarded Body," 21. See their whole introduction, 1–28, for their overview of the cultural and historical contexts for investigations of sexual and gender ambiguity and a discussion of the cultural politics of the body.

104. See my explanation of how onnagata performance "subverts" on p. 58.

105. Judith Butler, *Gender Trouble* 139.

106. Judith Butler, *Gender Trouble* xiv.

107. Nakamura Shikan, interview. Ichikawa Ennosuke, interview. Fujita Hiroshi, interview. Watanabe Tamotsu, interview. Gunji Maskatsu, interview.

108. The Grand Kabuki is the official kabuki company, which is "managed" by Shōchiku Ltd.

109. Judith Butler, *Gender Trouble* 112.

110. Jill Dolan, "Geographies of Learning" 433.

111. Judith Butler, *Gender Trouble* 32.

Chapter 3 Precursors and Unruly Vanguards

1. Furuido Hideo, interview. Furuido cites the *shirabyōshi* and later *miko* as the models that early onnagata used to construct the *himesama* (princess) and *musume* (young girl) role types. He gave the example of the famous *Musume Dōjōji* (The Maiden of Dōjō Temple) dances of the kabuki repertoire, and emphasized that the onnagata stylized their gender acts from adolescent or even younger performers.

2. Benito Ortolani, *The Japanese Theatre*, revised edition (Princeton: Princeton University Press, 1990) 77.

3. Kawatake Shigetoshi, *Nihon Engeki Zenshi* (Tokyo: Iwanami Shoten, 1959) 91–92; Benito Ortolani, *The Japanese Theatre* 76–77.

4. Benito Ortolani, *The Japanese Theatre* 77, 79–80.

5. Benito Ortolani, *The Japanese Theatre* 77.

6. Kawatake Shigetoshi, *Nihon Engeki Zenshi* 90–93.

7. Benito Ortolani, *The Japanese Theatre* 45.

8. Kawatake Shigetoshi, *Nihon Engeki Zenshi* 273; Benito Ortolani, *The Japanese Theatre* 65.

9. Kawatake Shigetoshi, *Nihon Engeki Zenshi* 100.

10. Kawatake Shigetoshi, *Nihon Engeki Zenshi* 101; Gunji Masakatsu, *Kabuki Nyūmon* 40–41.

11. Inoura Yoshinobu, *A History of Japanese Theatre I: Noh and Kyōgen* (Yokohama: Kokusai Bunka Shinkokai, 1971) 52–53.

12. Kawatake Shigetoshi, *Nihon Engeki Zenshi* 273–274.

13. Watanabe Tamotsu, personal interview, Tokyo, 1992.

14. Exact dates for Okuni are not known, but she is supposed to have performed as a *miko* (shrine maiden) around 1581, and her name disappeared from records about 1612. See Ariyoshi Sawako, *Kabuki Dancer*, trans. James R. Brandon (Tokyo: Kodansha International, 1994) for a "historical" fiction of Okuni's life and performance styles.

15. *Kabuki no Zōshi*, qtd. in Domoto Yatarō, *Kamigata Engekishi* (Tokyo: Shun'yodo, 1944) 24.

16. See further reference to *Narihira* in *wakashu* kabuki section in this chapter.

17. Domoto Yatarō, *Kamigata Engekishi* 25.

18. I use the term *keiseikai* (prostitute buying) for the prostitute procuring skits and scenes in all phases of early kabuki. Kawatake Shigetoshi uses *yūjokai* interchangeably with *keiseikai* in reference to the *yūjo* kabuki appropriation of Okuni's prostitute buying skits and the later *yarō* kabuki versions of the same skit. See Kawatake Shigetoshi, *Nihon Engeki Zenshi* 245, 280, 292. However, Moriya Takeshi uses the term *chaya asobi* (dallying at the tea house), in reference to the early prostitute buying skits in Okuni and *yūjo* kabuki. See Moriya Takeshi, *Kinsei Geinō Kōgyōshi no Kenkyū* (Tokyo: Kōbundō, 1985) 66. Benito Ortolani uses *yūjo-kai*, translated as "whore-buying," for the favorite scenes in kabuki since the *yūjo* kabuki days. See Benito Ortolani, *The Japanese Theatre* 179.

19. Domoto Yatarō, *Kamigata Engekishi* 25–26.

20. Watanabe Tamotsu, *Kabuki Handobukku* (Tokyo: Shinshokan, 1993) 62. There is a great deal of conjecture concerning the identity of Okuni's male partner. Watanabe and Domoto both name an ex-samurai, Nagoya Sanza or Sanzaburō, as the male partner. But facts substantiating Nagoya Sanza's existence are unclear. Further, the male character in the early skits might have been named Sanza and thereby confused with the real person. For my purposes, the important point is that scholars conjecture from texts and pictures that a man played the female gender role in Okuni's prostitute buying scenes. See Domoto Yatarō, *Kamigata Engekishi* 25.

21. Domoto Yatarō, *Kamigata Engekishi* 26–27.

22. Kawatake Shigetoshi, *Nihon Engeki Zenshi* 252.

23. Judith Butler, "Performative Acts and Gender Constitution: An Essay in Phenomenology and Feminist Theory," *Performing Feminisms*, ed. Sue-Ellen Case (Baltimore: Johns Hopkins University Press, 1990) 273.

24. *Kabuku* is the third base, *shūshikei*, or Japanese dictionary form of the verb, meaning "to slant." *Kabuki*, in this early usage, was the second base or *renyōkei* of the verb, which was sometimes used to make verbal nouns, here: Okuni's kabuki.

25. Domoto Yatarō, *Kamigata Engekishi* 8.

26. Benito Ortolani, *The Japanese Theatre* 164–165.

27. Kawatake Shigetoshi, *Nihon Engeki Zenshi* 227–242; Gunji, *Kabuki Nyūmon* 51–53.

28. Domoto Yatarō, *Kamigata Engekishi* 25; Gunji Masakatsu, *Kabuki Nyūmon* 50–52; Gunji Masakatsu, personal interview, Tokyo, 1993.

29. Toita Yasuji, *Onnagata no Subete* (Tokyo: Shinshindo Publishing Co., 1990) 25.

30. See later section in the present chapter for details on *bakufu* bans.

31. See Cecilia Segawa Seigle, *Yoshiwara* 8–9, 20–23, for more explanation on the legislation and prostitute world inside and outside the licensed quarters. She notes that many samurai, in the period of great displacement, 1600–1640, became brothel owners, which may have contributed to restricting women from public performance.

32. I have not read where any scholar says that *yūjo kabuki* was exclusively women. There were some troupes that included some male performers who the *bakufu* banned several times. Managers of the established *yūjo kabuki* troops were men. See Moriya Takeshi, *Kinsei Geinō* 66.

33. Gunji Masakatsu, *Gunji Masakatsu Santeishū*, volume 1 (Tokyo: Hakusuisha, 1991) 70.

34. Kawatake Shigetoshi, *Nihon Engeki Zenshi* 269–270. Kawatake accounts for all the contributions of *yūjo* kabuki. He also lists the acts and dances of *yūjo* kabuki and Okuni's version (245).

35. Like the *yūjo* performers, early onnagata were to make extensive use of dance techniques to theatricalize their gender acts and advertise their erotic talents. Later, onnagata would also use the solo dance medium for the fullest expression of their gender art.

36. The *shamisen* is a plucked three-string instrument. The importance of the *shamisen*'s contribution to kabuki's performance styles, narratives, and techniques cannot be emphasized enough. For further explanation of the shamisen's contributions to kabuki's *kata* and its unique musical style for chanted text, see William Malm, "Music in the Kabuki Theatre," *Studies in Kabuki*, ed. James R. Brandon, William P. Malm, and Donald H. Shively (1978; Honolulu: University of Hawaii Press, 1979) 135–140; and William Malm, *Nagauta: The Heart of Kabuki Music* (Tokyo: Tuttle, 1963).

37. *Gidayu* or *joruri*, *nagauta*, *kiyomoto*, *tokiwazu*, and *geza* accompaniment are among the music styles that feature the shamisen in kabuki. An example of the sensual atmosphere associated with the shamisen is the entrance of the courtesan Yūgiri in *Kuruwa Bunshō* (Love Letter from the Licensed Quarter). For more examples like Michitose in *Naozamurai* (Naozamurai) see chapter 8 of this book, under the section on *yūjo* role types.

38. Jacob Raz, *Audience and Actors: A Study of their Interaction in Japanese Traditional Theatre* (Leiden: Brill, 1983) 136.

39. Jacob Raz, *Audience and Actors* 149. This was also happening in *wakashu* kabuki, where audiences and patrons undoubtedly saw the beautiful boys' sexual and artistic attributes.

40. Benito Ortolani, *The Japanese Theatre* 163.

41. These divisions were based on male occupations although women did participate as farmers, artisans, and merchants. The outsider classes included occupations such as sex workers and entertainers, which could be male or female.

42. Furuido Hideo, interview.

43. Herman Ooms, "The Struggle for Status: Lower and Non-Status Groups in Tokugawa Japan"; Tsukada Takashi, "Stratified and Composite Social Groups in Tokugawa Society," Conference on "Down and Out Status Groups in Tokugawa Japan," UCLA Center for Japanese Studies, Los Angeles, 25 January 1997. Both scholars discussed the complicated social world of composite social groups within the *hinin* groups and the different status of performers like the kabuki actors who had received a *zuryō* (title).

44. Gunji Masakatsu, *Kabuki Nyūmon* 116.

45. Benito Ortolani, *The Japanese Theatre* 162.

46. Benito Ortolani, *The Japanese Theatre* 164. Ortolani's explanation is fascinating and sheds light on Kawatake's brief reference to *kabukimono*, in *Nihon Engeki Zenshi* 243.

47. Benito Ortolani, *The Japanese Theatre* 165.

48. Benito Ortolani, *The Japanese Theatre* 167.

49. Ayako Kano, *Acting like a Woman in Modern Japan* (New York: Palgrave, 2001) 66–73. While there is not enough space here for a longer discussion of Kano's use of "queering" in relationship to the kabuki onnagata, her reading of government authority and the alignment of gender and sex in theatrical performance raises new questions concerning the manipulation of the female body in relationship to nationhood.

50. For detailed explanations of each ban on the early troupes and subsequent stages of kabuki in the Edo period, see Moriya Takeshi, *Kinsei Geinō*. For further information on bans on mixing men and women in performance, see 42–90.

51. James R. Brandon, ed., *The Cambridge Guide to Asian Theatre* (Cambridge: Cambridge University Press, 1993) 147.

52. Kawatake Shigetoshi, *Nihon Engeki Zenshi* 267.

53. Moriya Takeshi, *Kinsei Geinō* 73. Kawatake Shigetoshi points out bans were continually reissued as there was no way of controlling all performances in the country. Further, each city had its own way of dealing with the Edo based *bakufu* bans. See Kawatake Shigetoshi, *Nihon Engeki Zenshi* 268–269.

54. Moriya Takeshi, *Kinsei Geinō* 77. By 1642, non-licensed prostitution was illegal, and the *bakufu* had succeeded in setting up separate areas for theatre and prostitution entertainments.

55. Cecilia Segawa Seigle, *Yoshiwara* 8.
56. Jennifer Robertson, "The Shingaku Woman: Straight from the Heart" 91.
57. Economically, *yūjo* kabuki performers were playing at the edge of the masculine merchant world. As outcasts they had no obligations or allegiances in the feudal system. As women without husbands, they were also outside the Confucian system that would have bound their bodies and their earnings to their husband's families. I suggest that early kabuki women had a certain amount of independence with their double occupations of prostitution and performance, which threatened the *bakufu* and merchant-class men. The government's recourse was to prohibit their performance activities and sanction licensed prostitution, thereby restricting any itinerant, non-licensed quarter female prostitute from doing independent business. Kabuki women were cut out of both occupations and dismissed from any rivalry with the male entertainment economy.
58. Jennifer Robertson, "The Shingaku Woman: Straight from the Heart" 91–92. See also Kaibara Ekken, *Onna Daigaku*.
59. Kawatake Shigetoshi, *Nihon Engeki Zenshi* 268–269. Kawatake writes of the lost opportunity of *yūjo* kabuki in which men and women performed together and where a female actor was at the heart of the performance. In a sense, the space occupied by the female body was erased. There was no need for the *wakashu* to substitute for a vacated role.
60. I explain in subsequent chapters of this book how the status of onnagata in the kabuki troupe may reflect some characteristics of the position of women in the Edo period. But the subordinate position of the boy to the older man in *wakashu* male/male relationships, could also have served as a model for onnagata troupe status and gender act stylization.
61. Kawatake Shigetoshi, *Nihon Engeki Zenshi* 272.
62. Furuido Hideo, interview.
63. Hattori Yukio, "Kabuki: Kōzō no Keisei," *Nihon no Koten Geinō: Kabuki*, ed. Geinōshi Kenkyūkai, volume 8 (Tokyo: Heibonsha,1971) 27.
64. Hattori Yukio, "Kabuki: Kōzō no Keisei" 27–28.
65. Moriya Takeshi, *Kinsei Geinō* 88–89.
66. Hattori Yukio, "Kabuki: Kōzō no Keisei" 27–28. For more examples of *bakufu* bans on boy love and urban violence, see Gary P. Leupp, *Male Colors* 161–170.
67. Hattori Yukio, "Kabuki: Kōzō no Keisei" 28.
68. Hattori Yukio, "Kabuki: Kōzō no Keisei" 27–28.
69. Donald H. Shively, "The Social Environment of Tokugawa Kabuki," *Studies in Kabuki: Its Acting, Music, and Historical Context*, ed. James R. Brandon, William P. Malm, and Donald H. Shively (1978; Honolulu: University of Hawaii Press, 1979) 9.
70. Moriya Takeshi, *Kinsei Geinō* 89.
71. Kawatake Shigetoshi, *Nihon Engeki Zenshi* 284–285. Kawatake cites several incidents where *daimyō* (feudal lord) who were higher ranking than samurai and connected with the court, were involved in violent quarrels over *wakashu* partners and love suicides with *wakashu*.

72. Various editions of bans limited certain content and styles of performance and restricted performers from visiting their patrons in their theatre boxes. They continuously prohibited "afternoon art and evening work," referring to the *wakashu* performer's prostitution during and after the show.

73. Moriya Takeshi, *Kinsei Geinō* 81.

74. *Edo no Meishoki* qtd. in Kawatake Shigetoshi, *Nihon Engeki Zenshi* 285–286.

75. The *wakashu* troupe leaders and management as well as the performers probably participated in inventing different camouflage to keep their popular enterprises going.

76. See Leupp, *Male Colors* 11–57, for an explanation of the pre-Tokugawa development of *nanshoku* (the way of male love). Leupp also details the economic and social context and practice of *nanshoku* in the Edo period, including many references to *wakashu* and *onnagata*.

77. Gunji Masakatsu, interview.

78. Kawatake Shigetoshi, *Nihon Engeki Zenshi* 273. Kawatake also mentions certain roles like Yoshitsune, a noble young male role, as an example of a *wakashu* styled role that is usually played by an onnagata in certain dance plays.

79. Furuido Hideo, interview.

80. Kawatake Shigetoshi, *Nihon Engeki Zenshi* 273. Note that here Kawatake uses the term "*hentai seiyoku.*" "*Seiyoku*" refers here to sexual desire. "*Hentai*" can mean "transformative" or "abnormal." Later Kawatake uses the term *tosakuteki*, meaning "perverted" to describe *shudō*, the way of boy love (274). Kawatake expresses his position on various sexualities throughout the section in his book on *wakashu*. I think the "transformative" or "in a state of change" is a more accurate description in this case.

81. Kawatake Shigetoshi, *Nihon Engeki Zenshi* 306–307.

82. Gunji Masakatsu, *Kabuki to Yoshiwara* (Tokyo: Tanro Shobo, 1956) 71.

83. For more explanation on ages and man boy love see Paul Gordon Schalow, introduction, *The Great Mirror of Male Love* 27–42. I question his use of "male" and "female" in this context and suggest that "inferior" and "superior" refers to a boy and adult man. His explanation of samurai and boy lovers is particularly applicable to onnagata and tachiyaku role types.

84. *Yodarekake* (1665), qtd. in Shibayama Hajime, *Edo Danshokukō* (Tokyo: Hihyōsha, 1992) 119.

85. Shibayama Hajime, *Edo Danshokukō* 38.

86. Leupp, *Male Colors* 47–57.

87. Kawatake Shigetoshi, *Nihon Engeki Zenshi* 277–278. Kawatake explains what he calls the *chūseibi* (between genders beauty) of the *Narihira* dance of *wakashu* kabuki.

88. Shibayama Hajime, *Edo Danshokukō* 120.

89. Shibayama Hajime, *Edo Danshokukō* 122.

90. Kamigata refers to the area of Osaka, Kobe, and Kyoto, which is where the courtly and refined culture had been based. Edo was the center for the military government and considered a rougher and less sophisticated cultural milieu.

91. See section on Segawa Kikunojō I (1693–1749) in chapter 4 of this book.

92. "*Wakashu* onnagata" is a term I made up to describe the *wakashu* who made the transition to onnagata and performed in the period from *wakashu* to *yarō* kabuki, approximately, 1640s through the 1680s. *Iroko* (love child) was the general term used for a boy prostitute performer after the *wakashu* bans. Early onnagata who had been *wakashu* should be distinguished from the kabuki role type, *wakashugata*, which came into use about 1662. See Gunji Masakatsu, *Gunji Masakatsu Santeishū* volume 2, 212–214.

93. Usually the Genroku era, known as the golden age of culture in the Edo period, runs through the 1740s.

94. Kawatake Shigetoshi, *Nihon Engeki Zenshi* 284, 286. For further explanation of *monomane kyōgen zukushi* see, Moriya Takeshi, *Kinsei Geinō* 130–134.

95. Of course, there were many variations on this boy body base. As the play contents and roles changed, performers created variations on the *wakashu* based onnagata gender acts. The variations also became patterned into role types. For detailed explanation of Genroku kabuki, see Kawatake Shigetoshi, *Nihon Engeki Zenshi* 325–327 and Torigoe Bunzō, *Genroku Kabukikō* (Tokyo: Yagi Shobo, 1991).

96. Gunji, *Gunji Masakatsu Santeishū* volume 2, 201–202.

97. Gunji, *Gunji Masakatsu Santeishū* volume 2, 201–214. Gunji explicates the appearance of the characters for onnagata, and the various readings of these characters. For my purposes, the appearance of the term "onnagata" in 1641, when it was used for the division of male and female role players in *wakashu kabuki*, was a significant moment for the initiation of kabuki gender role divisions. Around the same time Murayama Sakon (1638) and Ukon Genzaemon (1648) are described as onnagata, which is followed by other star *wakashu* who kept performing in *yarō* kabuki (1655–), such as Tamagawa Sennojō, (1660). However, Gunji argues that the first naming of a category of actors as a certain role type was in 1658, when *waka* was added to onnagata, making it, *wakaonnagata*, meaning "young" onnagata. Given the different readings of the characters for the "kata" of onnagata, I think that in 1697, when onnagata was officially written with the character èó for female, and the character å` for *kata* meaning shape or form, which replaced the earlier character for *kata*, i° meaning "person," could be considered the actual naming of the onnagata gender role designation. The earlier designations are still important for the conscious separation of women from female gender role players. See Kawatake Shigetoshi, *Nihon Engeki Zenshi* 307. Kawatake comments on Itoyori Gonzaburō, a performer who was first to enact a female role in 1687, and how this is different from being named an "onnagata."

98. Kawatake Shigetoshi, *Nihon Engeki Zenshi* 288–289. *Iroko* and *butaiko* were designations for those boy prostitutes employed at houses of prostitution who also performed on stage.

99. Donald Shively, "The Social Environment of Tokugawa Kabuki" 37–39. I would add that the man–boy love experience was the source for onnagata gender acts of erotic allure.

100. Kawatake Shigetoshi, *Nihon Engeki Zenshi* 289.
101. Kawatake Shigetoshi, *Nihon Engeki Zenshi* 306–307.
102. Kawatake Shigetoshi, *Nihon Engeki Zenshi* 278, 282, 288. From about 1642 on, the *bakufu* continually issued restrictions. Edo, Kyoto, and Osaka each dealt with the restrictions separately, with Edo, as the samurai capitol, having the most leniency and exceptions to the rules.
103. Kawatake Shigetoshi, *Nihon Engeki Zenshi* 284, 286.
104. Moriya Takeshi, *Kinsei Geinō* 140–179. This section contains a detailed explanation of the establishment of a theatre quarter and the rules for theatre owners and actors in the Osaka, Kyoto, and Edo.
105. Kawatake Toshio, "Binan no Keifu," *Kabuki* (Kikanzashi) 30 (1 October 1975): 51.
106. *Yarō* is a derogatory name for a lower-class "fellow." It also could mean a cheap male prostitute. See Donald Shively, "The Social Environment of Tokugawa Kabuki" 10. *Yarō kabuki* did not have an official beginning or ending. The name may have been attached to the first shaved *wakashu* performances to emphasize that they no longer had the *wakashu* charm. It seems theatre managers, being under pressure of the *bakufu* and wanting to the negative connotation of *yarō*, replaced *yarō* kabuki with the term, *monomane kyōgen zukushi*, the "fully enacted plays," and *tsuzuki kyōgen*, "continuous plays." The title of "continuous plays" came about after the prohibitions on the *shimabara kyōgen* performances around 1658. See Moriya Takeshi, *Kinsei Geinō* 47–49.
107. Kawatake Shigetoshi, *Nihon Engeki Zenshi* 292–293. *Shimabara kyōgen* was banned in 1658, but continued to be enacted in various guises within other plays. Kawatake notes how the *Shimabara* sequence was probably a model for the developing *nuregoto* (love scenes) of later plays.
108. Hattori Yukio, "Kabuki: Kōzō no Keisei," 34–38.
109. Torigoe Bunzō, interview.
110. Kawatake Shigetoshi, *Nihon Engeki Zenshi* 278. Kawatake alludes to the strength of the *wakashu* aesthetic as women also emulated that ideal. He comments on the highly esteemed "Narihira-like *wakashu*," the young boy who possessed the beauty of the mythic poet courtier, Narihira. The beautiful adolescent boy had become the icon of beauty. Onoe Baikō VII, personal interview, Tokyo, 1993. Ichikawa Ennosuke III, personal interview, Tokyo, 1993.
111. Furuido Hideo, interview. See Hattori Yukio, "Kabuki: Kōzō no Keisei" 31.
112. Kawatake Shigetoshi, *Nihon Engeki Zenshi* 309–310.
113. Donald Shively, "The Social Environment of Tokugawa Kabuki" 37–39. If an actor had been a *wakashu, iroko*, or *butaiko* performer, he most likely engaged in *danshō*, professional male prostitution. This is a part of all early onnagata experience and reference for erotic acts.
114. Adachi Naoru, *Kabuki Gekijō Onnagata Fūzoku Saiken* (Tokyo: Tenbōsha, 1976) 147. Adachi uses the verb *sessuru* for serving guests, which can mean serving sexual favors as well as *sake*.

115. Ihara Saikaku, *The Great Mirror of Male Love*, trans. Paul Goodman Schalow (Stanford: Stanford University Press, 1990) 247–248.
116. Ihara Saikaku, *The Great Mirror* 254–256.
117. See Ihara Saikaku, *The Great Mirror* 245–253, 293–300 for descriptions of manners and acts related to serving guests. For paintings and prints of *wakashu* and onnagata see Hattori Yukio, *Edo no Shibai-e o Yomu* (Tokyo: Kodansha, 1993) 47–74, 88, 97, 141, 187, 198–199.
118. Furuido Hideo, interview.
119. Hattori Yukio, "Kabuki: Kōzō no Keisei" 34–38.
120. Ihara Saikaku, *The Great Mirror* 235.
121. Moriya Takeshi, *Kinsei Geinō* 141.
122. Ihara Toshirō, ed. *Kabuki Nempyō*, ed. Kawatake Shigetoshi and Yoshida Teruji, revised edition, volume 1 (1956; Tokyo: Iwanami Shoten, 1973) 73.
123. Furuido Hideo, interview.
124. Hattori Yukio, "Kabuki: Kōzō no Keisei" 40.
125. Donald Shively, "The Social Environment of Tokugawa Kabuki" 41.
126. See Mizuki Tatsunosuke I (1673–1745), Nakamura Tomijūrō I (1719–1786), and Sawamura Tanosuke III (1845–1878), in chapters 4 and 5 of this book for different accounts of self-styled roles.
127. See chapters 7 and 8 for descriptions of basic body postures, gestures, and role types.
128. Faubion Bowers, *Japanese Theatre* 51.
129. Kawatake Shigetoshi, *Nihon Engeki Zenshi* 255, 258–260. Note Kawatake's comparison of *yūjo* kabuki with the postwar "strip" shows of Tokyo.
130. Donald Shively, "The Social Environment of Tokugawa Kabuki" 9.
131. Gunji Masakatsu, *Kabuki no Bigaku* 301.
132. Gunji Masakatsu, *The Kabuki Guide*, photo. Yoshida Chiaki, trans. Christopher Holmes (1987; Tokyo: Kodansha International Ltd., 1990) 18.
133. Gunji, interview. Gunji also argues that the reading of the body, and sensing erotic communication between bodies is not bound to heterosexuality. He also feels that erotic expression and perception is culturally specific and non-Japanese may not feel or "get" *iroke* in kabuki without cultural conditioning. For a detailed discussion on the relationship between Kabuki and Yoshiwara, Edo's female prostitute licensed quarter, see Gunji, *Kabuki to Yoshiwara*.
134. Gunji, *Kabuki no Bigaku* 312–313. See also 313–318, "Onnagata no Iroke." Gunji cites many examples of *iroke* in onnagata gender acts from later Edo period plays and scenes.
135. Onoe Baikō VII, interview. Baikō VII suggests that everything an onnagata does on stage must be physically attractive. An onnagata uses his *iroke* (erotic allure) to fill the stylized forms with sensual beauty.

Chapter 4 Star Designing and Myth Making

1. Fujita Hiroshi, *Onnagata no Keizu* 36–37. See his Appendix II for other chronologies and lists of star onnagata of the prewar and postwar periods. Different historians designate their own periods of kabuki development.

2. Watanabe Tamotsu, *Musume Dōjōji*, revised edition (1986; Tokyo: Shinshindō, 1992) 12–15. Watanabe outlines the performance history of *Musume Dōjōji* by focusing on the reformations made by star onnagata. In his last chapter, Watanabe analyzes a part of *Musume Dōjōji*, which clearly demonstrates how the innovations reflect the star performers' physical styles. See pp. 453–491.

3. Toita Yasuji, *Onnagata no Subete* 41–55.

4. Toita Yasuji, *Onnagata no Subete* 44.

5. Toita Yasuji, *Onnagata no Subete* 10–12.

6. Jane Gaines, "Costume and Narrative: How Dress Tells the Woman's Story," *Fabrications: Costume and the Female Body*, ed. Jane Gaines and Charlotte Herzog (New York: Routledge, 1990) 200.

7. Jane Gaines, "Costume and Narrative" 200.

8. James R. Brandon, lecture, Japanese Theatre Seminar, University of Hawaii, Fall 1989.

9. Jane Gaines, "Costume and Narrative" 201.

10. Jane Gaines, "Costume and Narrative" 200.

11. Onoe Baikō VII, interview.

12. The *guchi* or *kuchi* refers to mouth or taste. The title may be translated as "words about the actors as played by a shamisen," or the "taste of the actors," or from the "mouth of the actors via the shamisen."

13. Quoted in Tsuchiya Keiichirō, *Genroku Haiyū Den* (Tokyo: Iwanami Shoten, 1991) 46.

14. Tsuchiya Keiichirō, *Genroku Haiyū Den* 46.

15. See chapter 7 of this book for an analysis of the onnagata intentional body.

16. Fujita Hiroshi, *Onnagata no Keizu* 36–37. This is one discussion of the layers of stylization and the onnagata's body beneath. See also Watanabe Tamotsu, *Musume Dōjōji* 76–77, for his discussion of the print image of Tomijūrō I and the different depictions by different artists and these layers of images over the performer.

17. The *Yakusha Hyōbanki* (Actor's Reviews or Critiques), is one of the most important documents of Edo kabuki performance. The earliest review, *Yarōmushi*, published in 1659, followed the format established by the *Yūjo Hyōbanki* (Courtesan's Reviews) that was basically a lyrical "want ads" advertising the performing prostitutes. Published annually, it was a record of actors and their careers as well as a visual and literary exposition of critical methods and standards of evaluations. Even if the critiques fictitiously extolled and exaggerated the sensual beauty of an onnagata, which physical traits and performative acts were repeatedly praised or critiqued is evidence of the standards and ideals for onnagata performance. See "Yakusha Hyōbanki," Shimonaka Hiroshi, ed., *Kabuki Jiten* 389–390. See Adachi Naoru, *Kabuki Onnagata Gekijō Fūzoku Saiken* 110, for explanation of rank ratings.

18. Adachi Naoru, *Kabuki Onnagata Gekijō Fūzoku Saiken* 211.

19. Tsuchiya Keiichirō, *Genroku Haiyū Den* 38.

20. Tsuchiya Keiichirō, *Genroku Haiyū Den* 58–59.

21. Tsuchiya Keiichirō, *Genroku Haiyū Den* 46–47. There was a smaller size head used for the graphic representation of women than for the representation of

onnagata in their female gender roles. This differentiation started after the bans on *wakashu* performers with the rise of the new men's kabuki onnagata in the last decades of the seventeenth century.

22. Tsuchiya Keiichirō, *Genroku Haiyū Den* 46.

23. Tsuchiya Keiichirō, *Genroku Haiyū Den* 45.

24. As stated earlier, when reintroducing a Japanese term after several chapters, I sometimes repeat its English translation.

25. Tsuchiya Keiichirō, *Genroku Haiyū Den* 47.

26. Tsuchiya Keiichirō, *Genroku Haiyū Den* 59.

27. Tsuchiya Keiichirō, *Genroku Haiyū Den* 52–53.

28. Kawatake Toshio, *Kabuki: Sono Bi to Rekishi* (Tokyo: Nihon Geijutsu Bunka Shinkōkai, 1992) 24.

29. To a certain degree, the worlds of the *yūjo*, *iroko*, and the onnagata shared and exchanged fictions. But given the domination of male prescriptions for female behavior, including *yūjo*, I suggest that onnagata were the designers and creators of the basic *kata* for the onnagata role types.

30. Jennifer Robertson, "The 'Magic If': Takarazuka Revue of Japan," *Gender in Performance*, ed. Laurence Senelick (Hannover: University of New England Press, 1992) 50.

31. Yoshizawa Ayame I, "The Words of Ayame," (Ayamegusa), comp. Fukuoka Yagoshirō, *The Actor's Analects*, trans. and ed. Charles Dunn and Torigoe Bunzō (1969; Tokyo: University of Tokyo Press; New York: Columbia University Press, 1969) 56–57.

32. Yoshizawa Ayame I, "The Words of Ayame" Item V, 52; Item XX, 60–61; Item XXVI, 63.

33. Tsuchiya Keiichirō, *Genroku Haiyū Den* 162–163.

34. Tsuchiya Keiichirō, *Genroku Haiyū Den* 156–157.

35. Charles Dunn and Torigoe Bunzō, introduction, *The Actor's Analects*, 14–15 trans. and ed. Charles Dunn and Torigoe Bunzō (1969; Tokyo: University of Tokyo Press; New York: Columbia University Press, 1969). The editors conjecture that the writings existed from about 1750, but the oldest published collection is from 1776.

36. Yoshizawa Ayame, "Ayamegusa" 291–275, "The Words of Ayame" 49–66.

37. Yoshizawa Ayame, "The Words of Ayame" Item XII, 55; Item II, 50.

38. Yoshizawa Ayame, "The Words of Ayame" Item VII, 53.

39. Yoshizawa Ayame, "The Words of Ayame" 53, "Ayamegusa" 285.

40. Yoshizawa Ayame, "Ayamegusa" 286.

41. Jennifer Robertson, "The 'Magic If' " 50.

42. Yoshizawa Ayame, "The Words of Ayame" 53.

43. Yoshizawa Ayame, "The Words of Ayame" 53.

44. Nakamura Jakuemon VI, personal interview, Tokyo, 1993.

45. Judith Butler, *Bodies That Matter* 234.

46. Yoshizawa Ayame, "The Words of Ayame" 49–66, "Ayamegusa" 291–275.

47. Benito Ortolani, *The Japanese Theatre* 181.

48. Watanabe Tamotsu, *Onnagata no Unmei* (Tokyo: Chikuma Shobo, 1991) 124.

49. Judith Butler, *Bodies That Matter* 231–232.

50. Nakamura Jakuemon IV, interview.

51. See chapter 6 of this book for description of *kudoki*.

52. Yoshizawa Ayame I, "The Words of Ayame" 56, "Ayamegusa" 284–285.

53. Gunji Masakatsu, interview. See Nishikata Setsuko, *Nihon Buyō no Sekai* (Tokyo: Kodansha, 1988) 36–38.

54. Gunji Masakatsu, *Odori no Bigaku* (Tokyo: Engeki Shuppansha, 1957) 93–100.

55. James R. Brandon, *Kuruwa Bunshō* (Love Letter from the Licensed Quarter), *Kabuki, Five Classic Plays*, trans. and ed. James R. Brandon (Cambridge: Harvard University Press, 1975) 217–237. Note Brandon's precise description of the interplay between performer gestures and lyrics sung by the *takemoto* and *tokiwazu* ensemble, pp. 233–237.

56. Gunji Masakatsu, interview.

57. Gunji Masakatsu, *Odori no Bigaku* 101–106. See Brandon, "Form in Kabuki Acting," *Studies in Kabuki* 77–81, for an explanation of *shosagoto* and *furi* (specialized gesture) and transformation works.

58. Watanabe Tamotsu, *Musume Dōjōji* 38–39.

59. "Yakusha Ware Miutsuro," quoted in Watanabe Tamotsu, *Musume Dōjōji* 42.

60. See Watanabe Tamotsu, *Musume Dōjōji* 45–52, for his discussion of Kikunojō I's evolution and his changes in onnagata looks and aesthetics.

61. This image was still created and designed by men. The image of Kyoto as the older sophisticated, cultural capitol was in contrast to Edo, the rough and unsophisticated new capitol.

62. Watanabe Tamotsu, *Musume Dōjōji* 40.

63. Watanabe Tamotsu, *Musume Dōjōji* 44.

64. Watanabe Tamotsu, *Musume Dōjōji* 45.

65. Most of the time I use the popular or shortened title of a play. The short titles are adequate for researching more information on the plays. English titles change depending on the translator.

66. Kawatake Shigetoshi, *Kabuki Meiyūden* 96.

67. In contemporary kabuki, onnagata may regularly perform certain male gender roles like Yoshitsune in *Kanjinchō* (The Subscription List) or Katsuyori of *Honchō Nijūshikō*. These characters are young refined male roles reminiscent of *wakashu* roles that recalled the courtier, Narihira. An onnagata who carefully maintains his onnagata gender stylization in these male gendered youth roles, can play with the gender ambiguity of his male youth acts and onnagata gender acts.

68. Kawatake Shigetoshi, *Kabuki Meiyūden* 94.

69. This happens in other performance genres. For example, John Wayne was the movie cowboy hero and the movie cowboy hero was John Wayne. Or in contemporary Takarazuka, the all-female review, the male gender role stars, *otokoyaku*, are the "male" stars. To various degrees, performers assimilate the representation until they are the representation.

70. Adachi Naoru, *Kabuki Onnagata Gekijō Fūzoku Saiken* 228–229.

71. A *waka* quoted in Adachi Naoru, *Kabuki Onnagata Gekijō Fūzoku Saiken* 228. No source is given.

72. Imao Tetsuji, "Onnagata Hiden," *Engeki Hyakka Daijiten* volume 1, 509. Imao cites the "Yakusha Rongo Kashira" as his source for the existing fragments of the *Onnagata Hiden*. Publishing and recording dates for the original are unknown.

73. See Imao Tetsuji, " 'Onnagata Hiden' to Kikunojō no Ishiki," *Engekigaku* 1 (1958): 52–57.

74. Uehara Teruo, "Onnagata Geidan Tsunagi Kangae," *Kabuki* (Kikanzasshi) 7.1 (1974): 50.

75. Uehara Teruo, "Onnagata Geidan" 50.

76. Yoshizawa Ayame, "Ayamegusa" 280–279; "Words of Ayame" Item XXII, 62.

77. Uehara Teruo, "Onnagata Geidan" 51. He quotes from "Ayamegusa," and "Onnagata Hiden," without citing sources for these quotations.

78. Toita Yasuji, *Onnagata no Subete* 43–44.

79. Ruth Shaver, *Kabuki Costume* (Tokyo: Tuttle, 1966) 69–70.

80. Kawatake Shigetoshi, *Kabuki Meiyūden* 96.

81. Ruth Shaver, *Kabuki Costume* 69–70.

82. Watanabe Tamotsu, *Musume Dōjōji* 71.

83. Kawatake Shigetoshi, *Kabuki Meiyūden* 100.

84. Kawatake Shigetoshi, *Kabuki Meiyūden* 100–101.

85. Watanabe Tamotsu, *Musume Dōjōji* 318, 324.

86. Watanabe Tamotsu, *Musume Dōjōji* 329.

87. Segawa Kikunojō III was one of the three onnagata to ever hold the position of *zagashira* (troupe head), a title for troupe leader used in Edo. This title and position was reserved for the leading tachiyaku, with the exception of very few onnagata: Nakamura Tomijūrō I, Segawa Kikunojō III, and Iwai Hanshirō V. However, even on the *banzuke*, the ranking list of actors for a show, onnagata were never listed before tachiyaku. Watanabe calls this restriction a reflection of the "Dansonjohi" (lit. male value/female vulgarity) policy: "Revere man, humble woman," or male domination. In this case, onnagata takes the position of the "humble woman." See Watanabe Tamotsu, *Musume Dōjōji* 309.

88. Kawatake Shigetoshi, *Kabuki Meiyūden* 161.

89. Kawatake Shigetoshi, *Kabuki Meiyūden* 163.

90. Watanabe Tamotsu, *Musume Dōjōji* 351–352.

91. Watanabe Tamotsu, *Musume Dōjōji* 352–353.

92. Watanabe Tamotsu, interview.

93. Watanabe Tamotsu, *Musume Dōjōji* 355.

94. Watanabe Tamotsu, *Musume Dōjōji* 355.

95. Watanabe Tamotsu, interview. Watanabe used "*shoka suru*," (to digest) to explain how, after a period of stylization and experimentation, the onnagata image had been digested, literally, through their bodies, on to the stage, and then through the spectators' perception. All their postures, vocalization patterns, gestures, all their *kata*, gradually became an onnagata fiction with onnagata as the referent.

96. Watanabe Tamotsu, *Musume Dōjōji* 372.
97. Watanabe Tamotsu, *Musume Dōjōji* 354. Watanabe describes Hanshirō IV's particular approach to playing the lowest class of female prostitute with a humorous edge.
98. Torigoe Bunzō, interview.
99. Gunji Masakatsu, interview.

Chapter 5 Modernity, Nation, and Eros: Boys versus Women

1. Jacob Raz, *Audience and Actors* 136. See his Chapter Five, "Kabuki in the Edo Period and Its Audiences," for more on class interaction and *bakufu* policies.
2. Toita Yasuji, *Onnagata no Subete* 15–16. It is interesting that the committee referred to women as *onnago* (girls).
3. Ihara Toshirō, *Meiji Engekishi* (1933; Tokyo: Hō Shuppansha, 1975) 506.
4. Kawatake Shigetoshi, *Nihon Engeki Zenshi* 1003. See also "Ichikawa Kumehachi," *Engeki Hyakka Daijiten* volume 1 166.
5. Kawatake Shigetoshi, *Nihon Engeki Zenshi* 1004.
6. Komiya Toyotaka, ed., *Japanese Music and Drama in the Meiji Era*, trans. Edward G. Seidensticker and Donald Keene (Tokyo: Ōbunsha, 1956) 259.
7. Komiya Toyotaka, ed., *Japanese Music and Drama in the Meiji Era* 259. For more on the interaction between early foreign style performance and kabuki performers, see, Ortolani, *The Japanese Theatre* 233–267.
8. It is beyond the scope of this analysis to dissect the sociocultural circumstances of the masculinist powers that aimed at keeping all professional traditional performing arts in the hands of men.
9. Faubion Bowers, *Japanese Theatre* 223. Bowers argues further that erotic scenes continued to be censored through World War II. Given the length of time of censorship, one may conjecture that the Edo style eroticism associated with onnagata gender acts has not been directly observed by contemporary young onnagata. Even the contemporary senior generation onnagata, like Utaemon VI, Jakuemon IV, or the late Baikō VII, who may have observed the Edo style onnagata as children, had as their models the onnagata like Utaemon V and Baikō VI and others from the post–Meiji reform era.
10. David Goodman, *The Cambridge Guide to Asian Theatre*, ed. James R. Brandon (Cambridge: Cambridge University Press, 1993) 153–154.
11. Sawamura Tanosuke IV, interview.
12. I could call this a kind of "queering" of onnagata *kata*, but I suggest instead that here the eros of the beautiful boy is what is inflected. Please see Phlugfelder's work on same-sex love in the Edo period.
13. Kataoka Hidetarō II, personal interview, Tokyo, 1992. Hidetarō II used the English words "gay boy."
14. Ichikawa Ennosuke III, interview.
15. Nakamura Matagorō II, personal interview, Tokyo, 1992. He also felt that the set *kata* did not change, but emphasized that *how* one performed the *kata* changed with the Meiji reforms.

16. For a description of the Theatre Reforms and the initial period of changes in Meiji Kabuki, see Ihara Toshirō, *Meiji Engekishi* Chs. 9–10.

17. Gunji Masakatsu, interview.

18. Kawatake Shigetoshi, *Nihon Engeki Zenshi* 794–801.

19. Gunji Masakatsu, interview.

20. Ichikawa Ennosuke, interview. Nakamura Kankurō, personal interview, Tokyo 1992. The exceptions that tachiyaku like to play are the onnagata transformation dance roles which may have *himesama*, *yūjo*, or *musume* roles within them, like *Musume Dōjōji*, or Sarafina in *Momijigari* (Maple-viewing Party).

21. Kawatake Shigetoshi, *Nihon Engeki Zenshi* 809–815. The Society for Theatre Reform and many other individuals also contributed to this epoch-making viewing.

22. The first play performed for the Emperor, the court, and foreigners was *Kanjinchō* (The Subscription List). It is a nō-derived dance play, with no female or lower class characters. There is one refined young male role, Yoshitsune, which is frequently played by an onnagata. *Kanjinchō* was a politically safe choice for kabuki's first "showing" as a classical art, and it is noteworthy that any controversy over the onnagata was avoided in this instance.

23. Nakamura Jakuemon IV, personal interview, Tokyo, 1991.

24. Ihara Toshirō, *Meiji Engekishi* 178–179. This description is in a long quoted passage that, Ihara notes in the text, is from "Kawatake Kisue's additional notes." Ihara gives no footnote or other source reference.

25. Engekikai Editorial Board, "Hassei Iwai Hanshirō," *Hyakunin no Kabuki* July 1995: 30. In this special edition of *Engeki Kai*, there are some of the earliest photographs of the Meiji kabuki actors. It is particularly informative for gender act analysis to see the first photo documented onnagata in costumes and poses. The Meiji, Taishō, and early Shōwa *Engeigahō* magazines are also sources for onnagata photographs. The Otani Library in Tokyo houses a vast collection of kabuki photographs that are available for viewing. Waseda University's collection is another source for photo documentation.

26. Ihara Toshirō, *Meiji Engekishi* 177.

27. Komiya Toyotaka, ed., *Japanese Music and Drama in the Meiji Era* 209. See also the description of Hanshirō VIII by Danjūrō IX in Ihara Toshirō, *Meiji Engekishi* 177–178.

28. There are exceptions like the *musume* role in *Benten Kozō* (Benten Kozō), where an onnagata reveals his male body beneath the onnagata gender acts. But, in this case, the *musume* character is really a disguise for a male character, Benten Kozō. This role is frequently played by a *kaneru yakusha*, an actor who plays both onnagata and tachiyaku roles. Only a few onnagata play this role.

29. Some onnagata did experiment with Western female attire, but the period dresses still covered most of their body, which is essential to onnagata gender performance. The contemporary onnagata Bandō Tamasaburō V has played female gender roles in several Western plays, for example *Nastajza* by Andrei Wadja, and *Elizabeth* by Francis Orrs. In both cases, he wore long gowns and elaborate wigs. In a sense, he manipulated the Western costuming using his

stylized onnagata gender acts. Even in his "Super Kabuki" productions, Ichikawa Ennosuke III has been careful to stay with kimono-like costumes and wigs for the female gender roles.

30. Ihara Toshirō, *Meiji Engekishi* 192.

31. Ihara Toshirō, *Meiji Engekishi* 193. Ihara also cites how he was incredibly bright, even a kind of genius with his insight and sensuality.

32. Engeki Kai Editorial Board, "Sansei Sawamura Tanosuke," *Hyakunin no Kabuki*, July 1995: 34.

33. Ihara Toshirō, *Meiji Engekishi* 191.

34. Ihara Toshirō, *Meiji Engekishi* 191.

35. Kawatake Shigetoshi, *Nihon Engeki Zenshi* 748.

36. Ihara Toshirō, *Meiji Engekishi* 191. See also 194–195 on his relationship with Danjūrō IX, which might also have sensationalized Tanosuke III's image.

37. Although the actors are quite different, contemporary Utaemon VI, now in his late seventies, performs with a crippled foot, barely moving on stage. In 1995, I saw a rehearsal where he was brought onstage in a wheelchair with an oxygen mask. Yet, Utaemon VI's earlier image of exquisite beauty somehow remains over his aged body beneath. Media participate in reinforcing his youthful beauty image with photographs and specials on the young Utaemon.

38. James Brandon, personal conversation, Honolulu, 1994.

39. Matsuda Osamu, "Kabuki to Gensōsei," *Rising* No.12 March 1989: 54–56.

40. Marvin Carlson, *Performance, A Critical Introduction* (New York: Routledge, 1996) 28–29.

41. Nohara Akira, *Heisei no Kabuki* (Tokyo: Maruzen, 1994) 66. The Meiji period onnagata were also the first onnagata to have photographic and film recordings of their model art. Perhaps the star image of Utaemon V and Baikō VI benefited from this new media recording of their onnagata acts.

42. Toita Yasuji, *Rokudaime Kikugorō* (Tokyo: Engeki Shuppansha, 1956) 148–149.

43. Onoe Baikō VII, interview. Nakamura Shikan VII, interview.

44. I translate *kokoro* directly as "heart." However, its meaning may come closer to an untranslatable heart/mind/spirit concept. *Kokoro* is also not only related to the inner life of the enacted character, but the performer's heart/mind/spirit energy connection to the *kata*, and through the *kata* to the performed role.

45. Bandō Tamasaburō V, interview.

46. Nakamura Utaemon V, *Kabuki no Kata: Kaigyoku Yawa* (Tokyo: Bunkoku Shobo, 1950) 430. All references to Utaemon V's *Kabuki no Kata* are from this edition.

47. Mizuochi Kiyoshi, *Edo no Kyaria U-man* 137. For more explanation of this role, see his section on Yodogimi in this book, pp. 134–137.

48. See Plate 29, "Yodo no Kata Yatsu Sugata" (Eight Attitudes of Yodogimi) in Nakamura Utaemon V, *Kabuki no Kata*.

49. Nakamura Utaemon V, *Kabuki no Kata* 101.

50. Nakamura Utaemon V, *Kabuki no Kata* 102.

51. Nakamura Utaemon V, *Kabuki no Kata* 131–138.
52. Nakamura Utaemon V, *Kabuki no Kata* 102.
53. Gunji Masakatsu, interview.
54. For more details on Utaemon V's career see Ōzasa Yoshio, *Nihon Gendai Engekishi*: Meiji—Taishō Volume (1985; Tokyo: Hakusui, 1990) 329–347; Ihara Toshirō, *Meiji Engekishi*; Kawatake Shigetoshi, *Nihon Engeki Zenshi*; and Maya Kyoko, *Watashi no Utaemon* (Tokyo: PMC, 1990). There were other onnagata who also contributed to the onnagata revival, especially noteworthy performers from the Kamigata areas. See Mizuochi Kiyoshi, *Kamigata Kabuki* (Tokyo: Tokyo Shoseki, 1990) for more on these performers.
55. Onoe Baikō VI, *Onnagata no Geidan* (Tokyo: Engeki Shuppansha, 1988). All references to Baikō VI's *Onnagata No Geidan* are from this edition.
56. Bandō Tamasaburō V, interview.
57. Onoe Baikō VI, *Onnagata no Geidan* 152.
58. Onoe Baikō VI, *Onnagata no Geidan* 97.
59. Gunji Masakatsu, interview.
60. Bandō Tamasaburō V, interview. He used this phrase in English.
61. Sawamura Tanosuke VI, interview.
62. Bandō Tamasaburō V, interview.

Chapter 6 The Aesthetics of Female-Likeness

1. A discussion of and comparison to tachiyaku aesthetics is beyond the scope of this dissertation, but some of the aesthetic elements discussed here may also arise in tachiyaku performance. I would suggest that an exclusively male bodied theatre based outside a bipolar gender system might produce its own aesthetic system.
2. Onoe Baikō VI, interview.
3. See James R. Brandon, "Form in Kabuki Acting" 65–113, and Samuel L. Leiter, trans. and comm., *The Art of Kabuki: Famous Plays in Performance* (Berkeley: University of California Press, 1979). Both scholars deal extensively with *kata* and stylized performance.
4. James R. Brandon, trans. and comm., introduction, *Kabuki: Five Classic Plays* (Cambridge: Harvard University Press, 1975) 23. See Brandon's discussion of *kizewamono* (true domestic plays) and stylization, pp. 21–24.
5. Gunji Masakatsu, *Kabuki no Bigaku* (Tokyo: Engeki Shuppansha, 1963) 18–19, 37.
6. Gunji Masakatsu, *Kabuki no Bigaku* 35.
7. Gunji Masakatsu, *Kabuki no Bigaku* 36.
8. Gunji Masakatsu, *Kabuki no Bigaku* 36.
9. I would also add grotesque beauty as an important aesthetic of onnagata gender performance, but I do not analyze this aesthetic in the current document.
10. Bandō Tamasaburō V, interview.
11. Bandō Tamasaburō V, Nakamura Ganjirō III, Onoe Baikō VI, Watanabe Tamotsu, interviews.

12. Ichikawa Ennosuke III, interview.
13. *Uso* is a word used by several actors to describe what they do onstage. *Uso* is not just related to fantasy or fiction; rather, it is seen as dissembling or deliberately hiding the truth. It may have arisen from the *bakufu* restrictions, which forbade the representation of real samurai and nobility in play and role content. Kabuki performers responded by setting stories and characters in earlier eras, changing and adding subplots and aliases. Perhaps the "lie" moved further from the truth over time, to become an aesthetic requirement. Part of the audience's enjoyment comes from how the *uso* makes a game of guessing what the truth may be.
14. Sawamura Tanosuke VI, interview. After several discussions about comparative realism ranging from Stanislavsky actor training realism and movie realism, to *shingeki*-style realism, Tanosuke VI concluded that kabuki has its own realism, and one culture's stage realism may not be understood by another culture.
15. Nakamura Fukusuke IX, personal interview, Tokyo, 1993. Bandō Tamasaburō V, interview.
16. Bandō Tamasaburō V, interview.
17. Hattori Yukio, interview.
18. Bandō Tamasaburō V, Nakamura Shikan VII, Onoe Baikō VII, Onoe Kikugorō VII, Nakamura Tokizō V, were among those interviewed who remarked specifically on the ambiguity and transformativity of onnagata performance.
19. I never heard an onnagata refer to "onnagata" as something opposite to "tachiyaku."
20. Shikan VII, Ganjirō III, and Tamasaburō V describe *aimai* to be something that could have several meanings, or something that could change in meaning, and thus feel mysterious or unsettling.
21. Mizuochi Kiyoshi, interview. Watanabe Tamotsu, interview.
22. See chapter 7 of this book, "The Intentional Body."
23. Nakamura Shikan VII, interview.
24. I would extend my hypothesis to include the influence of the adolescent boy body on women's ideal sensual body and on the entire Japanese fashion industry whose aim, I think, is to market the adolescent boy body as a "universal" body of youth and beauty.
25. Ruth M. Shaver, *Kabuki Costume* (Tokyo: Charles Tuttle Co., 1966) 114.
26. Kabuki Costume Lecture Demonstration, Kabuki no Ki Meeting, Tokyo, April 1993.
27. See Liza Crihfield Dalby, *Kimono, Fashioning Culture* (New Haven: Yale University Press, 1993) 17–20, for an explanation of the parts of the kimono and its characteristics.
28. Besides gender, kimono characteristics may also indicate the age, rank, class, and occupation of the wearer.
29. Examples of *nimaime* role types are Motome in the *michiyuki* (travel sequence) of *Imoseyama* (The Mountains Imo and Se), Yukihime's husband Naonobu in *Kinkakuji* (The Golden Temple) and Izaemon in *Kuruwa Bunshō* (Love Letter from the Licensed Quarter).

30. By wrapping, I mean the myriad ways the kimono is pulled around the body, folded over, and then closed in such a way as to produce a set shape and line. See Liza Crihfield Dalby, *Kimono, Fashioning Culture*, for extensive explanations on kimono wrapping and kimono styles for men and women.

31. Liza Crihfield Dalby, *Kimono, Fashioning Culture* 275.

32. Liza Crihfield Dalby, *Kimono, Fashioning Culture* 275.

33. The male character does remove the wide *obi*, sash, and *uchikake* (coat-like over kimono), which, in this case, are more strongly marked as female-like. Accessories added to the kimono may indicate a more specific gender, class, or role type code, but these may also vary. The dance *Yasuna*, is another example of how the kimono, when slipped on and wrapped and then unwrapped, transforms the character through various shadings of genders.

34. I also do not call the *wakashu* aesthetic a queer aesthetic primarily because it is based in a different cultural and political configuration.

35. Gary P. Leupp, *Male Colors, The Construction of Homosexuality in Tokugawa Japan* (Berkeley: University of California Press, 1995) 133.

36. Gary P. Leupp, *Male Colors* 133.

37. Gary P. Leupp, *Male Colors* 176.

38. Gary P. Leupp, *Male Colors* 178.

39. Gary P. Leupp, *Male Colors* 178.

40. An example is Tomijūrō I's famous multiple change dance work, *Kyōganoko Musume Dōjōji*, in which the onnagata transforms from a *shirabyōshi* to a *musume* who also acts out being a *yūjo*, and ultimately sheds several layers of kimono for a serpent-patterned kimono representing, in a sense, the transformed state of the *musume* consumed by jealousy and transformed into a serpent dragon-like being. In his book, *Musume Dōjōji*, Watanabe Tamotsu charts the sections of *Kyōganoko Musume Dōjōji*. He graphically depicts the stages of transformations in this dance. Also see Gunji Masakatsu, *Kabuki no Katachi, Gunji Masakatsu Santeishū*, volume 2 (Tokyo: Hakusuisha, 1991) 201–233. Gunji gives a comprehensive summary of the creation and breakdown of kabuki role types through the Edo period, which indicates the general gender ambiguity and the evolution from specialization in one gender role type to the multiple role and multiple gender role performer. See pages 229–231 of the same volume 2 comparing contrasting gender role ideas of Ayame I and Kikunojō I.

41. Ann Rosalind Jones and Peter Stallybass, "Fetishizing Gender: Constructing the Hermaphrodite in Renaissance Europe," *Body Guards: The Cultural Politics of Gender Ambiguity*, ed. Julia Epstein and Kristina Straub (New York: Routledge, 1991) 81, 105.

42. David M. Halperin, "Historicizing the Sexual Body: Sexual Preferences and Erotic Identities in the Pseudo-Lucianic *Erotes*," *Discourses of Sexuality: From Aristotle to Aids*, ed. Donna C. Stanton (Ann Arbor: University of Michigan Press, 1992) 260.

43. Ichikawa Ennosuke III, interview.

44. Gunji Masakatsu, *Kabuki no Bigaku* 317, 315. Gunji discusses *kōshoku*, which can mean lust or passion for something.

45. Gunji Masakatsu, interview.

46. Gunji Masakatsu, *Kabuki no Bigaku* 315.

47. Bandō Tamasaburō V, interview.

48. Asahi Earphone Guide Service, Tokyo: 1990–1993. The Japanese guides invariably will tell the spectator when an action or a sequence is a famous "moment of *iroke*," or "full of *iroke*," or that "now is the moment when the onnagata shows his *iroke*."

49. Onoe Kikugorō VII, personal interview, Tokyo, 1993.

50. Gunji Masakatsu, *Kabuki no Bigaku* 301–318.

51. Nakamura Jakuemon IV, personal interview, Tokyo, 1992 and 1993. Jakuemon IV and Baikō VII used the verb *hiku* which means to pull, attract, or draw in.

52. See my description of the Agemaki *dōchū* (courtesan parade) from *Sukeroku*, in this chapter. Other examples of the subtle drawing in *iroke* abound in performances of *yūjo* role types such as Yatsuhashi in *Kagotsurube* (Kagotsurube), Ohatsu in *Sonezaki Shinjū* (Love Suicide at Sonezaki), and Umegawa in *Koibikyaku Yamato Orai* (Love Messenger from Yamato).

53. *Iroke* is not limited to onnagata performance, but the aesthetic points are very different for the tachiyaku who, besides playing the male gender over a male body, also may reveal much more real flesh. The tachiyaku stylization of erotic allure employs different performance strategies.

54. I call these "breathe-taking" moments.

55. The aural aspect of sensuality related to the wearing of the kimono is a culturally based experience. The Japanese audience knows the sound of the *obi* being pulled off, either from wearing kimono for special occasions or from watching period movies or television samurai serials where characters wear kimono. For both men and women, this is like an aural symbol for the act of undressing. Even without the sound, the kinesthetic experience of the *obi* unwinding is a culturally based experiential icon. Perhaps a certain internationalization of kinesthetic perceptions has occurred through film and TV viewing of Japanese costuming, architecture, and other artistic pursuits, which has opened up this avenue for non-Japanese spectators. However, most of the sensually aesthetic devices used by onnagata are based on Edo period "physicality" or acts related to the body based on cultural prescriptions.

56. Sawamura Tanosuke VI, interview.

57. Watanabe Tamotsu, interview.

58. Nakamura Shibajaku VII, personal interview, Tokyo, 1992.

59. Nakamura Shibajaku VII, interview.

60. Judith Butler, *Gender Trouble* 14.

61. James R. Brandon, private conversation, 1995.

62. Nakamura Shikan VII, interview.

63. I encountered a great deal of debate over the meaning of *kudoki*. Among them, Furuido Hideo comments in his interview that real *kudoki* required that the female character perform a tragic episode with a pure heart. Whereas Nishikata Setsuko explains that *kudoki* may indeed be a female character's appeal, like a soliloquy, to the world: expressing the pain, passions,

and jealousies over a lost love. See Nishikata Setsuko, *Nihon Buyō no Sekai* (Tokyo: Kodansha, 1988) 86.

64. Nishikata Setsuko, *Nihon Buyō no Sekai* 86.

65. This play is commonly called *Sakurahime* (Princess Sakura or The Scarlet Princess). See this seduction scene in James R. Brandon, trans. and comm., *The Scarlet Princess of Edo, Kabuki, Five Classic Plays*, 266–269. Tsuruya Namboku IV was the main author of *Sakurahime*, which was first staged in Edo in 1817.

66. Nakamura Jakuemon IV, interview.

67. James R. Brandon trans. and comm., *Love Letter from the Licensed Quarter, Kabuki, Five Classic Plays*, 213–237. For complete and detailed translation with performance notes detailing all stage *kata* and history, this volume is invaluable. See also *Kuruwa Bunshō*, Toita Yasuji, ed. and comm., *Meisaku Kabuki Zenshū*, volume 7 (Tokyo: Sōgensha, 1969) 281–380. Although an early version is attributed to Chikamatsu Monzaemon, a 1793 version is considered the first version related to the contemporary version.

68. The original play, of which this is the extant part, is attributed to Chikamatsu Monzaemon (1653–1724). Izaemon, the main tachiyaku role is played in the *wagoto* (gentle style) performance style typical of the Kamigata area.

69. James R. Brandon, *Love Letter from the Licensed Quarter* 231.

70. Cecilia Segawa Seigle, *Yoshiwara* 157.

71. James R. Brandon, *Love Letter from the Licensed Quarter* 232.

72. James R. Brandon, *Love Letter from the Licensed Quarter* 234.

73. Onoe Baikō VI, *Onnagata no Geidan* 190–192; Watanabe Tamotsu, *Onnagata Hyakushi* (Tokyo: Seiabō, 1978) 41–43.

74. James R. Brandon, *Love Letter from the Licensed Quarter* 234.

75. Nakamura Jakuemon IV, interview.

76. Although I use the word "erotic" frequently in this document, I do not fully address the questions of "erotic to whom? and for what purposes?" These questions raise further questions about differences and ambiguities of sexualities and desires and the assumed hegemony of the heterosexual eroticism, which I hope to focus on in the future.

77. The suffering spoken of here is not limited to physical suffering, but includes agony of the heart/mind. For example, Masaoka of *Meiboku Sendai Hagi* (The Disputed Succession), Tamate Gozen of *Sesshū Gappō Ga Tsuji* (Gappō and his Daughter Tsuji), Fuji no Kata and Sagami of *Kumagai Jinya* (Kumagai's Camp), and Onoe of *Kagamiyama* (Kaga Mountain) are only a few of the most important onnagata roles whose major scenes center around the enactment of deep heart/mind torment. The *zankoku* aesthetic may arise in all play types and onnagata role types.

78. Hattori Yukio, *Zankoku no Bi, Nihon no Dentō Engeki ni Okeru* , trans. Frank Hoff (Tokyo: Hōgashoten, 1970) 254–251. Frank Hoff translates *zankoku*, as cruelty, and Hattori explains one kind of *zankoku* scene as torture, which most frequently involves female characters. I chose the word torture because the cruel actions performed on the onnagata tend to be extended over time. Onnagata use slow controlled *kata*, which communicate a kinesthetic pain of long-lasting, tortuous torment.

79. Gunji Masakatsu, *Kabuki no Bigaku* 14.
80. Gunji Masakatsu, *Kabuki no Bigaku* 14.
81. Gunji Masakatsu, *Kabuki no Bigaku* 19.
82. Watanabe Tamotsu, interview.
83. Ichikawa Ennosuke III, interview. Ennosuke III strongly feels that the *otokorashii* onnagata is the real kabuki onnagata. Without the ambiguity of the *otokorashii* onnagata, the onnagata, according to Ennosuke III, has lost his erotic attraction. He also feels that all aspects of kabuki have been repressed since the World War II, postwar occupation.
84. David M. Halperin, "Historicizing the Sexual Body" 239, 261.
85. David M. Halperin, "Historicizing the Sexual Body" 261.
86. David M. Halperin, "Historicizing the Sexual Body" 239.
87. Bandō Tamasaburō V, interview.
88. James R. Brandon, "Introduction," *Kabuki, Five Classic Plays* 23.
89. There are exceptions for "smaller" in the grand entrances of courtesan roles like Agemaki and the transformation roles of demon/witches like Katsuragi. But in these cases, they are still controlled and refined.
90. David M. Halperin, "Historicizing the Sexual Body" 246.
91. *Yotsuyakaidan* by Tsuruya Namboku IV, first performed in 1825.
92. Chikamatsu Monzaemon, *Onnagoroshi Abura no Jigoku*, Takemoto-za, Osaka, July 1721; Kabuki version: Naka-za 1721.
93. According to James R. Brandon, a mica-like compound is added to the water to produce a glittering reflection suggestive of oil.
94. James R. Brandon, "Appendix B," *Kabuki, Five Classic Plays* 354.
95. Gunji Masakatsu, *Kabuki no Bigaku* 34; Gunji Masakatsu, interview.
96. Bandō Tamasaburō V, interview.
97. Gunji Masakatsu, *Kabuki no Bigaku* 34.
98. Nakamura Matsue V, interview.
99. Gunji, *Kabuki no Bigaku* 9–10, 14–15. See the first chapter, "Kabuki no Bi," 9–37, for a discussion on the kabuki pleasure and dementia aesthetic.
100. Watanabe Tamotsu, *Onnagata Hyakushi* 189.
101. Nakamura Shikan VII, interview.
102. Watanabe Tamotsu, "Gei no Fukasa, Uta/ Bai no Jūshūkō," revision of "Jūshūkō" from *Honchō Nijūshikō*, Kabuki-Za, Tokyo, April 1990, *Kabuki Gekihyō* (Tokyo: Asahi Shinbunsha, 1994) 77–74.
103. *Seki no To*, Gunji Masakatsu, ed. and comm. *Buyōgekishū, Meisaku Kabuki Zenshū*. volume 19 (Tokyo: Sogen Shinsha, 1970) 58–72. See also Gunji Masakatsu, ed., *Seki no To*, "Buyōshū," *Kabuki-on-Stage* 25 (Tokyo: Hakusuisha,1988) 43–66. These two volumes contain complete plays and notes. Both of these versions are notated, but the "Onstage Series" includes extensive footnotes and references to sources for important images in the chanted lyrics.
104. Nakamura Nakazō I (1736–1790) originated the tachiyaku role, Sekibei/Kuronushi. Nakazō I was well known for his dance roles. This analysis is primarily based on the performance at the National Theatre in 1991. The male role of the barrier guard and villain, Sekibei/Kuronushi

was played by Ichikawa Danjūrō XII, and Bandō Tamasaburō V played the two female roles, Komachi and Sumizome. I also observed the 1992 National Theatre performance with Nakamura Tomijūrō V as Sekibei/ Kuronushi, Nakamura Matsue V as Komachi, and Nakamura Ganjirō III as Sumizome. Komachi/Sumizome was performed by Segawa Kikunojō III.

105. One onnagata usually plays both female roles, Komachi and Sumizome. It is a demanding play for the onnagata because it requires a wide range of role type *kata*. The onnagata must play a *himesama* (princess) role, a *yūjo* (courtesan) role, and a spirit role that performs *onnabudō* (female warrior) *kata* for the final fight scene.

106. The music for *Seki no To* is in the *tokiwazu* style. The author was Takarada Jurai. The music is considered one of the greatest *tokiwazu* compositions. The narrative style of *tokiwazu* gives the onnagata the opportunity to perform long sections of abstract and mimetic dance.

107. Watanabe Tamotsu, *Onnagata Hyakushi* 271–272.

Chapter 7 The Intentional Body

1. See chapter 1 of this book for an explanation of how I use the term in this text. There are various categories of onnagata gender acts. Gender acts that make up the intentional body are one such category.

2. Many traditional dance performance forms use deep muscle contractions to hold or move the torso and limbs in prescribed aesthetic patterns. In Western ballet, the technique of "turn out" (in which the trochanter is rotated back and down in the hip joints), which is the basis for all other movement design, allows the legs to extend higher and stabilizes the torso and limbs in the solar plexis area. See Nishikata Setsuko, *Nihon Buyō no Sekai* 148–149.

3. See Kagayama Naozo, *Kabuki no Kata* (Tokyo: Sogensha, 1957) for complete explanation of *kata* and James R. Brandon, "Form in Kabuki Acting" 63–132.

4. Onoe Baikō VI, *Onnagata no Geidan* 296.

5. Onoe Baikō VII, interview. Baikō was quoting from his predecessor, Onoe Baikō VI who quoted his father, Kikugorō V, a tachiyaku, in his *Onnagata no Geidan*, "The onnagata performs with the heart of the *kōken* for the tachiyaku." See Onoe Baikō VI, *Onnagata no Geidan* 295.

6. Onoe Baikō VII, interview.

7. Onoe Kikugorō VII, interview.

8. Sawamura Tanosuke VI and Ichikawa Ennosuke III, both spoke frequently of this idea of intending their physical manipulations to approach an ideal beauty, that is not defined as female or feminine. Other onnagata, such as Nakamura Matsue V, said the ideal beauty varied with role types.

9. Onoe Baikō VII, interview. See Onoe Baikō VI, *Onnagata no Geidan* 67–68.

10. Kataoka Hidetarō II, interview.

11. In the context of kyōgen, Nomura Mansaku used this phrase in reference to killing the "self" in order to let the spirit of the role inhabit the stage.

Onnagata also used it to refer to the real pain they experienced from hours in the onnagata costumes and kneeling postures. Nomura Mansaku, class lecture, University of Hawai'i, Honolulu, March 1988.

12. Ichikawa Ennosuke, *Ennosuke no Kabuki Kōza* 59.

13. Ichikawa Ennosuke, *Ennosuke no Kabuki Kōza* 59.

14. Onoe Baikō VI, *Onnagata no Geidan* 67.

15. Bandō Tamasaburō V, interview.

16. Washida Seiichi, "The Meaning of Costuming: Dance and Fashion," Buyō Gakkai (Dance Scholars Forum), Ritsumeikan University, Kyōtō, Japan, 18 May 1996. Washida theorized that the costuming of the body in performance, like designer fashion wear, set up the situation where the costuming made an "inter-body" and the performer had no body; that is, "Karada wa 'body' [English] ga nai." ("As for the performer body, there is no body.") Gunji Masakatsu responded that the kabuki onnagata might fit into his paradigm.

17. Herbert Blau, "Ideology and Performance," *Theatre Journal*, December (1983): 22.

18. Watanabe Tamotsu, "Naze 'Onnagata' na no ka?", *Bungei Shunjū* Deluxe #9 September 1979: 92.

19. Watanabe Tamotsu, interview.

20. Onoe Baikō VII, Nakamura Shikan VII, Nakamura Jakuemon VI, Furuido Hideo, were among those who responded to this in interviews. Furuido also referred to the illusions of the feminine, which Edo period onnagata produced through various physical constraints.

21. Nakamura Matsue V, interview. Matsue V (1948–) is the adopted son of Utaemon VI. He was adopted by Utaemon VI when he was five.

22. Ichikawa Ennosuke III, interview. Nakamura Shikan VII, interview.

23. In interviews, most onnagata refrained from saying that any one point was more important than the other as these physical changes had to work in ensemble to create the role. See discussion of dance for further reference to the hierarchy of performance skills.

24. Ennosuke III and Tamasaburō V both spoke of the contradictory roles of the onnagata. But, Tamasaburō V emphasized that no matter what, the onnagata was not the center of the action, even if he was the center of attraction. No matter how *medatsu* (eye-catching) they appear, onnagata are there to facilitate the main action performed by the tachiyaku.

25. Onoe Baikō VII, interview.

26. Nakamura Ganjirō III, interview.

27. Onoe Baikō VII, interview.

28. Nakamura Jakuemon VI, interview.

29. Bandō Tamasaburō V, interview.

30. Tachiyaku also have group stylizations. For example, in supporting roles of groups of soldiers, courtiers, or brothel guests, they have a gendered positionality that is also designed and set for the particular scene. With very few exceptions, in the case of both male and female roles being of equal rank, onnagata will take the lower or rear position.

31. The group onnagata should not be compared to a corps in classical ballet. The shifts of line and design here are extremely subtle and arise from aesthetic principles that are not based on one point perspective and proscenium, box staging that dominates classical ballet design.

32. Fuji no Kata is a court-class wife role and Sagami is a samurai wife role. The play is a *jidaimono* (history or period play type). Onnagata call both roles *jidainyōbō* (period wife) roles.

33. By "gaze" I mean the general placement of where the eyes are looking. "Focus" on the other hand, means the deliberate and specific direction of the gaze that an onnagata may use to pinpoint or emphasize something. Both of these are important skills learned in the study of kabuki *nihon buyō* (kabuki dance).

34. Bandō Tamasaburō V, interview.

35. Nakamura Matsue V, interview.

36. Kamoji Torao and Nakamura Jakuemon IV, "Katsura (1)—Tokoyama to Onnagata," *Gei no Kokoro*, ed. Fujio Shinichi (Tokyo: Sanichi Shobō, 1977) 167–177. This article consists of two interviews with Jakuemon and his *tokoyama* (wig dresser) who describe in detail the importance of the wig and wig dresser on the onnagata's performance. See also Ruth Shaver, *Kabuki Costume* 301–336, for an explanation of the wig making process and a description of wig types and decorations and their variations according to roles and role types.

37. Miura Hirō, personal interview, Tokyo, 1993. Miura is the *tokoyama* for the Onoe Kikugorō family line onnagata. During our interviews, he demonstrated the process of combing and dressing several onnagata role type wigs for Baikō VII, Kikugorō VII, and Kikunosuke V (1977–).

38. During my interview with Miura, he introduced me to several of the tachiyaku *tokoyama*, who showed me the many varieties of tachiyaku *tabo* and *bin* and their intricate stylizing. Miura also commented that there are many more varieties of tachiyaku hair types, and, even though the onnagata wigs look decorative, the tachiyaku wigs are truly complex and nuanced. Among the main family line *tokoyama*, the tachiyaku *tokoyama* hold a slightly higher position than the onnagata *tokoyama*.

39. Miura Hirō, interview.

40. Nakamura Ganjirō III, interview. Ganjirō III and others are somewhat critical of the use of natural styled wigs.

41. Nakamura Matsue V, interview.

42. I only saw Utaemon VI's Yatsuhashi on video. The moment of his smile really was extraordinary because the smile distorted the perfect face of the onnagata. It was one of those kabuki moments when you could see simultaneously the actor, Utaemon VI and the courtesan role, Yatsuhashi. Also known as *Sanno Jiroszaemon* (Sanno Jirozaemon), it was first staged in 1889; Kawatake Shinshichi III is the principal author.

43. Sawamura Tanosuke VI, interview.

44. Onoe Baikō VII, interview. Nakamura Matagorō II, interview.

45. Sawamura Tanosuke VI, interview.

46. Nakamura Fukusuke IX, interview. Kataoka Hidetarō II and Bandō Tamasaburō V, among others, made similar comments.
47. Trinh T. Minh-ha, "Not You/Like You" 372–373.
48 Nakamura Ganjirō III, interview.
49. See Gunji Masakatsu, *Odori no Bigaku*. This volume covers the aesthetic basics and history of kabuki dance, including the particular contribution of *wakashu*, onnagata, and women courtesans. Gunji carefully distinguishes between two types of movement in kabuki dance, *odori* and *mai*. The "drawing in" that I am referring to here is probably related to *mai*, which is based in nō dance movement.
50. Mark Oshima, a kabuki dance scholar, commented that his kabuki dance master said that the *tatehiza* position was used by women courtesans, who, because they did not wear underwear, and did not want to stain their kimono used this raised position to prevent this. This may be so, as many aesthetic forms arise from practical necessities.
51. Kawatake Toshio, introduction and notes, *Kabuki Ehon Jūhachiban*, photo. Iwata Akira, trans. Helen V. Kay (San Francisco: Chronicle Books, 1984) 102–103. Kawatake describes Agemaki's Five Festival costumes, which were designed by the star onnagata, Iwai Hanshirō V.
52. Bandō Tamasaburō V, interview.
53. Nakamura Matagorō II, interview. Sawamura Tanosuke VI, interview.
54. However, the performer's will functions in a prescribed culture of the kabuki troupe that, on one hand seems to exist in a vacuum. But on the other hand, it is also a culture of diverse and ambiguous ideologies of gender, class, and sexuality both on and off the stage.

Chapter 8 Performative Gender Role Types

1. "yaku" and "gara," *Kōjien*, 3rd ed. (Tokyo: Iwanami Shoten, 1988) 2398, 504. See also "yaku" and "gara," *Kenkyusha's New Japanese-English Dictionary*, 4th ed. (Tokyo: Kenkyusha, 1974) 1961, 317. "Gara" may also refer to a person's physical build or stature.
2. I use the term *yūjo* according to the *yakugara* used in Watanabe Tamotsu's *Onnagata Hyakushi* and after discussions with several kabuki actors. According to Nakamura Ganjirō III, *yūjo* is a more general and the appropriate term for *yakugara*. Where as, *keisei*, which some performers may use generally, refers only to a high ranking type of *yūjo*.
3. Watanabe Tamotsu, *Onnagata Hyakushi* 249–294.
4. Toita Yasuji, *Onnagata no Subete* 133–134.
5. Toita Yasuji, *Onnagata no Subete* 165–171, 177–182, 189–193. Note that Toita's *yūjo* role type takes up seventeen pages compared to the other role types of three to four pages.
6. Mizuochi Kiyoshi, *Edo no KyariaŪman: Kabuki Shukujoroku* (Tokyo: Kamakura Shobo, 1989) 8–9. The "Kyaria Ūman" in Mizuochi's title is the loan word made from "career woman," which is Mizuochi's contemporary title for the courtesan role type, which was the first major onnagata role of early kabuki.

7. Mizuochi Kiyoshi, *Edo no Kyaria Ūman* 11–12.
8. Mizuochi Kiyoshi, *Edo no Kyaria Ūman* 8–9.
9. Watanabe Tamotsu, "Yakugara," *Kabuki Jiten* 388.
10. Mizuochi Kiyoshi, *Edo no Kyaria Ūman* 8–9.
11. Nakamura Matagorō II, interview. Matagorō II emphasizes that restraint should heighten one's intensity, in fact, less outward movement requires greater focus and energy.
12. Nakamura Matagorō II, interview.
13. Watanabe Tamotsu, *Onnagata Hyakushi* 3. Watanabe uses *omokage* for what I translated as "personages," which could also mean "faces," "figures," or "appearance." I think Watanabe is referring to the role type as a fictional character. See "Omokage," *Kenkyusha's New Japanese-English Dictionary* 1300; "Omokage," *Kōjien* 359.
14. Watanabe Tamotsu, *Onnagata Hyakushi* 3.
15. Watanabe Tamotsu, *Onnagata Hyakushi* 4.
16. Watanabe Tamotsu, *Onnagata Hyakushi* 4.
17. Watanabe Tamotsu, *Onnagata Hyakushi* 5, 97, 103, 111.
18. Watanabe Tamotsu, *Onnagata Hyakushi* 4. Watanabe does a brief comparison to Western female roles such as Ophelia of *Hamlet*, and Nora of *A Doll's House*, and questions whether these could be classified into *yakugara* like "young girls" or "wives." He concludes that these characters could not be classified; they are too individualistic and they exist apart from their stage "acts."
19. Gunji Masakatsu, *Kabuki Nyūmon* 126. See also Hattori Yukio, "Kabuki: Kōzō no Keisei" 27–28.
20. Kawatake Shigetoshi, *Nihon Engeki Zenshi* 378.
21. Watanabe Tamotsu, "Yakugara," *Kabuki Jiten* 386–388. *Monogatari* generally means story, but here Watanabe is referring to the famous fictional history tales, like the *Heike Monogatari*, from which kabuki borrows many characters.
22. Toita Yasuji, "Yakugara," *Engeki Hyakka Daijiten*, volume 5 426–427.
23. Gunji Masakatsu, interview. In several conversations, Gunji emphasized that the stereotypes should not be confused with ideal classical figures or real persons. They are fictions unique to the Edo period.
24. Noma Mitsuyoshi, introduction, *yūjo Hyōbankishū*, ed. Tenri Toshokan Zanhon Sosho, volume 11 (Tokyo: Yagishoten, 1973) 1–10. Noma explains the publication history, style, and contents of the early reviews. He suggests there might have been an earlier publication in 1642.
25. Gunji Masakatsu, interview.
26. Matsuzaki Hitoshi, "Yarō Hyōbanki," *Kabuki Jiten* 398.
27. Gunji Masakatsu, *Kabuki no Katachi, Gunji Masakatsu Santeishū*, volume 2 202–206.
28. In an earlier version of the play, the onnagata role was a young *keisei*, a *yūjo* role type, who becomes possessed. In the contemporary version, the main role is a young female court class person, a *koshō*, which is like a court-class *musume* role type.
29. Earle Ernst, *The Kabuki Theatre* 171.
30. Bandō Tamasaburō V, interview.

31. Jennifer Robertson, "The Shingaku Woman: Straight from the Heart" 106–107. See Robertson's conclusion on relationship of the experiences of real women in the Edo Period and the idealized female-likeness of kabuki onnagata.

32. Adachi Naoru, *Kabuki Onnagata Gekijō Fūzoku Saiken* 203–204.

33. Gunji Masakatsu, *Odori no Bigaku* 96–97. Note Gunji's description of changes early onnagata made in costumes that changed their physical shape. The widening of the *obi*, and lengthening of the sleeves were among the first gender acts that onnagata invented to differentiate their female-like *yakugara*.

34. Gunji Masakatsu, interview. Hattori Yukio, interview. Hattori Yukio, *Hengeron: Kabuki no Seishinshi* (Tokyo: Heibonsha, 1975) 55–60, 61–96. See Hattori's discussion of transformation dance aesthetics, techniques, and spiritual connections in early kabuki history.

35. Hattori Yukio, interview.

36. Iwai Hanshirō VIII qtd. in Watanabe Tamotsu, *Onnagata Hyakushi* 149.

37. Gunji Masakatsu, *Odori no Bigaku* 90–92. Gunji explains the connections between the ghost dances, transformation dances, and onnagata. See "The Hengemono Period" section, pp. 106–112 for further explanation of transformation dances.

38. The *suppon* is a lift located at the seven–three position near the main stage on the *hanamichi*. A *suppon* entrance, with dry ice smoke, is largely reserved for supernatural beings.

39. Sumizome of *Seki no To* (The Barrier Gate), Oiwa of *Yotsuyakaidan* (The Ghost of Yotsuya), or Kasane of *Kasane* (Kasane) are other examples of characters in states of disarray and transformation that make their yakugara acts ambiguous.

40. Gunji Masakatsu, *Odori no Bigaku* 275–281. "Hengemono," and "Masakado," Gunji Masakatsu, *Nihon Buyō Jiten* (Tokyo: Tokyodo Shuppan, 1977) 366–367, 381–382.

41. In April 1996, at the Kabuki-Za, Nakamura Ganjirō III, in *Kuzu no Ha Kowakare* (Kuzu no Ha's Child Separation), performed three roles: the Princess Kuzu no Ha role, the fox disguised as the wife Kuzu no Ha role, and the fox role partially disguised as the wife Kuzu no Ha role. The changes from the princess to wife roles were done offstage, but minutes apart, requiring the performer to switch immediately between two sets of *yakugara* gender acts. In the wife role, he gradually let the fox-like acts appear and grow gradually stronger, until the final transformation into the fox spirit in the final dance scene. First produced in 1734, *Kuzu no Ha* is part of the onnagata transformation legacy.

42. Please note there were many other contributing factors to the diversification of *yakugara*, like play types, new plays, styles of production, troupe organization, public taste, and so forth.

43. Onnagata spoke of these roles using *keisei* or *yūjo* interchangeably. However, *keisei* refers to a *yūjo* of high status, while *yūjo* is a generic term for all ranks and types. I use *yūjo* as the general classification following Watanabe Tamotsu's role type divisions. The term for the *yūjo* role type has its own

performative etymology. The Chinese character for *yū* may also be read as *asobi* which means variously to play, amuse, or entertain, and is a central concept in artistic pursuits in Japanese culture. *Jo* is one of the readings for the Chinese character for *onna*. Both can mean female or woman. There is also an association of *asobi* (play) of the gods, which was both spiritual and physical. *Yūjo* could mean "play female" or "female of pleasure" where "pleasure" is a mixture of physical, aesthetic, and spiritual delight and desire.

44. Nakamura Tokizō V, interview. Nakamura Shikan VII, interview. Onoe Baikō VII, interview.

45. Tobe Ginsaku, "Onnagata no Gihō to Seishin" 149–150. In my dissertation I limit my argument to the stage gender acts, and do not propose to prove their reverberations in the social world of Edo or contemporary kabuki.

46. Furuido Hideo, interview.

47. Bandō Tamasaburō, interview.

48. Nakamura Jakuemon IV, interview. Bandō Tamasaburō V, interview.

49. Furuido Hideo, interview.

50. Tsuda Noritake, *Handbook of Japanese Art* (Tokyo: Tuttle, 1976) 410–411. See pp. 451–452 for pictures of Kannon, a goddess-like figure whose crown of rays is similar to the *bodhisattva* style spoken of here.

51. Watanabe Tamotsu, interview.

52. In case there is any problem with the use of this term, as I have stated in chapter 2 of this book, my use of the term "female-likeness" is particular to this text. It describes the fictional gender role produced by onnagata performing their gender acts. It does not mean that an onnagata is trying to imitate a woman, that is, to be like a certain woman. The onnagata "fiction of female-likeness" is a doubled invention: first "female" is constructed within each specific culture. It follows that something that is "like" the constructed "female" is yet another construction made out of the first. The referent for "likeness" is not a woman but the constructed "female." I wish to keep the ambivalent feeling that the term "likeness" has: it is not any one thing completely, and its "likeness" to something can be anywhere on a scale from vaguely to explicitly and beyond.

53. While actors and playwrights created roles and worlds that required different kinds of performance, the *jinkō no bi* aesthetic itself also shaped a style of performing and appearing on stage.

54. I realize that this is a paradox, but I think that fashion of any era, in a sense, covers to reveal. That is, the more covered and manipulated the body's exterior, the more ambiguous and transformative the body beneath becomes.

55. Watanabe Tamotsu, *Onnagata Hyakushi* 16.

56. Watanabe Tamotsu, *Onnagata Hyakushi* 59.

57. Watanabe Tamotsu, *Onnagata Hyakushi* 16. It could be argued these examples reflect a late kabuki decadence, but here I am discussing them from the point of view of the contemporary performance of onnagata *yakugara*.

58. Watanabe Tamotsu, *Onnagata Hyakushi* 58.

59. Watanabe Tamotsu, *Onnagata Hyakushi* 171–172.

60. Within the licensed quarters like the Yoshiwara of Edo, female *yūjo* had their own system of hierarchy but, unlike onnagata, they were physically trapped by their owners. The authorities kept them in their quarters by creating an economy that forced the expenditure of their earnings. Enforced expenditures such as kimono, bedding, entourage, and so forth, were mandatory for a *yūjo* to keep up her ranking and status and kept her poor. Cecilia Segawa Seigle, *Yoshiwara* 78–80.

61. Watanabe Tamotsu, *Onnagata Hyakushi* 14–15.

62. Cecilia Segawa Seigle, *Yoshiwara* 61–67.

63. Movement to lyrical singing or chanting was a performance technique assimilated from the doll puppet theatre and other earlier forms of chanting and dance performance.

64. *Kurozuka* means "black mound" but here refers to a place name.

65. Note that most of these lover sequences are in the Kamigata style plays where the male gender role is performed in the *wagoto* style. However, I think that my argument is still valid: in *nureba* sequences, the gender acts of onnagata and tachiyaku appear similar and ambiguously gendered.

66. Nakamura Shikan VII, interview.

67. Fujinami Kodōgu Inc., storehouse tour and lecture, Asakusa, Tokyo, 1996.

68. This scene, called the *Yoshinoyama Michiyuki* (Travel Dance through the Yoshino Mountains), is famous for its special *iroke*. I think it also demonstrates Watanabe's *ura* and *omote* theory of the beauty of the *yūjo* role type and onnagata aesthetics. For a description, see Aubrey S. and Giovanna M. Halford, *The Kabuki Handbook* (1956; Tokyo: Charles E. Tuttle, 1981) 369–370.

69. See chapter 3 on *wakashu* and *yūjo* kabuki.

70. Judith Butler, *Gender Trouble* 141.

71. Jill Dolan, "Geographies of Learning" 433; Jennifer Robertson, "Gender-Bending in Paradise: Doing 'Female' and 'Male' in Japan" 51.

Chapter 9 Toward a New Alchemy of Gender, Sex, and Sexuality

1. For clarity in this final chapter, I will again give the English translation for some terms I have already used substantially throughout the text.

2. Hirosue Tamotsu, *The Secret Ritual of the Place of Evil* 7.

3. Laurence R. Kominz, *The Stars Who Created Kabuki: Their Lives, Loves and Legacy* (Tokyo: Kodansha, 1997) 257.

4. Laurence R. Kominz, *The Stars Who Created Kabuki* 183.

5. Laurence R. Kominz, *The Stars Who Created Kabuki* 181–223, 250–261.

6. Judith Butler, *Gender Trouble* 134.

7. Here "played" is not used in a derogatory manner, but refers to the Japanese term *asobi*, which can mean "play" or "pleasuring" or "entertainments."

8. Onoe Baikō VII, interview.

9. Sawamura Tanosuke VI, interview.

10. Judith Butler, *Gender Trouble* 141.

11. Judith Butler, *Gender Trouble* 141.

12. Terayama Shūji, "Onnagata no Kebukasa ni tsuite," "Kabuki: Barokisumu no Hikari to Kage," *Kokubungaku*, June special edition, 20.8 (1975): 100.

13. Gunji Masakatsu and Nakamura Utaemon, "Taidan: Kabuki to Gei no aida," "Kabuki: Barokisumu no Hikari to Kage," *Kokubungaku*, June special edition, 20.8 (1975): 20.

14. Onoe Kikuzō VI, personal interview, Tokyo, 1993.

15. Judith Butler, *Gender Trouble* 141.

16. Judith Butler, *Gender Trouble* 139.

17. Judith Butler, *Gender Trouble* 139.

18. Judith Butler, *Gender Trouble* 141.

19. Bandō Tamasaburō V, interview.

20. Kathy Foley, Final Address, Mythic Dimensions Conference, University of California, Santa Cruz, 19 April 1997.

21. Bandō Tamasaburō V, Onoe Baikō VII, Sawamura Tanosuke VI, personal interviews.

BIBLIOGRAPHY

Adachi Naorō. *Edojidai Geidō no Fūzokushi*. Tokyo: Tenbōsha, 1976.

———. *Kabuki Gekijō Onnagata Fūzoku Saiken*. Tokyo: Tenbōsha, 1976.

Asahi Earphone Guide Service, Tokyo: 1990–1993.

Baba Masashi. *Onna no Serifu*. Tokyo: NHK Books, Nihon Hoshoshuppan Kyokai, 1992.

Bandō Tamasaburō. Personal interview. Tokyo. January 1993.

Bernstein, Gail Lee, ed. *Recreating Japanese Women, 1600–1945*. Berkeley: University of California Press, 1991.

Blau, Herbert. "Ideology and Performance." *Theatre Journal* 35 (1983): 441–460.

Bowers, Faubion. *Japanese Theatre*. 1952. New York: Hill and Wang, 1959.

Brandon, James R., trans. and comm. *Kabuki, Five Classic Plays*. Cambridge: Harvard University Press, 1975.

———. "Form in Kabuki Acting." *Studies in Kabuki: Its Acting, Music, and Historical Context*. Ed. James R. Brandon, William P. Malm, Donald H. Shively. 1978. Honolulu: University of Hawaii Press, 1979. 63–113.

———. Lecture. University of Hawaii, Honolulu. March 1989.

———, ed. *The Cambridge Guide to Asian Theatre*. Cambridge: Cambridge University Press, 1993.

Butler, Judith. *Gender Trouble*. New York: Routledge, 1990.

———. "Performative Acts and Gender Constitution: An Essay in Phenomenology and Feminist Theory." *Performing Feminisms*. Ed. Sue-Ellen Case. Baltimore: Johns Hopkins University Press, 1990. 270–282.

———. "Imitation and Gender Insubordination," *Inside/Out, Lesbian Theories, Gay Theories*. Ed. Diana Fuss. New York: Routledge, 1991. 13–31.

———. *Bodies that Matter*. New York: Routledge, 1993.

Carlson, Marvin. *Performance, A Critical Introduction*. New York: Routledge, 1996.

Case, Sue-Ellen. "Classic Drag: The Greek Creation of Female Parts." *Theatre Journal* 37 (1985): 317–328.

———. *Feminism and Theatre*. New York: Methuen, 1988.

Cavaye, Ronald. *Kabuki, A Pocket Guide*. Phot. Tomoko Ogawa. Tokyo: Charles E. Tuttle Company, 1993.

Clark, Timothy T., Osamu Ueda, and Donald Jenkins. *The Actor's Image: Print Makers of the Katsukawa School*. Ed. Naomi Noble Richard. Chicago: The Art Institute of Chicago, 1994.

Dalby, Liza Crihfield. *Kimono, Fashioning Culture*. New Haven: Yale University Press, 1993.

de Lauretis, Teresa. *Technologies of Gender*. Bloomington: Indiana University Press, 1987.

Doane, Mary Ann. "Film and the Masquerade: Theorizing the Female Spectator," *The Sexual Subject*, Screen. New York: Routledge, 1992. 227–243.

Dolan, Jill. "Gender Impersonation Onstage." *Gender in Performance*. Ed. Laurence Senelick. Hanover: University of New England Press, 1992. 3–13.

————. "Geographies of Learning: Theatre Studies, Performance, and the 'Performative,' " *Theatre Journal* 45 (1993): 417–441.

Domoto Masaki. *Danshoku Engekishi*. Tokyo: Shupposha, 1976.

Domoto Yatarō. *Kamigata Engekishi*. Tokyo: Shun'yodo, 1944.

Dunn, Charles J. and Torigoe Bunzō, eds. and trans. *The Actor's Analects*. Tokyo: University of Tokyo Press, 1969; New York: Columbia University Press, 1969.

Durham, Valerie. "Evil Women in *Kabuki*: The *Akuba* Role Type." Unpublished paper. Tokyo Keizai University. n.d. 1–12.

————. "Meiji Shoki no Dokufumono ni okeru Akujozokei no retorikku. (sono ni)" *Tokyo Keizai Daigaku Jinbun Shizenkagaku Ronshu*. 88 (July 1991): 108–190.

"Edo no Sui ga Ikizuku: Kabuki Onnagata no Adesugata." *Meiryū*. October 1991: 4–22.

Engekikai Editorial Board. "Hassei Iwai Hanshirō." *Hyakunin no Kabuki*. July 1995: 30+.

Epstein, Julia and Kristina Straub, eds. *Body Guards: The Cultural Politics of Gender Ambiguity*. New York: Routledge, 1991.

Ernst, Earle. *The Kabuki Theatre*. 1956. Honolulu: The University Press of Hawaii, 1974.

Foley, Kathy. Final Address. Mythic Dimensions Conference. University of California Santa Cruz. Santa Cruz. 19 April 1997.

Fujima Toshinami. Lecture. ITI Nihon Buyō Workshop. Tokyo. August 1992.

Fujita Hiroshi. *Onnagata no Keizu*. Tokyo: Shindokushosha, 1970.

————. Lectures. NHK Kabuki Lecture Series. NHK Centre Tokyo. October–May 1992–1993.

————. Personal interview. Tokyo. March 1993.

Furuido Hideo. Personal interview. Tokyo. May 1993; January 1995.

Gaines, Jane. "Costume and Narrative: How Dress Tells the Woman's Story." *Fabrications: Costume and the Female Body*. Ed. Jane Gaines and Charlotte Herzog. New York: Routledge, 1990. 180–211.

Gluck, Carol. "The Past in the Present," *Postwar Japan as History*. Ed. Andrew Gordon. Berkeley: University of California Press, 1993. 64–95.

Gunji Masakatsu. *Kabuki to Yoshiwara*. Tokyo: Asahi Shobo, 1956.

————. *Odori no Bigaku*. Tokyo: Engeki Shuppansha, 1957.

————. *Kabuki no Bigaku*. Tokyo: Engeki Shuppansha, 1963.

Gunji Masakatsu et al., ed. and comm. *Meisaku Kabuki Zenshū*. 25 volumes to date. Tokyo: Sōgen Shinsha, 1968–.

————, ed. and comm. *Seki no To. Buyōgekishū*. *Meisaku Kabuki Zenshū*. Volume 19. Tokyo: Sogen Shinsha, 1970. 58–72.

————. *Nihon Buyō Jiten.* Tokyo: Tokyodo Shuppan, 1977.

————, ed. and comm. *Kabuki Meiyū Jidai, Butai Shashin: Taishō kara Shōwa e.* Photo. Mitsui Takanaru. Tokyo: Nigensha, 1988.

————. "The Development of Kabuki." Trans. Andrew L. Markus. *Tokugawa Japan: The Social and Economic Antecedents of Modern Japan.* Ed. Chie Nakane and Shinsaburo Oishi. Tokyo: University of Tokyo Press, 1990. 192–212.

————. *The Kabuki Guide.* Photo. Yoshida Chiaki. Trans. Christopher Holmes. 1987. Tokyo: Kodansha International Ltd., 1990.

————. *Kabuki Nyūmon.* Tokyo: Bokuyōsha, 1990.

————. "Kabuki Wa Ikinokoreru ka." Special Edition. "Theatre—Romanticism on the Scene." Presented by Atelier Peyotl. *Yasō* 28 (1991). 180–193.

————. *Gunji Masakatsu Santeishū.* 6 volumes Tokyo: Hakusuisha, 1991.

————. Personal interview. Tokyo. September 1992; May 1993; June 1993; May 1995; June 1995.

————. "Nikutai no Bi." The Body in Asia Forum. Space Zero, Tokyo. 5 March 1993.

————. *Gunji Masakatsu Gekihyōshū.* Tokyo: Engeki Shuppansha, 1995.

Gunji Masakatsu and Nakamura Utaemon. "Taidan: Kabuki to Gei no aida." "Kabuki: Barokisumu no Hikari to Kage." *Kokubungaku.* June special edition. 20.8 (1975): 6–24.

Halford, Aubrey S. and Giovanna M. *The Kabuki Handbook.* 1956; Tokyo: Charles E. Tuttle, 1981.

Halperin, David M. "Historicizing the Sexual Body: Sexual Preferences and Erotic Identities in the Pseudo-Lucianic *Erotes.*" *Discourses of Sexuality: From Aristotle to Aids.* Ed. Donna C. Stanton. Ann Arbor: University of Michigan Press, 1992. 236–261.

Hanayagi Chiyō. *Nihon Buyō no Kiso.* Tokyo: Toko Shoseki, 1981.

Hasegawa Yukio. *Onnagata no Kenkyū.* Tokyo: Ritsumeikan Shuppanbu, 1931.

Hattori Yukio. *Zankoku no Bi.* Trans. Frank Hoff. Tokyo: Hōgashoten, 1970.

————. "Kabuki: Kōzō no Keisei." *Nihon no Koten Geinō*: Kabuki. Ed. Geinoshi Kenkyukai. Volumes 8 Tokyo: Heibonsha, 1971. 7–85.

————. *Hengeron: Kabuki no Seishinshi.* Tokyo: Heibonsha, 1975.

————. *Edo Kabuki.* Tokyo: Iwanami Shoten, 1993.

————. *Edo no Shibai-e o Yomu.* Tokyo: Kodansha, 1993.

————. Personal interview. Tokyo. June 1993.

Hirosue Tamotsu, ed. *Akubashō no Hassō.* Tokyo: Sanseido, 1970.

————. "The Secret Ritual of the Place of Evil." Trans. David G. Goodman. *Concerned Theatre Japan.* Volume 2. nos. 1–2. Tokyo, Japan 1971.

————, ed. *Sakurahime Azuma Bunshō.* Kabuki On-stage. Volume 5. Tokyo: Hakusuisha, 1990.

Ichikawa Ennosuke. *Ennosuke no Kabuki Kōza.* Tokyo: Shinchosha, 1984.

————. Personal interview. Tokyo. March 1993.

Ihara Toshirō. *Kinsei Nihon Engekishi.* 4th ed. Tokyo: Waseda Shuppanbu, 1927.

————, ed. *Kabuki Nempyō.* 8 volumes. 1956. Revised edition. Kawatake Shigetoshi and Yoshida Teruji. Tokyo: Iwanami Shoten, 1973.

————. *Meiji Engekishi.* Tokyo: Ho Shuppansha, 1975.

Imao Tetsuya. *Henshin no Shisō.* Tokyo: Hosei Daigakukyoku. 1970.

Imao Tetsuji. " 'Onnagata Hiden' to Kikunojō no Ishiki." *Engekigaku*. 1 (1958): 52–57.

Inoura Yoshinobu. *A History of Japanese Theatre I: Noh and Kyogen*. Yokohama: Kokusai Bunka Shinkokai, 1971.

Ishii Tatsurō. *Issei no Sexuality*. Tokyo: Shinjuku Shobo, 1991.

Jenkins, Ronald, comm. and curator. *The Floating World Revisited*. Portland: Portland Art Museum, 1993.

Jones, Ann Rosalind and Peter Stallybass. "Fetishizing Gender: Constructing the Hermaphrodite in Renaissance Europe." *Body Guards: The Cultural Politics of Gender Ambiguity*. Ed. Julia Epstein and Kristina Straub. New York: Routledge, 1991. 80–111.

Kabuki Hyōbanki Kenkyūkai. *Kabuki Hyōbanki Shusei*. 1st Period. 10 volumes 1 Index. Tokyo: Iwanami Shoten, 1972.

———. *Kabuki Hyōbanki Shūsei*. 2nd Period. 10 volumes. Tokyo: Iwanami Shoten, 1987.

Kabuki Costume Lecture Demonstration. Kabuki no Ki Meeting. Tokyo. April 1993.

Kagayama Naozo. *Kabuki no Kata*. Tokyo: Sogensha, 1957.

Kaibara Ekken. "Onna Daigaku." 1672. Trans. Professor Basil Hall Chamberlain. *Women and Wisdom of Japan*. Comm. Takaishi Shingorō. 1905. London: John Murray, 1914. 33–46.

Kanezawa Yasutaka. *Kabuki Meisaku Jiten*. Tokyo: Seiabō, 1959. 129–130.

Kataoka Hidetarō II. Personal interview. Tokyo. November 1992.

Kawatake Mokuami. *Kochiyama to Naozamurai*. *Meisaku Kabuki Zenshū* Ed. and comm. Kawatake Toshio. Volume 11. Tokyo: Sogensha, 1969. 281–380.

———. *Naozamurai*. Trans. and comm. Samuel L. Leiter. *The Art of Kabuki: Famous Plays in Performance*. Samuel L. Leiter. Berkeley: University of California Press, 1979. 205–254.

Kawatake Shigetoshi. *Nihon Engeki Zenshi*. Tokyo: Iwanami Shoten, 1959.

Kawatake Toshio. "Binan no Keifu." *Kabuki Kikanzashi*. 8.2.30. (1 October 1975): 48–61.

———, comm. and notes. *Kabuki Ehon Juhachiban* (Danjūrō's Lucky Eighteen). Trans. Helen V. Kay. Photo. Iwata Akira. San Francisco: Chronicle Books, 1984.

———. *Kabuki: Sono Bi to Rekishi*. Tokyo: Nihon Geijutsu Bunka Shinkokai, 1992.

———. Kabuki History and Performance Lecture. ITI Kabuki Workshop. The National Theatre, Tokyo, August 1993.

Kenkyusha's New Japanese-English Dictionary. Ed. Shinmura Izuru. 4th. ed. Tokyo: Kenkyusha, 1974.

Kōjien. Ed. Masuda Koh. 3rd. ed. Tokyo: Iwanami Shoten, 1988.

Kominz, Laurence R. *The Stars Who Created Kabuki: Their Lives, Loves and Legacy*. Tokyo: Kodansha, 1997.

Komiya Toyotaka, ed. *Japanese Music and Drama in the Meiji Era*. Trans. Edward G. Seidensticker and Donald Keene. Tokyo: Obunsha, 1956.

Leiter, Samuel L. *Kabuki Enclyclopedia, An English Language Adaptation of Kabuki Jiten*. Westport: Greenwood Press, 1979.

———, trans. and comm. *The Art of Kabuki: Famous Plays in Performance*. Berkeley: University of California Press, 1979.

————. *New Kabuki Encylopedia, A Revised Adaptation of Kabuki Jiten*. Westport: Greenwood Press, 1997.

Leupp, Gary P. *Male Colors: The Construction of Homosexuality in Tokugawa Japan*. Berkeley: University of California Press, 1995.

Link, Howard A. comm. and curator. *The Theatrical Prints of the Torii Masters*. Tokyo: Charles E. Tuttle, 1977.

Malm, William. "Music in the Kabuki Theatre." *Studies in Kabuki: Its Acting, Music, and Historical Context*. Ed. James R. Brandon, William P. Malm, and Donald H. Shively. 1978. Honolulu: University of Hawaii Press, 1979. 133–175.

Matsuda Osamu. "Kabuki to Gensōsei," *Rising* No. 12 March 1989: 54+.

Matsuda Seifu. *Kabuki no Katsura*. Tokyo: Engeki Shuppasha, 1959.

Matsumoto Shinko. *Meiji Zenshii Engeki Ronbun*. Tokyo: Engeki Shuppansha, 1974.

Maya Kyoko. *Watashi no Utaemon*. Tokyo: PMC, 1990.

Miura Hirō. Personal interview. Tokyo. February 1993.

Mizuochi Kiyoshi. *Edo no Kyaria Ū-man: Kabuki Shukujoroku*. Tokyo: Kamakura Shobo, 1989.

————. *Kamigata Kabuki*. Tokyo: Tokyo Shoseki, 1990.

————. *Heisei Kabuki Haiyūron*. Tokyo: Engeki Shuppansha, 1992.

————. Personal interview. Tokyo. May 1992.

Moriya Takeshi. *Kinsei Geinō Kōgyōshi no Kenkyū*. Tokyo: Kōbundō, 1985.

Nakamura Fukusuke IX. Personal interview. Tokyo. June 1992.

Nakamura Ganjirō III. "Beni to Oshiroi." *Gei no Kokoro*. Ed. Fujio Shinichi. Tokyo: Sanichi Shobo, 1977. 142–153.

————. Personal interview. Tokyo. August 1992; May 1994.

Nakamura Jakuemon IV and Kamoji Torao. "Katsura (1) Tokoyama to Onnagata." *Gei no Kokoro*. Ed. Fujio Shinichi. Tokyo: Sanichi Shobo, 1977. 167–177.

Nakamura Jakuemon IV. Personal interview. Tokyo. November 1992; March 1993.

Nakamura Matagorō II. Personal interview. Tokyo. December 1991.

————. Lectures. National Theatre Kabuki Training Program. Tokyo. 1991–1992.

————. Lectures. Kabuki Workshop for Foreigners. ITI (International Theatre Institute) Tokyo. August 1993.

Nakamura Matsue V. Personal interview. Tokyo. April 1992.

Nakamura Tokizō V. Personal interview. Tokyo. February 1992.

Nakamura Shibajaku VII. Personal interview. Tokyo. May 1992.

Nakamura Shikan VII. Personal interview. Tokyo. October 1992.

Nakamura Utaemon V. *Kabuki no Kata: Kaigyoku Yawa*. Tokyo: Bunkoku Shobo, 1950.

The National Theatre of Japan, ed. *Kabuki no Ishō*. Tokyo: Fujin Gahōsha, 1974.

Nishikata Setsuko. *Nihon Buyō no Sekai*. Tokyo: Kodansha, 1988.

Nohara Akira. *Heisei no Kabuki*. Tokyo: Maruzen, 1994.

Nojima Jusaburō, ed. *Kabuki Jinmei Jiten*. Tokyo: Nichigai Associates, Inc., 1988.

Nolte, Sharon H. and Sally Ann Hastings. "The Meiji State's Policy Toward Women." *Recreating Japanese Women, 1600–1945*. Ed. Gail Lee Bernstein. Berkeley: University of California Press, 1991. 151–174.

Nomura Mansaku. Class lecture. University of Hawai'i, Honolulu. March 1988.

Noma Mitsuyoshi. Introduction. *Yūjo Hyōbankishū*. Ed. Tenri Toshokan Zanhon Sosho. Volume 11. Tokyo: Yagishoten, 1973. 1–29.

Ohara Rieko. *Kurokami no Bunkashi*. 1988. Tokyo: Tsukiji Shokan, 1992.

Onoe Baikō VI. *Onnagata no Geidan*. Tokyo: Engeki Shuppansha, 1988.

Onoe Baikō VII. Personal interview. Tokyo. January1992.

Onoe Kikugorō VII. Personal interview. Tokyo. February 1993.

Onoe Kikuzō VI. Personal interview. Tokyo. May 1993.

Ooms, Herman. "The Struggle for Status: Lower and Non-Status Groups in Tokugawa Japan." Conference on "Down-and-Out Status Groups in Tokugawa Japan." UCLA Center for Japanese Studies, Los Angeles. 25 January 1997.

Ortolani, Benito. *The Japanese Theatre*. Revised edition. Princeton: Princeton University Press, 1990.

Oshima, Mark. "The Keisei as a Meeting Point of Different Worlds: Courtesan and the Kabuki *Onnagata*." *The Women of the Pleasure Quarters*. Ed. Elizabeth de Sabato Swinton. Worcester: Worcester Art Museum, 1995. 86–105.

Ōzasa Yoshio. *Nihon Gendai Engekishi: Meiji—Taishō hen*. 1985. Tokyo: Hakusui, 1990.

Phelan, Peggy. *Unmarked*. London: Routledge, 1993.

Pronko, Leonard C. *Theatre East and West*. Berkeley: University of California Press, 1967.

———. Lecture Demonstration. "Onnagata Constuction and Performance: *Masakado*." Asst. Takao Tomono. When Art Became Fashion: Kosode in Edo-Period Japan. Exhibition and Conference. Los Angeles County Museum of Art, Los Angeles. 16 November 1992.

———. Personal interview. Tokyo. March 1992.

Raz, Jacob. *Audience and Actors: A Study of their Interaction in Japanese Traditional Theatre*. Leiden: Brill, 1983.

Robertson, Jennifer. "Gender-Bending in Paradise: Doing 'Female' and 'Male' in Japan," *Genders* Number 5 (Summer 1989): 51.

———. "The Shingaku Woman: Straight from the Heart," *Recreating Japanese Women, 1600–1945* Ed. Gail Lee Bernstein. Berkeley: University of California Press, 1991. 88–107.

———. "The 'Magic If': Takarazuka Revue of Japan," *Gender in Performance*. Ed. Laurence Senelick. Hanover: University of New England Press, 1992. 46–67.

———. "The Politics of Androgyny in Japan: Sexuality and Subversion in the Theater and Beyond," *American Ethnologist*. Volume 19 Number 3 (August 1992): 420.

Said, Edward W. *Orientalism*. New York: Vintage Books, 1979.

Saikaku Ihara. *The Great Mirror of Male Love*. Trans. Paul Goodman Schalow. Stanford: Stanford University Press, 1990.

Sasai Eisuke and Konno Hironobu. "Sarasara yukitai," Special edition. "Theatre—Romanticism on the Scene." Presented by Atelier Peyotl. *Yasō* 28 (1991). 167–179.

Sasai Eisuke. Personal interview. Tokyo. April 1993.

Sato Moyako. *Sawamura Gennosuke*. Tokyo: Kofusha Shoten, 1974.

Sawamura Tanosuke VI. Personal interview. Tokyo. March 1991.

———. Lectures. National Theatre Kabuki Training Program. Tokyo. 1991–1992.

Scott, A.C. *The Kabuki Theatre of Japan*. 1955. New York: Collier Books, 1966.

Secor, James Leo. *Kabuki and Morals: The "Onnagata" Heroine as Ethical Example in the Late 18th Century*. Diss. 1987. Ann Arbor: University of Michigan Press, 1989.

Seigle, Cecilia Segawa. *Yoshiwara: The Glittering World of the Japanese Courtesan*. Honolulu: University of Hawaii Press, 1993.

Shaver, Ruth. *Kabuki Costume*. Tokyo: Tuttle, 1966.

Shibayama Hajime. *Edo Danshokukō*. Tokyo: Hihyosha, 1992.

Shimonaka Hiroshi, ed. *Kabuki Jiten*. 1983. Tokyo: Heibonsha, 1991.

Shively, Donald H. "The Social Environment of Tokugawa Kabuki." *Studies in Kabuki: Its Acting, Music, and Historical Context*. Ed. James R. Brandon, William P. Malm, and Donald H. Shively. 1978. Honolulu: University of Hawaii Press, 1979. 1–61.

Shōchiku Co, Ltd. *Grand Kabuki Overseas Tours 1928–1993*. Tokyo: Shochiku, 1994.

Sievers, Sharon L. *Flowers in Salt: The Beginnings of Feminist Consciousness in Modern Japan*. Stanford: Stanford University Press, 1983.

Stallybass, Peter. "Transvestism and the 'Body Beneath'." *Erotic Politics: Desire on the Renaissance Stage*. Ed. Susan Zimmerman. London: Routledge, 1992. 64–83.

Studlar, Gaylyn. "Masochism, Masquerade, and the Erotic Metamorphoses of Marlene Dietrich." *Fabrications: Costume and the Female Body*. Ed. Jane Gaines and Charlotte Herzog. New York: Routledge, 1990. 229–249.

Suwa Haruo. "Kamigata Wagoto no Nimaime." *Kabuki Kikanzashi* 30 (10 October 1975): 82–93.

———. *Kabuki no Hōhō*. Tokyo: Benseisha, 1991.

Takahashi, Hiroko. *Sandaime Utaemon no Onnagata Gei*. Tokyo: Sangetsushobo, 1993.

Takechi Tetsuji. *Takechi Kabuki*. Tokyo: Bungei Shunju Shinsha, 1955.

———. *Dentō Engeki no Hassō*. Tokyo: Hagashoten, 1967.

Takechi Tetsuji and Nakamura Senjaku. Recorded discussion. "Takechi Kabuki to Chikamatsuza." *Nakamura Senjaku Shashinshū: Kamigata no Onnagata to Chikamatsu*. Photo.Yoshida Chiaki. Ed. Saito Tomoko, Iwata Akira. Tokyo: Koyoshobo, 1984. 63–86.

Tenri Toshokan Zanhon Sosho, ed. *Yūjo Hyobankishu*. Volume 11. Tokyo: Yagishoten, 1973.

Terayama Shūji. "Onnagata no Kebukasa Ni Tsuite." "Kabuki: Barokisumu no Hikari to Kage." *Kokubungaku*. June special edition. 20.8 (1975): 99–101.

Tobe Ginsaku. "Onnagata no Gihō to Seishin." *Kabuki*. Kikanzasshi. 12 (1 April 1971): 138–160.

Toita Yasuji. *Rokudaime Kikugorō*. Tokyo: Engeki Shuppansha, 1956.

———. *Onnagata no Subete*. Tokyo: Shinshindo, 1990.

Toita Yasuji, ed. and comm. *Kuruwa Bunshō*. *Meisaku Kabuki Zenshū*. Volume 7. Tokyo: Sogen Shinsha, 1969. 281–380.

Tominaga Heibee. *Gei Kagami*. *The Actor's Analects*. Trans. and ed. Charles Dunn and Torigoe Bunzō. 1969; Tokyo: University of Tokyo Press; New York: Columbia University Press, 1969. English 38–48. Japanese 299–292.

Torigoe Bunzō. *Genroku Kabukikō*. Tokyo: Yagi Shobo, 1991.

———. "Kabuki Onnagata no Seiritsu to Kansei." *Meiryu*. October 1991: 16–17.

———. Personal interview. Tokyo. March 1993.

Trinh T. Minh-ha. "Not You/Like You: Post-Colonial Women and the Interlocking Questions of Identity and Difference." *Making Face, Making Soul: Haciendo Caras*. Ed. Gloria Anzaldua. San Francisco: Aunt Lute Foundation, 1990. 371–375.

———. Lectures. "Postcoloniality and Its Tools." University of California, Berkeley. Fall 2003.

Tsuchiya Keiichirō. *Genroku Haiyūden*. Tokyo: Iwanami Shoten, 1991.

Tsukada Takashi. "Stratified and Composite Social Groups in Tokugawa Society." Conference on "Down-and-Out Status Groups in Tokugawa Japan." UCLA Center for Japanese Studies, Los Angeles. 25 January 1997.

Uehara Teruo. "Geidan ni Miru." *Kabuki Kikanzashi* 19 (1 January 1973): 36–43.

Uehara Teruo. "Onnagata Geidan Tsunagi Kangae." *Kabuki*. Kikanzasshi. 7.1 (1974): 50+.

Waseda Daigaku Tsubouchi Hakase Kinen Engeki Hakubutsukan, ed. *Engeki Hyakka Daijiten*. 6 volumes 1960. Tokyo: Heibonsha, 1983.

Washida Seiichi. "The Meaning of Costuming: Dance and Fashion." Buyō Gakkai. Ritsumeikan University, Kyoto, Japan. 18 May 1996.

Watanabe Tamotsu. *Kabuki ni Joyū o*. Tokyo: Bokushoten, 1965.

———. *Onnagata Hyakushi*. Tokyo: Seiabo, 1978.

———. "Naze 'Onnagata' na no ka?" *Bungei Shunjū* Deluxe #9 September 1979: 91–97.

———. *Kabuki Techo*. Tokyo: Shinshindo, 1982.

———. *Kabuki no Yakushatachi*. Tokyo: Shinshindo, 1983.

———. *Musume Dōjōji*. Revised 1st edition 1986. Tokyo: Shinshindo, 1992.

———. *Onnagata no Unmei*. Tokyo: Chikuma Shobo, 1991.

———. Personal interview. Tokyo. November 1992.

———. Lectures. NHK Kabuki Lecture Series. Tokyo. 1992–1993.

———. *Kabuki Handobukku*. Tokyo: Shinshokan, 1993.

———. *Kabuki Gekihyō*. Tokyo: Asahi Shinbunsha, 1994.

Watanabe Tsuneo and Iwata Jun'ichi. *The Love of the Samurai, A Thousand Years of Japanese Homosexuality*. Trans. D.R. Roberts. London: GMP Publishers Ltd., 1989.

Yoshida Chiaki, photo. and comm. *Kabuki: The Japan Times Photo Book*. Tokyo: The Japan Times, Ltd., 1971.

Yoshizawa Ayame I. *Ayamegusa*. Rec. by Fukuoka Yagoshirō. *The Actor's Analects*. *Yakusha Rongō*. Trans. and ed. Charles J. Dunn and Torigoe Bunzō. 1969; Tokyo: University of Tokyo Press; New York: Columbia University Press, 1969. English 49–66. Japanese 291–275.

GLOSSARY

Major Terms and Expressions

aimai	曖昧	ambiguity
akuba	悪婆	evil female role type
aragoto	荒事	wild style
baba	婆	old woman, grandmother role
bakufu	幕府	Tokugawa governing body
bishōnen	美少年	beautiful boy or youth
—no bi	美少の美	beauty of male youth
bin	鬢	flared side-locks of the wig or hair
bōshi	帽子	forehead scarf
bugaku	舞楽	court dances
bushidō	武士道	way of the samurai
butaiko	舞台子	stage child
chaya asobi	茶屋遊び	entertainments associated with prostitute procurement
chigo	稚児	boy-acolytes
—ennen	稚児延年	boy-acolyte version of ennen
chimimōryō	魑魅魍魎	transforming spirit role types
danshō	男娼	male prostitute or prostitution
dōchū	道中	courtesan parade
deshi	弟子	apprentice
ebōshi	烏帽子	black court-style lacquered hat
ennen	延年	banquets with entertainments
eri	襟	collar
eriashi	襟足	nape of the neck
furisode	振袖	long furling kimono sleeves
gara	柄	pattern, design, character, or nature
geidan	芸談	art discussions
geta	下駄	wooden clogs
gidayū	義太夫	song narration, ballad drama
hakama	袴	long, loose skirt-like pants
hana	花	lit. flower (related to nō aesthetics and kabuki performance)
hana gei	花芸	lit. flower art, dance art

hanamichi	花道	raised rampway from the back of the auditorium to the stage
hashigakari	橋懸	bridge-form passageway to main stage
haragei	腹芸	lit. gut art, emotional truth
hengemono	変化物	transformation piece, transformative beings
himesama	姫様	princess role
hinin	非人	nonhuman
inakamusume	田舎娘	country girl role
iro	色	sensual coloring
iroke	色気	erotic allure
—no bi	色気の美	the beauty of erotic allure
iroke o dasu	色気を出す	radiating erotic allure, attract
iroko	色子	lit. love child, boy prostitute performer
ishōkata	衣装方	costumer
itoyori	糸より	lit. braiding threads, weaving line dance
jidainyōbō	時代女房	period wife role type
jigei	地芸	lit. earth art, acting art
jinkō no bi	人工の美	artificial beauty
jo ha kyū	序　破　急	traditional performance pattern in time and space: introduction, breaking apart, acceleration
jorō	女郎	female prostitute role, licensed prostitute
jōruri	浄瑠璃	chanted drama of the puppet theatre
joyū	女優	actress, or woman actor
kabuki	歌舞伎	music, dance, skill: kabuki
kabuki	歌舞妓	early form of kabuki: music, dance, prostitute
kabuki mono	歌舞伎者	kabuki people, radical types
kabuki no bigaku	歌舞伎の美学	kabuki aesthetics
kabuku	かぶく	to slant, to shift off center, to be outside the norm
kagema onna	陰間女	woman onnagata prostitute performer
kamae	構え	physical carriage and posture
kamiko	紙衣	paper kimono
kamisuki	髪梳	hair combing
kamuro	かむろ	courtesan attendant
kanashimi	悲しみ	deepening sorrow
kaneru yakusha	兼ねる役者	a combination actor, tachiyaku who play male and female gender roles
kankaku	感覚	sensual perception
kanzashi	簪	long spike-like hair ornament
karada o korosu	体を殺す	killing the body
kata	型	stylized forms
katsura	鬘	wig
katsurekimono	活暦物	living history plays
keisei	傾城	high-ranking courtesan

keiseikai	傾城買	prostitute buying scene
kihon	基本	basics, fundamentals
—no kata	基本の型	basic forms
kiryō	器量	image
kiseru	煙管	long slender smoking pipe
kitsuke	着付け	under kimono
kizewamono	生世話物	raw or real life contemporary plays
kochō	胡蝶	butterfly, type of early dance performed by children
kōken	後見	stage assistant
kokoro	心	heart
koshi	腰	solar plexus, lower pelvic region
kudoki	口説き	lament, longing, persuasion
kusemai	曲舞	type of dance and music adopted into nō
machimusume	町娘	city girl role
maonnagata	真女形	pure onnagata, onnagata who plays exclusively onnagata roles
maegami	前髪	front forelock
mage	髷	top knot of wig or hair
midaregami	乱れ髪	astray or disordered hair
mie	見得	stopped action pose
miko	巫女	virgin temple maidens
miryoku	魅力	fascination, charm
mochigami	持紙	pad of tissue papers
monomane	物真似	imitation
—kyōgen zukushi	物真似狂言尽	fully enacted performance
murasaki bōshi	紫帽子	purple forehead scarf
musume	娘	daughter, young girl role
nadegata	撫肩	sloping shoulders
nakigami	泣き紙	crying paper
nanshoku	男色	male love
nimaime	二枚目	young male lover role
nureba	濡場	"wet" or erotic love scene
nureru	濡れる	to get wet, excited
nyōbō	女房	wife role
obi	帯	sash wrapped and tied at waist of kimono
odeko	おでこ	prominent brow
odoriko	踊子	female child dancer
oiran	花魁	top ranking courtesan role
omoiire	思入れ	an emotionally charged pause
onna budō	女武道	female warrior
onnagata	女形	female form, female gender role specialist
onnagata no kihon	女形の基本	onnagata fundamentals
onna kabuki	女かぶき	female kabuki
onnappoi	女っぽい	feminine

onnarashisa	女らしさ	female-likeness
onnayakusha	女役者	female actor
otoko no geisha	男の芸者	male geisha
otokoppoi	男っぽい	masculine
oyajiwakashu	親父若衆	older man and boy relationship
sajiki	桟敷	side galleries in kabuki theatres
sarugaku	猿楽	miscellaneous entertainments with comic pantomime
sen	線	line (of the body)
—o kiru	線を切る	cutting a line (of the body)
sewanyōbō	世話物女房	contemporary wife role
shamisen	三味線	plucked three string instrument
shinjū	心中	love suicide
shinri	心理	psychology
shirabyōshi	白拍子	early prostitute performer who dressed in male attire
shōnen	少年	adolescent boys
shosagoto	所作事	lit. gesture piece, dance drama
shudō	衆道	the way of boy love
sudare oriru	簾下りる	rolling down the screens (as lovers embrace)
sugata	姿	postural shape
suso	裾	hems of the kimono skirts
tabi	足袋	cloth socks with bifurcated toe space
tabo	髱	back neckline hair gathered in various shapes
tachiyaku	立役	lit. standing role, male gender role specialist
tamatebaco	玉手箱	jewel box, pandora's box
tatehiza	立膝	lit. standing knee, kneeling with one knee raised
tateoyama	立女形	the highest ranking onnagata in a troupe, also pronounced tateonnagata
tayū	太夫	top ranking courtesan role
tenugui	手拭	long scarf-like towel
tokoyama	床山	wig dresser
tsuke	ツケ	wooden clappers beat on a board
uchikake	打掛	over kimono
ukiyō-e	浮世絵	floating world picture
uso	嘘	lie, illusion
wagoto	和事	gentle style
wakane	若音	high-pitched boy soprano
wakaonnagata	若女形	young onnagata
wakashu	若衆	youth, young boy, boy prostitute performer
wakashu jorō	若衆女郎	*wakashu* female prostitute
warabemai	童舞	children's dance
yaku	役	position, duty, or role
yakugara	役柄	role type

yarō	野郎	fellow or adult male
yōshiki	様式	stylization
yūjo	遊女	courtesan
zankoku	残酷	torture
—no bi	残酷の美	the beauty of torture

INDEX

Page numbers in bold indicate illustrations.